The Bostonians:
Painters of an Elegant Age, 1870-1930

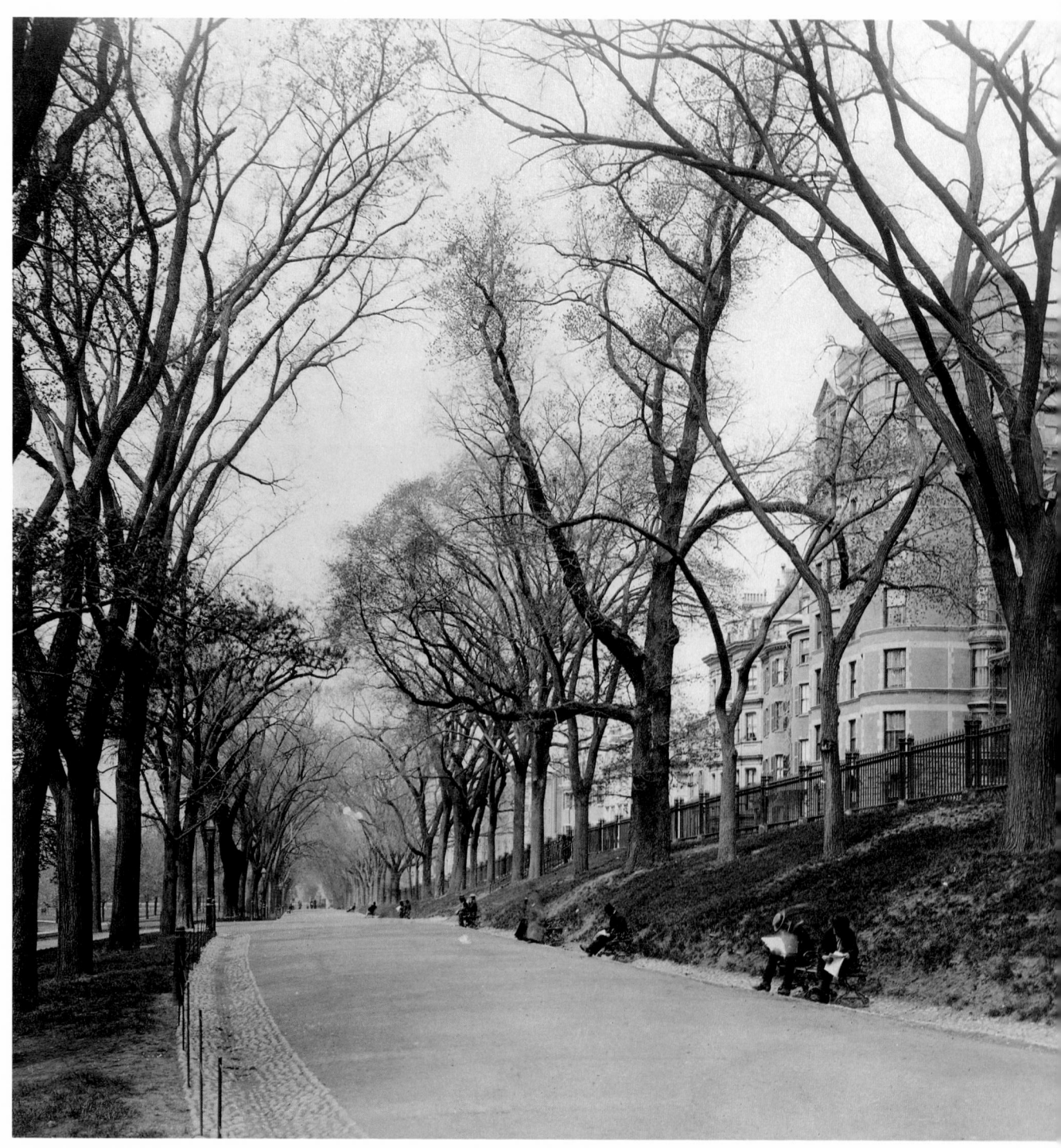

The Bostonians

Painters of an Elegant Age, 1870-1930

Trevor J. Fairbrother

with contributions by

Theodore E. Stebbins, Jr.
William L. Vance
Erica E. Hirshler

Museum of Fine Arts,
Boston

The exhibition and catalogue are made possible by grants from Shawmut on the occasion of their 150th anniversary; the Luce Fund for Scholarship in American Art, a project of The Henry Luce Foundation, Inc; and the National Endowment for the Arts, a Federal agency.

Library of Congress
Catalogue Card No. 86-60610

ISBN: 0-87846-269-4 (paper)
ISBN: 0-87846-271-6 (cloth)

Typeset and printed by
Acme Printing Co., Medford, Massachusetts
Designed by Carl Zahn

Cover (and jacket) illustrations:
Front: IGNAZ GAUGENGIGL
Portrait of Man and Dog, ca. 1905. (cat. no. 9)
Back: JOHN SINGER SARGENT,
Mrs. Fiske Warren (Gretchen Osgood) and her Daughter Rachel, 1903 (cat. no. 8)

Photo Credits:

Boston Athenaeum: figs. 4, 25; Boston Public Library: frontispiece, figs. 1, 13, 23; Copley Society, Boston: fig. 18; Essex Institute, Salem, Mass.: fig. 24; Guild of Boston Artists: fig. 45; Isabella Stewart Gardner Museum, Boston: fig. 41; Joan Michelman, Ltd., New York: fig. 14; Society for the Preservation of New England Antiquities, Boston: figs. 29, 42, 43; Vose Galleries, Boston: fig. 38

Exhibition Dates:
Museum of Fine Arts
June 11–September 14, 1986
The Denver Art Museum
October 25, 1985–January 18, 1987
Terra Museum of American Art, Chicago
March 13–May 10, 1987

Changes in exhibition:
Boston only:
cat. nos. 1, 22, 47, 56, 93, 100, 103, 104, 107
Boston and Denver only:
cat nos. 3, 4, 18, 35, 72, 75, 109
Boston and Chicago only:
cat. nos. 62, 92
Denver and Chicago only:
cat. no. 28
Denver only:
cat. no. 91

Foreword

The Museum of Fine Arts is honored that Shawmut has chosen to sponsor *The Bostonians: Painters of an Elegant Age, 1870-1930*. The project is the first major survey of Boston painting during its richest artistic and intellectual era, when several of the leading artists were instructors at the Museum School. Many of the works are from the Museum's holdings and were acquired during the artists' lifetimes; one comes from Shawmut's own fine collection. Shawmut's sponsorship of the exhibition enables the public to rediscover the variety and quality of our city's art during a period when it deliberately set an example to the nation.

On behalf of the trustees, overseers, and staff of the Museum of Fine Arts, I extend our deep gratitude for the vision and civic leadership Shawmut has demonstrated by this support.

RICHARD D. HILL
President
Museum of Fine Arts

Shawmut is pleased to have the opportunity to sponsor the outstanding exhibition and catalogue *The Bostonians: Painters of an Elegant Age, 1870-1930*. Boston's reputation as the Athens of America is attributable in large part to the Museum's series of outstanding exhibitions, as well as to the many fine artists who have worked here and continue to do so.

We believe it is vital that the arts receive the support of the entire community, and we are glad to be able to provide funding for "The Bostonians" show. It is particularly meaningful for us to do so this year, the 150th anniversary of our founding. We believe we couldn't have chosen a better event to be the focal point of our anniversary celebration.

JOHN P. LAWARE
Chairman
Shawmut Corporation

Contents

Lenders to the Exhibition

Addison Gallery of American Art, Phillips Academy, Andover, Massachusetts

Berry-Hill Galleries, New York

Bowdoin College Museum of Art, Brunswick, Maine

Virginia Bailey Brown

Canajoharie Library and Art Gallery, New York

Cooper-Hewitt Museum, Smithsonian Institution's National Museum of Design, New York

The Corcoran Gallery of Art, Washington, D.C.

Howard Dittrick Museum of Historical Medicine, Cleveland Medical Library Association, Ohio

President and Fellows of Harvard College, Cambridge, Massachusetts

Mr. and Mrs. Graham Hood

Mr. and Mrs. Raymond J. Horowitz

Ira and Nancy Koger Collection

David J. Latham

Maier Museum of Art, Randolph-Macon Woman's College, Lynchburg, Virginia

Dr. and Mrs. Charles M. Malkemus

The Metropolitan Museum of Art, New York

Museum of Art, Rhode Island School of Design, Providence

Museum of Fine Arts, Boston

National Academy of Design, New York

National Museum of American Art, Smithsonian Institution, Washington, D.C.

The Pennsylvania Academy of the Fine Arts, Philadelphia

Shawmut Bank of Boston

Sheldon Memorial Art Gallery, University of Nebraska, Lincoln

Smith College Museum of Art, Northampton, Massachusetts

Sterling and Francine Clark Art Institute, Williamstown, Massachusetts

Daniel J. Terra Collection, Terra Museum of American Art, Chicago

Mr. and Mrs. Abbot W. Vose

Worcester Art Museum, Massachusetts

Anonymous Private Collections

Preface

Boston has loved painting almost from the very beginning of its history. During the 1670s, the small town of perhaps 3,600 inhabitants nurtured a handful of artists, including the Freake Limner, who made up the first "American School." In the eighteenth century, Boston was home for generation after generation of painters, each one including the preeminent talents of the time, beginning with John Smibert in the 1730s, followed by Joseph Badger and Joseph Blackburn; then, in the years before the Revolution, John Singleton Copley took the art of portraiture to undreamed-of heights. His departure for England in 1774 marked the beginning of a depressed period for the arts in Boston and America, but Boston's status was reaffirmed when the greatest Federal painter, Gilbert Stuart, made the city his home from 1806 until his death in 1828, while teaching the city and the nation a new, advanced style of portraiture. Stuart was succeeded by the powerful, enigmatic figure of Washington Allston, whose work we showed in depth in 1980, and he in turn by another brilliant group of painters including William Morris Hunt (last seen here in the Memorial Exhibition of 1979), Winslow Homer (whose watercolors we exhibited most recently in 1977), and George Inness.

All this background, all these artists, set the stage for what may be our city's favorite group of painters, the Boston School at the turn of the century. The Museum itself, founded as it was in 1870, played an important role in the formation of the group, for the major figures – including Tarbell, Benson, Paxton, and Philip Hale – all taught at the Museum School, which became the center for Boston's painters. Their unique and charming style, their devotion to tradition and to craft, and their national significance are all studied in the present exhibition, which is the most important showing of their work since the MFA's Tarbell-Benson exhibition of 1938, and the first major exhibition of the School as a whole.

The Museum of Fine Arts has always felt a special interest in and a special obligation toward the artists of our own area, and the families of Boston and New England have responded in each generation by entrusting to our permanent care the best of Boston's paintings. As the collection is preeminent in the work of Copley, Stuart, and Allston, so it is with the work of the Boston School; many of the fine examples included herein are from the MFA. Fortunately, this process continues, and we point with pride and gratitude to several very generous recent gifts: for example, the five daughters of Charles Hopkinson have presented the Museum with *The Hopkinson Family* (cat. no. 17); Mrs. Eugene C. Eppinger recently donated the superb *New England Interior* by Tarbell (cat. no. 65); Ernest Major's splendid *Portrait of Miss F.* (cat. no. 14) was given by Harold and Esther Heins; and the Charles Coolidge family have given their scintillating, sunlit picture by Benson (cat. no. 55) just in time for the exhibition.

On this occasion we are particularly grateful to all of the lenders and donors who have made the show possible; to Shawmut, whose generous sponsorship has underwritten the beautiful catalogue and the showing in Boston; to the Luce Fund for Scholarship in American Art, a program of The Henry Luce Foundation, Inc., whose grant has made possible the extensive research effort underlying the exhibition; and to the National Endowment for the Arts for its support.

JAN FONTEIN
Director

Acknowledgments

Three years ago the scholarly phase of this reevaluation of the Boston School was inaugurated with a generous grant to the Museum from the Henry Luce Foundation. I am deeply grateful to the director, Jan Fontein, for giving me the opportunity to research and to realize the exhibition. My colleague Carol Troyen, Associate Curator of American Paintings, paved the way with her splendid 1981 exhibition and catalogue *The Boston Tradition*, which surveyed the Museum's American paintings with local associations and spanned the two hundred years between the careers of Smibert and Prendergast. Theodore E. Stebbins, Jr., the John Moors Cabot Curator of American Paintings, suggested an exhibition on the heyday of Boston painting from 1870 to 1930 and gave wise counsel from the start through the final editing of the text.

The entire Department of Paintings and its conservation staff have been supportive in countless ways. Perhaps the most pleasing and tangible result is the cleaning and restoration of pictures and frames that were damaged or dirty; Alain Goldrach, Brigitte Smith, Jean Woodward, Irene Konefal, Rita Albertson, Yvonne Szafran, James Barter, and Michael Morano deserve our thanks for providing a fresh appreciation of many of the objects. Patricia Loiko, Harriet Rome Pemstein, and Pamela J. Delaney have shared the enormous volume of administrative and bureaucratic duties; Erica E. Hirshler (National Endowment for the Arts Intern) gave continued assistance on all aspects of the project and wrote insightful biographies of the artists; and Cynthia Fleming has been a tireless and superlative research assistant.

In the administrative offices of the Museum I am deeply obliged to Ross Farrar and to all his colleagues, including G. Peabody Gardner III, Kathy Duane, and Janet Spitz, for overseeing the project and for securing local and federal funding for its presentation. Carl Zahn, Director of Publications, is responsible for the beauty and character of this catalogue, and Judy Spear, the editor, gave expert advice on its text. Photographers John Woolf, John Lutsch, and their colleagues provided dozens of excellent illustrations for the catalogue, and Janice Sorkow, Manager of the Photographic Services Department, coordinated this and the gathering of photographs from other institutions. Linda Thomas, Registrar, and Lynn Hermann Traub, Assistant Registrar, supervised all aspects of the loan and transportation of the art. Tom Wong, Museum Designer, and Judith G. Downes, Chief Exhibition Designer, have created a sensitive installation in Boston. The staffs of Buildings and Grounds, the Department of Education, the Library, the Museum Shop, Publicity, the School of the Museum of Fine Arts, and Special Events and Food Services have all contributed to the success of this project. Special mention must be given to the Department of Prints, Drawings, and Photographs – in particular, to Cliff Ackley, Sue Reed, David Becker, and to their conservation staff: Roy Perkinson, Elizabeth Lunning, and Joan London; I am indebted to them for their help with the works on paper, including the painstaking restoration work they have done for many months.

In his essay "Redefining 'Bostonian' " William L. Vance, Professor of English at Boston University, gives a lively new approach to the complexities of the cultural milieu, and I take pride in the fact that such a fine piece of writing results from this exhibition. Three local institutions have been especially helpful to all contributors to the catalogue: the Archives of American Art, the Boston Public Library, and the Boston Athenaeum. We are indebted to S. Morton Vose II and the staff of the Vose Archives, Dictionary of American Painters Project, who generously shared their research and aided us in checking biographical facts about the artists. It is impossible to list all of the people in museums, libraries, academia, art galleries and collecting circles who have assisted; however, the following individuals were particularly kind: Warren

Adelson, Tim Albright, Louise Ambler, Esther Anderson, Bruce and Enid Beal, Morton Bradley, David S. Brooke, Jeffrey R. Brown, Janice Chadbourne, Carol Clark, Harold D. Clark, Jr., William A. Coles, Kathryn Corbin, Sally Dodge, Monique van Dorp, Tom Dunlay, Cynthia English, Stuart Feld, Susan Fleming, Abigail Booth Gerdts, Rollin van N. Hadley, Isabella Halsted, Esther Heins, Christine Hennessey, Mary Jane Hickey, Frederick D. Hill, James Berry Hill, Sinclair H. Hitchings, Pam Hoyle, D. Roger Howlett, Kenneth Kelleher, Franklin Kelly, John T. Kirk, Beverly Lombard, Lawrence J. Lynch, Patricia Marr, Nancy Mathews, Joan Michelman, Lilly Millroy, M. P. Naud, Edward J. Nygren, Richard Ormond, William and Nancy Osgood, Virgilia H. Pancoast, Meg Perlman, Bonnie Porter, Eric Rosenberg, William McKennan Rust, Mrs. John L. Schaffer, Edward Shein, Mrs. William A. Shurcliff, Susan Sinclair, Mrs. John B. Staley, Miriam Stewart, Diana Strazdes, Susan E. Strickler, Barbara Swan, Wendy Swanton, William Penrose Tarbell, William H. Truettner, Robert C. Vose, Jr., Robert C. Vose III, Abbot Williams Vose, Alfred J. Walker, Robert G. Workman, and many private collectors.

TREVOR J. FAIRBROTHER
Assistant Curator,
American Paintings

Introduction: The Course of Art in Boston

THEODORE E. STEBBINS, JR.

Boston always took it for granted that the best painters in America were her own, and for much of the city's history, this assumption was valid enough. From the Freake Limner in the late seventeenth century to Smibert and Copley in the eighteenth and then Gilbert Stuart in the first quarter of the nineteenth century, painting in America meant the portrait, and for the ablest talents and most modern styles in portraiture, one looked to Boston. However, by the time of Stuart's death in 1828, Boston's position – artistically, economically, and in other ways – had changed dramatically. It was now only the third largest city in the nation, relatively small and provincial in comparison to cosmopolitan Philadelphia and to commercial New York, which was booming as a result of the newly opened Erie Canal. Nonetheless, in Boston great fortunes continued to be made in shipping and trade, and later in textiles and railroads, by Elias Hasket Derby, Thomas Handasyd Perkins, John Murray Forbes, and Amos and Abbott Lawrence, among others; they and their descendants, together with a handful of families whose money and position dated from before the Revolution, made up the tightly knit "Brahmin" class that dominated Boston for the entire nineteenth century and beyond.

In terms of culture, Boston became during this time the undoubted literary and educational center of the nation. William L. Vance, in his essay below, writes of Boston's reliance on the written word. The birth of mature American letters, the so-called American Renaissance, was fueled by writers from Puritan and Brahmin families of Boston, Concord, Cambridge, Salem, and nearby Maine, including Emerson, Thoreau, Hawthorne, James Russell Lowell (of the wealthy textile family), Francis Parkman (who in ill health dictated his *Oregon Trail* to his cousin, Quincy Adams Shaw), and Henry Wadsworth Longfellow.

As Boston came to dominate America's literary mainstream, so at the very same time it began to rescind its traditional, oft-stated demand for the "latest and best" in furnishings and paintings. Stuart's portrait-painting students and successors prospered, but they were hardly major masters. At a time when New York was quick to patronize new and demonstrably American painters who were working in innovative modes, depicting everyday, middle-class rural and frontier life in "genre" paintings and celebrating on canvas the grandeur of American landscape scenery with topographical exactitude, Boston instead lionized Washington Allston, who became the leading painter in the city in the years between his return from London in 1818 and his death in 1843. A Harvard-educated gentleman, like so many of the prominent writers, Allston himself was an author and theorist, an intellectual and idealist. As a painter, he looked not to America and the present, as did New York's burgeoning Hudson River School and its genre painters led by William Sidney Mount; rather, he venerated Europe and the past. This "man of genius," as Coleridge called him, painted practically no commissioned portraits, his landscapes were done from romantic memory rather than observation, and his great love was history painting after biblical or Shakespearean texts in the style of Venetian Renaissance masters. Allston fitted Boston's increasingly literary attitude, where ideas in art seemed more important than their visual realization, and it was easy for Bostonians – as accustomed to artistic prominence as they were – to assume that the English critic Anna Jameson was correct in describing Allston as "not only the greatest painter America has yet produced, but one of the greatest painters of the age." In fact, Allston symbolizes (though he surely did not cause) Boston's turn toward an art that was idealistic rather than materialistic, one that was poetic in spirit, European-minded, historically conscious, subtly colored, and looked

for alternatives to what Bostonians called the "crass materialism" of New York.

Allston's death in 1843 and the discovery that his long-anticipated masterpiece, *Belshazzar's Feast*, lay in unfinished ruin in his studio, made manifest the city's swift and complete fall from artistic preeminence. Amid the prospering merchants and the superb writers one could point, in painting, only to the small talents of a Francis Alexander or a Chester Harding. There *was* a truly magnificent marine painter who was just beginning his careeer to the north of Boston in Gloucester, but his style seemed primitive, unsophisticated, and very literal to eyes that had so loved Allston, and it would require another full century before Fitz Hugh Lane was fully recognized.

When William Morris Hunt returned to Boston in 1855 after studying with Thomas Couture and making friends with the great Barbizon master Jean-François Millet in France, he must have been greeted as a prodigal son. With his handsome urbanity, his passion and artistic flair, and his close European connections, he fitted Boston's requirements exactly and he must have seemed a pure artistic genius from the Allston mold. In addition, he was a New Englander, well born, and his lack of wealth was quickly remedied when he married a Boston heiress – following the examples of Allston and Copley before him.

What boded best for the future, however, was Hunt's progressive taste. His own loose, painterly style and his preference for feeling and sincerity over the niggling reproduction of nature's details all looked to the future, to the replacement of Hudson River and Ruskinian styles with a broader French mode influenced by Barbizon; moreover, he played a major role in several other important areas. For one, through his own classes, he prepared the ground for the establishment of the School of the Museum of Fine Arts in 1876; and as a teacher of many women artists during the seventies, he surely made the way easier for the numerous female painters who were active in the Boston School in later years. And even more important was the role he played as tastemaker and proselytizer for modern French painting. It was he who persuaded Boston collectors, notably Quincy Adams Shaw, to collect the work of Millet – which resulted eventually in the Museum of Fine Arts owning thirty-nine paintings and thirty-one pastels of Millet, all gifts from Boston families. Millet was by far the most socially concerned of the Barbizon masters, and even without Hunt, his strong, noble peasants and his barren fields would have appealed to Boston's puritanism and to her moral, reformist sensibility. Moreover, when Hunt and Boston were buying his work, Millet was a truly modern artist, not yet appreciated in his own country. This love of the new, seen in the taste for Millet, harks back to Boston's eighteenth-century tradition, and it, in turn, led directly to Boston's subsequent love affair with the Impressionists and especially with Monet, who was actively collected in Boston from the late eighties on. Thus, Hunt's contributions were extraordinary, and the fact that he narrowly missed being an artist of the first rank, of truly great accomplishment, does not change the fact that his leadership and his attitudes set the stage so well for those who followed.

During the two decades after Hunt's death in 1879, the Boston art scene was both spirited and progressive. The Museum School, the Cowles School, Massachusetts Normal, and numerous others provided excellent instruction; there were a half-dozen fine local dealers, who were augmented by shows from Durand-Ruel and other European visitors; the Museum presented numerous contemporary exhibitions, beginning with retrospectives of Hunt and Rimmer; and there was active patronage and collecting of much of the best and most adventurous French and American painting. Spiritual leader of the school was the expatriate John Singer Sargent, who was widely consid-

ered the leading modern painter in the world, and was nowhere more admired than in Boston. From much the same mold as Allston and Hunt, he was thought their worthy successor and more, for his was a truly international reputation. Following his lead, Boston surely could regain its rightful position in the American art world. He was both elegant and well connected, and though never a permanent resident of Boston, he was one of the Gloucester Sargents whose forebears had on numerous occasions commissioned portraits from Copley, and his domicile was London, a place Bostonians revered. Sargent established for Boston the very model of what to paint and how to paint it: dark yet dashing portraits were executed in a Van Dyck manner with the women in thoughtful poses, beautifully dressed within elegant interiors, while the men were soberly portrayed, their confident faces gleaming against dark backgrounds. Landscapes were entirely different: here, if time allowed, one worked in oil in the style of Sargent's friend, Monet; or, if traveling, in dashing sunlit watercolors. This brilliant and highly original dichotomy of styles was Sargent's own invention, and it was perfect for the time: portraits were aristocratic above all, and they recalled the Old Masters in their dignity and their careful drawing and craftsmanship, while the landscapes satisfied every urge for French *plein-air* modernity.

The major figures had taken their places by 1889, when Tarbell and Benson joined the faculty at the School of the Museum of Fine Arts. For a decade or more, Bostonians produced as fine a body of work as was made anywhere in America. The group of "The Ten" was a *Who's Who* of many of America's best resident painters of the time (though lacking Winslow Homer, who declined an invitation to join, and Thomas Eakins and Albert Ryder, who weren't asked); half of the founding members in 1898 were Boston painters while half were New Yorkers, and it could be argued either way as to which city was the greater art center.

This Boston renaissance, following the city's artistic decline in the early and middle years of the nineteenth century, must have seemed to augur well for the future. However, even in these halcyon times, one can see signs of trouble. As early as 1889, the brilliant young painter Dennis Bunker, despite his social and artistic successes, had moved away from Boston, to New York. Still, Bunker was temperamental, and a New Yorker by birth, so one could explain his move simply on personal grounds. However, in the same year the Boston-born Childe Hassam came back from Europe, and he too left to settle in New York. The loss of these able painters – perhaps the greatest talents then working in Boston – was a serious blow, and deprived the city's artists of two important colleagues. Another innovator, Maurice Prendergast, later followed in their footsteps, making a similar move to New York in 1914. Significantly, of all Boston painters, it was Hassam and Prendergast who most truly understood the technique and implications of Impressionism. They were the only Boston painters who, rejecting Sargent's methodology, utilized it in all of their work, painting Impressionist landscapes, still lifes, and, most important, interiors, figures, and portraits as well. Moreover, they both (especially Prendergast) explored Impressionism far enough to develop their own Post-Impressionist styles. Other Boston painters, for the most part (Philip Hale is an exception), used an unadventurous landscape style derived from Monet, and never went any further.

In terms both of creating and of collecting art (phenomena that are always related), Boston simply seems to have lost its adventurous spirit around 1900, or by 1910 at the latest. One sees various kinds of evidence for this; for example, Boston had loved Monet more than any other modern French painter, and his works were collected by many Boston families over the years – so that the Museum of Fine Arts today owns thirty-nine of his paintings, all but two of them gifts from local collectors.

Yet of these thirty-nine, only three date from after 1900; the latest example is a Venetian scene from 1908, and apparently no Bostonian followed Monet into his late work or ever bought one of the magnificent, nearly abstract, late pictures. Progressive Boston collecting nearly comes to a stop at this time: the Nabis, Post-Impressionists, Cubists, and Futurists were not bought by Boston collectors until the 1950s, when the city regained its energies, developing the technical industries of Route 128 and renewing its optimistic view of the future.

What began in the eighties as an embrace of the new on the part of Boston painters slowly became stale and repetitive, as any style does. New blood came, but the values, methods, and style of the eighties remained in place, unchallenged. William M. Paxton, who joined the Museum School faculty in 1906, symbolizes the great gap that once again had grown up between the New York mainstream and provincial Boston. A fine draftsman, an academic who looked to Vermeer and Gérôme for his roots, Paxton was idolized in Boston. At the same time, his work was dismissed as old-fashioned and "shallow" by New York critics who in the first decade of the twentieth century had seen and absorbed innovative painting that for years would be unrecognized in Boston, including the Ashcan School of Henri and Sloan, and the work of Cézanne, Matisse, and Picasso that Alfred Stieglitz was showing at his gallery.

All movements become sterile, and many artists fail to develop, but what happened in Boston was that the culture of the city itself changed. How this happened among writers was first made clear in Van Wyck Brooks's seminal study *New England: Indian Summer, 1865-1915*, which found the city at the end of the nineteenth century becoming increasingly peevish, self-complacent, and narrow. Charles Francis Adams wrote that Boston had by the turn of the century become "stationary," that its trouble "is no current of

fresh outside life everlastingly flowing in and passing out."[1] His brother Henry developed this pessimistic thesis at length in his *Education of Henry Adams*, and others wrote again and again to the same point. Even before Brooks's book, Elmer H. Davis took up the seasonal image in 1928 and said of Boston: "It is flawless, complete, finished, static, dead; it lies before you in autumnal sunset splendor"[2]

What had happened to Boston's enterprising character? Two words can answer that: satisfaction and fear. The satisfaction can be well illustrated in the words of Oliver Wendell Holmes: "The influence of a fine house, graceful furniture, good libraries, well-ordered tables, trim servants, and above all, a position so secure that one becomes unconscious of it, gives a harmony and refinement to the character and manners."[3] Satisfaction with privilege and power combined with a fear of change. Not only was the world turning upside down with the Labor Movement, the Women's Movement, the inventions of the auto and the airplane, the work of Freud and Einstein, the Great War, and finally the Depression – all combining to destroy the genteel, Edwardian era in America – but Boston's upper class faced special fears. For one thing, the change from a rural to an urban society was especially quick and severe. By 1900 Massachusetts was the most thoroughly industrialized of all the states, and three-quarters of the population lived in cities. Immigrants from southern and eastern Europe poured into Boston and other urban areas in the region, and Boston changed from being a merchant city of 200,000 in 1850 to an industrial metropolis with over one million people by 1900.[4] Scholars point to the "intensification of dramatic class and ethnic cleavages" in Massachusetts in the late nineteenth century, with "the gulf between classes becoming greater than ever before or since."[5]

Boston's culture was especially poorly equipped to deal with these changes. A special report in *Fortune* magazine for February 1933 reported that "present-

day Boston is an investor's city. Its power and initiative are gone," and it laid the blame for this on "the great family trusts which stand between the Bostonians and the activities of everyday life."[6] Many other writers reinforce these points. Frederic Jaher notes the "long-term decline and eventual collapse of the New England textile industry, the upper-class economic base,"[7] reporting that while textile company dividends averaged seven percent between 1860 and 1910, they fell to four percent or less thereafter. The "spendthrift trust" was perfected in Boston, so that income went to Brahmin heirs who had neither the energy nor even the legal right to make their own capital investments or to take risks. Jaher's excellent recent study of Boston class and economics suggests that "Against the modern demands for efficiency, mobility, adaptability, innovation, objectivity, achievement, and coordination, the genteel objectors raised the claims of loyalty, sentiment, inheritance, tradition, community, and authority."[8] This summary applies to the painters: no one would suggest that their undoubted qualities (tradition, sentiment, and the like) are unworthy ones, but only that their fervent adherence to past styles (to old loyalties, as it were) made it impossible for them to adapt to a changing world or – because they became so entrenched – to be replaced. In addition, Bostonians were notoriously loyal to their painters; once an artist was accepted, he or she was accepted for life. Thus, when the Museum of Fine Arts offered a commission for the decoration of its rotunda in 1916, the job went naturally to the painter still most admired in Boston, John Singer Sargent, who was by then well past his most creative years. In retrospect, Boston's love of Sargent was both fortunate and unfortunate – fortunate in having provided for the city's painters a brilliant role model in the eighties and nineties, but unfortunate in that Sargent's work, unlike that of an Eakins, a Ryder, or a Whistler, had few of the formal or subjective implications that in other hands and for other cultures made a transition into the modern era more logical and more palatable. In Boston, what happened instead was that the Boston School style, based on Sargent, remained as dominant in 1930 as it had been in 1910, and it has retained great influence over Boston taste to this day.

Ample evidence of this development can be found in contemporary literature, both in its relative decline from the heroic days of Emerson, Thoreau, and Hawthorne and in its treatment of Boston itself. William Dean Howells, who lived in Cambridge and Boston, often wrote about the city and its habits, and the evidence of Boston's decline is graphic, albeit fictional, in such novels as *A Woman's Reason* (1883) and the *Rise of Silas Lapham* (1885). In the earlier book, Howells studied the character and temperament of a young woman, the result being an astonishing indictment of the rigid rules governing her behavior in polite society, of the impracticality of the education women were given, and the harm that could come from the ritualized, indirect way in which they were taught to communicate. Brahmins are pilloried, and the only straightforward, generous people in the book are Everton, the Jewish money-lender, and Margaret, the Irish servant, both representing classes that threatened the Brahmin. The heroine herself seems to have stepped directly out of a Tarbell or Benson interior, her half-lit face suggesting little individuality but only repression, while her whole attention is fixed upon her pearls, her teacup, or her sewing. In both books Howells dealt with family and with money and the loss of it. In *Silas Lapham* one character speaks of Boston's isolation and of the city's sometimes unjustified self-confidence, saying: "The Bostonian ought never to leave Boston. Then he knows – and then only – that there can be *no* standard but ours."[9] In retrospect, this comment applies especially well to the Boston painters, who after early European study seldom traveled much except to their summer

houses, and yet were totally confident in the rightness of their ways.

New York had to face the same incredible changes that occurred in every field in the first decade of the twentieth century. How was it able to make the transition with more ease and with artistic creativity? For one thing, it was already far more of a melting pot than was Boston, and its old aristocracy lacked both the homogeneity and the strength of Boston's. Many great fortunes, including those of Rockefeller, Harriman, and Hill, were new ones; prominent, artistocratic German Jewish families such as the Warburgs and the Lehmans had their own domains. In addition, New York was still in the ascendency, still optimistic. In art, it had a strong faction of conservative painters led by J. Alden Weir, but it was somehow big enough and varied enough to provide support for innovation. The Ashcan School ("The Eight") included leftist illustrators such as John Sloan and George Luks, as well as Robert Henri, who had changed his name because his gambler father had killed a man. Alfred Stieglitz played an important role in introducing both the European modernists and some of the best new American talents, including John Marin and Arthur G. Dove. The innovative styles of Alfred Maurer, Walt Kuhn, George Bellows, Oscar Bluemner, Joseph Stella, and Abraham Walkowitz, among others, were as varied as their ethnic, political, and geographic backgrounds. These painters were busy celebrating their artistic discoveries and their adopted city. In Boston, on the other hand, the painters were to an amazing degree either Brahmin (in the literal sense of being from one of the forty or so long-time, dominant families) or very close in attitude and association to that rigid, ethnically unified upper class.[10] Thus, they shared their fears, and they suffered in the end from the same loss of innovative instinct and the same conservatism.

This is not to suggest that middle- and upper-class artists cannot be talented or progressive, for history proves otherwise, but rather that Boston's artists as a group were essentially Brahmins, and thus that they shared that class's keen sense of a society on the defensive. Like the class as a whole, the artists became very much of a closed society. Moreover, the fact of so much breeding and wealth surely aided the tendency of the artists toward conservatism and dilettantism; it also explains why some of the abler painters produced so little work, as they lacked the artist's normal economic motive. When Tarbell, Benson, and Paxton left the permanent faculty of the Museum School in 1912-1913, they were succeeded by lesser painters who entirely shared their aesthetic aims and practices. In 1930 the early era of the Museum School came to an end with the death of Philip Hale and the resignations of both Tarbell and Benson from the School's Council. The School was entering troubled times, caused both by the impact of the Depression upon enrollment and by the Trustees' efforts to update and to modernize the curriculum and faculty.

In retrospect, one finds signs of weakness even in the seventies and eighties. Charles Eliot Norton, who was Harvard's Professor of the Fine Arts from 1873 to 1898, is described this way by one observer: "His aesthetic feeling was weak and derivative, but his scholarly feeling was strong, while his ethical feeling dominated all the others."[11] Art became a bearer of moral and ethical standards. It was seen as something that almost any educated person could do, and a great many Bostonians painted. It came to be "a good thing," rather than the result of a passion for truth. The pleasures of shared values and craft methods were celebrated over the taking of aesthetic risks. Art became a social enterprise. Mr. Alden, the Boston collector in George Santayana's *Last Puritan*, thought it "a public duty . . . for those who could afford it to encourage art in a new country." Art was for him a good cause, a charity; visual acumen and a love of painting were unnecessary for the collector, who thought that

"selfish and worldly people . . . would be quick to buy the good pictures: an unselfish and public spirited citizen would rather buy the others"[12] In the end, Van Wyck Brooks does not exclude even Mrs. Gardner, the city's greatest collector, from her share of the blame for Boston's predicament:

She saw Giorgione's finest points, as she saw the virtues of Sargent and Whistler, who blazed like meteors over the world of fashion. But she did not see the Yankee Giorgiones, Maurice Prendergast, Winslow Homer, Ryder. The innocent eyes that perceived these wore no veils.[13]

NOTES

1. Charles Francis Adams, *Autobiography* quoted in Van Wyck Brooks, *New England: Indian Summer* (New York: E.P. Dutton, 1940), p. 504.

2. Quoted in Russell B. Adams, Jr., *The Boston Money Tree* (New York: Thomas Y. Crowell Company, 1977), p. 215.

3. Oliver W. Holmes, "The Autocrat of the Breakfast Table," quoted in Frederic C. Jaher, *The Urban Establishment* (Urbana: University of Illinois Press, 1982), p. 84.

4. Jack Tager, "Massachusetts and the Age of Economic Revolution," in *Massachusetts in the Gilded Age*, edited by Jack Tager and John W. Ifokovic (Amherst: University of Massachusetts Press, 1985).

5. Alexander Keysson, "Social Change in Massachusetts in the Gilded Age," in ibid., p. 137.

6. "Boston," in *Fortune* 7, no. 2 (February 1933), pp. 100, 106.

7. Jaher, *The Urban Establishment*, p. 89.

8. Ibid., p. 120.

9. William Dean Howells, *The Rise of Silas Lapham* (New York: Random House, 1951), p. 58.

10. To be specific on this point: by a rough, conservative estimate, half of the ninety-six painters whom we consider leading members of the Boston School (see the biographies on pp. 198-230) were at least moderately wealthy and well connected. A number were very wealthy, indeed, and many of them were Brahmins or married to Brahmins.

11. Brooks, *New England: Indian Summer*, p. 251.

12. George Santayana, *The Last Puritan* (New York: Charles Scribner's Sons, 1936), p. 20.

13. Brooks, *New England: Indian Summer*, p. 438.

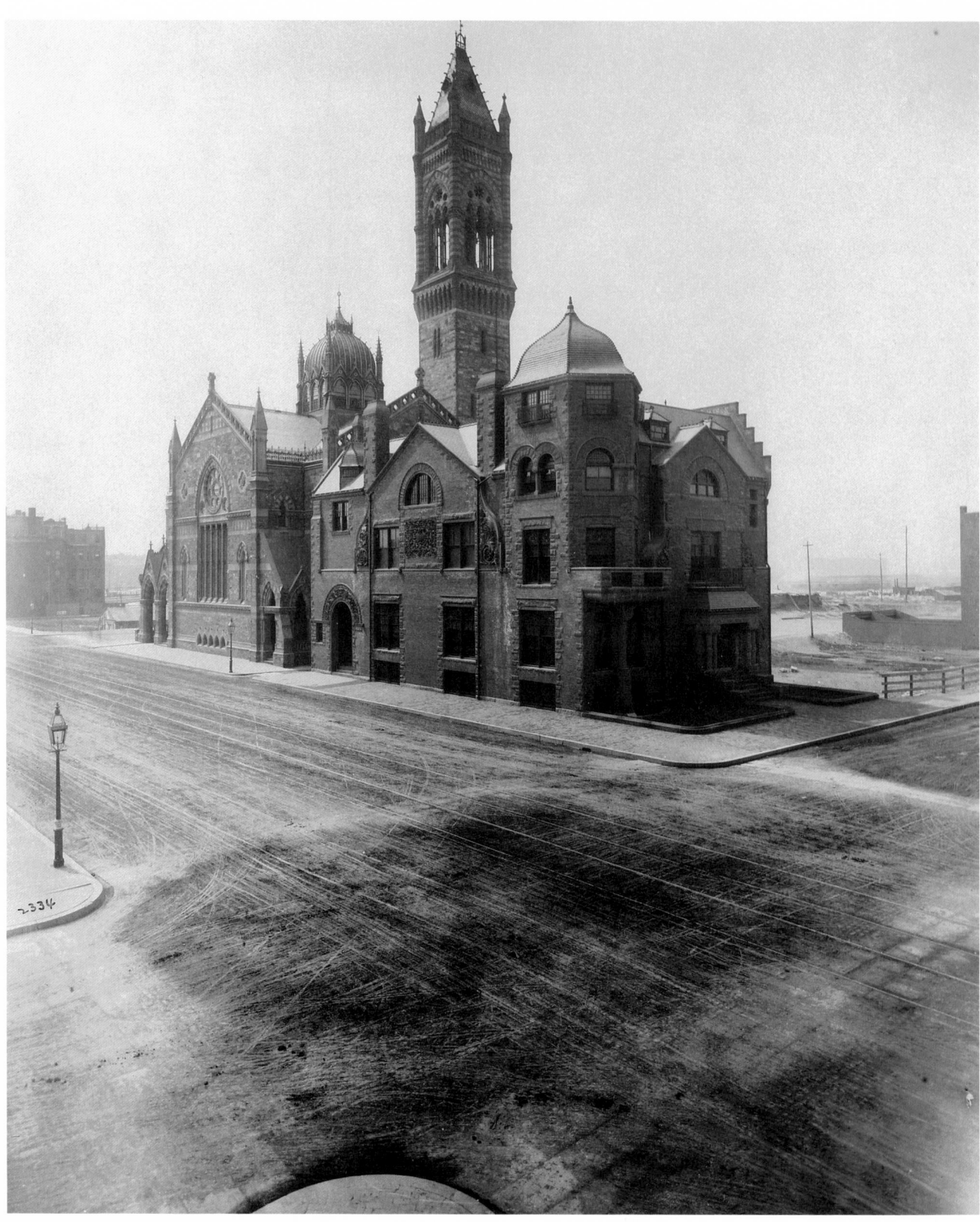

Redefining "Bostonian"

WILLIAM L. VANCE

"I shall be much abused for the title," Henry James wrote to his brother William in 1884, referring to his new novel, *The Bostonians*. He was right. *The Bostonians*, which was soon to be serialized not in Boston's own *Atlantic Monthly* but rather in a New York magazine, the *Century*, was widely perceived as a satire on a city of "witches and wizards, mediums, and spirit-rappers, and roaring radicals." This characterization in the opening pages comes, however, from the mouth of the de-Bostonized Mrs. Luna, who has been to Europe and will soon settle in New York, "that bright amusing city." Moreover, Mrs. Luna's words are addressed to a Mississippian, whose pleasure in hearing Boston ridiculed she takes for granted. Henry protested to William that he himself "hadn't a dream of generalizing," and to prove that he had no "invidious intentions," he promised to write another book to be called *The Other Bostonians*.[1] But in fact his novel depends, for its point of departure, upon the idea that places have distinctive identities based upon communal values that have been persistently expressed through historical actions – through what their most prominent citizens have actually said, done, and created. That Boston had long been populated with disgruntled idealists devoted to reform of the world was common knowledge. "Boston folks are full of notions" was a proverb even in Rhode Island, while jokes about hypercritical audiences, entrance examinations at the city limits, and a race of people who wore spectacles even in their cradles, were sufficiently numerous to indicate that other Americans knew what made "Bostonians" different.[2] Again according to Mrs. Luna, their motto was "Whatever is, is wrong" (p. 4). However unrepresentative of the less articulate and possibly embarrassed "other Bostonians," these were the people who had given Boston its "name" and made possible James's disinterested ideological triangulation of reformist Boston, reactionary Mississippi, and hedonistic New York.

The simplification to the point of caricature that such definition involved was becoming less plausible and therefore more widely objectionable by the 1880s than it might have been a generation earlier. The "other Bostonians" whose existence and right to the title James acknowledges were not the foreign-born whose proprietary promenade in front of the State House would so disconcert him on his return in 1905. They were rather those cultivated, wealthy, and worldly Bostonians whose social and political conservatism actually controlled the city, even though they were not the ones who made it different from New York or Philadelphia. In *The Education of Henry Adams*, Adams admits that he – who was the quintessential "Bostonian" by virtue of a name paradoxically associated with both tradition and rebellion, that is, with a rebellious tradition – was actually the son of two Bostons: that of an intellectual political aristocracy then located in the library and parlor of the Adams mansion on Mount Vernon Street, and that of his grandfather Brooks, located in financial offices on State Street. One Boston gave the Adams children Bibles, the other gave them silver mugs. In his youth the city of the Word carried on genteel warfare with the burgeoning city of Mammon, but in the course of his lifetime the worldly city triumphed. The larger fundamental symbolic opposition with which the *Education* opens is that between Boston and Quincy: it is Quincy that maintains the rural eighteenth-century "New England" values that Boston once shared, but to which its primary powers are now indifferent or opposed. The rhetoric of Adams's book requires simplification and caricature even more than James's fiction does, and it equally encourages equivocal uses of the term "Bostonian."[3] While conceding that an entirely different breed of Bostonian had emerged in his lifetime, in nothing

does Adams prove himself more Bostonian than in his rebellion against Boston, effected by leaving it to take up a permanent post of critical observation across from the White House. If Boston had temporarily lost national political power, it still had at least one person hereditarily predisposed to assert that "Whatever is, is wrong." But he did it while living elegantly and comfortably in a house built by a leading architect of the day – H.H. Richardson – the same whom "the other Bostonians" would hire to build a masterpiece of urban architecture for their own new Boston, the lavishly decorated Trinity Church. These Bostonians did not think that the Word was opposed to silver mugs.

The familiar notion that Boston entered a period of decline soon after the Civil War derives from the fact that writers usually have only one criterion of health: the vigor of verbal discourse. Boston had been founded upon the Word, and had maintained its identity through fidelity to the word. The dogmatic messages (Puritanism, Unitarianism, Transcendentalism) changed successively, but all the preachers trusted their medium. Boston had affected national – and therefore world – history chiefly through the rhetoric of its revolutionaries and its abolitionists, and had become both historian-pedagogue and civilizing poet to the expanding nation through its publishing companies and its Parkmans and Longfellows. Naturally, writers would see a relative failure of the word as absolute failure; in their eyes, if "Bostonian" did not mean literary, it meant very little. To the end of the century Boston's literary identity continued to attract talents from all of New England, some from New York, and many from as far as Ohio, South Dakota, and California. By the 1890s and after, however, those most capable of learning her chief lesson – the critical use of the word – turned it against her. Thinking of Boston's culture as dying or dead, they departed and broadcast their views to the world. Not

the ironies of Henry James only, but those of George Santayana and William Dean Howells (who had proved more than anyone how successfully a sufficiently literary outsider could become a true Bostonian), would indicate that Boston had become stale. The ironies of the disaffected would be gathered up and given a melancholy frame by literary historians (fellow disciples of the word), who would entrap their thought in fallacious metaphors of Indian Summers and Long Afternoons. Boston after the Civil War was presented as gathering its last autumnal fruits before placidly lapsing into irrelevance. Eventually a critic would worry over the "problem" of Boston, a "problem" arising from exclusions necessitated by the critic's own arbitrary definition of culture. Boston had ceased to be itself because it failed (under radically altered circumstances) to fulfill the potential said to be implicit in the literary-ethical values of an earlier generation.[4]

But the people who defined themselves through the creation of a virtually new city in the half-century following the Civil War thereby changed the meaning of "Bostonian." To characterize this city and its culture as in decline, and these people as feeble filopietists and desiccated aesthetes cut off from their nourishing rural New England roots, is an absurdity from any point of view but that of agrarian, anti-urban, "literary" values. By annexation and landfill Boston tripled its area by 1880, and between 1880 and 1930 the population of the central city doubled, and that of the metropolitan area tripled – reaching more than two million.[5] After the catastrophic fire of November 9-10, 1872, Bostonians found the energy, resources, and will to rebuild the entire central business district without public subsidy, making it "in all respects better than before," according to a proud commentator just eight years later. The district now had "more spacious streets" and "more elegant structures" and – not coincidentally – new water pipes and

improved fire hydrants.[6] On the other side of the Common, Bostonians sustained for half a century the Herculean task of filling in the Back Bay. Begun in 1857, the project was judged by 1880 to have given Boston "its West End, its fashionable quarter," comparable to London's, and as alone having made possible Boston's transformation into "a great city" that might astonish visitors into thinking of St. Petersburg or Paris – comparisons hardly dreamed of, or even desired, in the 1840s.[7] In the 1870s most of the architecturally varied brick, brownstone, and granite townhouses between Clarendon and Hereford Streets were built, along with luxurious apartment buildings and the most modern hotels. In the same decade many great churches were completed, including the Brattle Square Church on Commonwealth Avenue (1871), the New Old South Church (1875), and Trinity Church (1877), both on what would become Copley Square, and the Roman Catholic Cathedral of the Holy Cross (1875) in the South End – all enormous edifices in comparison with the old Colonial and Federal places of worship. In 1883 the gaudy Gothic Church of the Advent was completed at the foot of Beacon Hill to satisfy a newly felt need for ritual among High Church Episcopalians, who worried neither about the material cost nor about the material expression of their beliefs. In 1888 the foundations were laid for the city's most imposing cultural and architectural statement, the Boston Public Library, which required seven years to complete. During this period the Museum of Fine Arts – founded in 1870 – rose first in Gothic magnificence on Copley Square in 1876 and three decades later prodigally abandoned this building and rose again in Beaux Arts splendor far out on the Fenway. Other dynamic and expanding institutions also kept on the move: Boston College, founded in 1860 by the Jesuit Fathers in the South End, began to build grandly at Chestnut Hill in 1909. The Harvard Medical

School, installed in a new building at Copley Square in 1883, moved out on Huntington Avenue as early as 1906. The Massachusetts Institute of Technology in the 1860s inhabited a fine building next to the stately Museum of Natural History in Copley Square, but in 1916 leaped all the way across the Charles River into quarters vaster still. In 1900 the Massachusetts Horticultural Society and the Boston Symphony Orchestra, the latter just founded in 1881, both deserted celebrated and quite recent (1865 and 1852) edifices near the Common to inhabit even more splendid halls on either side of Massachusetts Avenue. Two years later the New England Conservatory opened its doors near Symphony Hall, and after two more years received the addition of Jordan Hall. A short distance beyond, the ornate Boston Opera House rose up before the end of the decade. In 1906 the Romanesque root of the Christian Science Mother Church, planted only in 1894, sprouted a mammoth annex with a classical dome. Many other great changes occurred in the city, not by inevitable natural processes, but by force of individual and collective will: below ground America's first subway was installed, while above Frederick Law Olmsted laid out a great urban park system that stretched all the way from the original Common to the much vaster Franklin Park, the favorite project of Hugh O'Brien, an energetic Irish mayor. In 1900 South Station opened as a centralizing terminus for lines from the south and west; and in 1910 the Charles River dam went up, providing a fresh-water basin modeled after Hamburg's and – not incidentally – relieving the city of a twice-daily tidal stench.[8]

Present-day inhabitants of Boston – whether they consider themselves Bostonians or not – can hardly imagine Boston without most of these features of its topography, nor perceive them as less Bostonian than the Harbor and Faneuil Hall, Beacon Hill and the State House, or the Common and Park

Street Church. These new spaces with new buildings were the creation of a people who, having emerged victorious in the national conflict, did anything but lapse into passive and proud complacency. The small, provincial pre-war city of enormous national influence and apparent local cohesion, in which a great mayor (the builder of Quincy Market) could become the president of Harvard College without a sense of dislocation, was gone. But that city was not, evidently, what most Bostonians wished Boston to be. Far from resisting the urban expansion that resulted from industrialization and immigration, the new Bostonians seized the chance to make a great, diversified, and more cosmopolitan city, and risked losing one identity to achieve another.

That Boston in 1880, when it was 250 years old, considered itself a city more embryonic than senescent is evident in a remarkable publication in honor of that anniversary. In spite of its sepulchral title, *The Memorial History of Boston* is ultimately a visionary work that anticipates a long future growth, as though a quarter-millennium were only the natural gestation period for a city destined to greatness. Its editor, the librarian Justin Winsor, remarks that the author of the *Chronological History of New England* (1736), "seeking a start, began with the Flood," consequently failing to get beyond 1633.[9] But the *Memorial History* itself, jettisoning scriptural origins in favor of the latest geological wisdom, starts further back still – with the glacial retreat that left three small peaks rising above a prehistoric bay. An illustration shows the Great Auk as one of the first inhabitants of the peninsula: "the intelligence with which this Bostonian looks forth from the printed page is most gratifying," commented the reviewer in the *Atlantic Monthly*; "That eye has speculation in it."[10] And in fact "speculation" – observant intelligence – is the single continuous trait that the diverse hands who compiled the *Memorial History* seem always to find as they describe the various elements of Boston's past and present. Perhaps few cities could commission a descendant of the Founder to write a chapter on the Founding, as a Winthrop here writes of a Winthrop, but the *History* is not excessively pious toward the past. On the contrary, the attitude is often consciously antiquarian, as though the Puritans were as distant as Druids. The chapter called "The Indian Tongue and Its Literature as Fashioned by Eliot and Others" is longer than the one entitled "The Literature of the Colonial Period." Some of the writers express contempt for Puritan beliefs, practices, and architecture – the only good thing about the last being that it was built with flammable materials. Even Bostonian buildings of the nineteenth century are ridiculed as the products of foolish fantasies, first Grecian then Gothic. The great day is now.[11]

The four fat volumes of the *Memorial History* certainly constitute a characteristically Bostonian achievement. By their mere existence they offer proof of a remarkably knowledgeable and literate citizenry able to work up so various a set of learned disquisitions on such short notice – something that, the *Atlantic Monthly* proudly suggested, probably no other city in the world could have done at the time. But the Boston that the *Memorial History* ultimately celebrates is not the one that produced its remarkable authors. It is instead an emerging modern metropolis whose new identifying interests are still in the process of realization: science, technology, industry, popular and specialized education, practical organized charities rather than the rhetoric of legislative reforms, and the professional advancement and independence of women as much as their domestic functions or their aesthetic idealization. Physical comforts, material abundance and material beauty, new styles of architecture, and the uplifting pleasures of art and music – as much as the often sterner trials of

the word – are all unabashedly favored. From the perspective of Henry Adams's businessman brother, Charles Francis, Jr., who wrote on the railroads for the *Memorial History*, Boston's "outlook for the future in 1880 was brighter than ever before in its history."[12]

The economic and social forces that made these transformations possible did not differ essentially from those of other American cities, and similar conditions naturally produced comparable results. Superficially it may therefore appear that in ceasing to be Bostonian as it had been, Boston simply became "American," much like any other place, even as the word "American" became a term with ever less certain meaning. There might be no disgrace in that, but in fact what Boston had been and already was did shape its new culture and give to the universal aspects of its urbanity a distinction definably Bostonian, recognizable and sometimes envied and imitated – and sometimes denigrated – by non-Bostonians. Distinction of course does not mean superiority, although the inhabitants of any place tend to think so. The claim by one of Oliver Wendell Holmes's interlocutors at the Autocrat's Breakfast-Table that "The Boston State-House is the hub of the solar system" is in a context suggesting that any citizen who identifies with his city perceives it as central. In this sense Parisians are no less provincial. But Dr. Holmes himself found Boston "just like any other place of its size," except for "its excellent fish-market, paid fire-department, superior monthly publications, and correct habit of spelling."[13] This claim seems modest enough, and in the next generation Bostonians watched even their literary monthlies decline – or move to New York, where they were sure to do so.[14] It was in the new characteristics of the city that Bostonians could find a basis for increased civic pride. Although indebted to the old identity, the new one found expression in more varied forms, forms that themselves fostered diversity, thereby producing an identity more diffuse, and more free.

Of the several lines along which a new Bostonian identity grew out of the old, we may follow three: the expansion of Boston's idea of culture to include arts more sensuous than literature; the attempt to establish the most advanced and accessible educational institutions anywhere, but now with a realization that the word is a vehicle to realms other than theology, philosophy, and law, that numbers are also useful, and that indeed there are organs to be trained other than the tongue; and finally, the development of its idea of Woman. These elements – culture, education, and a feminine ideal – are interrelated in the new Bostonian identity; all sustain the central efforts of the old identity: to redeem matter with mind, to shape abundance with taste, to use the common power for the individual good. The Bostonian "speculative eye" becomes more receptive, more practical, more tolerant of diversity, and permits itself pleasure; but it does not lose its intelligence.

Bostonians insisted disproportionately upon possessing cultural institutions comparable in quality and extent to those of cities far larger: nothing was too good for them. As a matter of course, they built a huge library to indicate the supreme value they had always placed upon the word, but they would also build temples of music and art. A literary culture would not suffice. Even the library would be not an austere barn furnished with plain desks and rudimentary shelves; it would be a beautiful Italian palace filled with marbles and murals (though not with nude statues – there *were* limits). The churches too – those already mentioned and many more – frequently became places to satisfy the eye and the ear as well as the mind. As the sermons became shorter the processions became longer, pipe-organs bigger, windows more rubied, and pews more plush. This more aesthetic religion was (and is)

easily satirized: "a gilded religion for a gilded age." Such satire itself rests upon puritan belief not only in the sufficiency of the word, but in its greater sanity and honesty. Unless one finds music dangerously irrational, painting essentially deceitful, and ritual mere hocus-pocus, one can take a more sympathetic view, as T.J. Jackson Lears has recently done in *No Place of Grace*.[15] Lears quotes Charles William Eliot as writing in 1896 (while president of Harvard) that one of the "most discouraging phenomena" of the preceding twenty years was the growth of "ritualism and aestheticism," accompanied by "increase of luxury" in New England. Lears observes that cultural historians like Thorstein Veblen, as much a "utilitarian moralist" as Eliot, simplified a complex reality with talk of "conspicuous consumption" and "status anxiety." Even more recent historians wear the "same ideological blinders," seeming to be "virtually obsessed by moral decline" and "dying elites." They show themselves incapable of imagining this cultural transformation as anything but decadent, as something instead authentically motivated and energetically creative. Someone who takes either religion or art more seriously may find that this new integration of the two (new for Boston, certainly) expressed and met profound psychological needs and constituted a protest against the alienating individualism and barren utilitarianism of "modern" society. Certainly present-day Bostonians who live in the enjoyment of what that age created and perpetuated must regard with skepticism undiscriminating devaluations of it based upon dogmatic social theories.

Even an unbeliever may see that to build a great church, to make it beautiful, and to worship in it is to assert a value beyond "usefulness" – one that is communal and one that transcends the present day by reference to the past and by embodiment in a form that will endure. These churches are also evolutionary from Boston's past rather than a break with it. The greatest example of the period, Trinity Church, actually represents a mean between pulpit-centered Puritanism and altar-focused Catholicism, for its size and shape were dictated by the needs of a great preacher of the Word – Phillips Brooks, whose large and growing congregation had to be around him, within earshot. On the other hand, the parishioners of the nearby New Old South Church, in whom the original Congregational strain had most persisted, saw fit to create something entirely different from the plain and steepled meetinghouse they abandoned on Washington Street: they erected a Northern Italian Gothic campanile beside a cheerfully decorated church; stencilers and stonecutters created multicolored patterns inside and out; and hidden within the leafy stonework of its Dartmouth Street courses, a very unecclesiastical cat crouches beneath a bird that is just a bird (fig. 1).

If a more hospitable religion now found itself expressible in stone, color, and music, it is also true that Bostonians participated fully in the commonly observed late-Victorian elevation of the arts themselves to the status and function of religion. The rise to prominence of music and art in the city's life is perhaps the most conspicuous innovation in its cultural identity.[16] The chapter on music in the *Memorial History* was naturally assigned to John Sullivan Dwight, editor of the pioneering *Dwight's Journal of Music*. Dwight happily surveyed the scene "from the height" of 1881, yet with the sense that Boston's musical instincts had just been awakened. "Before the year 1800, all that bore the name of music in New England may be summed up in the various modifications of the one monotonous and barren type, – the Puritan Psalmody," he remarked. Dwight (who started out as a Unitarian minister, went on to Brook Farm Transcendentalism, and finally found a rest in "the divine art," Music) traced four periods in the "progress" of music in Boston, all of which he had witnessed himself. The Handel and Haydn Society in 1815 had led the way with oratorios (the Word set to music). Dwight recalled that in his boyhood he

had watched one of the founders, a German who had played the oboe in Haydn's own London orchestra, conduct the fledgling Boston players. By 1818 this Society managed to give *The Messiah* complete for the first time in Boston. Next, the 1840s saw the canonization of Beethoven, "the profoundest, greatest master," whose music was pure music, religion without words. Thomas Crawford was commissioned to make a life-size statue for the central niche of the Music Hall. The need for this building had been demonstrated by the overflow crowds that had tried to hear Jenny Lind sing in a railroad station. In the 1850s Bostonians began to realize the importance of secular opera to "this great Republic," having heard an Italian troupe sing *Ernani* for the first time in 1847. Finally, since 1865 Bostonians had more and more turned to music as a popular art and a spiritual resource. They even took to manufacturing their own pianos (Chickering) and exporting them. The Harvard Musical Association, founded by Dwight in 1837 and located on Beacon Hill, gave one hundred concerts between 1865 and 1875. The fullest commitment to a musical future was made in 1867, when both the Boston Conservatory and the New England Conservatory were founded; to these was added shortly the School of Music at Boston University, and in 1874 the Cecilia Chorus helped to meet the growing demand to hear and be heard. In 1879, for the first time, a local Boston group proved itself capable of playing and singing *all* of Bach's *St. Matthew Passion* – a rare event even in Germany and England. Overflow crowds attended the two performances in the huge Music Hall. The one thing now *"urgently"* needed, noted Dwight in conclusion, is an orchestra entirely independent of any chorus. He had heard of Henry Lee Higginson's just-announced plan to keep "sixty men in constant practice" so they can give twenty open rehearsals and twenty concerts a year: "This looks like the beginning of a permanent first-class orches-

tra for Boston," Dwight gratefully wrote, confident that Boston, now a city musical in its very soul, would wholeheartedly respond.[17]

Higginson (see cat. no. 4) indeed found that his personal need for great music corresponded with a fully mature public interest. Inspired by Vienna, where he had studied as a young man, and to which, as the supremely musical city of the age, he constantly sent for advice, players, and conductors, Higginson insisted upon founding an orchestra of the highest caliber, but one accessible to Bostonian music-lovers of even "the slenderest purse." He pledged to cover the consequent deficits from his own annual earnings – a promise he kept until his death forty years later. In his eightieth year (1914) he told the members of his "noble orchestra" that his intention had been "to be satisfied with nothing short of perfection, and always to remember that we were seeking high art and not money: art came first, then the good of the public, and the money must be an after consideration." He had hoped to do a "good work" that "would leave a lasting mark in the world" and give "joy and comfort to many people." That was and remains the ideal function of the Boston Symphony Orchestra, but the assertion merely states in relation to one institution the principle that motivated the many groups that gave to Boston a lasting musical identity. As Higginson wrote elsewhere, "We all hold the creed that our national home is what we make it, and that by joint work we can make it beautiful and happy."[18]

A letter to Higginson from President Eliot of Harvard, written to express the gratitude of thousands of persons from all classes and races who had heard the orchestra during its first thirty-seven years, says that what he had "done for Boston and the country" is best appreciated "if we bear in mind that good music sustains and consoles the human spirit in times of adversity, and is, next to good literature, the best expression of public prosperity, social joy, and religious transport."[19] Music is now sec-

ond to literature as a means to the same ends; by implication, painting and sculpture are somewhat lower. Indeed, these arts were initially even more subservient than music to literary conceptions and utilitarian purposes; and in Boston they seem to have had an even more difficult time achieving independent status, since while music's only danger is that it may conduce to dance, the potential gross purposes and obnoxious "meanings" of the visual arts are limitless. Representation unmediated by language, and the very materiality of their media, make painting and sculpture inherently less spiritual than music. Arthur Dexter, writing on art in Boston in the *Memorial History*, therefore must begin like Dwight with the fact of an inherited Puritan antipathy. Only portraiture thrived until the nineteenth century, when, in 1826, "art" as an independent concern was finally born, and then only in the bosom of Boston's most literary institution – the Athenaeum, where catalogues for the exhibitions often provided a poem to go with the picture. Apart from these exhibitions, and the idealized landscapes and edifying scenes from the Bible, Spenser, Shakespeare, and Milton created by the lonely Washington Allston, who was regarded (and regarded himself) as essentially a "poet," nothing much happened in painting until William Morris Hunt arrived on the scene in 1862. In sculpture, Boston had managed to shame New York by being the first American city to purchase (for the Athenaeum) a work by the New York-born Thomas Crawford. His *Orpheus* was both beautiful and edifying, but it took Bostonians (William Sumner and Margaret Fuller leading the way) to discern its narrative and symbolic qualities. Boston also produced its own native geniuses. Thomas Ball, a "Boston boy" working in Florence, had produced "the most important statue within the city," the equestrian Washington erected at the foot of Commonwealth Avenue in 1869 (when the avenue still ran only two blocks to nowhere.) Also there was Dr. William Rimmer, an

expert in anatomy and a great teacher. Indeed, just as some thought Allston's lectures on art (published in 1850) were more successful than his pictures in conveying the *ideal* of beauty to which he aspired, so were Dr. Rimmer's lectures at first more popular than the agonized figures – including male nudes – that he expected people to look at. A tendency to prefer good talk about art to the thing itself also lies behind Bostonian admiration for William Morris Hunt. Hiding behind a screen, a disciple could take down the immortal *mots* about his divine art that this great teacher delivered while he worked. What he said just as much as what he painted inspired a devotion to art. Ironically, unlike Allston, Hunt himself no longer subordinated art to the word or to the Creator. What the *Talks About Art* (1878) argued was the irrelevance of talk – of literature – to art. "See what makes the *picture!*" he shouted; "The picture is what cannot be described in any other way than by painting. Literature cannot take the place of art." "There is no language in art but that of the eye," he declared. And he rejoiced in the belief that more people were going to galleries than to the library. Unfortunately, Bostonians, instead of buying pictures, tended to go home and paint their own.[20] But they did not fool themselves. In 1877 an exhibition of Hunt's work of the preceding five years astonished Dexter with its "variety and power," and two years later the Museum of Fine Arts honored the artist with an exhibition in its new building (fig. 2).

The founding of the Museum and the construction of its new building (fig. 3) are, of course, the climax of Dexter's account of 1881. "Built with brick, with ornaments of terra cotta, in Venetian Gothic style, it is a beautiful and most characteristic edifice, well described as one which no intelligent person, seeing it for the first time, could possibly take for anything but a museum," he wrote. The wit Tom Appleton called it "frozen Yankee Doodle,"[21] but Dexter's point

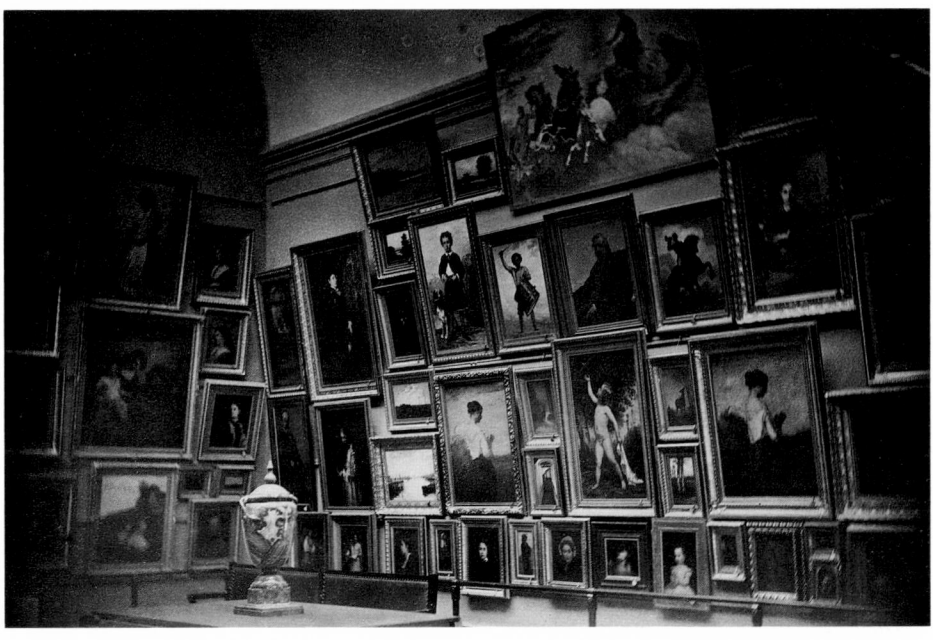

about its appearance is important. On a site neighboring two great churches (and within a decade a library), the temple of art was going to have its own unequivocal and equiponderant identity, for it had an independent educational and spiritual mission. For one thing, it contained a "gallery of casts" that was "one of the best in the world," and the value of Greek statuary in the cultivation of taste had been almost unquestioned since the relatively recent day in which Bostonians had started giving the matter any thought. Moreover, the Museum included a Museum School, which was explicitly intended less to produce artists than to "elevate public taste." And the public did respond. In 1880, there were over 170,000 visitors. "No city," Dexter boldly concluded, "has more genuine love of art or more earnest followers of it than Boston." To think of themselves as art lovers was something that Bostonians now liked to do. And events in the next half-century justified Dexter's confidence if not the untestable superlative of his claim.[22]

Nothing done in these years owed more to traditional Bostonian values and had

a more lasting effect upon the new identity of Boston than its commitment to a modern educational mission. Bostonians, who had founded both the first public school and the first university in America, continued to think that "Education was divine," as Henry Adams observed.[23] In 1780 they had established the American Academy of Arts and Sciences, which in 1880 the *Memorial History* still proudly classified as "essentially a Boston" institution.[24] This inherited esteem for education engendered in the new Bostonians the desire and the will to reforge it in contemporary forms. They spoke of their work in superlatives: the Girls' High School – itself a recent innovation – was the largest in the country, while the new double edifice housing the Latin and English High Schools that opened in March 1881, was said to comprise the largest "free public school" building in the world, surpassing "all others in this country in its magnitude, adaptation to its purposes, and the beauty of its construction." Equally distinctive was the maintenance of quality within a democratic system; in 1881 it could still be claimed that "There is no other large city where the children of all classes in

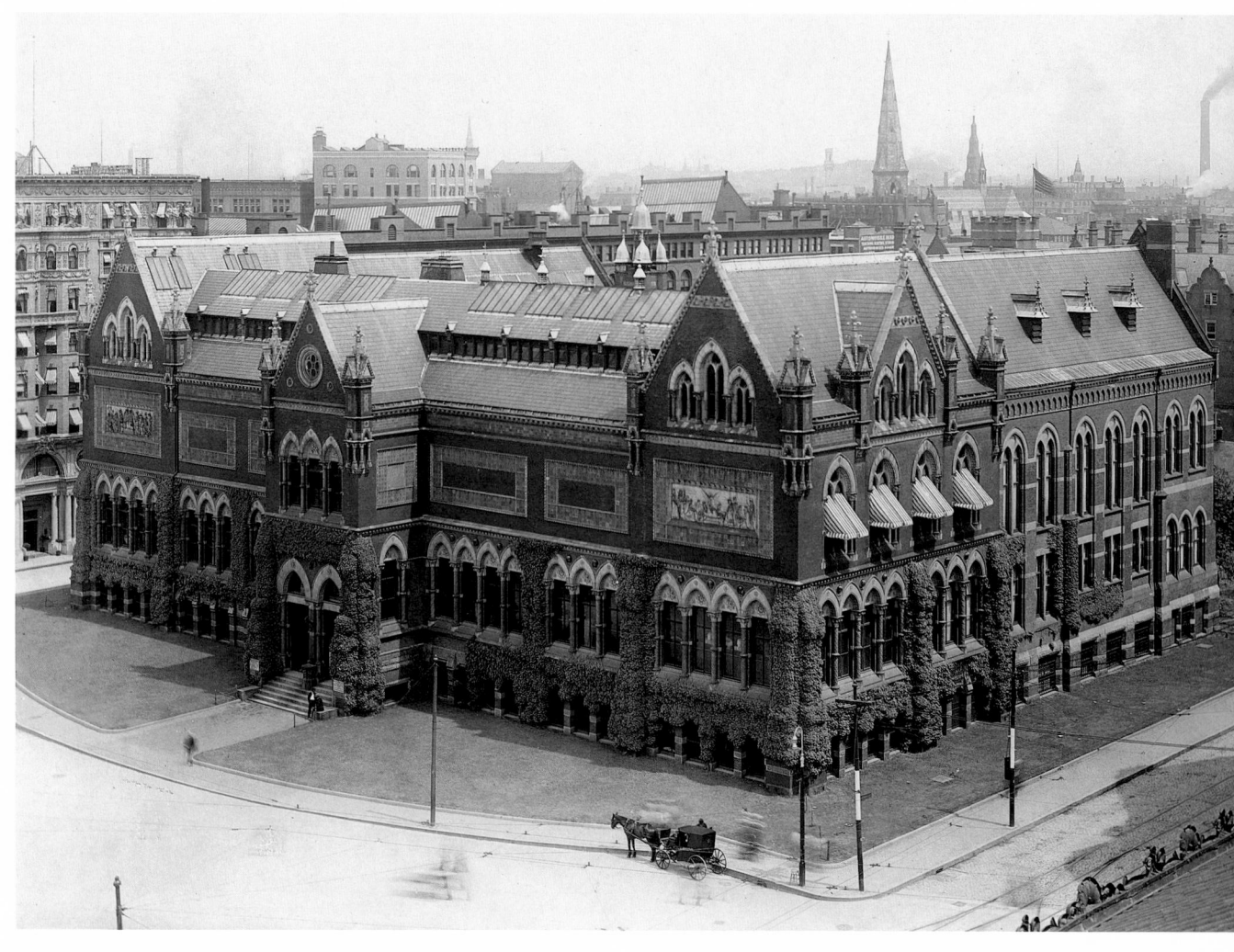

respect to social condition, are so generally educated in public schools."[25]

In higher education also, Bostonians sought to set standards unrivaled in modernity, quantity, quality, and accessibility. The founding of the Massachusetts Institute of Technology in 1861 constituted a decisive challenge to older conceptions of higher education based upon letters rather than science, upon liberal rather than applied knowledge, upon abstract and general truth rather than the inductive and particular (laboratory teaching was one of its novelties).[26] For the last three decades of the century the Institute shared a block of Back Bay land with the Boston Society of Natural History (founded 1830), with which it was allied. Together their three large buildings testified that contemporary scientific interests and values were no less important to the city than those represented by Trinity Church and the Museum of Fine Arts in the block above them. Boston University was incorporated in 1869, soon assimilating two professional schools of older foundation. Located initially in the heart of "old" Boston on Beacon Hill near the State House, it was, the *Memorial History* asserted, an entirely new thing, established on a "unique and comprehensive plan" that omitted no branch of knowledge. Its graduate school was boldly denominated "of All Sciences." The University included undergraduate schools of agriculture, music, and (before long) applied art, which offered alternatives without prejudice to the traditional curriculum. But perhaps more clearly signifying the aspirations of the University that was to bear the name of the city itself were the facts that its College of Liberal Arts opened with the highest admissions standards in America, its schools of theology and law had the most rigorous degree requirements anywhere, and its school of medicine was the first to require four years of training. Originally the pioneering New England Female Medical College, this medical school found a congenial home in a university that was from the first coeduca-

tional, and for a time the only university to admit women as candidates for all degrees (it granted the first American Ph.D. to a woman in 1877). Neither was there any religious test for either faculty or students.[27] The three founders of Boston University, who were emphatically new Bostonians, realized that neither the advancement of knowledge nor the education of the city's greatly diversified population was adequately served by tradition-bound and caste-bound Harvard. And other groups also naturally turned like good Bostonians to the founding of colleges as the natural means of advancing their interests and serving a heterogeneous population. Boston College (1863) and Emmanuel College (1919) were founded to assure Roman Catholic education for both men and women, the Emerson College of Oratory was founded in 1880 to develop the skill of speaking, Northeastern University in 1898 to serve the growing working class, and Simmons College in 1899 exclusively for women. These, together with colleges in the suburbs, made it forever impossible to think of Boston's identity apart from higher education, and also impossible to think of its intellectual identity as other than multifarious.

But Harvard, long the complacent historical core of that identity, also realized that it must become something different from the riotous young gentleman's finishing school that Henry Adams later caricatured and deplored in the chapter called "Harvard College." In the same year that Boston University was founded, Charles William Eliot began his long presidency of Harvard during which he transformed it into a university where specialization in all fields, even at the undergraduate level, took precedence over the classical curriculum. When Henry James revisited Boston's "academic suburb" in 1905, he puzzled over the failure of the young faces encountered in Harvard Yard to suggest a distinctive, cultivated male "type," or even to be collectively distinguishable from the "unmitigated

'business man' face" that struck every visitor to the United States as the nation's characteristic physiognomy. Although his own brother William was nearing the end of his career as one of the brightest luminaries in President Eliot's famous constellation of intellects, what James chiefly felt was that the practical new Boston and its hustling new Harvard were being driven by a "commercial energy" that served ends so varied and worldly as to have virtually no connection with the coherent city and university he had known. At a football game at Harvard Stadium James attempted to hear within the "many-mouthed uproar" that signified America's "more multitudinous modern hum," the ghostly voice of James Russell Lowell. That perfect Boston gentleman and man of letters had once been "the very genius of the spot, who had given it from so early the direct literary consecration without which even the most charming seats of civilization go through life awkwardly and ruefully, after the manner of unchristened children." Lowell's "papers," even more than Longfellow's, had legitimated Harvard, but now "a thousand local symptoms" indicated that "titles embodied in literary form are less and less likely, in the Harvard air, to be asked for":

That is clearly not the way the wind sets: we see the great University sit and look very hard, at blue horizons of possibility, across the high table-land of her future; but the light of literary desire is not perceptibly in her eye (nothing is more striking than the recent drop in her of any outward sign of literary curiosity)[28]

Obviously "proportions and relations had been overwhelmingly readjusted." The "little old place" had been "brave" in its "love of letters," a devotion that Lowell had embodied, and the "big new one" might be "going in, as it would itself say, for greater braveries still"; but for James, as for other men of letters, the betrayal of Lowell's literary faith was "dreadful." The new Bostonians, however, saw education as a means to

more modern ends, as the way to a desired new identity, to a brave new world indeed.

James placed his characterization of the woefully limited American male in the context of Boston, whose literary tradition might have been expected to modify and elevate the general type. He perceived instead (or, as he admitted, invented for his preliminary analytical purposes) a "disconnection . . . complete" between the old City on the Hill and the "pompous and prosaic" Boston of "new splendours." Stretching southward and westward on the inexpressive artificial flatland, the Back Bay serves as a platform from which to look back up to the "concentrated Boston of history, the Boston of Emerson, Thoreau, Hawthorne, Longfellow, Lowell, Holmes, Ticknor, Motley, Prescott, Parkman and the rest (in the sense either of birthplace or of central or sacred city)."[29] James's ruminations come to this sharp focus when, roaming between the two regions on Charles Street, he revisits the drawing-room of a familiar mansion situated at the foot of the Hill. This was the home of James T. Fields (publisher of the authors on James's list) and his wife Annie, a famous literary hostess. Long after her husband's death, Mrs. Fields (who was still alive at the time of James's visit) had kept up her hospitality to authors, having Sarah Orne Jewett as her "sister-hostess" in the Charles Street home (fig. 4). Annie Fields figures in many Boston memoirs of the period as the ideal type of the "Boston Woman," cultivated, intelligent, refined, and – like James's Olive Chancellor, who also lived on Charles Street with the same view of the water – active in charities.[30] In *The Bostonians* James described just such a "cushioned feminine nest" from the point of view of a manly man from Mississippi, who thought it typically "Bostonian":

He had always heard Boston was a city of culture, and now there was culture in Miss Chancellor's tables and sofas, in the books

*that were everywhere, on little shelves like
brackets (as if a book were a statuette), in the
photographs and watercolors that covered the
walls, in the curtains that were festooned
rather stiffly in the doorways.*[31]

The perspective is slightly satirical, but
twenty years later in *The American Scene*
James unequivocally admired the type
of the cultured American woman (like
Mrs. Fields) who had somehow survived
into a later generation to become the
mate to an entirely uncongenial emer-
gent male type. This mismatched pair
was for James the most interesting
social fact of contemporary America,
Boston included. Nothing was more
"striking than the fact that the women,
over the land – allowing for every ele-
ment of exception – appear to be of a
markedly finer texture than the men."
This "superiority" was "quite another
matter from the universal fact of the
mere usual female femininity," how-
ever. For James this quality was not a
gender-determined distinction, for it is
something that the sons of such women
ought to have inherited from them. To

what extent, James asked himself,
might even the Harvard undergraduate
bear not only the "stamp of the unre-
deemed commercialism" imprinted by
his father, but also some sign of a "dif-
ferent social 'value' imputable to his
mother"? James, whether he was look-
ing at people or at the new public
library, constantly watched for signs of
redemption – refined sensibilities and
intelligent, disinterested purposes –
which, he seems significantly to have
assumed, would probably be found
nowhere in America if not in Boston. If
women were now the primary carriers
of the old "culture," and Boston were to
remain the "city of culture," it would
possess what now was perceived as a
"feminine" character.[32] Otherwise, it
might become like Chicago or New
York – powerful "masculine" cities of
commerce, surely – in everything but
size.

Was the historic city having no effect
on the new one? James looked west-
ward along the long straight avenues of
the New Land and saw "that particular

look of the clear course and the large opportunity ahead, which, when taken in conjunction with all the will to live, all the money to spend, all the knowledge to acquire and apply, seems to marshal the material possibilities in glittering illimitable ranks." The *material* possibilities: James conceded to the "new Boston" "the possession of everything convenient and handsome under heaven . . ., all the accessories and equipments, a hundred costly things, parks and palaces and institutions, that the earlier community had lacked." But had the new city "no capacity for the uplifting *idea*, no aptitude for the finer curiosity"? For James even the new Public Library, rising amid this material splendor, while obviously a "fine" conception, "finely embodied," yet spoke to him "still more of the power of the purse and of the higher turn for business than of the old intellectual, or even of the old moral, sensibility." Images of dusky halls where Emerson had lectured and Wendell Phillips orated breathed "more of the consciousness of literature and of history than all the promiscuous bustle of the Florentine palace by Copley Square," even though it was more "delicately elegant, in truth . . . than most Florentine palaces." Trying to appreciate "the refinements of the present Boston" (the grand stair, the leonine monuments, the courtyard, the murals) amid the "healthy animation" that results from a social democracy somewhat excessive for a library, James finally fled across the Square to the Art Museum. There he found rest in the ancient "dim-eyed" Aphrodite (fig. 5): "Where was she ever more, where was she ever so much, a goddess – and who knows but that, being thus divine, she foresees the time when, as she has 'moved over,' the place of her actual whereabouts will have become one of her shrines?" The beneficent presence of this goddess seemed to make flowers bloom round her in Boston. Institutions are created, James wrote, in the hope that " 'people will come,' that is, individuals of value will, and in some manner work the miracle."

Doubtless formerly in America "individuals of value had to wait too much for things; but that is now made up by the way things are waiting for individuals of value."[33]

All along James had had in mind one exceptional "individual of value" whose forty years in Boston contradicted the opposition upon which his analysis rested. Now, to conclude with a hopeful reconciliation of Boston's two identities, he named her: Isabella Stewart Gardner, whose long years of collecting art had recently culminated in the opening of her palace, Fenway Court, on the western outskirts beyond the New Land. By finally perceiving the old values in non-literary form, James could drop his fundamental opposition: "[N]o impression of the 'new' Boston can feel itself hang together without remembrance of what it owes to that rare exhibition of the living spirit lately achieved, in the interest of the fine arts, and of all that is noblest in them, by the unaided and quite heroic genius of a private citizen." Operating within enormously complex conditions, so "undaunted a devotion to a great idea" had finally prevailed. "It is in presence of the results magnificently attained, the energy triumphant over everything, that one feels the fine old disinterested tradition of Boston least broken."[34]

Although James elsewhere paid tribute to the similar nobly visionary and unswervable spirit of Henry Lee Higginson (whose orchestra played at the opening of Fenway Court), it is right that his meditation on the "absolute" disconnection between the old and the new Bostonian identities should end by finding an image of continuity in an art museum (not a lecture-hall or a book of verse) and in a woman – but one very different from Mrs. Fields. At Fenway Court, commercialism (Mr. Gardner had speculated in Back Bay mansions, among other things) was redeemed by application of the old intellectual and moral energies and discriminations. The irony that the agent of this transformation was originally a New Yorker merely enhances the probability that

living so long in the distinctive atmosphere of Boston's aesthetic idealism (most specifically the Ruskinian medievalism of Charles Eliot Norton, with whom Mrs. Gardner read Dante) was what enabled her to become what she became and to create the unique institution that bears her name.

To *become* a Bostonian now meant something different from what it had implied when another New York society woman, Julia Ward Howe, had managed the same transformation a generation earlier. Mrs. Gardner's "great idea" was not that of Mrs. Howe, who had several. Julia Ward belonged to New York's "Four Hundred" and therefore already knew what she called "the Boston of the Forty" before her marriage. But it was into the distinctive "Boston of the teachers, of the reformers, of the cranks, and also – of the apostles" that she moved as quickly as possible, rejoicing in "the new resources of intellectual life which opened out before me" in 1844. Her immediate model was Margaret Fuller, of whom she later wrote a biography. She made her own debut by publishing a volume of verse, and she became the quintessential "Boston Woman" by composing and singing religious lyrics and by writing papers and giving speeches on everything from women's rights to Emmanuel Kant, all the time managing her large family and looking after her famous husband. By 1867 she was naturally invited to join the Radical Club in the first year of its existence. In old age she recalled that the Club consisted of "the most eminent thinkers of the day, in so far as Massachusetts is concerned," but that limitation was slight since "society rarely attains anywhere a higher level than that which all must recognize in the Boston of the last forty years."[35] So thoroughly was Mrs. Howe a citizen of strictly "literary" Boston, surviving into a place of broader culture and less strenuous morality, that she could insist that popular literacy had deprived sculpture and painting of any function in the modern age[36] – something that Nathaniel Hawthorne but never Mar-

garet Fuller might have said. Like Mrs. Gardner, Mrs. Howe had a house on Beacon Street (though a relatively modest one), and there she encouraged her nephew Francis Marion Crawford to write his books. But, as a male child of the new commercial age perfectly content to write potboilers, Francis often strayed across to the waterside of Beacon to enter Mrs. Gardner's more sensual realm; finally he fled Boston to escape this younger woman of a type so clearly different from his aunt.

When James mused over the possibility of Bostonians becoming worshipers of Aphrodite, just how much did he mean to suggest? Aphrodite was not merely the embodiment of feminine beauty; it was Boston's ignorance of Aphrodite as sexual power that had puzzled Henry Adams in the *Education*. "When Adams was a boy in Boston, the best chemist [= druggist] in the place had probably never heard of Venus except by way of scandal," he recalled. Why, he asked, was Woman "unknown in America?" Why was the country "ashamed" of her? Why was sex "sin" rather than "strength"? An "American Venus," he concluded, "would never dare exist." In American literature, sex was presented as a "force" rather than a "sentiment" only in the poetry of Walt Whitman (the publication of which, Adams might have mentioned, had been stopped in Boston in 1882). In American art, sex was evident only in "one or two painters" (William Morris Hunt?) "for the flesh-tones."[37] The American ignorance of Woman did not prevent Adams from agreeing with James that the American Woman, although "a failure," is distinctly superior to the American Man – not only more "civilized," but also more intelligent, more efficient, more generally capable – more anything that would serve Adams's satire of himself, his brothers, Henry Cabot Lodge, and Theodore Roosevelt. But she too, following her machine-driven husband, was changing – doomed like the Man, apparently, to an asexual marriage to machinery.[38]

Boston women neither shared Adams's pessimism nor saw their redeeming function in the city or the nation as he and James saw it. In the *Memorial History* the only chapter written by a woman is "The Women of Boston"[39] – evidently the only subject a woman was judged preeminently qualified to discuss. But the inclusion of such a chapter was itself a significantly Bostonian idea. The author, Mrs. Ednah D. Cheney, a writer devoted to social reform, was very satisfied with her topic, and she produced a remarkable period document.[40] In effect accepting as true what James and Adams would later write concerning both woman's superior qualities and her ignorance of Venus, Mrs. Cheney sketched a portrait of the Boston Woman as a historically achieved identity and then went on to stress all that was progressive – and therefore liable to disrupt her traditional functions and change that identity. We thus discover in the Boston Woman even more notably than in Adams himself the paradoxical identity of Boston: its rebellious traditionalism – the paired Bostonian tendencies identified by James as Reform and Restraint. Perhaps then not its cultural refinement but its fructifying conservatism is what truly made Boston a "feminine" city.

Happily quoting an English gentleman to the effect that "The Women" were "the most remarkable thing in Boston," Mrs. Cheney agreed that there is "a strong and recognizable type of Boston women whose characteristics are clear":

The Boston woman inherits from a line of well-bred and well-educated ancestors, mostly English, a physical frame delicate and supple, but enduring. It is capable of great nervous force and energy, and can be made to serve the mind and will almost absolutely. But she is liable to attacks of disease, and under unfavorable conditions her nervous energy degenerates into irritability. More intellectual than passionate, her impulses are under control; and she is reserved and cold in manner, while a gentle purity inspires confidence even before it awakens affection.

Mrs. Cheney's woman becomes even more interesting, if not more attractive, in succeeding paragraphs. One encounters variations of her in the novels of James and Howells: she is James's Olive Chancellor of *The Bostonians* and his imperious invalid Mrs. Newsome of *The Ambassadors*; she is the fretting and condescending Mrs. Corey of Howells's *Rise of Silas Lapham* and also his Mrs. March, the "true Bostonian" who spends all of *A Hazard of New Fortunes* shuddering at New York's egregious taste and general lack of restraint. Mrs. Cheney's woman may also be seen at different ages in some paintings of the period, such as Dennis Miller Bunker's *The Mirror* (cat. no. 60), William Paxton's *Tea Leaves* (cat. no. 67), Edmund Tarbell's *Reverie* (cat. no. 71), and Gretchen Rogers's *Woman in a Fur Hat* (cat. no. 11):

Her morality is stern and exacting, and she does not understand the temptations which beset other natures; her own sense of chastity is so high that, like the lady in Comus, *she walks amid a thousand dangers unheeding and unharmed. She shrinks from contact with evil until it appears as suffering, when duty and benevolence overcome her sensitiveness. She is speculative in theology, while conservative in her tastes; and though indulging great freedom of thought, is devout in her habits. This conflict sometimes produces a strain upon her feelings too great for endurance, and she seeks refuge in an established church. Perhaps this is only a brief rest in her onward career, or it leads to a life of moral or benevolent activity in which she is content. Her aesthetic nature is serious and refined, preferring the classic music to the modern opera, and pre-Raphaelitism to sensuous beauty. The subdued style of her dress marks her position in the scale of refinement. Aristocratic by tradition, she is in danger of becoming exclusive and narrow; but, liberalized by education, she is democratic in her work, if not in her tastes and social habits.*

This over-bold generalization quickly suffered some qualifications as Mrs. Cheney developed her essay. She wanted to say that the "Boston woman is exemplary in her conduct as a wife

and mother," a very orderly "house-keeper" who makes her home "a radiating centre of goodness and happiness." "But," she added, "Boston women are still more remarkable for their virtues in single life." A Boston woman (like the widowed Mrs. Cheney herself) could earn her own living "by labor of any kind, if she be honest, intelligent, and pure in her life, without losing the respect or the companionship of the most refined and respected." Mrs. Cheney even cited a shopkeeper and a hairdresser by name to prove her point, and then praised the entire class of female artists for insisting on selling their pictures (even when they are wealthy), "that they may be classed as artists, not as amateurs."[41]

A subsequent litany of historic Boston women inevitably represents the extraordinary as the typical. (Even James's Mrs. Luna finally admits that "It isn't the city; it's just Olive Chancellor."[42] But the city gets the credit (or the blame) for producing the recurrent type that Mrs. Cheney went on to delineate, even though it hardly coincides with her introductory sketch. The "Boston Woman" evidently recognizes her inheritance as deriving from the poet Ann Bradstreet, who perversely thought that a pen fit a woman's fingers just as well as a needle; from Mary Dyer, the Quaker who was hanged for her beliefs on Boston Common (not far from where a statue now honors her memory); and even from the witches of 1648-1652 – in fact, from any woman who conspicuously failed to conform. Phillis Wheatley, Abigail Adams, and Mercy Otis Warren, in their insistence upon the equal rights and talents of women, were thus simply following in the tradition established by the great mother of all Boston women: the intellectually courageous Anne Hutchinson, who powerfully disturbed the peace of Boston only seven years after it was founded. Mrs. Hutchinson had "vented" her "peculiar opinions" on shipboard all the way across the Atlantic, but when she landed the governor ignored reports of her "eccentricities"

because she was a "physician" who proved "very helpful in the times of childbirth" and illness. She waited two years to establish herself in the community before she began preaching heresy. Since her enemies could never discover one thing to say against her "matronly and religious character," Mrs. Cheney could safely conclude that "Her influence was very great, and has undoubtedly left its impress upon the life of Boston women to this day." The woman in the nineteenth century who had most reinvigorated this Bostonian model was Margaret Fuller, whose famous "Conversations" Mrs. Cheney herself had enjoyed in her youth. Miss Fuller's influence "lingers in all the life and character of Boston women," she asserted.

Can Woman be both the transmitter of Boston's rebellious tradition and its most refined cultural ideal? Mrs. Cheney did not cite Hawthorne's Hester Prynne as a fictional model for Boston women, although Hawthorne himself associated her with Anne Hutchinson, daring to suggest a connection between sexual and intellectual freedom that no one picked up until D.H. Lawrence read the book. Mrs. Cheney acknowledged no conflict between woman as the redemptive center of home and city and woman as an independent being. Yet she mentioned that only in 1855 was a new law passed "giving a woman the right to hold all property earned or acquired by her, independent of the control of her husband," and she was as proud of Massachusetts's legislative enlightenment as she was indignant that it took so long.

The question of woman's identity – and so of Boston's – was obviously one first of woman's education: it was not a question of her social function determining what she might learn, but rather a question of what she might learn determining what she might become. More than one of the young women framed within the pictures of this period and within the walls of their Bostonian "feminine nests" seem to be pondering their fates (see, for example,

Frank Benson's *Open Window*, cat. no. 74), and women's education was certainly one of the liveliest topics of the last third of the century. It naturally concerned Mrs. Cheney, as it did the male author of the *Memorial History*'s chapter on Education.[43] The idea of a Boston type – the refined and intellectual woman – leads to the realization that what the concept of an "educated woman" necessarily implies is diversity, and thus the fatuity of generalization. Girls had been admitted to public high schools in Boston only in 1852, and, as we have seen, to all branches of higher education only in 1869, with the founding of Boston University. But by 1879 the University had 147 women and 458 men in all its colleges; there was one woman in law, two in theology, thirteen in music, and forty-eight in medicine. (One recalls that the only unequivocally admirable modern woman in James's *Bostonians* is Dr. Mary J. Prance, who bears no resemblance either to Olive Chancellor or to Mrs. Cheney's generalized "Boston Woman.") Moreover, there were women on the University's Board of Corporators and on the visiting committees. To further these happy developments, the Massachusetts Society for University Education of Women had been founded in 1877 at the home of Mrs. William Claflin for the express purpose of providing free scholarships for women to Boston University, and to agitate for admission of girls to the Public Latin School so that they could properly prepare for the University or for admission to the Harvard "Annex" (later Radcliffe College). The indefatigable Elizabeth Peabody – a contemporary of Margaret Fuller upon whom James (a few years later) apparently modeled the character of old Miss Birdseye as a symbol of the supposedly defunct heroic age of New England reform (the age "of pure ideals and earnest effort, of moral passion and noble experiment"[44]) – makes an appearance in Mrs. Claflin's parlor, earnestly arguing the "claim of our girls for classical education." Mrs. James T. Fields, James's heroine of Charles Street, is

also mentioned as serving on a committee to press for the opening of the Latin School to women. In 1878 Girls' Latin was founded; three years later 148 girls were enrolled. Mrs. Cheney concluded: "Surely never before to women were nobler opportunities open than those which the near future promises." To women it must have seemed that fulfillment of the true identity of the Boston Woman – and so the identity of Boston itself – seemed possible only now. But it would be an identity whose virtue would be, paradoxically, that nothing certain could be said of it. A woman – a Bostonian – an American – might now be anything.[45]

Between 1909 and 1919 the cigar-smoking Amy Lawrence Lowell, who was a New Woman with an Old Name and therefore a perfect exemplar of Boston's rebellious tradition, carried on a long campaign to get published in *The Atlantic Monthly*.[46] She was, after all, a collateral descendant of James Russell Lowell, the magazine's first editor. But the incumbent, a genteel young New Yorker named Ellery Sedgwick, was not interested in the bold new voices Amy Lowell sponsored, and was certain that his readers were not. He rejected most of her own efforts at "polyphonic poetry," pointing out to her that it did not scan. When he did risk the fairly conventional ballad "Dried Marjoram," a typical reader complained that "a few more monstrosities like this will ruin the dear, old Atlantic Monthly." In 1914, having suffered another rejection, Amy Lowell wrote to him, "O Ellery, You are a dear, kind, non-understanding thing." She nevertheless went on to urge that he publish a story by an "exceedingly poor" author named D.H. Lawrence, who could produce something not "too violent and outspoken for your readers" if properly cautioned. Nothing by Lawrence was solicited by Sedgwick; Lawrence, he told Miss Lowell, was "fated never to succeed except with a few devotees of physical and psychological introspection." In Sedgwick's twenty-seven year editorship (1909-

1936) virtually nothing of permanent value appeared in the *Atlantic*. "We are sorry that we have no place in the *Atlantic* for your vigorous verse," he once informed Robert Frost. Half of the poems he did publish, written by a regular coterie of woman contributors, were on Death. Most of the others were on a morbid *ideal* of Art.[47] This was the journal that had originally published the best authors available – Emerson, Thoreau, Lowell, Longfellow, Motley, Parkman, Holmes, Mark Twain, Howells, James, Harte, Jewett – even Whitman once or twice, expurgated only slightly. In the 1880s it had serialized *The Portrait of a Lady*, one of the masterpieces of the age. Now the *Atlantic* represented a fear of the new that was increasingly evident in all parts of the culture. Sedgwick's desire to protect his readers from the "madness" of Gertrude Stein, whom Amy Lowell also promoted, is understandable; early Stein was not eagerly published by anyone.[48] But Sedgwick's replies to Amy Lowell show that far less bold innovations in form or content than Stein's both disgusted and frightened him. Having refused to accept her own essay in defense of Imagism (or "Amygism"), he did publish one with the thesis that free verse is merely a cover for "technical incompetence," proven by lengthy quotation from the works of Amy Lowell. To Lowell herself Sedgwick asserted that "The loosening bonds of society today are sufficiently mirrored in the anarchy of our newer verse."

Such a fear of what innovations in form and content both represented and promoted was not limited to the genteel readers to whom the *Atlantic* now addressed itself. In 1907 Mayor "Honey Fitz" Fitzgerald, having won an election with the promise of a "Bigger, Better, and Busier Boston," led the effort to ban a performance of Richard Strauss's opera *Salome*, an affair entirely *too* busy. This infamous constriction of the sense of the permissible, in which Sedgwicks and Fitzgeralds joined, threatened by 1930 to give a permanently illiberal meaning to the word "Boston." In 1927

and 1928 over sixty books were banned, including novels by Sinclair Lewis, Dreiser, Dos Passos, and Hemingway. In 1929 Eugene O'Neill's *Strange Interlude* was driven from the stage. "I curse you Boston," cried the Bostonian Harry Crosby from his exile in Paris:

> *City of Hypocrisy*
> *City of Flatulence*
> *(with your constipated laws)*
> *Unclean City*
> *(with your atlantic monthlies*
> *and your approaching*
> *change of life)*
> *I curse you*
> *in the name of Aknaton I curse you*
> *in the name of Rimbaud I curse you*
> *in the name of Van Gogh I curse you*[49]

But the failure of nerve and narrowing of vision that evoked this curse could not be permanent. In the long run, diversity and tolerance prevailed over conformity to formal and moral conventions. In 1929 the radical Ivan Goldberg wrote, "I am too good an American to be a truly good Bostonian," meaning that he favored free speech – even in Faneuil Hall.[50] Goldberg had been born in Boston's West End and grew up more familiar with Bertha's Brothel on Staniford Street than with the Aphrodite of the Art Museum. But he need not have conceded the name "Bostonian" to the "blue bloods" who now existed, he thought, in a "spiritual coma," nor have satirically distinguished the word from "American." For the possibility of an objective predication about a "Bostonian" had long since died, as it had also for an "American." This is evident in the volume published by the city in 1930 in celebration, along with parades and speeches, of its Tercentenary year. Envisioned as a fifth volume to the *Memorial History*, to cover the last fifty years, it was edited this time by a woman, Elisabeth M. Herlihy, and a woman wrote not only the essay "Woman's Widening Sphere" but also the one on Labor. The volume opens with an "Acceptance" by Mayor James M. Curley and "A Tribute" to "The City

of Kind Hearts" by Helen Keller. It then includes a long essay on the authors of the original *Memorial History*, written by Mark Anthony DeWolfe Howe, who made a career of memorializing things and people "properly" Bostonian.[51] The essay that differs most strikingly from the corresponding chapter of 1880-1881 is that on Religion: the Roman Catholic Church, formerly at the end of the list and receiving merely equal treatment, now comes first and is discussed at a length equal to that of all the Protestant sects combined; and an entirely new section – on Judaism – is added. But the chapters on politics, on commerce and industry, on the "arts, sciences, and professions," on social welfare, and on "progressive movements" also emphasize that Boston now belongs – by birthright and by creative and possessive action – both to the old families and to what are oddly called "the newer races." Any sense that serious conflict had attended the achievement of this pluralistic identity is naturally absent. There is instead a fairly pervasive suggestion of continuity: Boston was still Boston, only bigger and better than it had ever been.[52]

But whatever Boston was, to be a Bostonian could now be no more than a subjective state, a daily unconscious orientation to River and Bay, as a Denverite is constantly aware of a distinctive configuration of mountains to the west. A unique environment was all that Bostonians certainly shared, and no further assumption about the individual could be made.[53] The fact had long been developing, and, as we have seen, was not merely a matter of new ethnic groups, but of many movements toward diversification from within the core culture.

William Dean Howells's *Rise of Silas Lapham* ran simultaneously in the *Century* with James's *Bostonians*, and it also equivocated on the meaning of "Bostonian." Initially the point is made that the *nouveaux riches* Laphams of Vermont can never be Bostonians. Their taste is vulgar, their manners and grammar bad; more tellingly, they lack the secret knowledge that "true" Bostonians possess. In twelve years of residence they have never realized that the South End in which they live is unfashionable. When Mrs. Corey of Beacon Hill says that her family portraits are mostly by Copley, the name means nothing to Lapham. The Lapham daughters are taught to dance by Papanti, but they "did not even know" of his private classes, "and a great gulf divided them from those who did." [54] But in the course of the novel, a reversal occurs: when Bromfield Corey goes to visit Lapham at his office, walking "at a leisurely pace up through the streets on which the prosperity of his native city was founded, hardly any figure could have looked more alien to its life. He glanced up and down the façades and through the crooked vistas like a stranger. . . ." Corey's formerly aimless son having discovered possibilities of self-fulfillment in Lapham's paint business, Corey ironically realizes that his son is an authentic throwback to his ancestor of the China Trade: "You are so very much more a Bostonian than I am, you know," the deracinated dilettante confesses. And so too, in the long run, was Silas Lapham. For the Silas Laphams of real life did not retreat to their rural farms in moral purity and financial bankruptcy. They made their compromises and enjoyed their wealth, and their houses on "the waterside of Beacon Street" did not burn down. Some of them founded universities, built opera houses, and endowed libraries. In all cases they did as they pleased and became what they could, as did the son of Corey and the daughters of Lapham. And they were no less "Bostonian" for that.

encouraged by Hunt worked in several modes, and the variety of their work reflects that of the French artists they admired, including Bonheur, Corot, Daubigny, Decamps, Diaz, Dupré, Jacque, Lambinet, Rousseau, Troyon, and of course Millet. Thomas Robinson's *Hillside in Summer* (fig. 9) shows the sketchy style and simple compositions common to this Boston group. Robinson had studied with Gustave Courbet, but rather than seek to emulate his spirit, he was clearly satisfied to reflect pastoral themes. Artists such as Thomas Allen (1849-1924) and John B. Johnston (1847-1886) favored pictures of cattle in meadows. Much of this type of painting cannot be seen today as anything more than sincere but uninspired imitation, and most of these artists receive little or no mention in recent histories of American art; nonetheless, their work was highly regarded and even considered collectively as representing a Boston landscape school in the 1870s and '80s.[12]

Two painters of the period who stand out as genuine talents are J. Foxcroft Cole and J. Appleton Brown. Cole produced many village scenes and pastorals with cattle on his visits to France, and when a group of these was exhibited in Boston in 1872 Henry James remarked favorably on the fact that he would have assumed that they were from a French hand had he not known otherwise. James was also pleased to note that Cole's one American picture in the show was "pitched in a different key from its French companions."[13] Cole worked hard to avoid foreign mannerisms when he painted around Boston. Although the gentle greens of *The Aberjona River, Winchester* (cat. no. 21) may bring Corot to mind, the place is honestly and lovingly recorded, without the cattle, peasants, or cottages that would signal an attempt to imitate the European artists. Similarly, J. Appleton Brown applied his French-inspired style to sunny New England fields, orchards, and flower gardens (cat. no. 100) and left the viewer with a sense of place, weather, and the time of day. In 1877

the influential *Atlantic Monthly* isolated Brown, Fuller, and Hunt as the three most important "Boston painters" and suggested that poetry was their common bond:

. . . there is in all their works an element of poetry, whether of incident, or of suggestion, or, more fundamentally important than either, that strictly pictorial kind of poetry which is the artist's intense appreciation of the beauty of form, of color, of the effects of light and shade, which he finds in his subject and which become the motive *of his picture, the* reason why *he paints it, its inspiration.*[14]

The basis of the "poetry" in French painterly execution was firmly underlined in these remarks on a Hunt twilight scene: "No photograph, no pre-Raphaelite rendering of sticks and stones, could give this impression, could have this suggestiveness. It is not a portrait of the field as it actually was, but as it appeared to the quick sense of the poet-maker."

Winslow Homer

Winslow Homer (1836-1910) is not often considered for his close associations with Boston, but the city's artists and collectors played a special role in his career; moreover, he was born and maintained strong family ties there, and was buried in Cambridge. However, after being an apprentice lithographer and a magazine illustrator in Boston from 1854 to 1859, he did not live there again. In the 1860s he found national success following his move to New York, first as a versatile illustrator for *Harper's Weekly* and by 1865 as a painter of Civil War subjects. The landscapes and peasant subjects he painted during a year-long stay in France in 1867 indicate the influence of the Barbizon School and a close relationship with the aesthetic interests of Hunt. His paintings of the 1870s depicted East coast seaside and mountain resorts, country farms and schools in upstate New York, New England fishing villages, and the plantation life of southern blacks. Their subjects ranged from workers in their daily clothes to the most fashionable

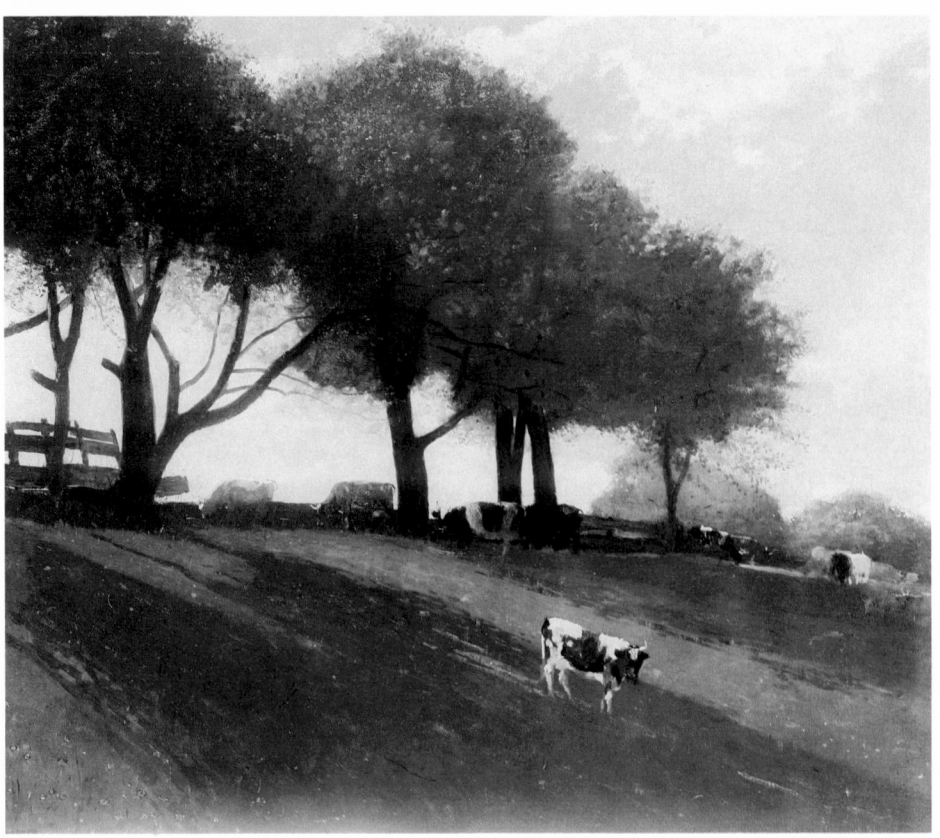

cosmopolitans and shepherdesses prettified like Little Bo-Peep. During the late '70s an occasional model was the young daughter of his friend J. Foxcroft Cole, who thus became an important contact between Homer and the Boston landscape painters. His diversity diminished when Homer spent two years painting fisherfolk in a seaside village in the north of England (1881-1882), then settled permanently in a house and studio beside the Atlantic Ocean in Prout's Neck, Maine. By the turn of the century Homer had won a great reputation, and was considered by many American and European critics to be the only true American artist, a myth that we still enjoy to an extent. We prefer to see him as a solitary hero and to separate his depictions of untamed nature and the struggle of life from the work of his contemporaries. But, in reality, Homer's withdrawal from society was far from complete. He always stayed in professional contact with the art world and with his dealers in New York and Boston; and of the two cities he was more in tune with Boston. During his first years in Maine, in fact, he said that Boston was the only American city in the United States that gave him any "practical encouragement."[15] His temperament was New England in character, and his social outlook was that of a New England gentleman. Though he lived in rural Maine, he shipped in food and clothes from Boston's finest purveyors. The famous watercolors that quietly extol humble old-time guides and trappers living in the wilderness were often painted on the preserves of the nation's most exclusive hunting and fishing clubs. As much as he and his work stand apart from the refined Boston painting that prevailed around 1900, he shared a great deal with two generations of Boston painters from Hunt to Benson, and his work was

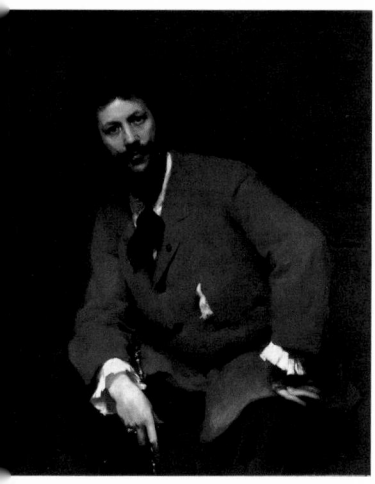

although Sargent considered it for the Paris Salon and the Venice Biennale, it was not publicly displayed again during Mr. Gardner's lifetime.

The reactions of Boston critics to Sargent's 1888 exhibition conveyed excitement at the exotic force that had just produced a significant group of modern pictures in their town. There was amazement at Sargent's eye for the style and exact fit of fashionable clothes and his feel for the texture of social privilege: "[His portraits] . . . breathe all the refinement, ease, opulence and delicate complexity of his age and country, for his work here is distinctively American."[27] At the same time, the portraits were dangerously close to the ostentation that Bostonians censured in New Yorkers and many foreigners, as the following tongue-in-cheek notice suggests:

[Boston propriety] . . . is still undecided . . . whether it was insulted or delighted. The first impression of many a well-bred Boston lady was that she had fallen into the brilliant but doubtful society one becomes familiar with in Paris or Rome [Sargent] actually presented people in attitudes and costumes that were never seen in serious, costly portraits before, and the painting was done in an irreverently rapid, off-hand, dashing manner of clever brush-work. Boston believes that there must be more dignity in dress and pose of subject, more painstaking and consecration in the painter and in his work.[28]

Sargent returned to paint portraits in New York and Boston in 1890, and again became more involved in Boston. Compared with the works of the 1887-1888 visit, Sargent's increasingly fluid manipulation of paint was apparent in the exuberant rendering of the dress and accessories in such 1890 works as *Miss Eleanor Brooks* (cat. no. 2). This development was related to his own recent attempts at *plein-air* impressionist painting, inspired by visits to Monet at Giverny. Miss Brooks's father, Peter Chardon Brooks, was an important Boston collector of modern art, with many examples of the Barbizon School and recent acquisitions of works by

Monet. Even though Sargent had incorporated certain mannerisms of Impressionism in his portrait style he came to be thought of more in terms of the other painterly style that influenced him – the bravura of Hals and Velázquez. The rich palette and impastoed details such as the jeweled tiepin in his *George Henschel* (cat. no. 5) have an "Old Master" quality, and it must have been apparent to art connoisseurs that the portrait of the Boit children (cat. no. 1) was an homage to the Velázquez masterpiece at the Prado, *Las Meninas*.

The portrait of George Henschel, although painted in England, illustrates the complexity of Sargent's connections in Boston. Henschel, a German-born singer, composer, and conductor, became the first conductor of the Boston Symphony Orchestra in 1881. He and Sargent shared a passion for the modern music of Wagner, and Henschel had as much influence on the developing musical tastes of Bostonians as Sargent had in painting. Henschel's patron was the founder of the Boston Symphony, Major Henry Lee Higginson, whom Sargent would paint on commission for Harvard University in 1903 (cat. no. 4).

By 1890 Sargent was closely involved with the principal cultural figures of Boston, who accepted him as their equal. Like Whistler, he lived in London, but he had cousins in Boston as well as worthy New England ancestors who had sat for Copley. His notoriety for "slap dash" and "cleverness" was outweighed by the accolades he had received in Paris and London; he was a gentleman and as modern as Boston desired – in short, a modern old master. He soon became a useful agent abroad, informing Isabella Stewart Gardner of a Persian rug, an early Spanish woodcarving, Whistler's Peacock Room, and works by Tintoretto, Watteau, Manet, Monet, Boldini, and Augustus John, all of which he thought worthy of her collection; he also recommended purchases to the Museum of Fine Arts (including El Greco's *Fray Hortensio Félix Paravicino*, acquired in

1904). Sargent's involvement with Boston was cemented by his friendship with all three members of the New York-based architecture firm of McKim, Mead, and White: in 1890 he was commissioned to paint one of the mural decorations of the new Boston Public Library, which they had designed. He would work on three decorative projects in Boston until his death in 1925 – the Public Library, the Museum of Fine Arts, and Harvard's Widener Library. All of his murals were done for Boston, an indication of his commitment to the city and of the city's belief that he was the greatest artist of his day.

Childe Hassam: picturesque New England and the modern city

Hassam, the son of a local hardware merchant, had already embarked on a piecemeal process of private lessons and apprenticeship with an engraver when the Museum School opened, which is probably why he did not attend. An important local influence was Ross Turner, whose watercolors provided him a model and kindled an interest in colonial buildings and local customs. A sampling of titles from Hassam's first one-man exhibition of watercolors at Williams and Everett's Gallery in Boston in 1882 suggests both the mood and imagery that he sought: *Road leading to Wayside Inn, Sudbury*; *Town Pump, S'conset* [Nantucket]; *Digging Bait*; *Cider Apples (Beverly)*; *Rocks, Nahant*; *Where the Lilies Grow*; *The Harvest Moon*. Hassam's first trip to Europe in 1883 was not for a period of study at an art academy; rather, it seems to have been a grand tour during which he produced many paintings. His 1884 watercolor exhibition at Williams and Everett's included village scenes in England and France, tourist sights in Pompeii, Venice, and Alhambra, and harbor views in Scotland, Holland, and Spain. These pursuits of the early 1880s were part of the international current that inspired Sargent's trips to paint genre scenes in Brittany, Spain, and Venice, and Homer's sojourn in an English fishing village at roughly the same time. Hassam, like Homer, came to prefer the picturesque scenes of his native New England to those of Europe, and his summertime painting activities were often devoted to old churches, houses, and gardens, reveling in the spirit of country places little changed by urbanization.

Three early examples of the New England picturesque vision are seen in Hassam's painting *The Old Fairbanks House, Dedham, Massachusetts*, Ross Turner's watercolor *A Garden is a Sea of Flowers*, and J. Appleton Brown's pastel *Old Fashioned Garden* (cat. nos. 46, 97, and 100, respectively). All were created during the summer, when artists traditionally left the city. Unlike the Hudson River School painters, who usually sought wilderness views to render with painstaking fidelity, this group looked for places with human associations and worked in lively *plein-air* styles. Hassam's depiction of the Fairbanks house in Dedham, built around 1637,[29] draws attention to its situation on a grassy hill flanked by noble elms, and the figure carrying a pail of water evokes the centuries-old patterns of life maintained there. This painting exhibits a transitional style, suggesting Barbizon influence in its dark tonalities, while leaning toward Impressionist execution. The gardens in the pictures by Turner and Brown reflect a growing awareness of all things "old-fashioned," their rich profusion suggesting a new hunger to recapture the color and spirit of the age they symbolized. They are subtle reflections of the historicist movement that was particularly associated with architecture and the decorative arts now known as the Colonial Revival.

Parallels to such quaint but unsentimental paintings of rural summer pleasures can be found in the poetry and literature of John Greenleaf Whittier, William Dean Howells, and Sarah Orne Jewett, and an important figure who stimulated the interrelationship of these literary and artistic circles was writer Celia Thaxter (1835-1894). In 1848 Thaxter's father, Thomas

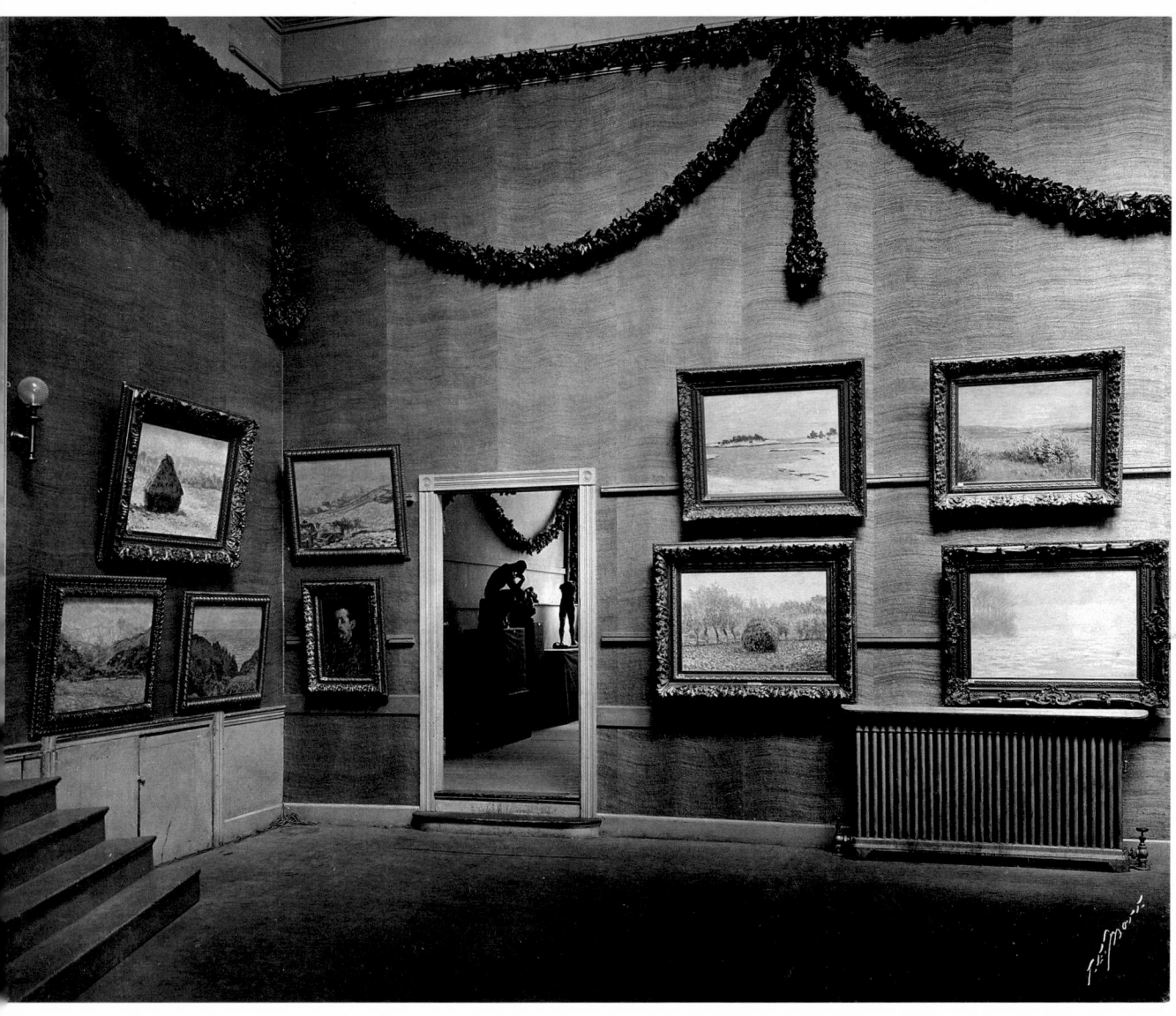

late 1880s. Four New Yorkers bought at least twenty-four Monets between them from Durand-Ruel's 1886 exhibition; Desmond Fitzgerald and Peter Chardon Brooks of Boston and John G. Johnson of Philadelphia all began to collect Impressionist art between 1886 and 1888. However, as with all new styles, the situation was one of gradual acceptance. Soon after admiring the Monet-Rodin exhibition held in Paris in 1889, Boston painter Lilla Cabot Perry visited Monet at Giverny, and wrote to American friends and relatives offering to buy them paintings for $500 apiece; she purchased a picture of Etretat for the only person who had responded positively, and was further astonished when "hardly any one [at home] liked it, the one exception being John La Farge."[39]

In 1891 a Boston reporter commented on what he saw as a new "fashion" in painting:

. . . leading Boston buyers of paintings – the first buyers, in other days, of Millets, Corots, Diazes and Daubignys – are now sending to Paris for this sort of thing, and Impressionism becomes the fashion. Some of our leading landscape artists praise it and preach it. Mr. J. Foxcroft Cole imports a number of Monets for collectors of authority. Mr. F. P. Vinton lectures upon the new light at the St. Botolph Club. Mr. Fenollosa, expert in Japanese art, exults in numberless discourses on the increasing Japanese influence evident in the use of simple, pure tints and unconventional composition. . . . Courbet and Hunt couldn't see color in nature as it really is. Tone, so much prized and labored for in the past, must go Mr. Vinton says the theory is that colors must no longer be mixed on the palette, but are to be laid side by side, either in dots or dashes, in pure tints, and left to mix optically on the retina.[40]

Unconvinced, this writer concluded that Impressionism was merely providing a new set of conventions for painters to imitate, conventions "in coarser forms and on lower planes both of technical accomplishment and artistic sensibility."

The seriousness of the Bostonians who had begun to collect Impressionist art was confirmed in 1892, when the St. Botolph Club exhibited twenty-one landscape paintings by Monet, all borrowed from ten local collectors, a Boston dealer, and one collector from Providence.[41] However, the battle was far from over, as demonstrated by the critic from the *Transcript*, Boston's cultivated newspaper, who maintained a conservative skepticism, and complained that ". . . the claims of Monet and of impressionism are still urged with excessive zeal by a considerable body of influential artists and amateurs, who are determined that Boston people shall agree with them. Excellent painters have been much harmed by this sort of propagandism, which is foreign to art."[42] The reservations of such critics apparently did not dampen the spirits of local collectors and artists. Two more Monet exhibitions were organized by the St. Botolph Club in 1895 and 1899, and in 1905 the Copley Society showed ninety-five paintings by Monet and eleven sculptures by Rodin (fig. 18). All of these events confirmed that Monet was the Impressionist whom Bostonians most admired; indeed, his art had become something of a cult with Boston collectors (analogous to their enthusiasm for Sargent), and the thirty-nine Monet oils and pastels now owned by the Museum of Fine Arts represent the beneficence of these early patrons.

Boston's first practitioners of impressionism were esteemed by the visiting Parisian critic S. C. de Soissons, who noted in his 1894 book *Boston Artists*: "The landscape painters are more successful [than the portraitists], for the reason that the pictures are more modern, and the treatment of light and atmosphere introduced by Monet is more conspicuous " He admired the "happy memories" and "poetic impressions" of nature made with a technique that he found the antithesis of "photographic reproduction."[43]

The closest American follower of the French style was Childe Hassam, whose earlier Boston style was much changed during his three-year stay in Paris

(1886-1889). Even in the '90s Hassam's execution could vary (becoming firmer and more detailed when the image was dominated by buildings or people, and looser for landscapes and garden pictures) but his impressionism was usually full-blown in the summer landscapes done on the Isles of Shoals, such as the 1892 watercolor *Dexter's Garden* and the 1899 oil of sunset's approach over the lighthouse of White Island (cat. nos. 101 and 35). Echoing the style of certain Impressionist landscapes from the early 1880s (those by Monet, Pissarro, and Renoir), both works create tapestry-like effects with arrangements of separate flicked strokes that intensify the illusion of brilliant sunlight. The compositional structure of *White Island Light* is indebted to Monet's 1889 *Ravine of the Creuse* series; similarly, the pinks in the sky and the bold mixture of blues and greens for the sea were inspired by color effects found in Monet paintings from the late 1880s, the period of Hassam's residence in France. It is a matter of debate whether Hassam's style should really be referred to as "neo-impressionist," given its origins in French work of the 1880s.

The extensive variety of American artistic responses to Impressionist style is illustrated by three unusual views of Boston painted in 1892-1893: Hassam's *Charles River and Beacon Hill*, Edward Simmons's *Boston Public Garden*, and Dwight Blaney's *Brookline Village in Snow* (cat. nos. 29, 30, and 27, respectively). All the artists had recently worked in Paris, and, although they shared a Boston past, they returned to very different American careers. Hassam and Simmons settled in New York, where Hassam concentrated on pictures of city life and Simmons turned to mural painting. Blaney lacked the professional training of the other two, and embarked on a career as a gentleman painter after an advantageous marriage. Their three cityscapes share a concern for unconventional points of view featuring large areas of empty foreground space (motifs associated with the French Impressionists, and

popularly interpreted as the influence of spatial effects found in Japanese prints). Perhaps the most ambitious of the group is that by the youngest artist, Blaney, in which a rather literal approach to evoking falling snow has an effect similar to the *pointillist* application of the Neo-Impressionists. The other two applied their paint more thickly and broadly: Hassam's animated strokes are ordered to suggest the sweep of the road and the vibrant light of the sky, but they lack a true Impressionist mixing of colors; Simmons was even less adventurous, using a conventional sketch style, which he enlivened with accents of bright color.

Winslow Homer had long been affected by the currents that produced Impressionism, but he did not wish to be identified with the slightly younger group of American impressionists who came to prominence in the course of the 1890s; one obvious reason for this was the gulf separating his recent heroic outdoor subject matter from the cheerful landscapes and scenes of prosperous living favored by American artists like Hassam. It is evident from his art of the 1870s and '80s that his 1867 Paris trip had allowed him to study the innovations of Courbet and Manet (see cat. nos. 44 and 22). The further impact of Impressionism on Homer in the early 1890s landscapes is suggested by *Sleigh Ride* (cat. no. 28). Compared with his epic and formally contrived figurative pieces of the same period this is a relatively informal depiction of a striking momentary effect in a painterly style. Homer's sensuous enjoyment of paint and color is at its best in the dramatic pinkish strokes suggesting the gleaming tracks cutting through the foreground. The strong asymmetrical design of the composition was, for Homer, an unusual exploitation of Japanese design principles, and its spareness parallels roughly contemporary landscapes painted in England and France by Whistler, and in Scandinavia by Albert Edelfelt and Peder Severin Krøyer.

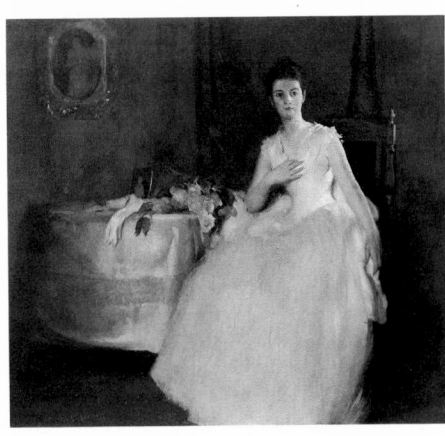

Edmund Tarbell and Impressionist Figure Painting

The career of Edmund Tarbell in Boston is a success story of the eager young man staking his career on a new style, progressing rapidly in the direction he and his local supporters favored, and coming to national prominence within a few years. Following study at Boston's Museum School and the Académie Julian in Paris, he supported himself as a portraitist while seeking success in Boston and New York exhibitions. Early notices acknowledge the strong influence of John Singer Sargent in his portraits and figure pieces.[44] In 1889 Tarbell was appointed to teach the painting class at the Museum School, and simultaneously his reputation grew. In 1890 he won the Thomas B. Clarke Prize at the National Academy of Design with his painting *After the Ball* (fig. 19), a narrative illustration of bourgeois life, complete with bouquet, long white gloves, and a warm glow of firelight. This painting by Tarbell lacks the sophisticated aura and fastidiously refined technique of Dewing's contemporary figure pieces (fig. 15, for example), but it was a popular and creditable success for the twenty-eight-year-old artist. Encouraged by the Clarke Prize, Tarbell declared a serious interest in impressionism by painting *In the Orchard* (cat. no. 47) in the summer of 1891. Over five feet wide, this early masterpiece was designed on a scale cal-culated to win attention at enormous, densely hung exhibitions; in fact, it served the artist in this way at the Chicago Columbian Exposition of 1893. The size of the canvas was important, for it apparently encouraged him to paint more freely and quickly, thus pushing him to far broader effects than he had previously explored. This ambitious statement was probably inspired by Renoir's *Luncheon of the Boating Party* (fig. 11), a picture of similar scale and theme, with a related composition (anchored on the left by a standing figure, more open in the center, and crowded at the right). Tarbell knew the Renoir well, since he had made catalogue illustrations for the New England Manufacturers' and Mechanics' Institute exhibition, in which it appeared in 1883.[45] The young subjects of these pictures reflect social and cultural differences between Paris and Boston, and show the different goals of the artists who painted them. The Renoir presents the lively socializing of coquettes, bare-armed oarsmen, and various other male types, all sated and convivial after their meal on the crowded terrace of a restaurant beside the Seine; it encompasses a spectrum of types in a hedonistic young set, and its view of the river reinforces the message of modern leisure with a sailboat and railway bridge. The Frenchman leaves the viewer curious about his personalities and the consequences of their interactions, whereas the American creates more of a self-contained illustration of a happy occasion, without broader allusions. The cast of characters in the Tarbell is smaller and comparably dressed; they occupy what appears to be a private fenced space, and quietly exchange pleasantries. The people include his wife, whom he had married in 1888, her younger brother and sister, and one of their friends.[46] Indeed, Tarbell's family life and surroundings became the subject for much of his work. *Mother and Child in the Pine Woods* (cat. no. 49) depicts his wife and their first child, Josephine, born in 1890, and here too Tarbell painted sunlight filtering

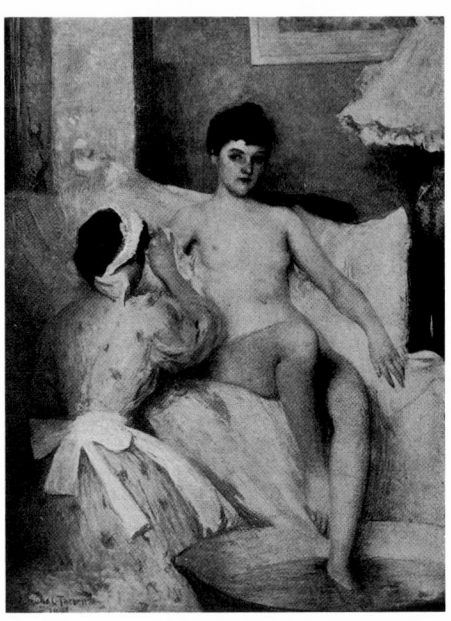

through trees and enlivened his image with impastoed sunny highlights on the dresses. The dimensions of this work (25 by 30 in.) were more typical of his impressionist scenes, and follow the size frequently used by Monet for his landscapes.

Wilbur Dean Hamilton's *Summer at Campobello, New Brunswick* (cat. no. 48) suggests the influence Tarbell's sunny conversation piece *In the Orchard* had after its appearance at the 1893 Chicago Exposition. This vignette of summer tourists mingling outdoors typifies the subject matter and moderate impressionist style that proved most popular in the latter part of the 1890s. The palette is bright and cheerful and the overall effect connotes pleasure in the act of painting rather than a statement of a radical new vision. The resort setting is as modern, optimistic, and charming as it would be in a contemporary novel by William Dean Howells.

The female nude was associated with French Impressionists, especially Renoir, but this subject rarely led to critical success for their American followers. About a year after completing *In the Orchard* Tarbell painted a boudoir scene with the same naturalism: *The Bath* (fig. 20), his only major frontal nude, won the Shaw Fund Prize ($1500) at the New York exhibition of the Society of American Artists in 1893. Despite that recognition from his artist colleagues, reviewers complained that it was slightly too realistic and coarse in execution to achieve "the charm which one expects in such a subject to relieve its animality."[47] Tarbell's other important nude, *The Venetian Blind* (1899, Worcester Art Museum), painted six years later, showed only the back and shoulders in a shadowed setting. Compared with *The Bath*, it was a discreet statement that could not harm his growing reputation; in fact, it became one of his most admired works, representing him at the Paris Universal Exposition in 1900, and four years later being singled out by Boston painter Philip Hale as "the best picture that has been done in America."[48]

The growing interest in impressionism discernible in Boston in the 1890s was confined to a minority of local collectors and artists. The situation probably perceived by most people was stated by William Howe Downes in his 1896 essay "Boston Art and Artists."[49] Although the accompanying illustrations included Sargentesque portraits by Tarbell and Benson, they were dominated by landscapes with sheep and cows and anecdotal genre pictures such as Abbott Graves's *Silent Partner*, in which a hurdy-gurdy man and dancing girl mourn a dead monkey. The text discussed twenty-seven men and mentioned eight "sisters of the brush and palette" in the last paragraph. The word impressionism was not used, a fact that is less surprising when one considers Downes's statement in an 1892 essay on the French Impressionists that ". . . their mannerisms are so pronounced and obtrusive as to preclude style and to offend taste."[50] However, Downes did suggest the style in connection with Tarbell, a "singularly penetrating and keen" observer; " . . . few modern painters of any school have given a more striking interpretation to the phenomena of light and color in relation to the human figure." Downes selected the

artists he felt had the greatest reputations and the most professional and popular esteem, without attempting to define regional characteristics or to isolate the most important group. Many of the names are forgotten by all but a few specialists.[51]

The Ten American Painters and the Marketing of Impressionism

In 1898, twenty years after the first exhibition of the Society of American Artists, a splinter group of ten withdrew from the Society and exhibited together at the Durand-Ruel Galleries in New York. They seceded in order to display their work in small, congenial installations, on the theory that their common interest in Impressionism would create harmony and preclude the odd mixtures of styles found in recent Society of American Artists exhibitions. The ten artists included three Bostonians (Frank Benson, Joseph DeCamp, and Edmund Tarbell) and seven who lived in New York (Thomas Dewing, Willard Metcalf, Robert Reid, John Twachtman, J. Alden Weir, and former Bostonians Childe Hassam and Edward Simmons). Abbott Thayer of Dublin, New Hampshire, and Winslow Homer of Scarborough, Maine, declined invitations to join the secession. Not wishing to imply narrow artistic focus, the group at that point took the name "The Ten." With the exception of Weir and Twachtman (who was succeeded on his death in 1902 by New Yorker William Merritt Chase), the New York members had close ties with Boston: Dewing and Hassam had been born there, and Metcalf, Reid, and Simmons had studied at the Museum School. Moreover, their annual exhibition traveled to the St. Botolph Club in Boston in 1900, 1902, and 1905.

In contrast to the creation of the Society of American Artists, the secession of The Ten did not involve a desire for freedom to work in a fundamentally new mode. Their most important contribution as a group was to exercise high aesthetic standards in the presentation of their work, although again they were popularizing reforms begun by Whistler in the 1870s and widely discussed by the mid-'90s.[52] For the inaugural exhibition their forty-five pictures hung in one room, grouped by artist. One critic was struck by the discretion of the framing: "The frames are modest enough to play into the pictures' hands. The whole room is a restful place. There are no bad pictures."[53]

The art of The Ten embodied the aesthetic ideals of the mainstream of American art at the turn of the century until their last exhibition in New York in 1917. In addition to group showings, the artists maintained individual careers and marketed their work shrewdly. They kept ties with the conservative National Academy of Design: for example, Benson and Tarbell were elected academicians in 1905 and 1906, respectively, and Weir became president in 1915. They were frequent contributors to the regular contemporary art exhibitions at the Pennsylvania Academy of the Fine Arts, Philadelphia; the Corcoran Gallery of Art, Washington; the Carnegie Institute, Pittsburgh; the Art Institute of Chicago; the Detroit Institute of Arts; and the Worcester Art Museum. These organizations constituted a circuit allowing the most successful pictures of the leading artists to be shown around the country, and the national reputations of Tarbell and Benson, in particular, were bolstered by the many medals and prizes they won on this circuit.

Philip Hale, a leading figure in the Boston art world, was not part of this core group of American impressionism, and his career was markedly different as a result. Only three years younger than Tarbell and Benson (his colleagues on the faculty of the Museum School), Hale adopted a more extreme and experimental modern style. His high-keyed color and mannered execution is seen in *Girls in Sunlight* (cat. no. 50), which belongs to a group of paintings he created at his summer house in Matunuck, Rhode Island. Hale's dance-like arrangement of diaphanous angelic figures may have been influenced by

Thomas Dewing, who was an instructor at the Art Students' League in New York when Hale studied there in the 1880s. Unlike Tarbell and Benson, Hale had actually worked in Giverny in the early '90s, but he avoided the style usually associated with Monet. His very long thin strokes and dazzling yellow monochrome are Neo-Impressionist in style and reflect the Symbolist works of Henri Martin and Giovanni Segantini; the built-up paint surface of such European paintings inspired Hale's rather decorative, textured works. Since he had not been elected a member of the Society of American Artists, Hale could not secede with The Ten. However, Durand-Ruel, The Ten's first dealer, held an exhibition of his brilliant sunlight pictures (including cat. no. 50) in 1899. Critical response was far less encouraging than it had been for The Ten a year earlier: Hale was characterized as an extremist of the impressionist movement and not taken very seriously. The extent to which he adapted his vision to that of the mainstream is evident in his highly successful picture from a decade later, *The Crimson Rambler* (cat. no. 53).

Maurice Prendergast and fin-de-siècle movements

From the modern point of view Maurice Prendergast was the only Boston artist of his generation to take a truly important place in the new art of the twentieth century. It is ironic and telling that his work was not shown at the Museum of Fine Arts during his lifetime. Social factors may have contributed to his exclusion from the mainstream of the Boston art world: he came from a modest background, was hard of hearing, and never married; he was not a teacher in any of the local art schools, and does not seem to have taken any private pupils. But the more important factor was the independent course he steered in his art, for he remained open to new artistic tendencies on both sides of the Atlantic; for example, on a visit to Paris in 1907 he

expressed admiration for the watercolors of Cézanne, a view that would have found few supporters in Boston at that time.

Prendergast had worked for several years in Boston as a commercial artist before traveling to Paris to study art (from 1891 until 1894). He was already in his early thirties and the venture required financial help from his younger brother Charles, a general assistant at Doll and Richards Gallery. Like many Boston artists he attended the academically oriented Académie Julian but felt no compulsion to follow such practices in his own work. He was more influenced by Art Nouveau, the mania for things Japanese, and a broad spectrum of French modern artists, including Toulouse-Lautrec, Gauguin, and the Nabis. Although three years older than Tarbell and Benson, Prendergast began to attract attention in Boston only in 1897, when their careers were soaring. He concentrated on watercolors and quickly reached artistic maturity in works like *South Boston Pier* (cat. no. 107), showing the new wharf jutting from Olmsted's Marine Park at Dorchester Point and reaching over the bay toward Castle Island. Prendergast made inspired decorative use of the boards, curving rails, gas lamps, ship masts, and industrial skyline in this sharply receding composition. Colorful subjects are placed to evoke the sense of random eddying motion of the bustling promenaders on a brisk day. Typical of Prendergast, none of the figures has detailed features, but great warmth for humanity is conveyed, while capturing the flux of a community at leisure. Prendergast worked from close observation of a scene, taking small sketchbooks to record people in parks, on the beach, and in the street. He did not depend on facial expressions to communicate observations of character, for he had a great eye for attractive or telling qualities in a person's carriage and dress.

The echo of Art Nouveau found in Prendergast's *South Boston Pier*, although it was most commonly seen in

Fig. 21
William McGregor Paxton, poster for the Boston Sunday Herald, March 31, 1895
Printed in black and tan ink on white paper, 18½ x 11½ in.
The Houghton Library, Harvard University, Cambridge

the graphic arts, was not unusual in Boston in the mid-1890s. Prendergast was one of the many painters who produced fine decorative illustrations in this style for Boston's book trade.[54] (Even William McGregor Paxton, who would become the leading exponent of a sleek and popular academic realism in the early 1900s, contributed stylized Beardsleyesque designs at the height of this craze, such as the *soigné* theater couple in an 1895 poster for the *Boston Sunday Herald*, fig. 21.) Prendergast's admiration for Japanese prints is evident in his colorful palette with its striking red accents and his freedom from traditional perspective, most evident in upright compositions (cat. no. 105, for example). This love of an oriental aesthetic may have begun for him in Boston, for the eastern collections of the Museum of Fine Arts had always been strong, and were frequently the focus of lectures by outstanding scholars such as Edward S. Morse and Ernest Fenollosa. The Museum's endorsement of Japanese art as an influence on modern American art was evident in an 1895 exhibition of woodblock prints by Arthur Wesley Dow, then an assistant to Fenollosa at the Museum. Dow's application of Japanese vision and technique to New England subject matter is seen in *Ipswich Village* (fig. 22), a small vividly colored work from that exhibition, in which the yellow, blue, violet, and red tones used for the buildings are similar to the brightest accents in Prendergast's watercolors. The doctrines of Dow and Fenollosa became the basis for Dow's widely influential book *Composition: A Series of Exercises in Art Structure for the Use of Students and Teachers* (1899).

When Prendergast exhibited and auctioned twenty of his works in Malden, Massachusetts, in 1897 the *Transcript* was taken with his "strikingly original style" and "distinct gayety and charm of color," noting:

His subjects comprise seashores with the figures of children at play on the sands, which are full of dainty and buoyant action, and are painted with a most felicitous and suggestive touch. He is a brilliant and distinguished colorist.[55]

This was the best review Prendergast received in Boston, and he was not the subject of a serious article anywhere until Washington's modern art collector Duncan Phillips wrote a memorial tribute in 1924. Fortunately, Prendergast found a helpful Boston patron soon after he returned from his studies in Paris, for around 1897 Sarah Choate Sears, wife of millionaire Joshua Montgomery Sears, began to purchase his watercolors, including *South Boston Pier*.[56] Unlike her friend and competitor Isabella Stewart Gardner, Mrs. Sears was an artist as well as a serious collector of modern art. She was a strong and active participant in several of the movements that flourished at the end of the century, exhibiting her watercolors in the same local shows to which Prendergast contributed. Her photographs were shown with the Boston Camera Club, where she was part of the circle of F. Holland Day. In 1897 she was a founding member of the Boston Society of Arts and Crafts (the first American organization of its kind) and her embroideries, based on William Morris designs, were included in its exhibitions. After supporting Prendergast by purchasing his work, Mrs. Sears and her husband funded his eighteen-month trip to Europe in 1898. Thus did Prendergast's "strikingly original style" begin to grow: he is now recognized as the most individual Boston artist to emerge in the 1890s, and although his interests were similar to those of the local impressionists, his fate in Boston in the early twentieth century was quite different.

"Banned in Boston" – Civic Identity in the Arts

In the late nineteenth century Boston prided itself on a reputation for cultivating the arts and humanities – it was the seat of literary genius, the home of Harvard and the Symphony, and took pride in national firsts: the free municipal library (founded in 1852) and the

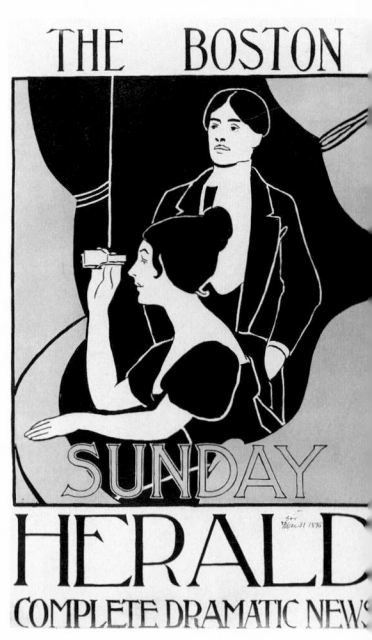

municipal art commission (established in 1890). However, lingering puritanism compounded with Victorian morality and provincialism could be destructive agents. Tension between the opposing traditions of freedom and restraint, innovation and conservatism, occasionally prevented the course of culture from running smoothly. The introduction of impressionism into Boston is a positive instance in which the conservative art community grew to an acceptance in the course of a decade, eventually making the city a center to collect, practice, and teach the new style. A graphic example of Boston's recalcitrance is provided by an ill-fated attempt to install Frederick William MacMonnies's 1893 bronze sculpture *Bacchante with Infant Faun* in the courtyard of the Boston Public Library (fig. 23).

The new Public Library, which opened to universal admiration in 1895, was the masterpiece of the American Beaux Arts movement, created by the New York architecture firm of McKim, Mead, and White. Its decorations included murals by the French master Puvis de Chavannes and two young American residents of London, Edwin Austin Abbey and John Singer Sargent. Ernest F. Fenollosa, Curator of the Japanese Department at the Museum of Fine Arts, wrote: "[The library murals are] the first great centre of a future civic series. Here the principle is first openly, and on a large scale, acknowledged by the public authorities. By their act, and by this first blaze of achievement, we set Boston as the earliest of seats of public pilgrimage, the veritable Assisi of American art."[57]

For the beautiful inner courtyard (which reminded Henry James of the "myriad gold-colored courts of the Vatican"), Charles McKim chose and offered as a gift the MacMonnies *Bacchante*. Created in Paris by the young American sculptor, the piece was slated for purchase by the French government until McKim saw it as ideal

for the center of the fountain in his Boston courtyard. In July 1896 a reduced model of the *Bacchante* went before the Art Commission, who approved all art that became the property of the city of Boston. A specially appointed committee of experts (including Boston artist Frederick Porter Vinton and New York sculptor Augustus Saint-Gaudens) voted five to four in favor of acceptance, but the Commission itself then voted four to one against that advice. All the objections were along the lines of a statement by Harvard Professor Barrett Wendell, who wrote in the *Transcript* that the *Bacchante* was "a drunken woman, unclothed, unquiet, vile."[58] As the debate became more vicious, it was decided to install the full-size sculpture in the library courtyard (fig. 23), rather than argue over a small-scale model. Seeing it in place, the Art Commission reversed its decision and proposed that the gift be accepted. A few weeks later, the Watch and Ward Society (founded in 1884 as the New England Society for the Suppression of Vice, and staunchly supported by such local worthies as Godfrey Lowell Cabot and clergymen Phillips Brooks and Edward Everett Hale) pronounced the sculpture "the glorification of that which is low and sensual and degrading." For the next six months public controversy was further aroused by the Bethel Total Abstinence League, religious groups, and youth organizations, while yellow journalism boomed. No one had objected to Sargent's mural depicting the Phoenician goddess Astarte, described in the 1895 library handbook as "the goddess of sensuality – beautiful, alluring, and heartless," attended by priestesses "swaying to the measure of a wanton and luxurious dance." But Sargent had experienced controversy in Paris with his risqué society portrait *Madame X* (1884, Metropolitan Museum of Art, New York); he also understood Boston enough to avoid actual nudity, and incorporated his sensuous deities into a ceiling teeming

with figures and emblems from pagan religions. Most Bostonians viewed Sargent's scheme as a historical interpretation, and seem to have been blind to its visual and emotional affinities with Europe's decadent Symbolist art movement.

In the midst of the outcry, the following sorts of opinion were expressed in Boston and elsewhere in support of the *Bacchante*:

Bostonian Thomas Russell Sullivan in his journal, October 13, 1896:

The wording of . . . [the Art Commission's] refusal is hopelessly provincial, and the tone of the press in commenting favorably upon their course is equally so. . . . The depressing little incident seems to drop us back a century or two towards the dark ages.

New York Sun editorial, October 19, 1896:

Life is a serious matter [in Boston]. Duty before pleasure, always. . . . Bostonians are not all of that way of thinking. Some of them are very wicked; but they are not joyful in their wickedness. It seems to make them more depressed than ever. They try to be merry, but they make a dismal failure of it. A community with that sense of moral responsibility cannot have spontaneity.

Wilson Davis in the Boston journal *Modern Art*, winter 1897:

Fair Bacchante! dull is he who cannot respond to your joy with the glad thought. . . . And so, may [she] . . . remain to enliven the beautiful courtyard; . . . may the twentieth century be allowed to receive her as a token of the willingness of Bostonians of this decade to cherish an healthful gayety.[59]

In the summer of 1897, the fearful library trustees asked McKim to withdraw his gift. He did so, and by the end of the year MacMonnies's *Bacchante* had been given to New York's Metropolitan Museum of Art.

The Bacchante incident revealed the dark side of Boston's prided enlightenment in the arts. Power was in the hands of the educated but conservative Bostonians involved with the Art Commission and groups like the Watch and Ward Society; their objection was not to nudity per se, but to the inappropriateness of the subject for the setting – a public institution of learning. However, the way in which they overrode the architect responsible for the project and the advice of the city's arbiters of taste was ultimately hostile. Despite their modern innovations in the 1890s, progressive Boston painters did not engender a *cause célèbre* analogous to that surrounding MacMonnies; however, the brouhaha left an impression, and in retrospect the outspoken traditionalist stance taken by artists like Hale and Paxton from around 1910 seems to stem from the thinking that prevailed when the *Bacchante* left Boston for New York.

IV 1900-1930: The Boston School

During the first three decades of this century Boston reached the pinnacle of its artistic aspirations. A certain Boston look was discernible in many pictures, and there prevailed within the city's unified class of patrons a widespread sense of satisfaction. In 1904 William Howe Downes gathered statistics on the arts in greater Boston and found "an army of professional artists" – including almost six hundred painters, about three hundred fifty architects, over one hundred engravers, and almost as many picture dealers. There were over eight hundred music teachers and twelve theaters employing actors; only the number of sculptors was deemed "insignificant." Downes made this analysis for his essay "Boston as an Art Centre," a spirited response to Herbert D. Croly's 1903 article "New York as the American Metropolis."[60] Croly had extolled the "manifest destiny" of New York following its emergence as the national headquarters of commerce and industry in the mid-nineteenth century: it was densely populated, racially mixed, socially diverse, and the focus of "the high vitality of American life." Eminent artists tended to live there, he reported, "not because it is a very beautiful city, not because New Yorkers are peculiarly appreciative of American art, but almost entirely because the association with fellow-craftsmen . . . is essential to artists." Downes's riposte came as a reflex to Croly's remark that Boston was "merely the metropolis of a locality, a provincial capital." He was confident that his town was taking a better course and avoiding mistakes made in New York. According to Downes, Boston was setting an example to the nation with her municipal art commission, regulations governing building height, and a park system whose borders were protected by "prohibition of advertising abuses." Boston eschewed the "Babylonic sky-scrapers" of New York as "inartistic monstrosities and immoral impositions," as well as fire hazards and robbers of sunlight and air. In his discussion of the qualities of history, tradition, and atmosphere essential to any art center, Downes also stressed Boston's wealth of monuments – from the colonial meetinghouses and Bulfinch State House to Saint Gaudens's 1897 memorial for Colonel Robert Gould Shaw and the black volunteers of the 54th Regiment.

The polyglot nature of New York and the lingering nobility of Boston were reflected in the differing artistic temperaments of the two cities, and their rivalry and mutual disdain increased between 1900 and 1930. New York's concentration of artists and galleries of diverse styles and vision – academics such as Kenyon Cox; the mainstream portraitists and landscapists including William Merritt Chase and six other members of The Ten; Robert Henri and the Ashcan painters; the modernists in the circle of dealer Alfred Stieglitz – fostered lively debate and made both the market and the critical milieu rich and complex. In contrast, the considerable diversity that had flourished in Boston during the 1890s began to wane. The achievements of Boston painters after 1900 were significant, but they became increasingly unified and focused on their own local preferences. During a time of tremendous social, economic, and industrial change (whose effects on an older aesthete were recorded by Henry James in *The American Scene* of 1907) Boston artists offered a renewed ideal of beauty, a conscious marriage of impressionist color, fine draftsmanship, and compositions inspired by the Old Masters. As some New York artists began to address the real lives of ordinary people, Bostonians continued to paint a peaceful and refined world of retreat – dignified portraits, reposeful interiors, gracious still lifes, and cheerful, gentle landscapes. The special character and importance of the Boston group was suggested in 1905 by New York artist and historian Samuel Isham:

. . . the desire for breadth, simplicity, and strong direct work . . . [gives] the whole body

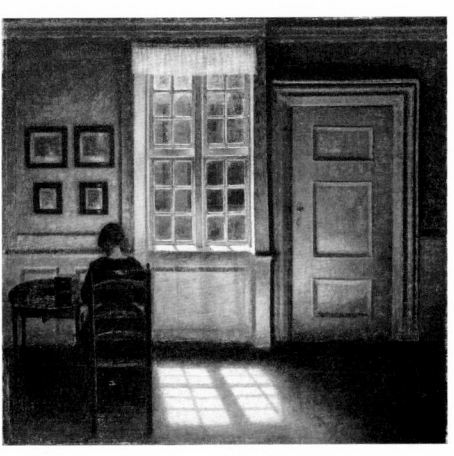

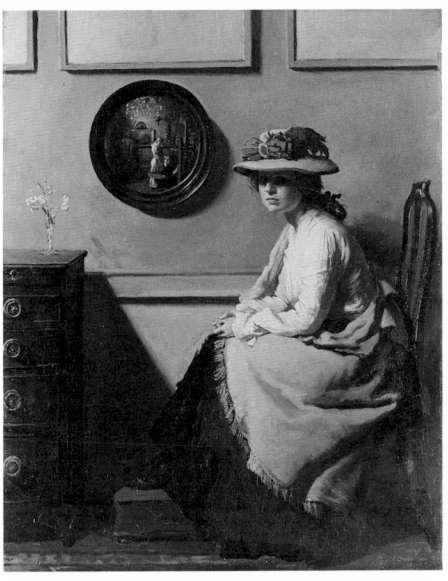

examples by the British Pre-Raphaelites
often had a moral tale to tell, as in
William Holman Hunt's *Awakening Con-
science* of 1853 (Tate Gallery, London).
In Paris in the 1860s and '70s the theme
was common ground for academic art-
ists like James Tissot and Alfred Ste-
vens (fig. 28), the avant-garde Impres-
sionists, and independent figures like
Whistler. During the 1880s and '90s the
still-popular subject attracted a variety
of practitioners on both sides of the
Atlantic: the Swede Carl Larsson and
the Dane Vilhelm Hammershøi (fig.
32); French Nabis Pierre Bonnard and

Edouard Vuillard; and Americans Wil-
liam Merritt Chase and Thomas
Wilmer Dewing (fig. 15). That Boston
artists would join this vogue was a natu-
ral extension of their openness to art in
the 1890s, but more surprising was the
way in which this international phe-
nomenon stimulated excitement among
local artists in the first decade of the
twentieth century, resulting in the
widely admired and long-lasting move-
ment surrounding Tarbell.

The emergence of the interior as a
favorite subject of Boston artists, and
the ways in which their works are char-
acteristically Bostonian, are complex
issues. Tarbell's 1899 work *Across the
Room* has much the same feeling of stu-
dio informality as William Merritt
Chase's *Friendly Call* of 1895 (fig. 30), in
which Chase depicted his wife receiving
a guest at their summer home in Shin-
necock, Long Island, amid an eclectic
array of art objects. In Europe Alfred
Stevens had long been a master of this
kind of scene from cosmopolitan life, as
seen in *The Visit* (fig. 28), his depiction
of a studio encounter painted in Paris
around 1875. When Tarbell painted
Girl Crocheting (cat. no. 66) in 1904 his
principal point of reference became

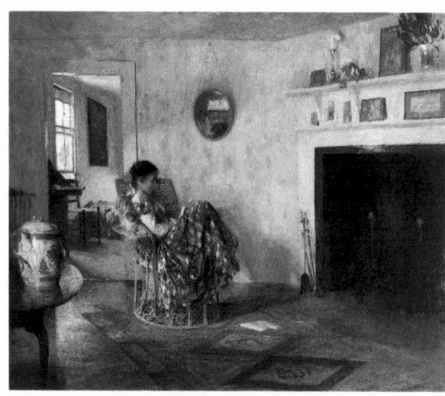

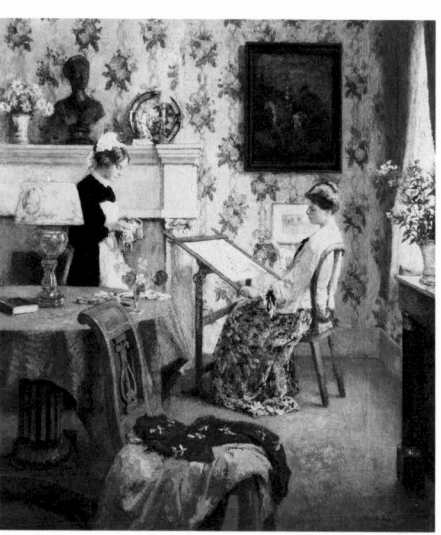

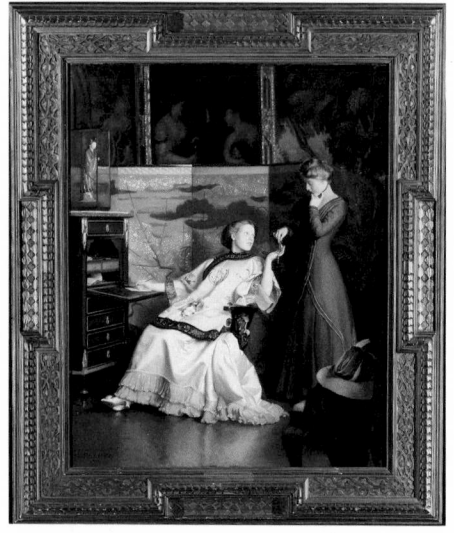

Vermeer. Similar forces were at work in England at about the same time, as can be seen in William Orpen's painting *The Mirror* of 1900 (fig. 33). Although suggesting a working woman (modeled by Orpen's mistress), this picture, like the 1904 Tarbell, represented a new interest in quoting from the past – the circular mirror in Jan van Eyck's 1434 *Arnolfini and his Wife* (National Gallery, London) and the pose and composition of Whistler's 1871 *Arrangement in Grey and Black: Portrait of the Painter's Mother* (Musée du Louvre, Paris). Tarbell was probably aware of the British interiors of Orpen, William Rothenstein, and their circle from art magazine illustrations, but the most telling influence on the evolution of his interiors was the

purchase of Vermeer's *Concert* by Isabella Stewart Gardner in 1892. That work was exhibited in Boston in 1897, and was on display at her house-museum, Fenway Court, from 1903. Another influence may have been photography, particularly the "portraiture" or documentation of rooms. A photograph from about 1892 (fig. 29) exemplifies the trend to bring a beautiful young woman into an spare, orderly, and grand interior with a prominent oriental vase; this room, from the home of Boston's Colonial Revival architect Arthur Little, stands in marked contrast to the conscious profusion and clutter of most contemporary stylish interiors in Boston (figs. 4 and 41).

Because the work is diverse, it is dangerous to suggest that all Boston paintings of interiors have a look that can be identified with certainty. If one looks objectively at all interiors being painted in Europe and America around 1905 one might conclude that "The sensitive interiors of Edmund C. Tarbell . . . might have been painted in any country," as C. Lewis Hind claimed in 1910.[76] However, in the broadest cultural reckoning, Tarbell's simplicity can be equated visually, spiritually, and morally with that of Vermeer, particularly in terms of their common Protestant heritage. Quite different again was Paxton's love of opulent display, which

seems at odds with the reputed restraint and propriety of Boston; it often comes closer to the French precedent of Stevens (fig. 28). Gari Melchers's *Penelope* (fig. 37) has the hallmarks of a Boston picture, but was painted by an American with no Boston connections during a period when he was a painting instructor at the Grand Ducal Academy of Fine Arts, Weimar, Germany (1909-1915). Similarly, the Philadelphia interiors of Daniel Garber, a teacher at the Pennsylvania Academy of the Fine Arts, are close in content and mood to those of the Tarbell group. And Lilian Hale's young women are hardly different in type or presentation from those found in "aesthetic" photographs by New Yorkers Clarence H. White and Gertrude Käsebier (fig. 34).

Nonetheless, despite these close connections with international trends, it is still possible to discern a local flavor in Boston interiors. It is frequently apparent in the very nature of the paint: an application that is careful, gentle, and knowledgeable; restraint from effects of color or execution that destroy the harmony of the whole; an overall finish that wants to be as much a part of a long artistic tradition as an expression of the individuality of the artist. A review of a 1922 exhibition of Boston paintings at the Carnegie Institute, Pittsburg, confirms this characterization:

The exhibition is strictly Bostonese. A restrained, colorless, flat, simple type of painting . . . highly technical and tonal in quality. . . . There is none of the sensational work, nothing to strike the eye forcibly. All of the paintings are done according to traditional training, but they make a fine collection.[77]

In recent years some scholars have discussed Boston paintings of interiors as "anti-feminist" expressions, promoting the view that women are merely "beautiful things."[78] This is true in the sense that these artists inevitably reflected a dominant cultural ideal of their period that privileged women should be decorative, ladylike, and seemingly free

from responsibility. Furthermore, the attitude was especially strong in Boston during the city's transition from the cosmopolitanism of the 1880s and '90s to the codified, single-minded conventionalism that had come to the fore by the 1910s. Most Boston women participating in this new cultural stance seem to have embraced such a vision of womanhood as morally and aesthetically correct. Female and male painters were equally likely to be carriers of these ideals in their imagery. Many women (some of them feminists) – for example, Lilian Hale, Edith Scott, and Gertrude Fiske (cat. nos. 88, 76, and 77, respectively) – regularly produced the same kinds of interiors as Tarbell and his male colleagues. The women and the settings depicted in works by both sexes were chosen for the cause of beauty, which they personify whether the scene is of sewing, flower arrangement, or idle reflection in bed.

Such generalized approaches rarely take into account the full visual evidence of the art, which does not universally conform to the sexist stereotype of the passive, submissive woman. The red-haired model of *Jade* (cat. no. 77) is a strong type, as is apparent in her demeanor, orange cloak, and broad-striped skirt; and the firm, committed look of women in many portraits often suggests their independence (for example, cat. nos. 3, 11, and 14). Further limiting and complicating this single-minded view of the Boston School is the attempt to "read" the pictures in terms of the postulates of Thorstein Veblen (*The Theory of the Leisure Class*, 1899) and George Santayana ("The Genteel Tradition in American Philsophy," 1913).[79] Both writers attacked the effete, polite Anglo-Saxon conservatism that dominated America and caused the young nation to repress its practical, aggressive, masculine forces. While it is important to acknowledge the limiting and repressive aspects of the society in which the Boston School operated, it is misleading to see their work primarily in such terms, since it was created in strict accord with a highly focused aes-

thetic program. Thus, the woman in Benson's quiet reverie *The Open Window* (cat. no. 74) is primarily an embodiment of the artist's admiration for Vermeer and for human sensitivity, and the painting a reflection of a Boston way of life as it existed for him and his colleagues. The opportunity to live in such an artistic and healthy-looking setting was an internationally held ideal (already replicated in cliché form by modern advertising). Moreover, the female achievement represented by such interiors often inspired pride, to judge from the comments of [Miss] Frances G. Curtis on Boston women between 1880 and 1930:

It may seem invidious and lacking in modesty to speak in superlatives of the 'Boston Interior,' but one of the outstanding features of Boston life has always been the beauty, charm and individuality of the house, the arrangements of the rooms, the living ways of the owners, something that is recognized the country over and that may be said to be due to the taste, judgment and discrimination of the woman of the family.[80]

The Landscape of Pleasure

The sunny impressionist landscapes of the 1890s continued through the 1920s with little change in style or attitude, recording idyllic settings in which the artists spent large parts of their lives. Even when the city was the subject, its mood was optimistic and pleasurable and, unlike New Yorkers, Boston artists showed little curiosity about the inhabitants who were not part of their cultural pattern. Thus, for example, the view in Tarbell's *Piscataqua River* (cat. no. 41) is from the garden of his house in New Castle, New Hampshire. Similarly, Theodore Wendel lived in an impressive seventeenth-century house in Ipswich, which he ran as a farm, and the Gloucester and Ipswich scenes he painted in all seasons show the beauty of the small New England towns (cat. nos. 33 and 34). In the face of relentless industrialization, fondness for earlier times increased; this nostalgia is as evident in the old architecture Childe Has-

sam sketched during his summers in New England (cat. no. 109) as it is in the "old-time" interiors of Tarbell.

The two most innovative landscape painters to emerge in Boston in the early 1900s were Hermann Dudley Murphy and Charles H. Woodbury. Both developed novel approaches to composition in which they advanced beyond the now-standard Impressionist style. Like their friend Maurice Prendergast, they had both been receptive to a broad range of modern art during their sojourns in France in the 1890s, but each produced less controversial work than Prendergast. Two marine paintings by Murphy and Woodbury (cat. nos. 36 and 37) demonstrate the impact of the Aesthetic Movement, and in particular its leading American exponent, the late James McNeill Whistler. Their reductively simple compositions and limited ranges of color have affinities with the subtle Art Nouveau ceramics made in the Boston area by the Grueby and Dedham potteries, as well as the Tonalist landscapes associated with New York artists Dwight W. Tryon and Thomas Wilmer Dewing. Of the two, Murphy's *Beach* is closer to Whistlerian doctrines with its abstract design, orientalized monogram, and relatively unadorned hand-carved frame of the artist's design. The choice of pale silvery gilding was intended to harmonize with the painting's delicate palette. Murphy was the leading American exponent of Whistler's reformist view that a frame should contribute to the aesthetic statement without rivaling the painting. With Charles Prendergast (the brother of Maurice) he started a framing business in 1903 and quickly made Boston the center of the frame reform movement. Its Celtic trade name – Carrig-Rohane – was related to the revival of Celtic decorative motifs that was part of the international Arts and Crafts Movement; in fact, Murphy first exhibited his frames at an exhibition of the Boston Society of Arts and Crafts in 1899.[81]

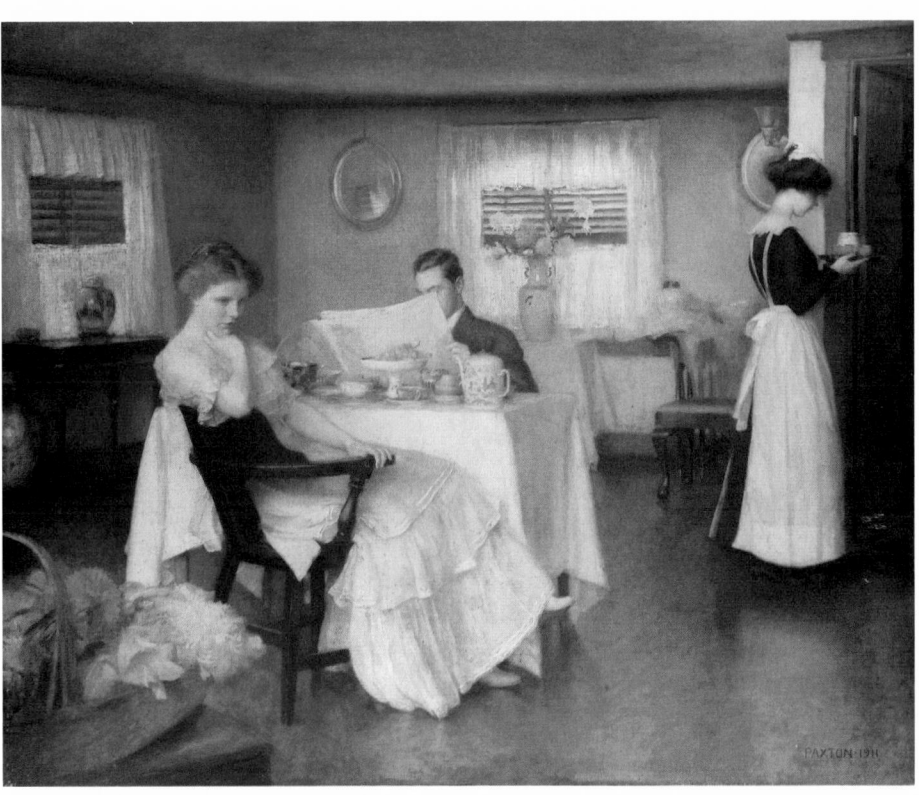

The Male Preserve

Men are noticeably absent in the interiors painted by Boston artists in the early years of this century. *My Family* and *The Breakfast Room* by Tarbell (cat. nos. 75 and 62) and *The Breakfast* by Paxton (fig. 38) are among the few exceptions, and in a sense they prove the rule, for *My Family* includes the artist's son, while the other two works portray married couples with little to say to one other. Paxton's intent was to depict the breakfast tiff familiar in popular sentimental novels, but he also showed, probably unwittingly, the separation of the sexes: the man seems to ignore the woman by reading his newspaper, conventional symbol of the outside world of business affairs. (Paxton shows a woman with a newspaper in cat. no. 69, however.) Most men simply were not at ease in the domestic indoors. To capture the male in his essence painters looked outdoors to the definable masculine pursuits of hunting and fishing in the unspoiled wilderness.

The archetypal outdoorsman, was, of course, Winslow Homer, and Bostonians had, since the 1880s, avidly bought his watercolors of Gloucester sunsets, sailing schooners, fisherwives by the sea, and especially Adirondack hunters and fly fishermen. Heroism was always one of Homer's subjects, whether involving the soldier, hunter, lifeguard, or fisherman. In the 1880s he codified masculine imagery of questing and confrontation, just as Tarbell would establish feminine precepts of beauty and refinement in the following decade. Homer's watercolor of a salmon rising to a fly captures the thrill and ambivalence of the moment when the fisherman's skill leads to its natural climax, the catch (cat. no. 92). Because Homer expressed his vision with such individual force, he had no rivals or imitators during his lifetime. For example, Frank Benson, a lifelong sportsman, made occasional paintings of flights of gamebirds during the 1890s, but he did not start his well-known sporting prints, watercolors, and

Fig. 39
Chart of a billiards tournament, 1905
Pastel on paper
The Tavern Club, Boston
The emblem of the Tavern Club is a bear.

Fig. 40
Postcard in the guest book of Dwight Blaney, post-
marked June 21, 1910
(inscribed on reverse: *DUX ET DECORUM EST /
PRO 8-GAUGE MORI*)

oils until 1912, two years after Homer's
death. Benson, as well as such followers
as Aiden Lassell Ripley and John
Whorf, continued this tradition of
American sporting pictures into the
1950s.

The sporting theme begun by Homer
grew from the male camaraderie fos-
tered at private clubs. Social interac-
tions between local artists and affluent
men from the business and professional
worlds were unusually strong in Bos-
ton. For example, Tarbell, Benson, and
Wendel were enthusiastic billiards play-
ers at Boston's Tavern Club, as can be
inferred from the delightful decorated
chart of the 1905 tournament (fig. 39),
and artists were also eager players in
the regular baseball games between the
St. Botolph Club and the Tavern Club.
The artistic depiction of outdoorsmen
at moments of excellence was a direct
extension of such social rituals of relax-
ation and competition. Benson, like
Homer, was a sportsman, and the diary
he made during his 1916 trip to one
hunting club, the Long Point Company
in Ontario, illustrates the extent to
which the worlds of art, finance, and
society overlapped. Once there, he used
the cabin of Arthur T. Cabot, a Boston
surgeon and art collector with a taste
for Monet and American impression-
ists, including Benson, La Farge,
Homer, and his sister Lilla Cabot Perry.
Benson's sponsor at the club was
Augustus Hemenway, a wealthy Boston
real estate broker and a collector with
interests similar to those of Cabot.[82] The
art he produced in this setting was
devoted to the solitary masculine hero,
as seen in his watercolor *Old Tom* (cat.
no. 94), later the subject of a popular
etching. The decorative aspects of his
hunting pictures were as important as
those of his interiors, a fact that is evi-
dent in the beautiful arabesques in a
painting of a flight of ducks attracted by
the decoys around a gunner's blind (cat.
no. 58). A humorous commercial post-
card preserved in the scrapbook of
Dwight Blaney (fig. 40) again illustrates
an artist's love of waterfowling, showing
the good fellowship that was a required

part of the social ritual at hunting clubs.
(Jovial exchanges of this sort were
never seen in the mythic presentations
of Homer and Benson.)

The example of William Sturgis Bige-
low illustrates that what was then seen
as the "feminine" environment of
urban culture and the "masculine"
world of outdoorsmanship could coex-
ist in the temperament of one individ-
ual. Epitomizing the luxurious environ-
ment of Bigelow's Beacon Street
townhouse were the elaborately carved
and gilded marble chimneypieces he
purchased in Italy, and the setting he
created was probably similar to that of
his friend Mrs. Jack Gardner when she
lived on the same street (fig. 41). The
enormous and outstanding group of
objects he collected in Japan (eventually
given to the Museum of Fine Arts, Bos-
ton) was the centerpiece of his varied
collection. In marked contrast to this
lifestyle, however, he retreated for
vacations to Tuckernuck, his island off
Nantucket, where women were simply
forbidden. Here his father had built a
plain, wooden summer structure (figs.
42 and 43) furnished with old Windsor
chairs, white ironstone china, and deco-
rated with arrangements of shells and
flintstones found locally. There, follow-
ing New England Transcendalist
beliefs, life became an idyll with nature,
while allowing Bigelow to socialize with
eminent public figures like Senator
Henry Cabot Lodge, or to study Bud-
dhist lore in the retreat of the library.
The side of Bigelow's temperament that
savored Tuckernuck inspired him to
collect the watercolors of Winslow
Homer, such as *Hudson River* (cat. no.
93). But when he was drawn by John

Fig. 41
Photograph of an interior at 152 Beacon Street,
Boston (residence of Mr. and Mrs. John Lowell
Gardner, ca. 1898)

Fig. 44
John Singer Sargent, *William Sturgis Bige-
low*, 1917
Charcoal on paper, 24¾ x 18⅞ in.
Museum of Fine Arts, Boston. Gift of the
Committee on the Museum. 17.3174

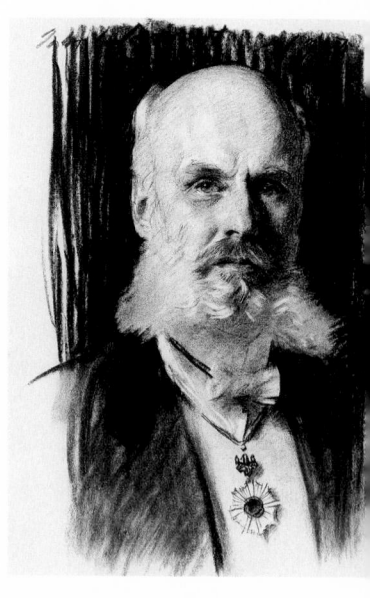

Singer Sargent (fig. 44) in honor of his
gifts and services to the Boston
Museum, he presented his urbane Bos-
ton exterior and wore the decoration
awarded to him by the Japanese
government.[83]

The Armory Show and Boston

In February 1913 the Association of
American Painters and Sculptors,
under the leadership of artist Arthur B.
Davies, presented its International
Exhibition of Modern Art at New
York's 69th Regiment Armory. Many
American artists were represented in
what is now called the Armory Show;
the work of the more liberal senior
members of the profession was
included but the younger generation
predominated. Only Hassam and Weir
represented The Ten, while Everett
Shinn was the one absentee from the
1908 "progressive" group The Eight
(those exhibiting being Davies, Robert

1.
JOHN SINGER SARGENT, *Daughters of Edward D. Boit*, 1882
Oil on canvas, 87 x 87 in.
Museum of Fine Arts, Boston. Gift of Mary Louisa Boit, Florence D. Boit, Jane Hubbard Boit, and Julia Overing Boit, in memory of their father, Edward Darley Boit. 19.124

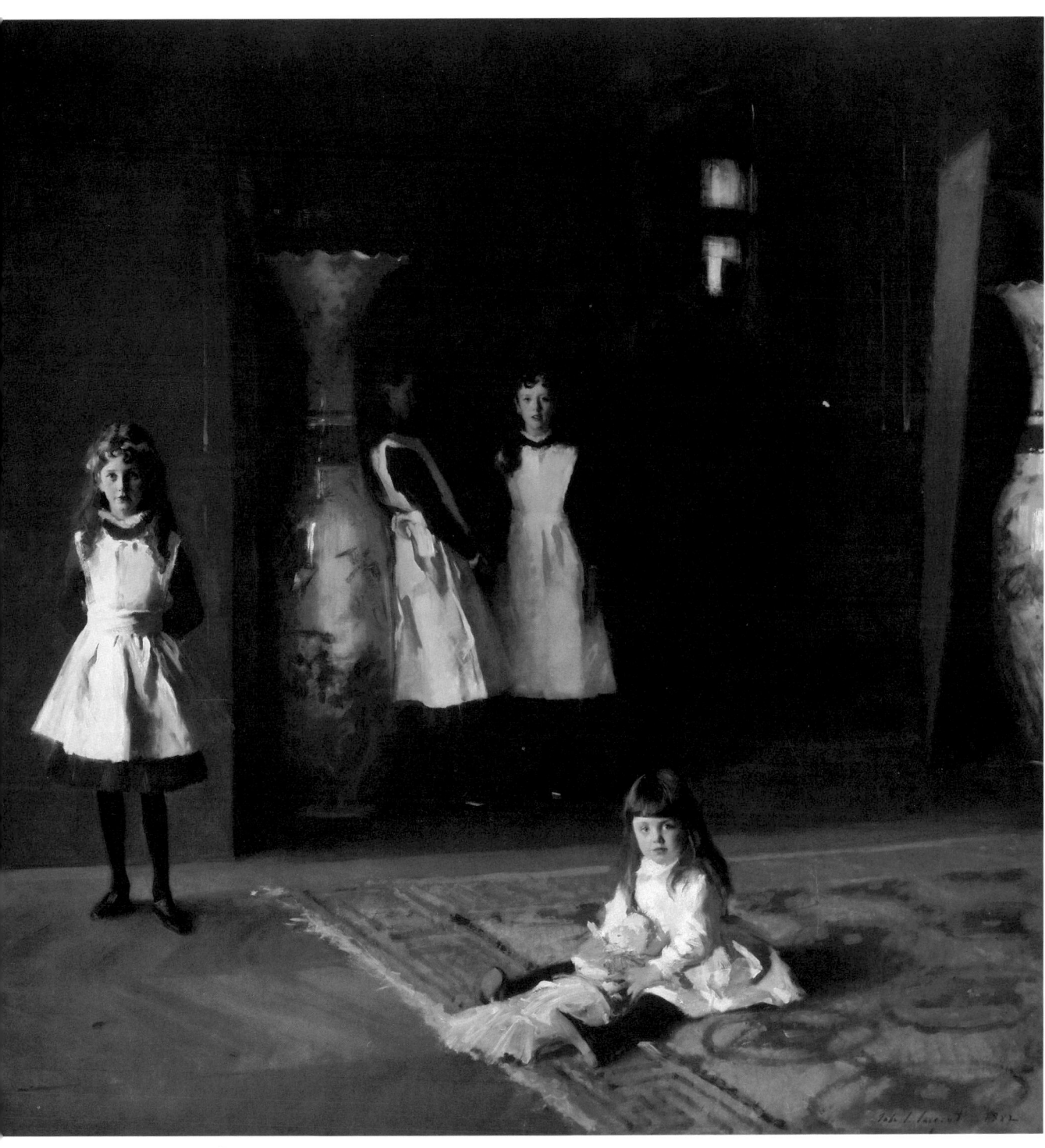

2.
JOHN SINGER SARGENT, *Miss Eleanor Brooks,*
1890
Oil on canvas, 61 x 31 in.
Private Collection

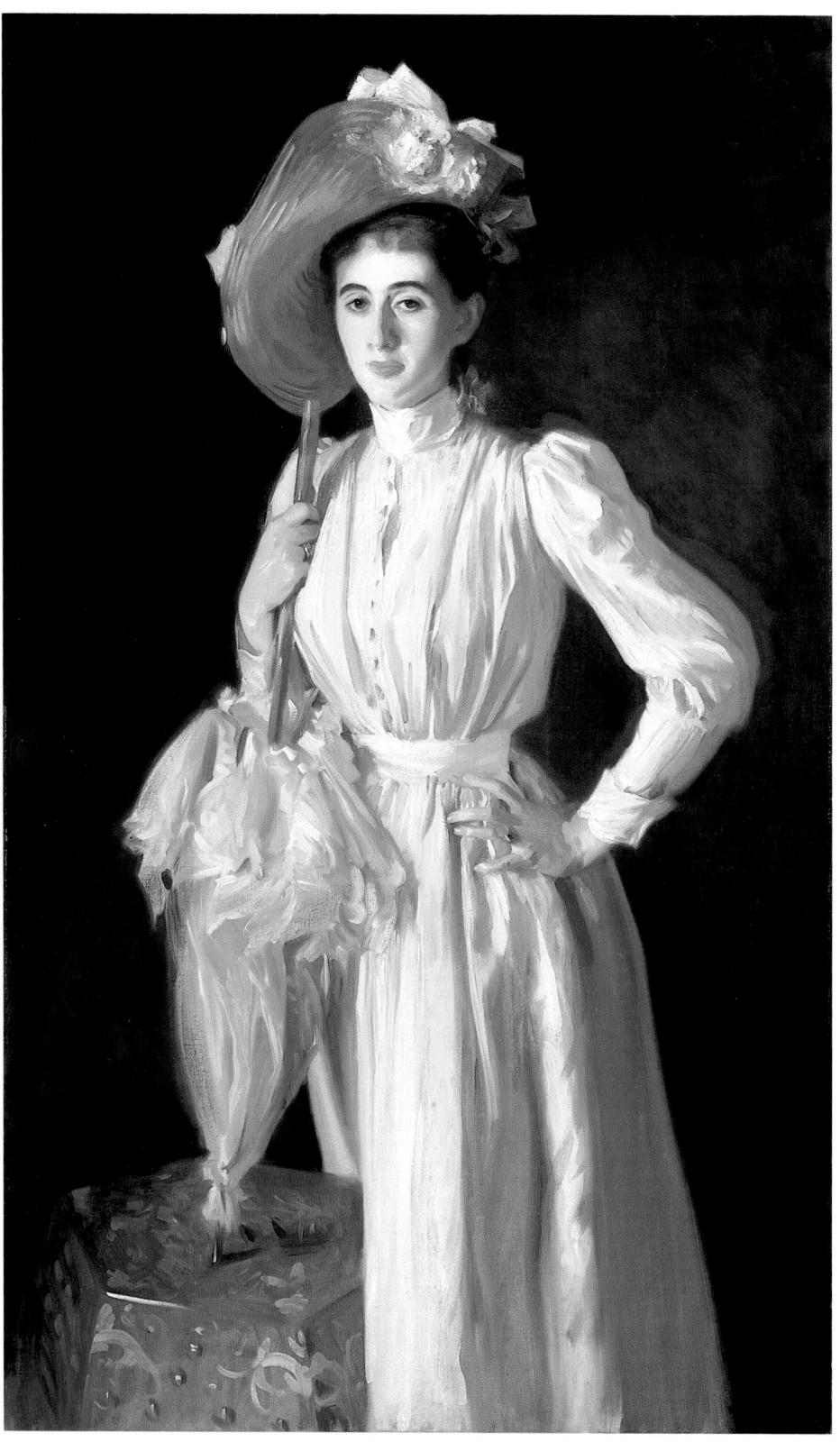

ᴸLEN DAY HALE, *Self Portrait*, 1885
Oil on canvas, 28½ x 38¾in.
Private Collection

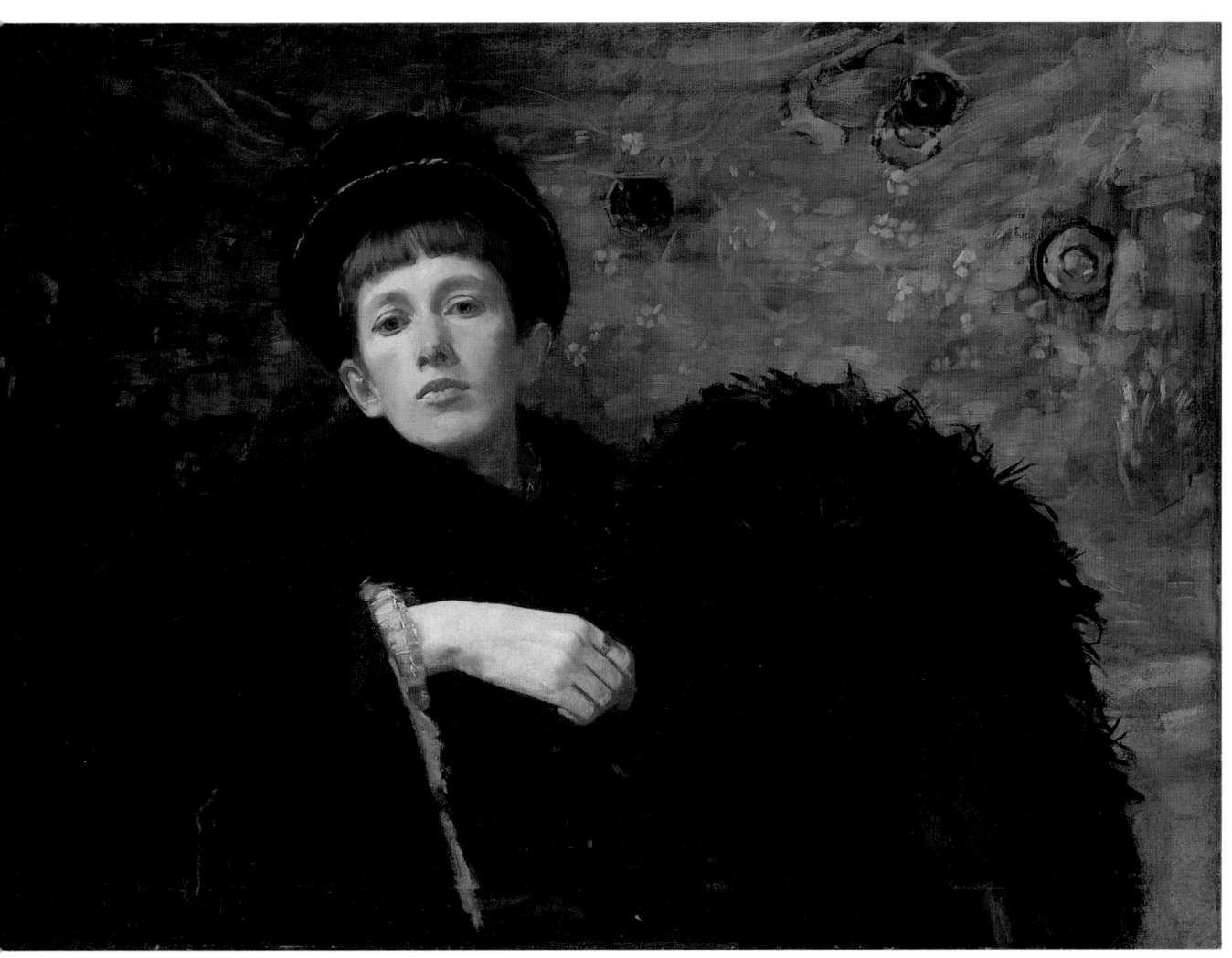

4.
JOHN SINGER SARGENT, *Henry Lee Higginson*,
1903
Oil on canvas, 96½ x 60¼ in.
President and Fellows of Harvard College; given
by student subscription to the Harvard Union,
1903

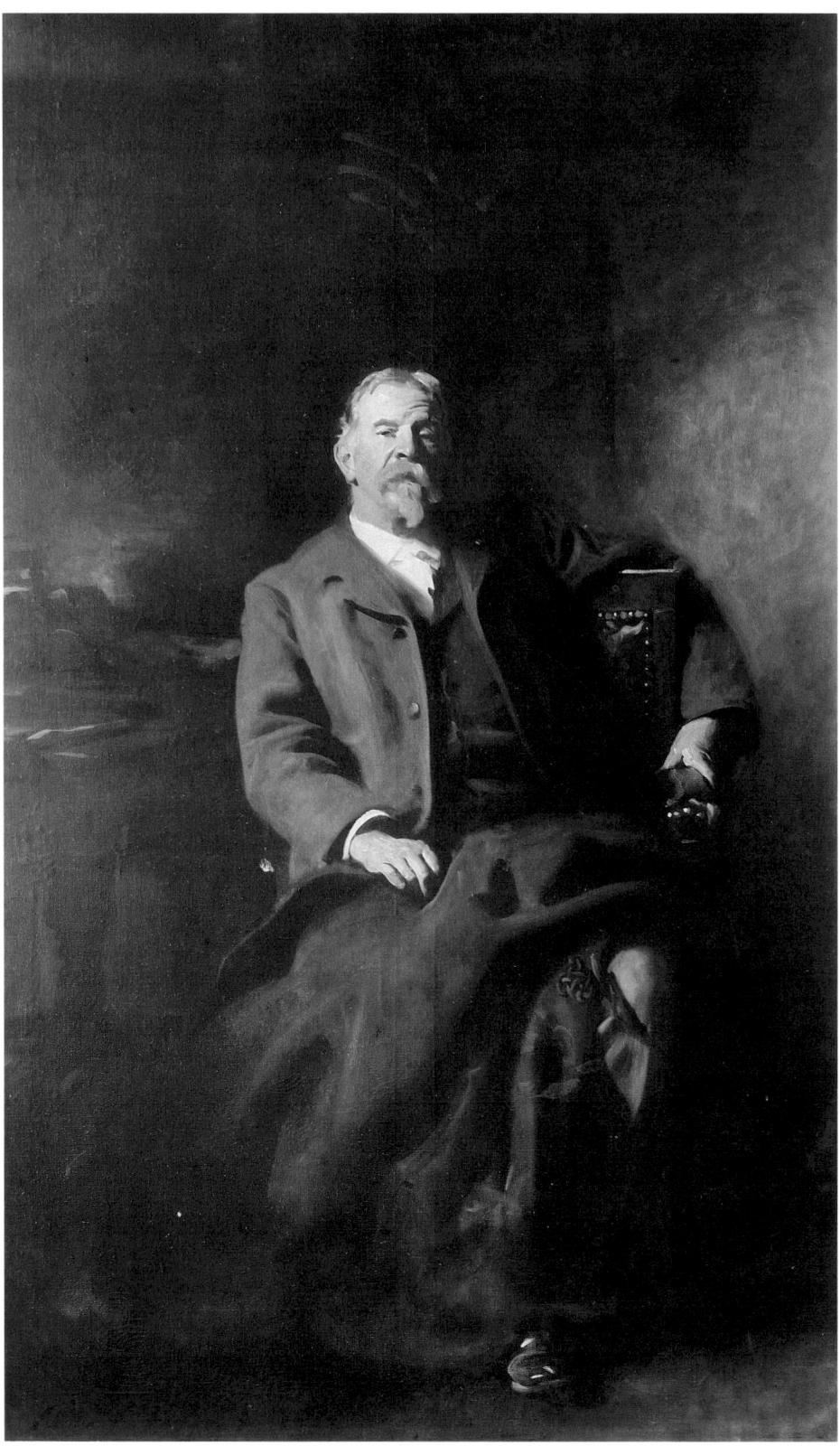

ᴏʜɴ Sɪɴɢᴇʀ Sᴀʀɢᴇɴᴛ, *George Henschel*, 1889
ʝil on canvas, 25 x 21 in.
ʔa and Nancy Koger Collection

6.
FREDERIC PORTER VINTON, *Stephen Salisbury III*,
1891
Oil on canvas, 50 x 40 in.
Worcester Art Museum. Bequest of Stephen
Salisbury III

8.
John Singer Sargent, *Mrs. Fiske Warren
(Gretchen Osgood) and her Daughter Rachel*, 1903
Oil on canvas, 60 x 40¼ in.
Museum of Fine Arts, Boston. Gift of Mrs. Rachel
Warren Barton and the Emily L. Ainsley Fund.
64.693

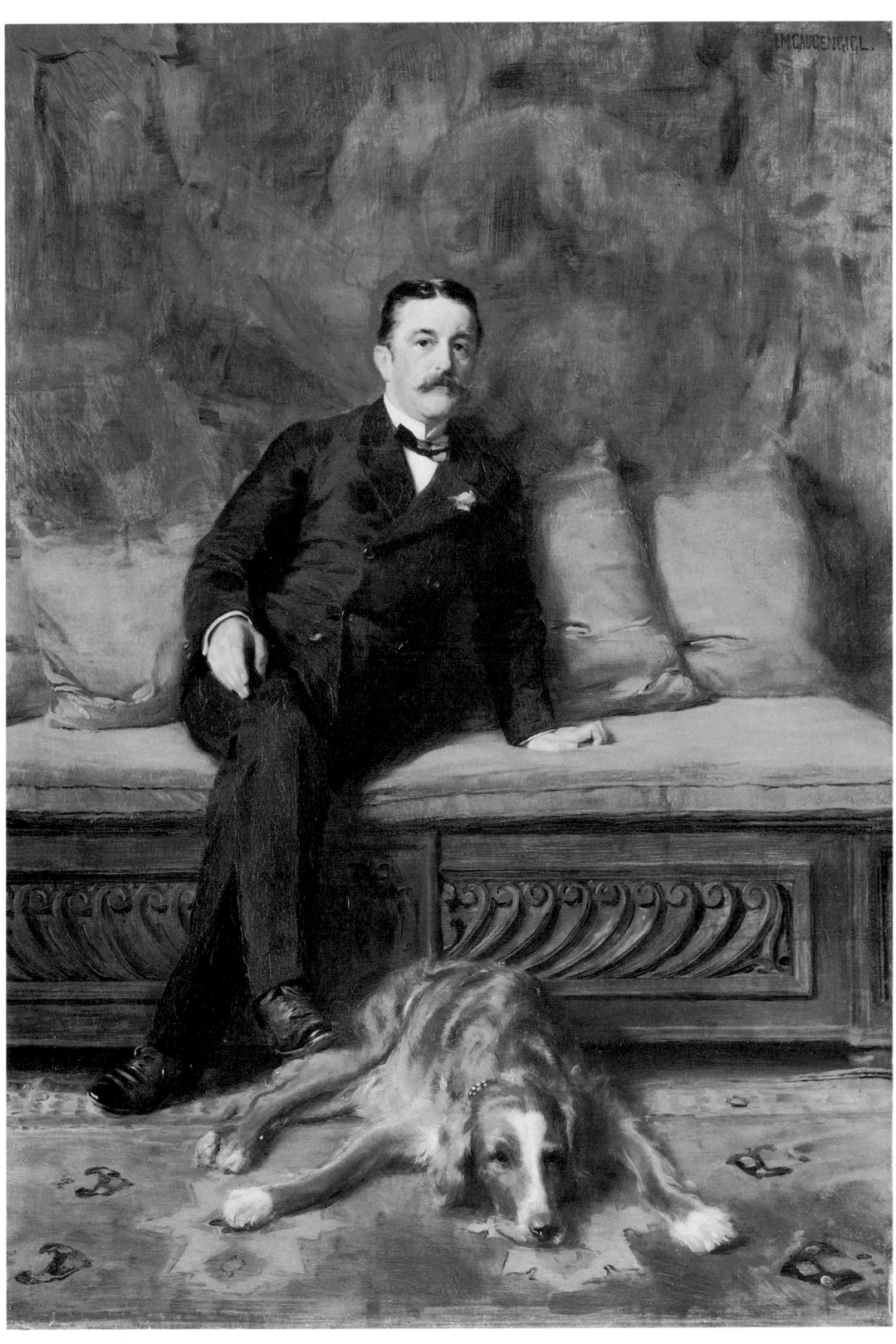

10.
JOSEPH RODEFER DECAMP, *Sally*, 1908
Oil on canvas, 26 x 23 in.
Worcester Art Museum

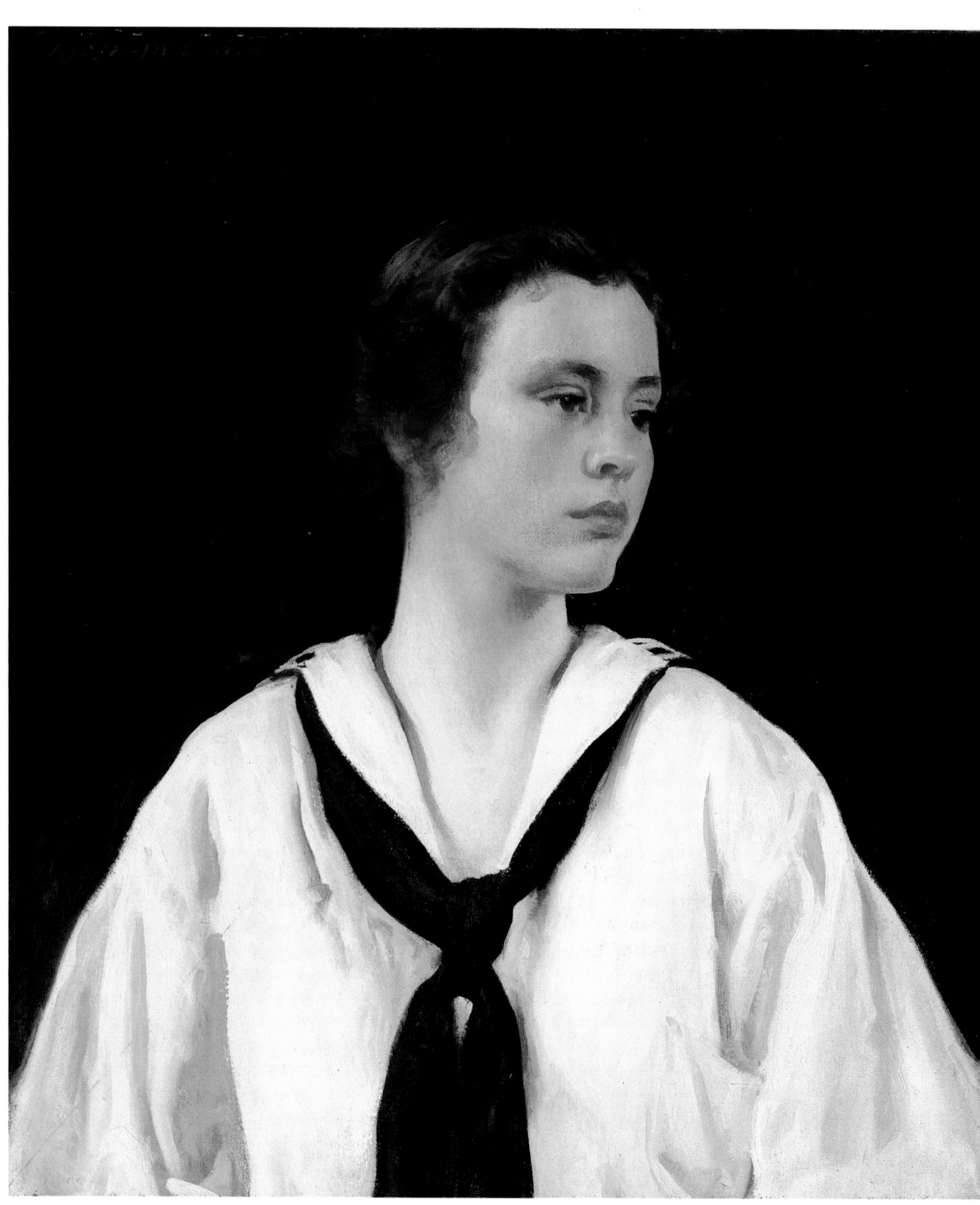

1.
GRETCHEN ROGERS, *Woman in a Fur Hat,*
a. 1915
Oil on canvas, 30 x 25¼ in.
Museum of Fine Arts, Boston. Gift of Miss Anne
Winslow. 1972.232

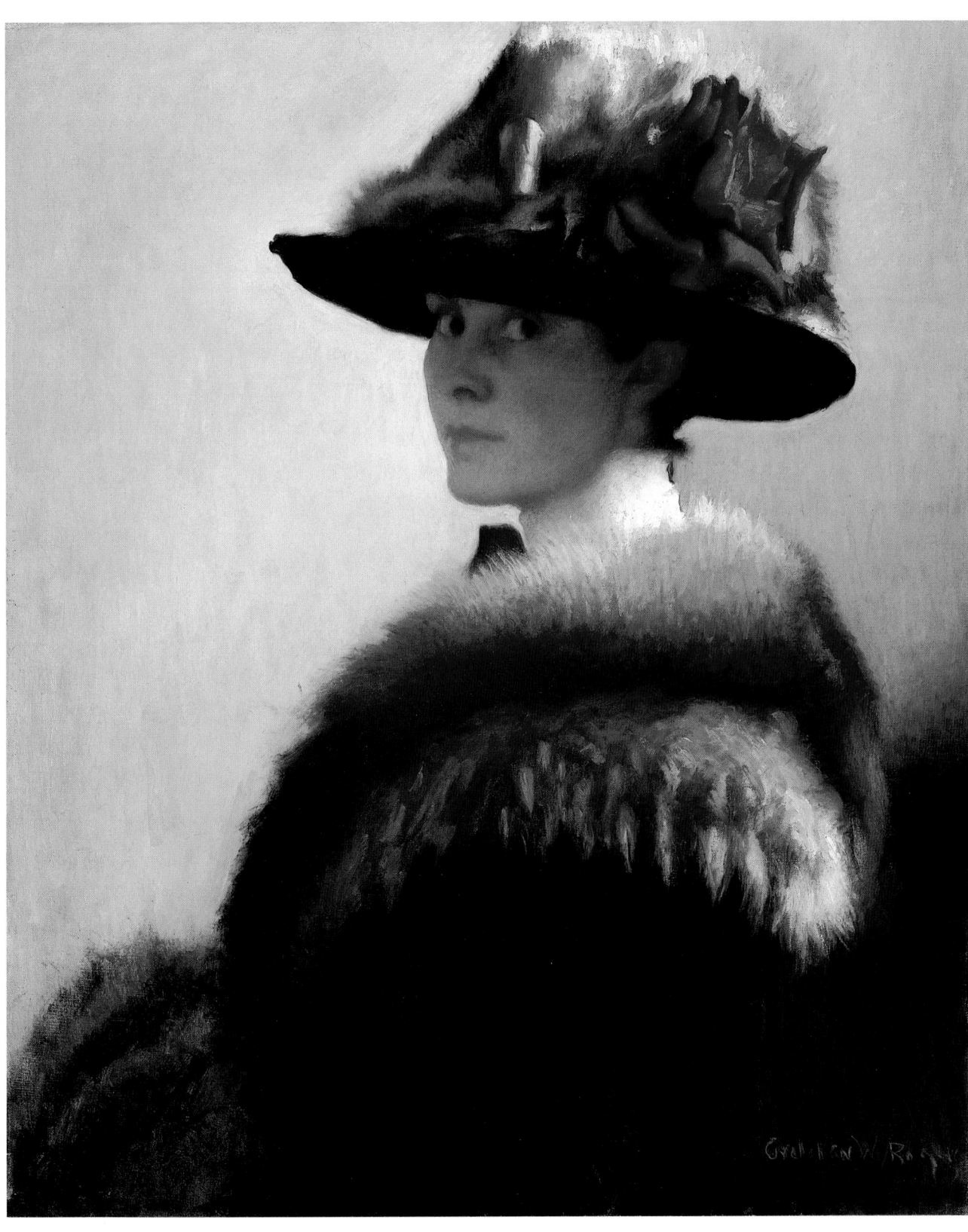

12.
EDMUND C. TARBELL, *Dr. Harvey Cushing*, 1908
Oil on canvas, 34 x 44 in.
Howard Dittrick Museum of Historical Medicine,
Cleveland Medical Library Association

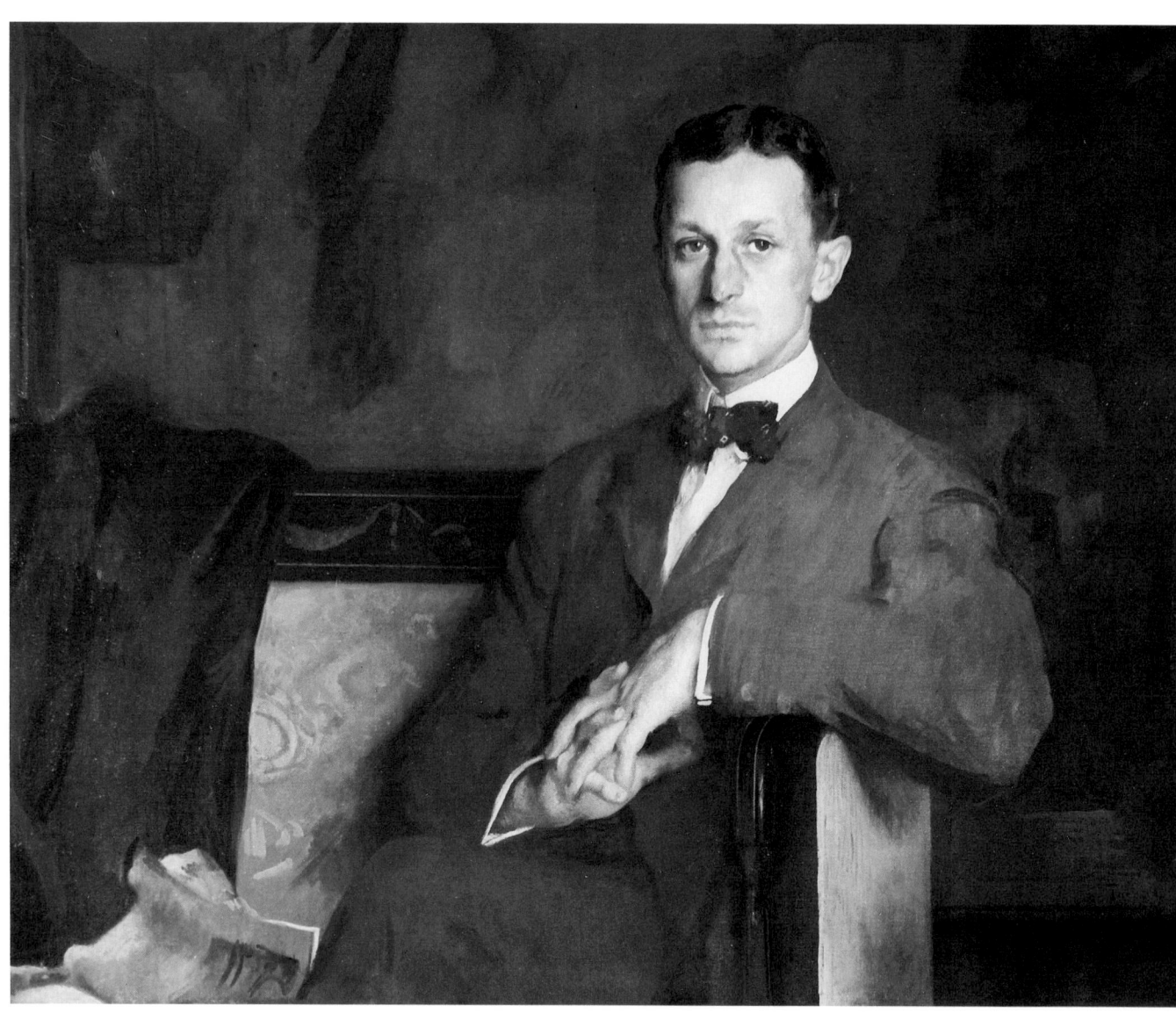

3.
ADELAIDE COLE CHASE, *The Violinist (John Murray)*, ca. 1915
Oil on canvas, 35½ x 24½ in.
Museum of Fine Arts, Boston.
The Hayden Collection. 16.97

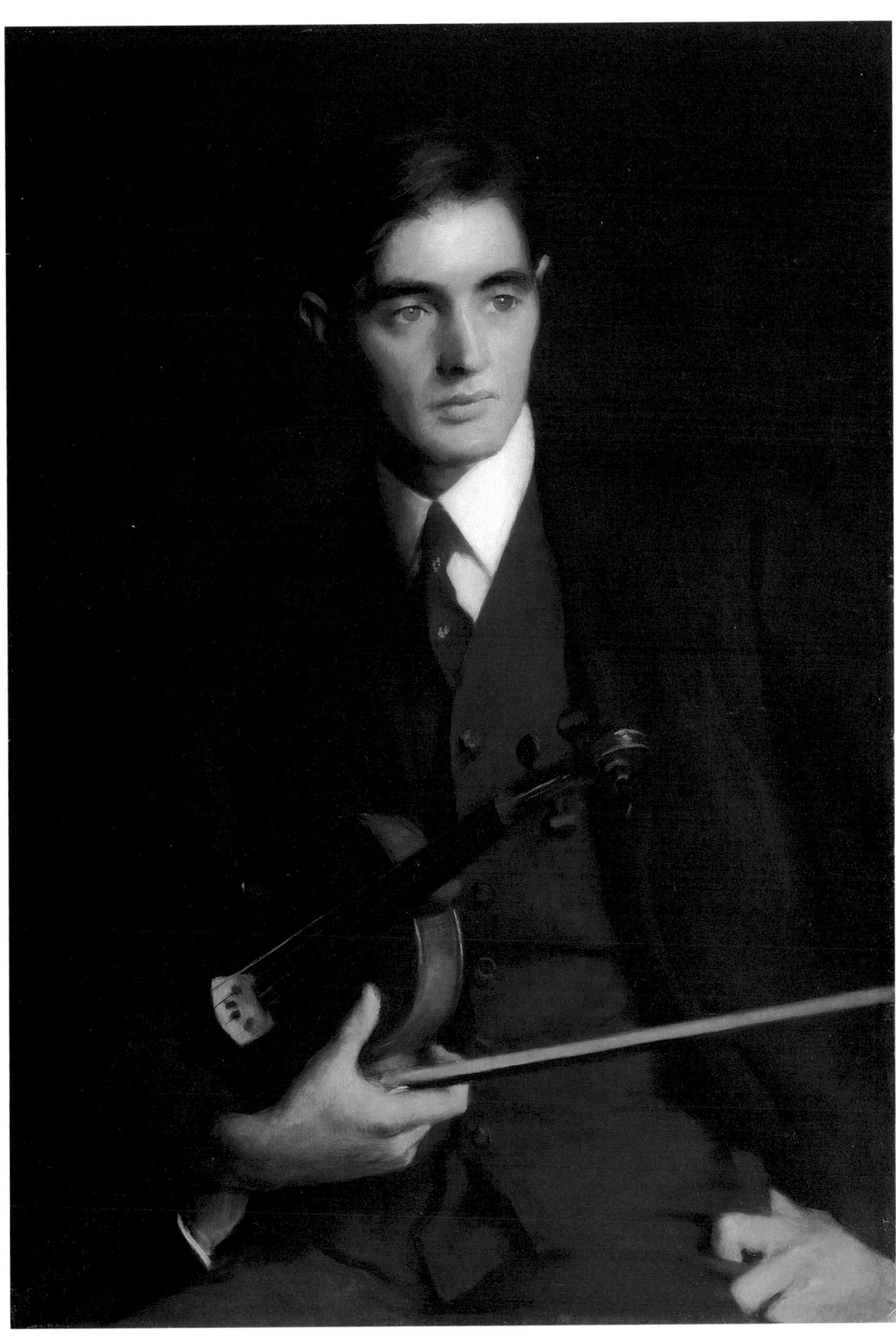

14.
ERNEST MAJOR, *Portrait of Miss F.*, ca. 1910
Oil on canvas, 40 x 30 in.
Museum of Fine Arts, Boston. Gift of Harold and
Esther Heins. 1984.795

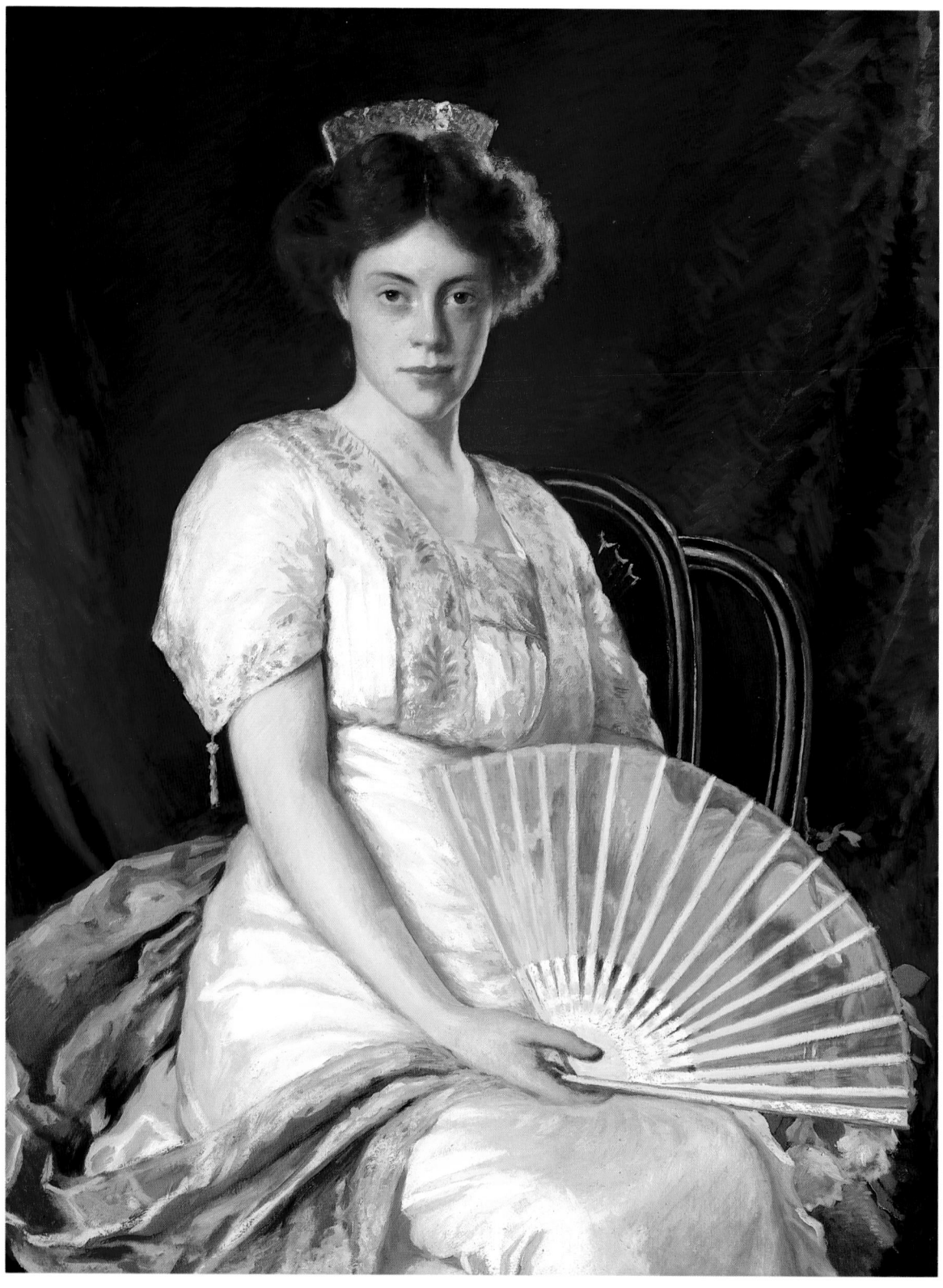

ILLIAM PAXTON, *Portrait of Elizabeth Blaney*,
16
l on canvas, 29½ x 24½ in.
ivate Collection

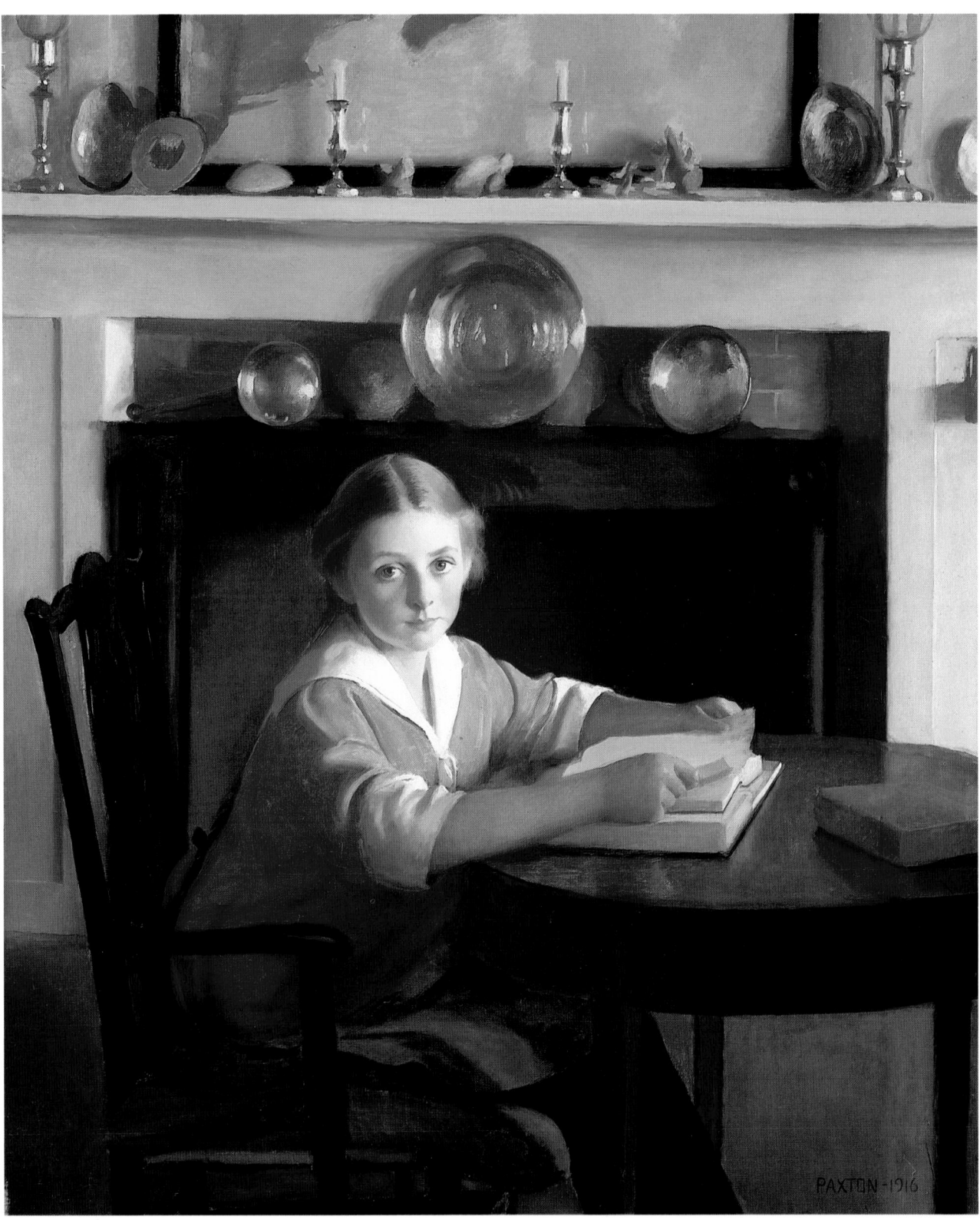

16.
CHARLES HOPKINSON, *H.H., The Artist's Daughter*, 1914
Oil on canvas, 30 x 24¼ in.
Museum of Art, Rhode Island School of Design,
Providence. Jesse Metcalf Fund. 18.552

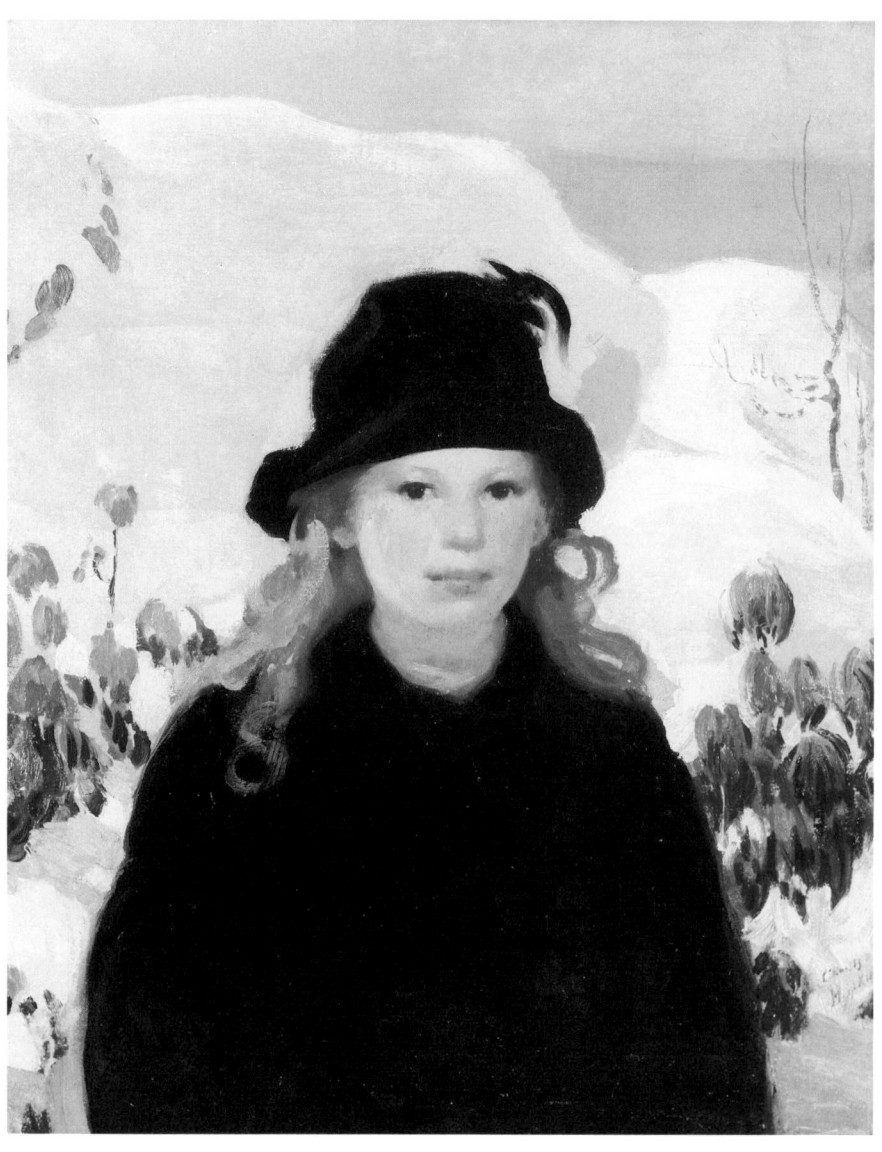

7.
CHARLES HOPKINSON, *The Hopkinson Family*,
1923
Oil on canvas, 51½ x 64½ in.
Museum of Fine Arts, Boston. Gift of Mrs. J.H.
Carr, Mrs. Isabella Halsted, Mrs. Alfred Rive,
Mrs. William A. Shurcliff, and Mrs. Lovell
Thompson, daughters of Charles Hopkinson.
1980.661

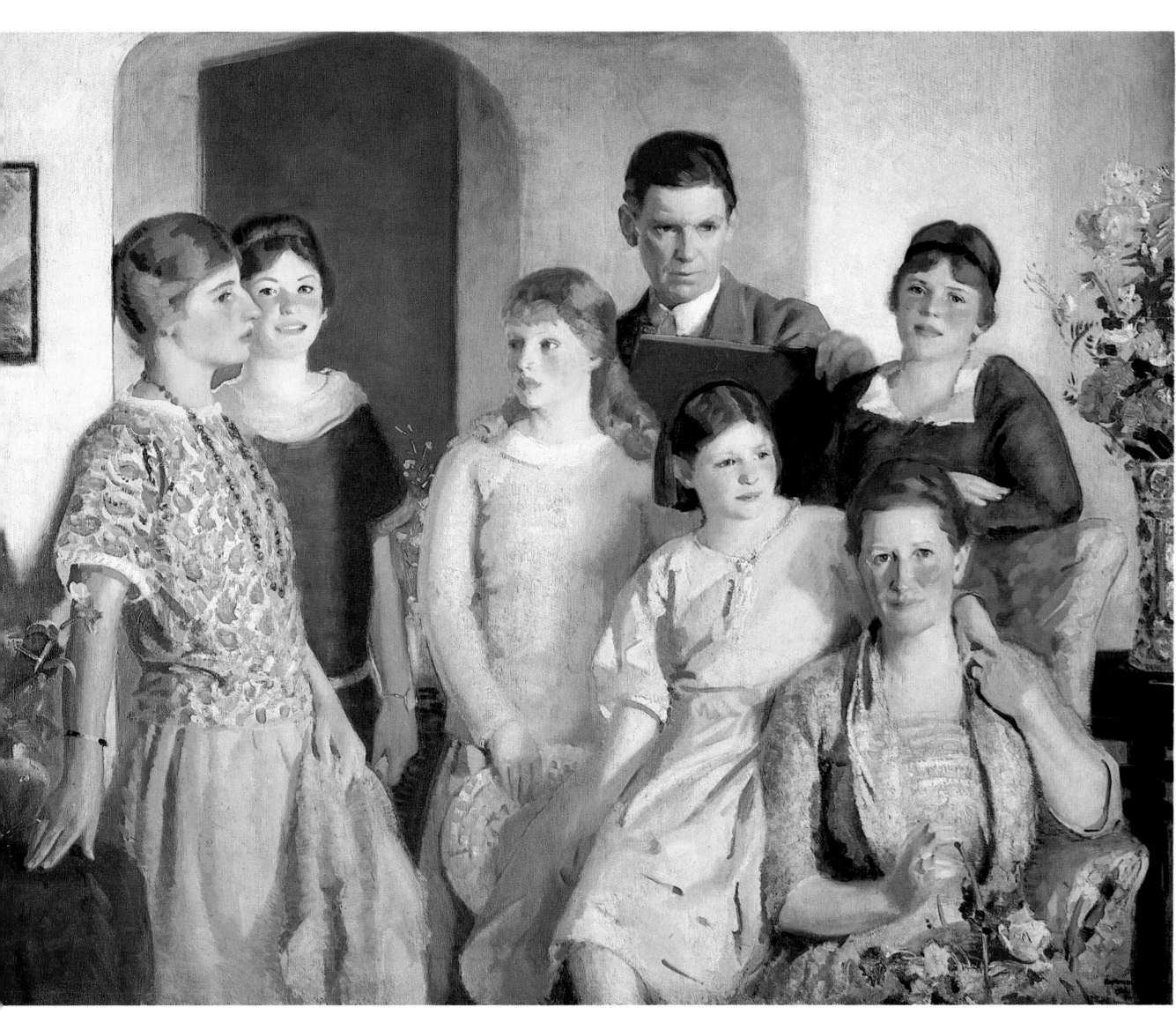

18.
MARION BOYD ALLEN, *Anna Vaughan Hyatt*,
1915
Oil on canvas, 65 x 40 in.
Maier Museum of Art, Randolph-Macon Woman's
College, Lynchburg

20.
WILLIAM MORRIS HUNT, *Gloucester Harbor*, 187
Oil on canvas, 21 x 31¼ in.
Museum of Fine Arts, Boston. Gift of H. Nelson
Slater, Mrs. Esther Slater Kerrigan, and Mrs. Ray
Slater Murphy, in memory of their mother, Mabe
Hunt Slater. 44.47

21.
.Foxcroft Cole, *The Aberjona River,
Winchester*, ca. 1880
Oil on canvas, 18¼ x 26 in.
Museum of Fine Arts, Boston. Gift of Alexander
Cochrane. 13.551

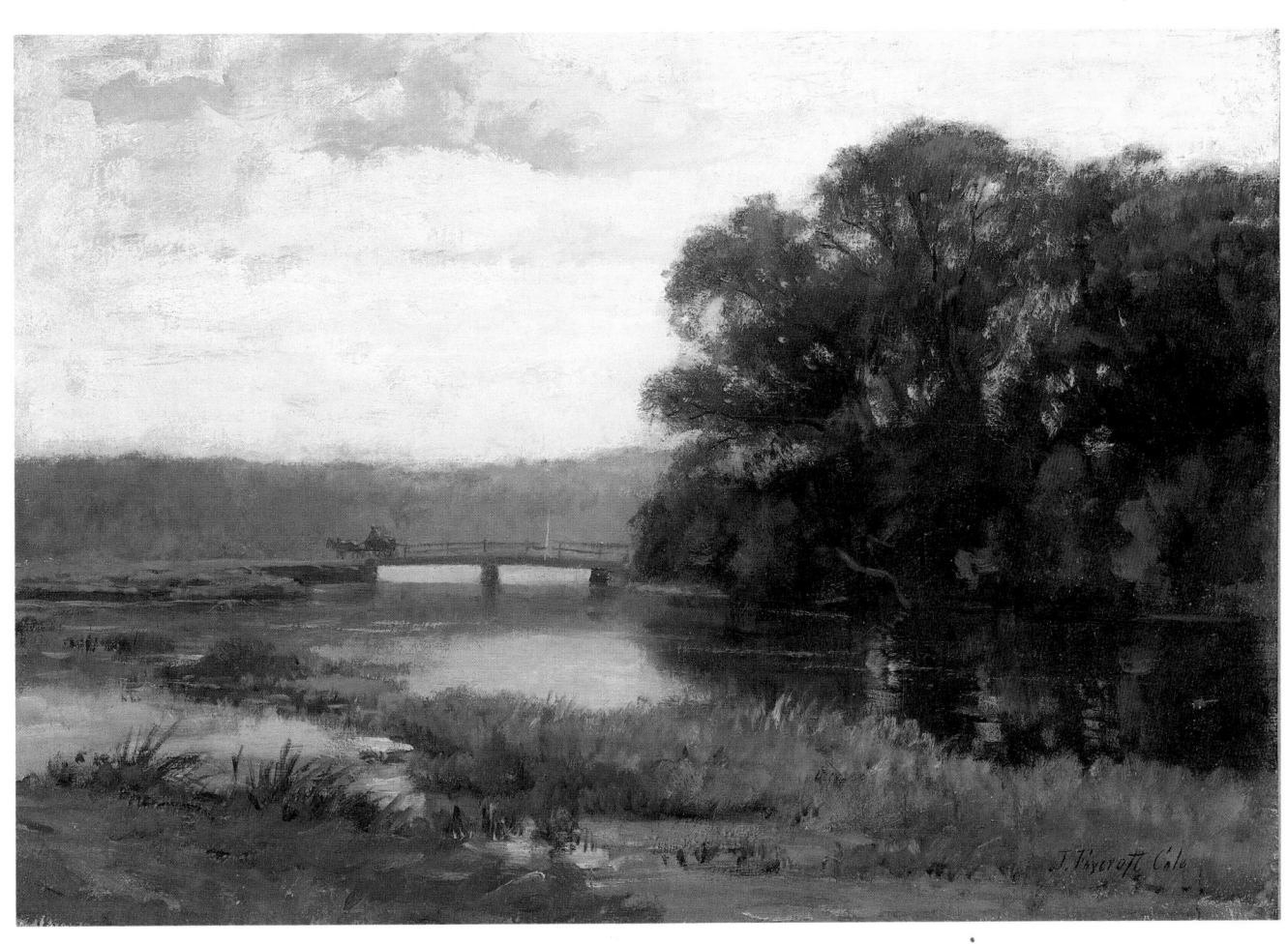

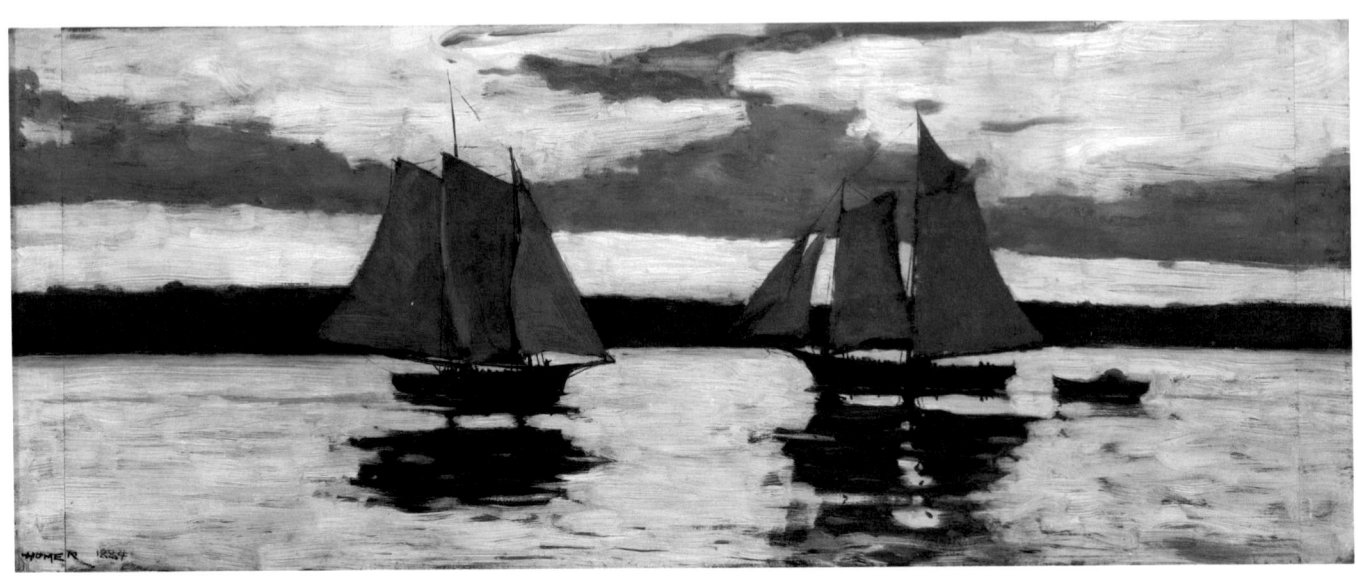

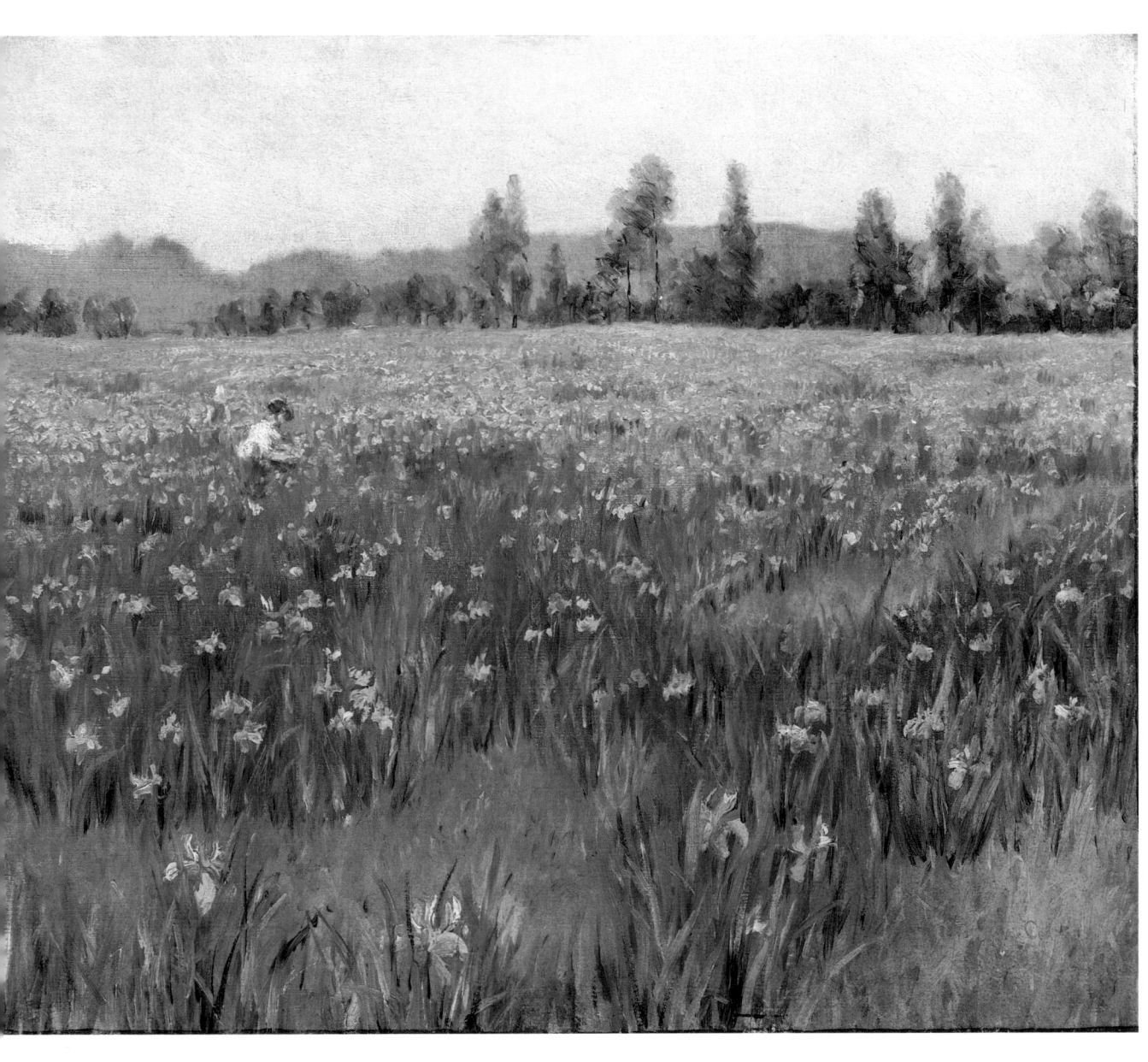

25.
FRANK BENSON, *Mount Monadnock*, 1889
Oil on canvas, 20 x 24 in.
Private Collection

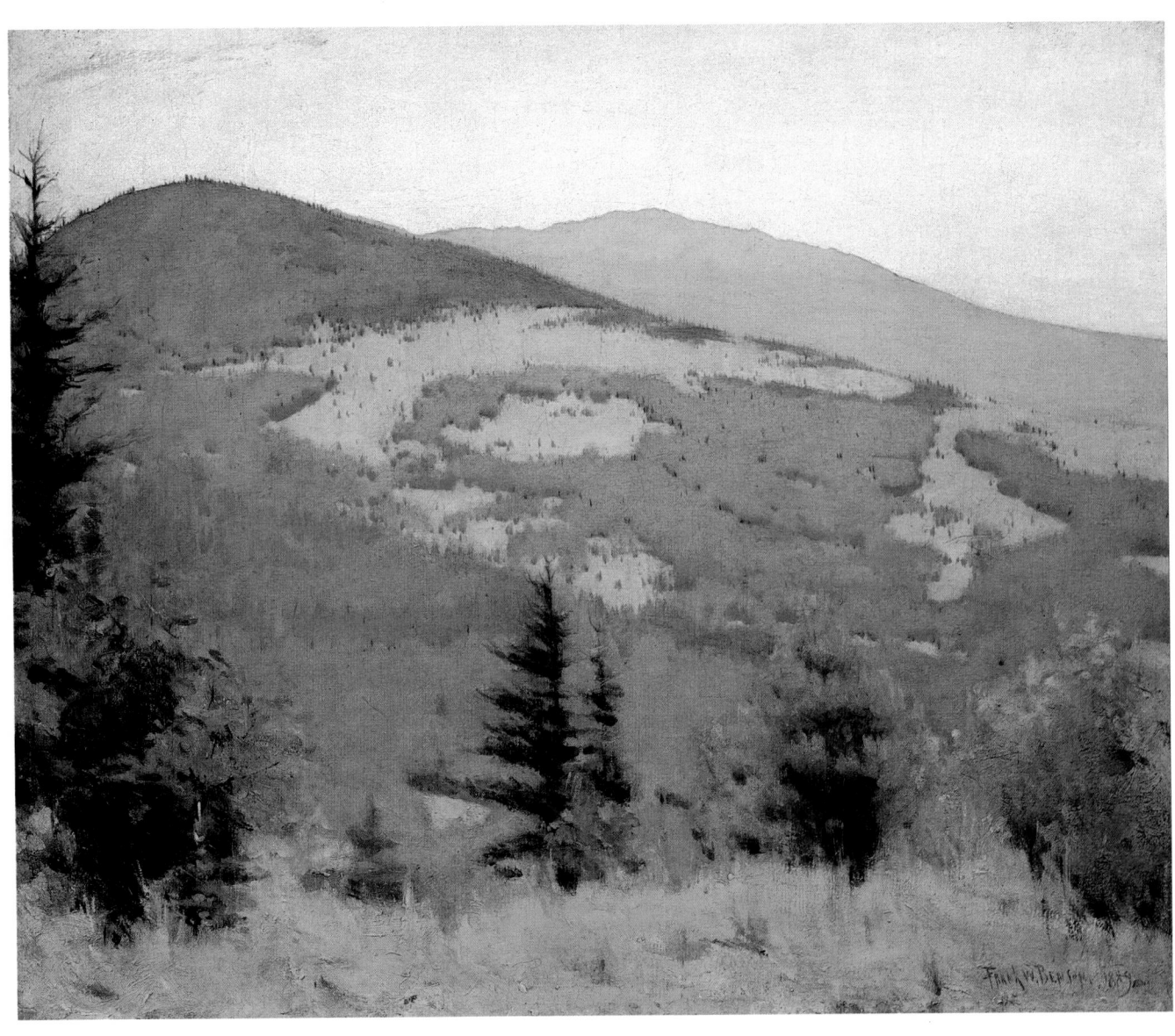

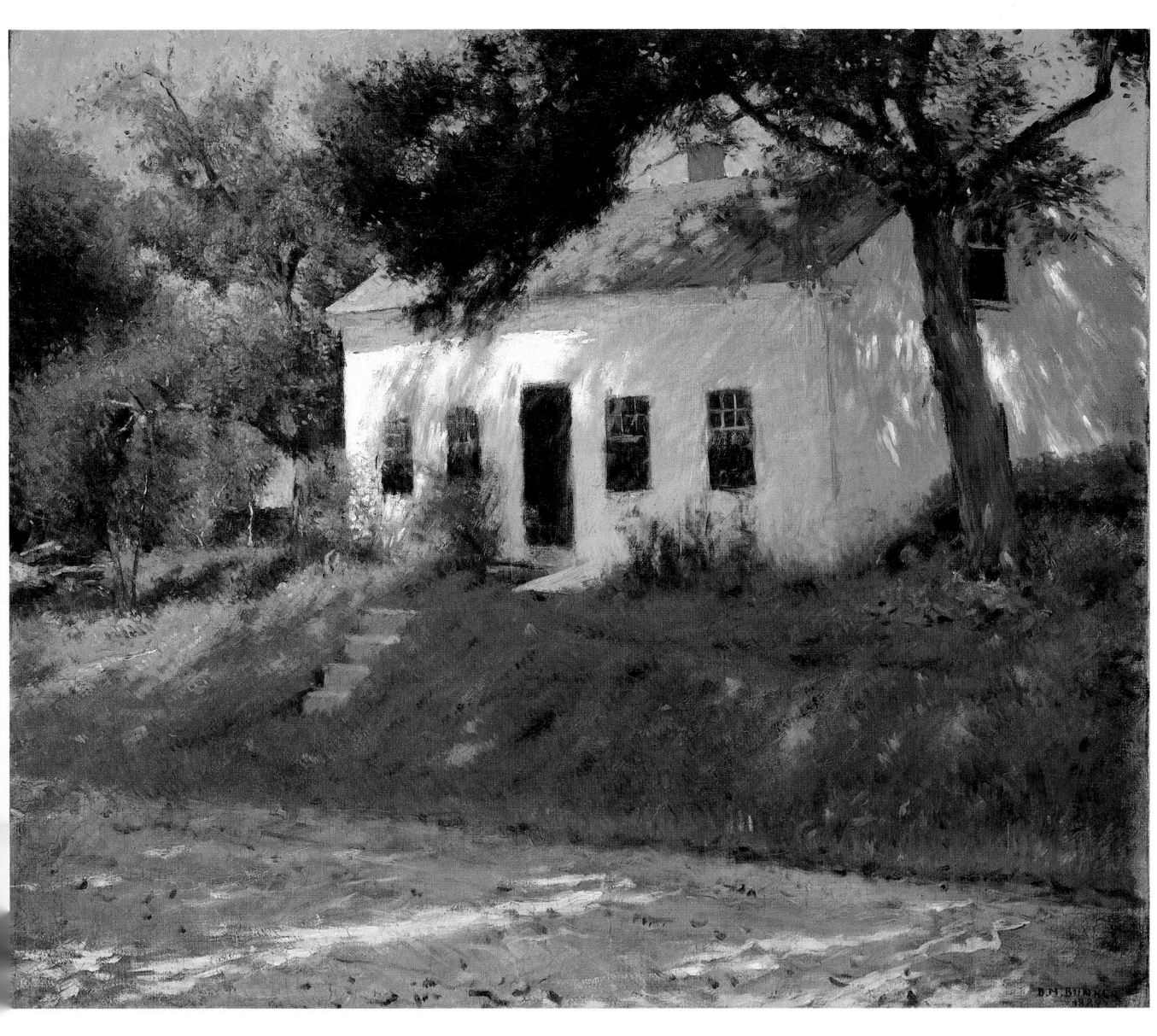

27.
DWIGHT BLANEY, *Brookline Village in Snow*, 1893
Oil on canvas, 25½ x 32¼ in.
Private Collection

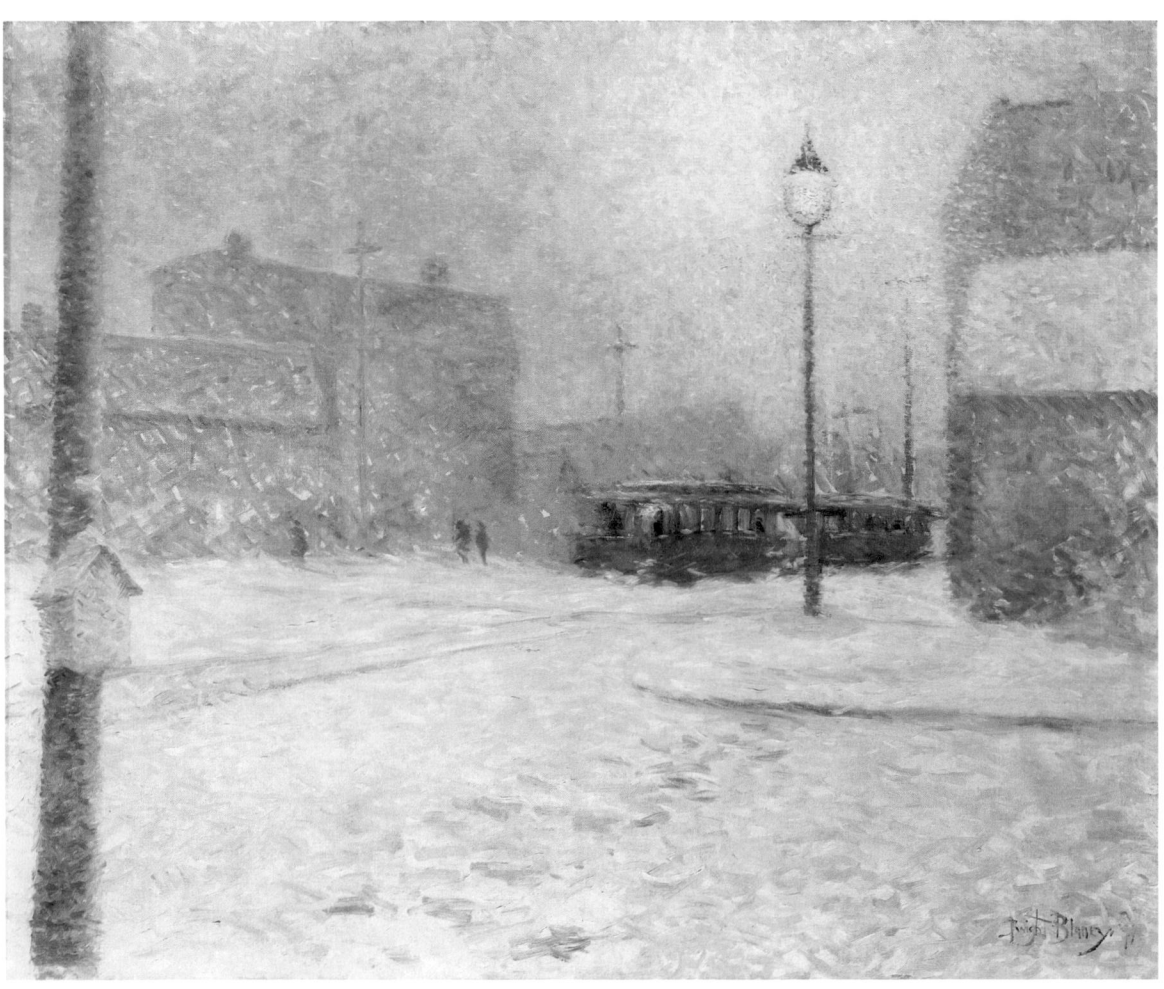

52.

Joseph Rodefer DeCamp, *Seascape*, ca. 1895
Oil on canvas, 25 x 29½ in.
Private Collection

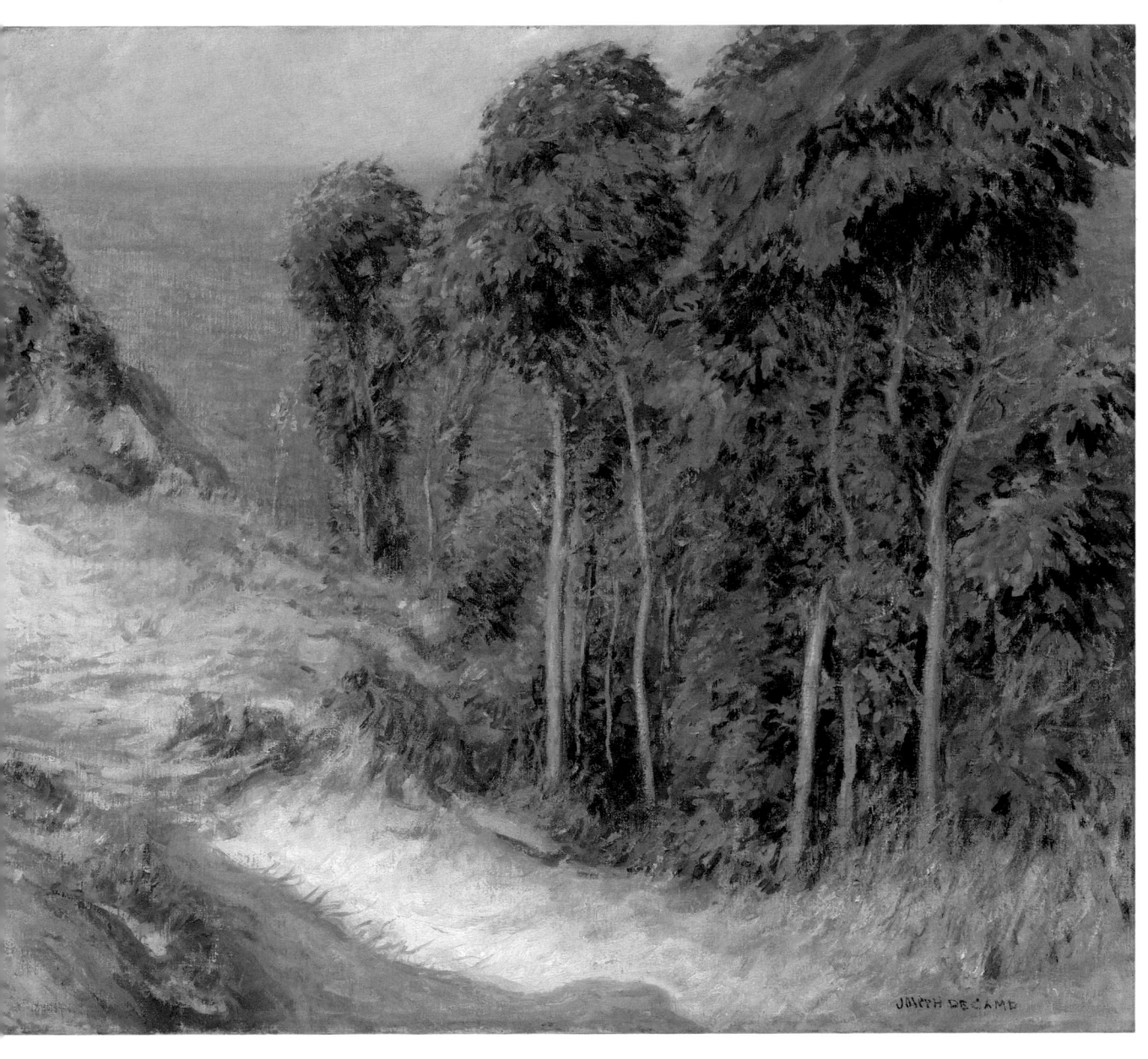

33.
THEODORE WENDEL, *Bridge at Ipswich*, ca. 1905
Oil on canvas, 24¼ x 30 in.
Museum of Fine Arts, Boston. Gift of Mr. and
Mrs. Daniel S. Wendel and the Tompkins
Collection. 1978.179

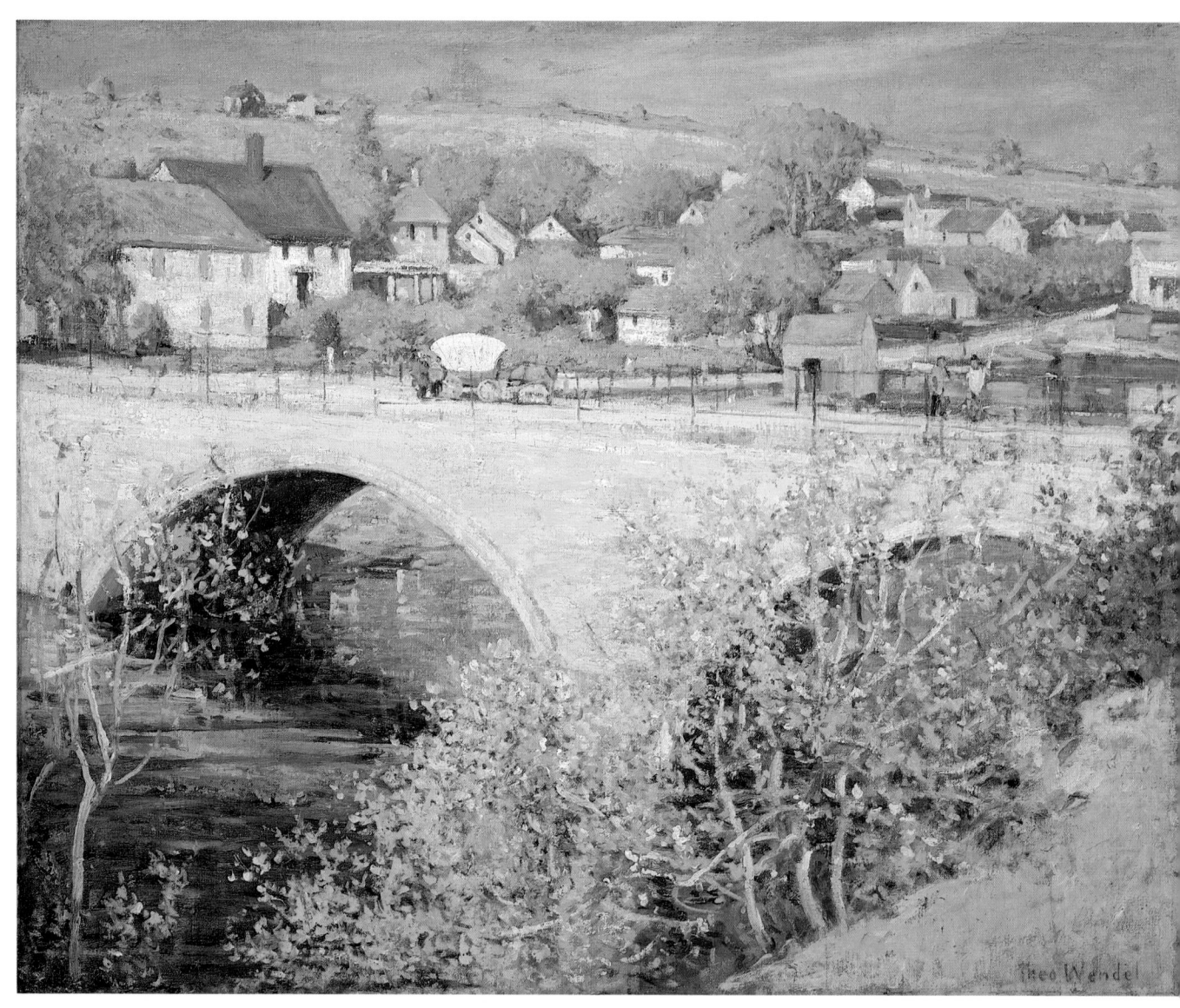

34.
THEODORE WENDEL, *Gloucester Harbor*, ca. 1905
Oil on canvas, 25 x 30 in.
Private Collection

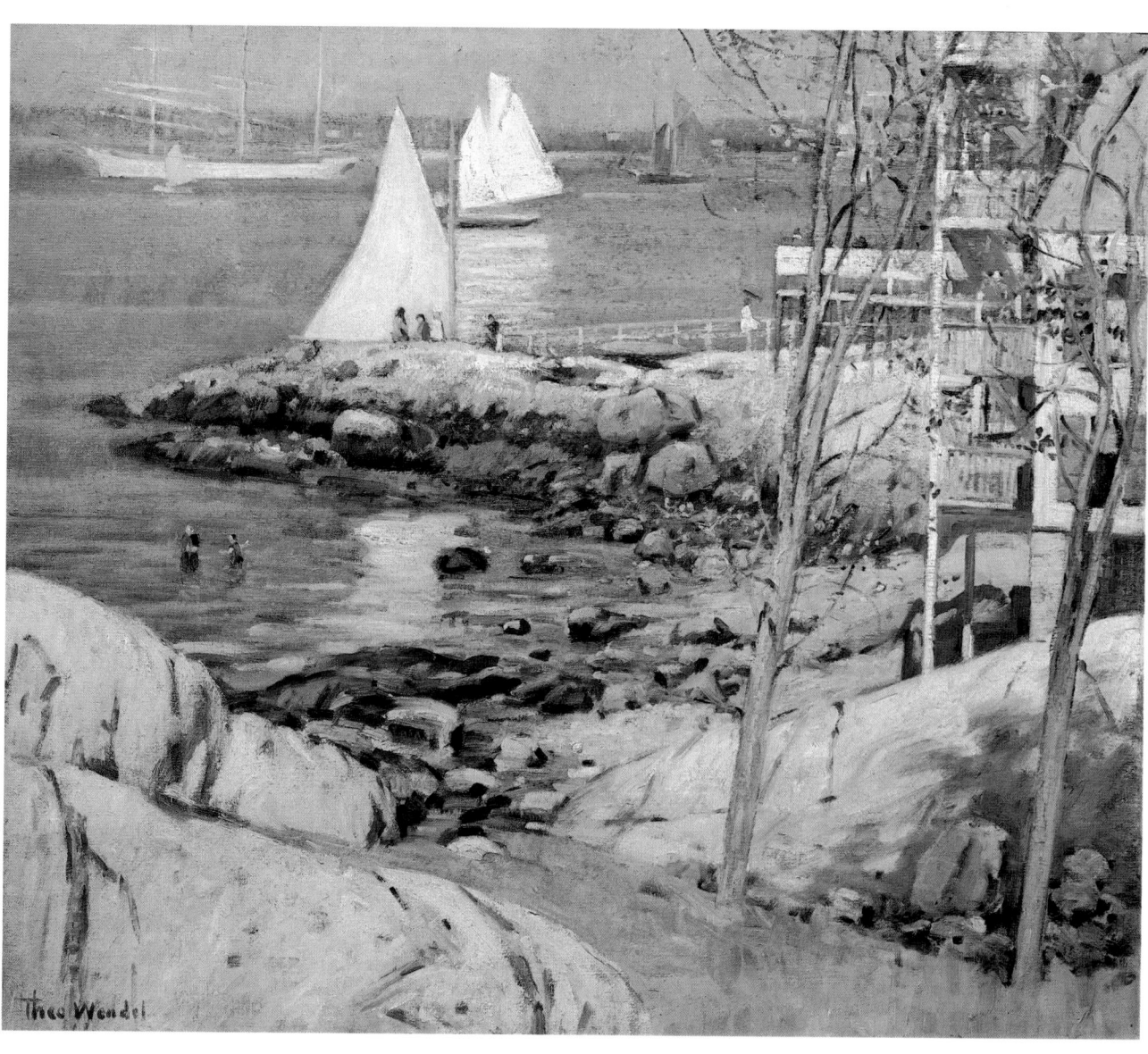

35.
CHILDE HASSAM, *White Island Light, Isles of Shoals, at Sundown*, 1899
Oil on canvas, 27 x 27 in.
Smith College Museum of Art, Northampton. Gift of Mr. and Mrs. Harold D. Hodgkinson (Laura White Cabot '22). 1973:51

36.
HERMANN DUDLEY MURPHY, *The Beach*, 1905
Oil on canvas (gilded handcarved frame designed
by Murphy), 20 x 27 in.
Bowdoin College Museum of Art, Brunswick,
Maine. 1969.46

38.
Philip Little, *A Bit of Maine*, 1911
Oil on canvas, 36¼ x 29¼ in.
David J. Latham, Boston

39.
ARTHUR GOODWIN, *Park Street Church, Boston*, ca.
1909
Oil on canvas, 20 x 24½ in.
Shawmut Bank of Boston

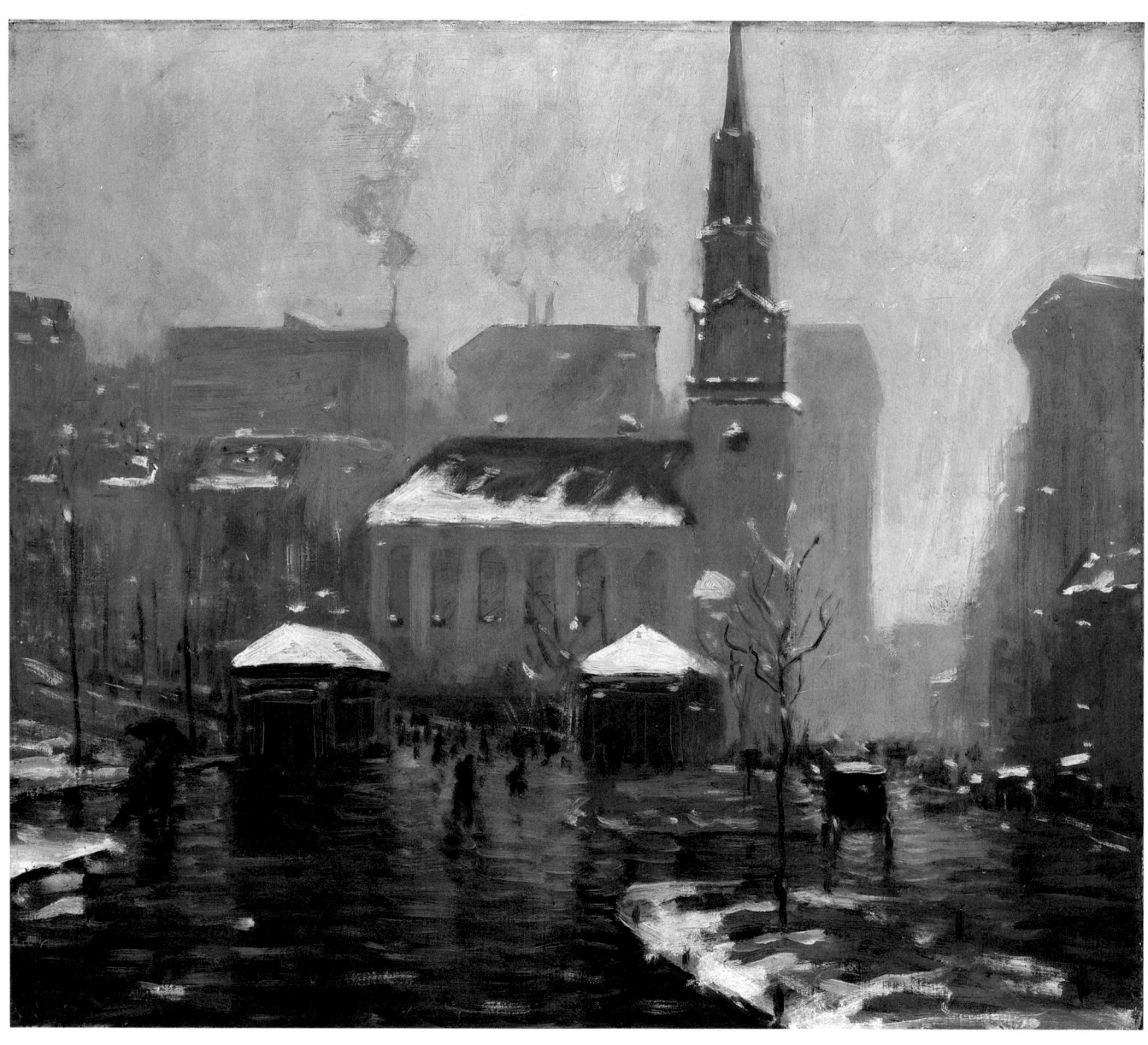

40.
ALDRO HIBBARD, *Winter Days*, ca. 1916
Oil on canvas, 30¼ x 34 in.
Museum of Fine Arts, Boston. Gift in Memory of
Elizabeth Brown Barrett. 20.598

41.
EDMUND C. TARBELL, *Piscataqua River*, 1909
Oil on canvas, 38 x 63 in.
Berry-Hill Galleries, New York

42.
LILIAN WESTCOTT HALE, *An Old Cherry Tree*, ca. 1930
Oil on canvas, 30 x 25 in.
National Academy of Design, New York

43.
FREDERIC PORTER VINTON, *La Blanchisseuse*,
1890
Oil on canvas, 18¼ x 24 in.
Museum of Fine Arts, Boston. Gift of Alexander
Cochrane. 13.554

6.
CHILDE HASSAM, *The Old Fairbanks House,
Dedham, Massachusetts*, ca. 1884
Oil on canvas, 22 x 22 in.
Museum of Fine Arts, Boston. Bequest of Kate
Talbot Hopkins. 1982.386

47.
EDMUND C. TARBELL, *In the Orchard*, 1891
Oil on canvas, 60½ x 65 in.
Private Collection

8.
Edward Wilbur Dean Hamilton, *Summer at Campobello, New Brunswick*, ca.1900
Oil on canvas, 28 x 28 in.
Museum of Fine Arts, Boston. Bequest of Maxim Karolik. 64.364

49.
EDMUND C. TARBELL, *Mother and Child in the
Pine Woods*, ca. 1892
Oil on canvas, 24¼ x 29½ in.
Private Collection

50.

PHILIP LESLIE HALE, *Girls in Sunlight*, ca. 1897
Oil on canvas, 29 x 39 in.
Museum of Fine Arts, Boston. Gift of Lilian
Westcott Hale. 53.2209

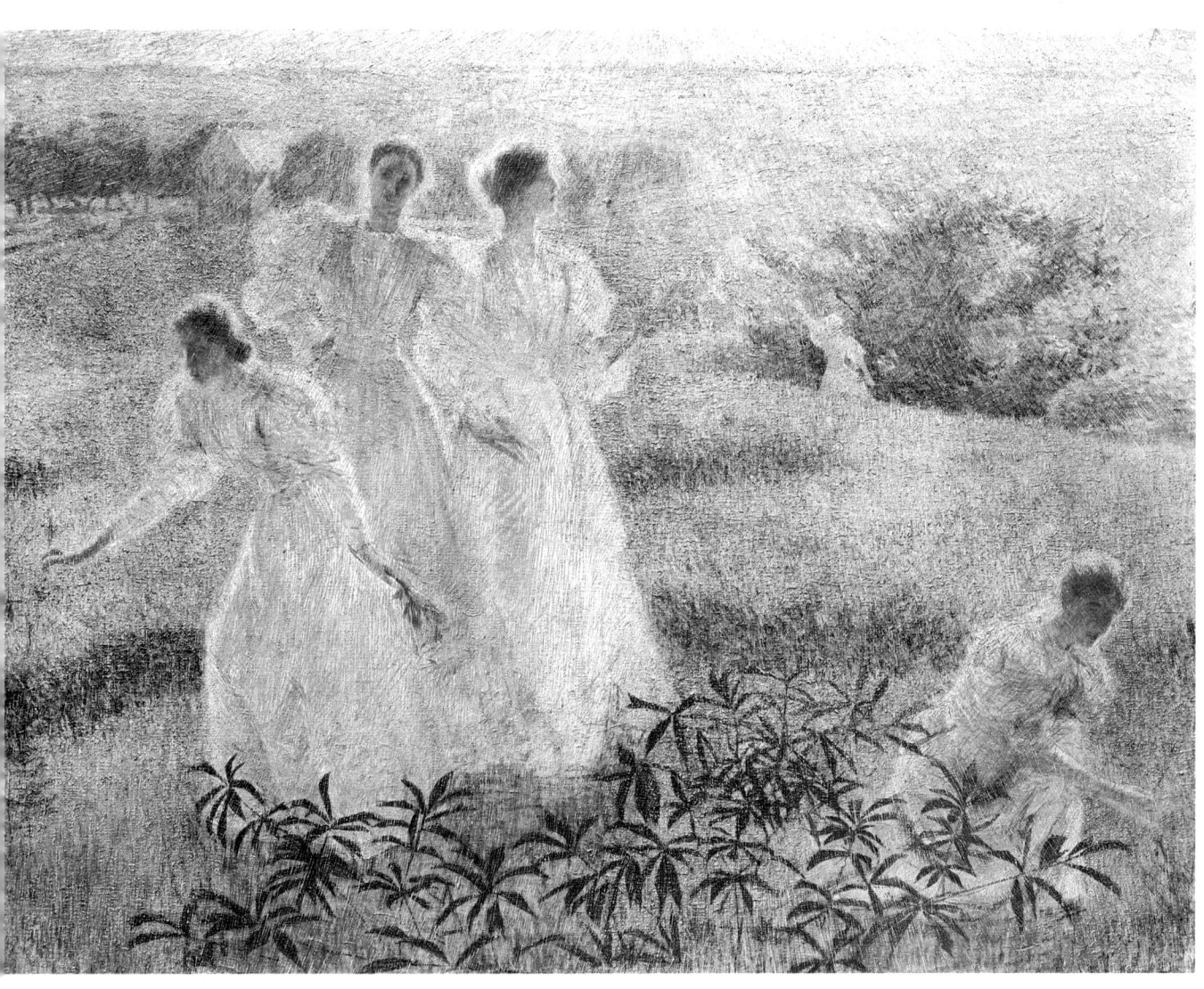

51.
CHILDE HASSAM, *Boston Common at Twilight,*
1885-1886
Oil on canvas, 42 x 60 in.
Museum of Fine Arts, Boston. Gift of Miss Maud
E. Appleton. 31.952

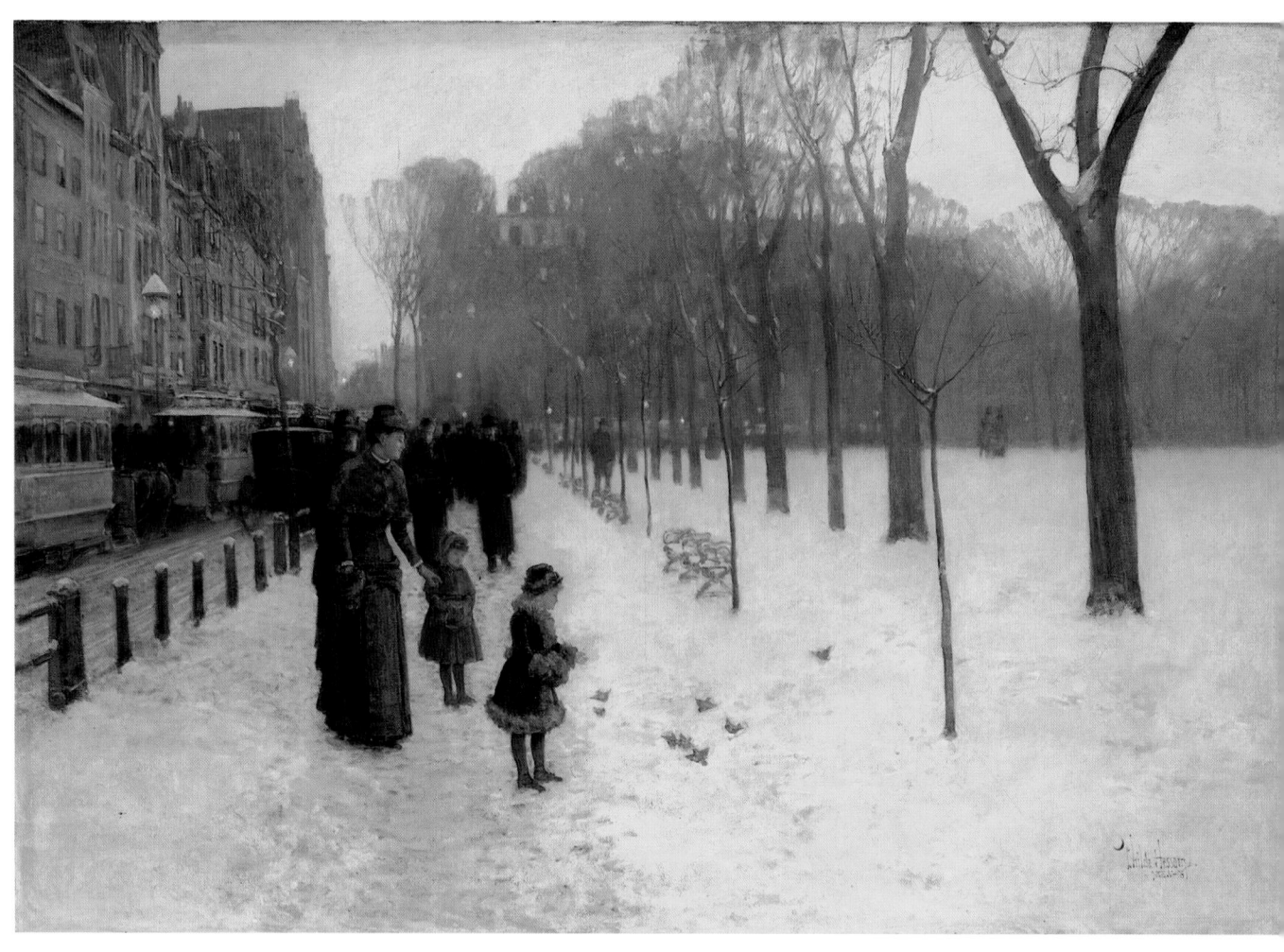

52.
MAURICE PRENDERGAST, *Salem Willows*, 1904
Oil on canvas, 26 x 34 in.
Daniel J. Terra Collection.
Terra Museum of American Art, Chicago.

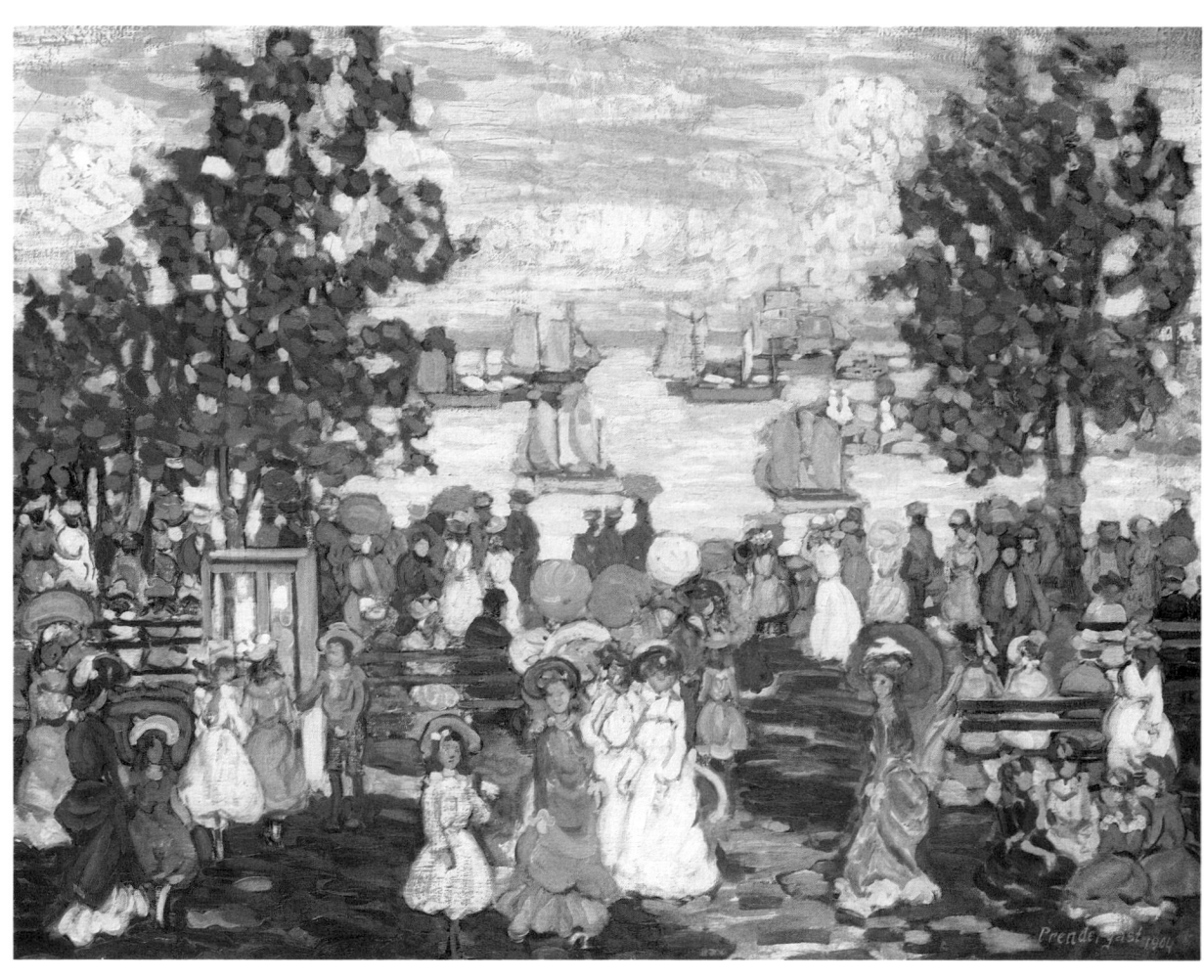

53.
PHILIP LESLIE HALE, *The Crimson Rambler*, ca.
1909
Oil on canvas, 25 x 30 in.
The Pennsylvania Academy of the Fine Arts,
Philadelphia. Temple Fund Purchase

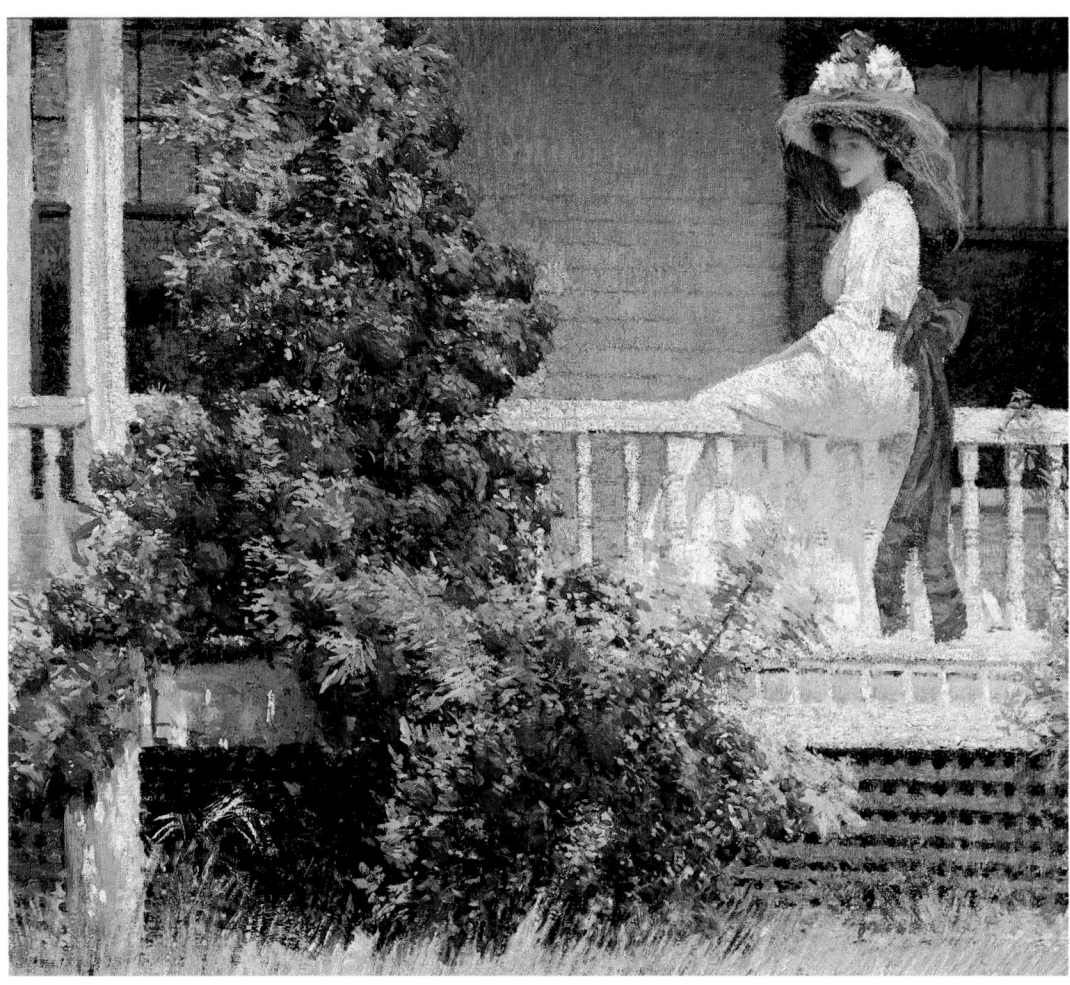

54.
MAURICE PRENDERGAST, *The Swans*, 1916-1918
Oil on canvas, 30⅛ x 43 in.
Addison Gallery of American Art, Phillips
Academy, Andover. Bequest of Miss L.P. Bliss

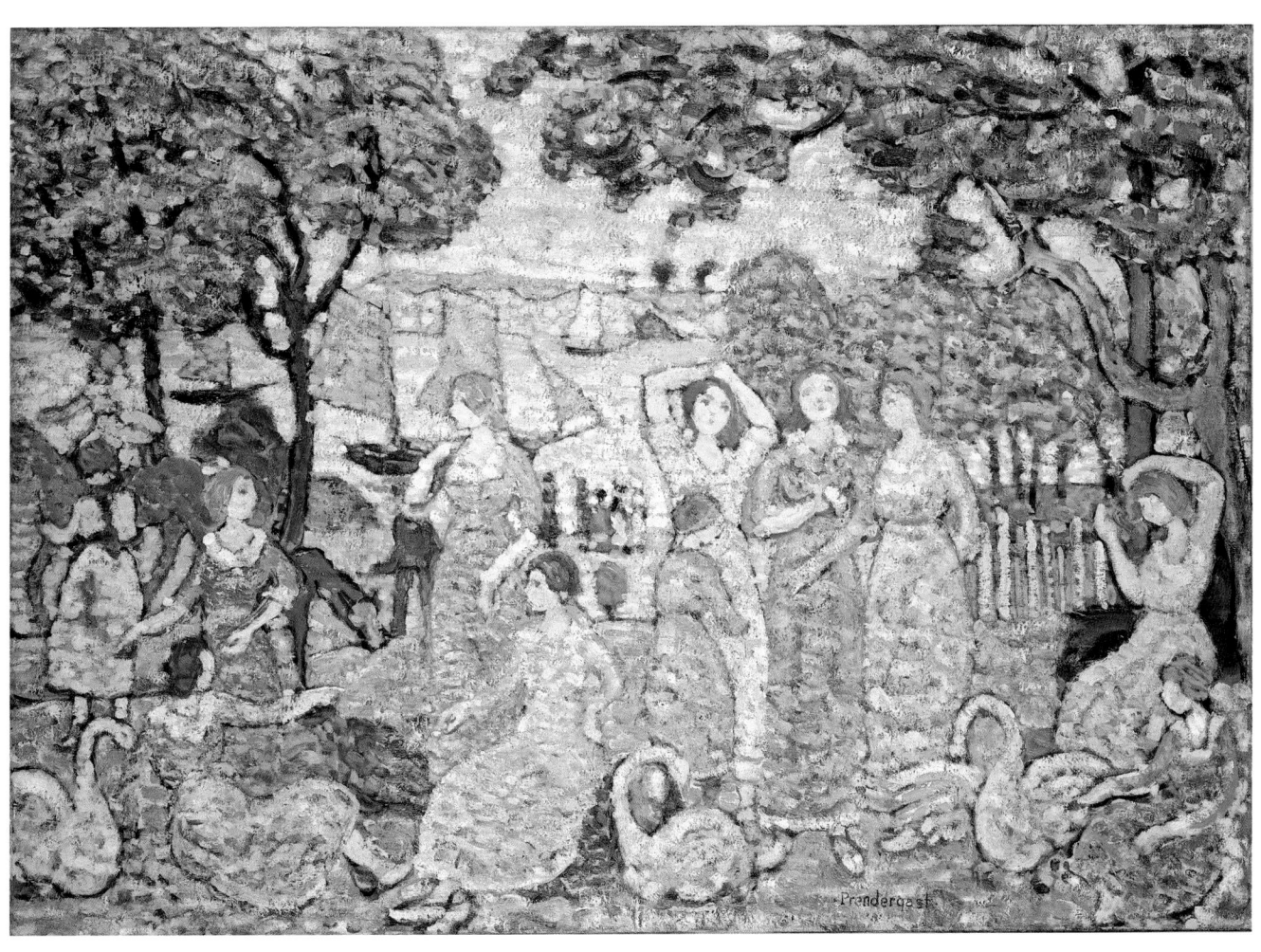

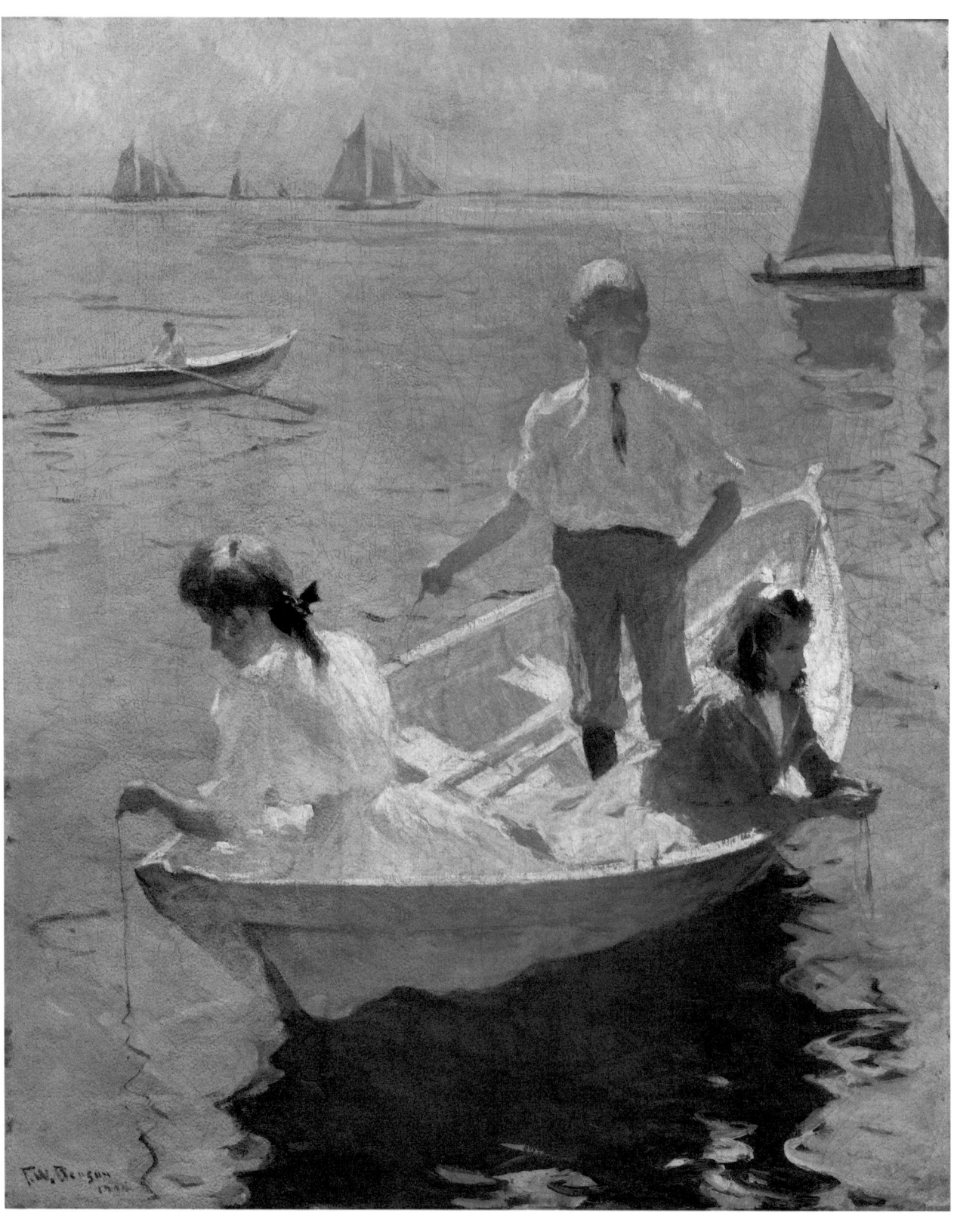

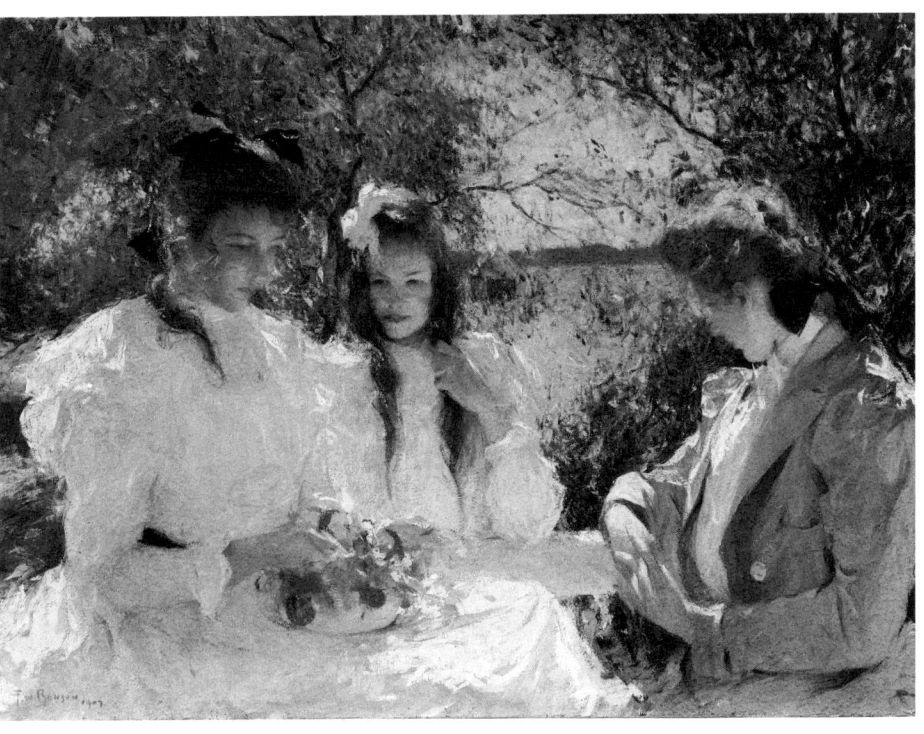

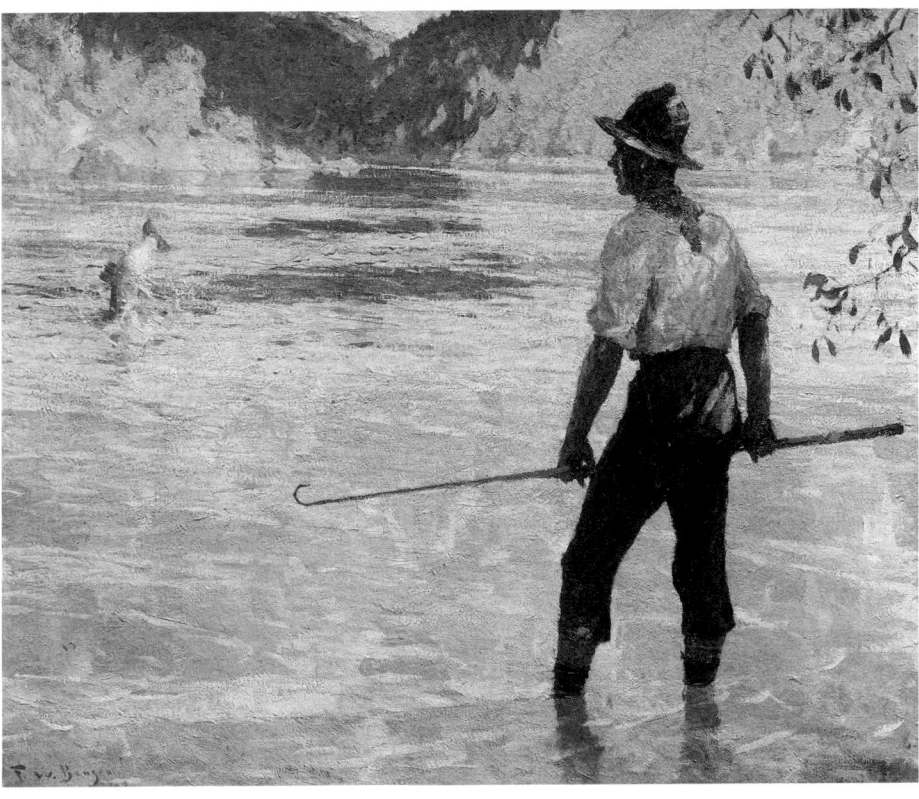

45

58.
Frank Benson, *Pintails Decoyed*, 1921
Oil on canvas, 36 x 44 in.
Museum of Fine Arts, Boston. Gift of Frederick L. Jack. 35.1230

59.
Charles Woodbury, *Ogunquit Beach Bathhouse*, 1924
Oil on canvas, 36 x 48 in.
Mr. and Mrs. Abbot W. Vose, Boston

58.
Frank Benson, *Pintails Decoyed*, 1921
Oil on canvas, 36 x 44 in.
Museum of Fine Arts, Boston. Gift of Frederick L. Jack. 35.1230

59.
Charles Woodbury, *Ogunquit Beach Bathhouse*, 1924
Oil on canvas, 36 x 48 in.
Mr. and Mrs. Abbot W. Vose, Boston

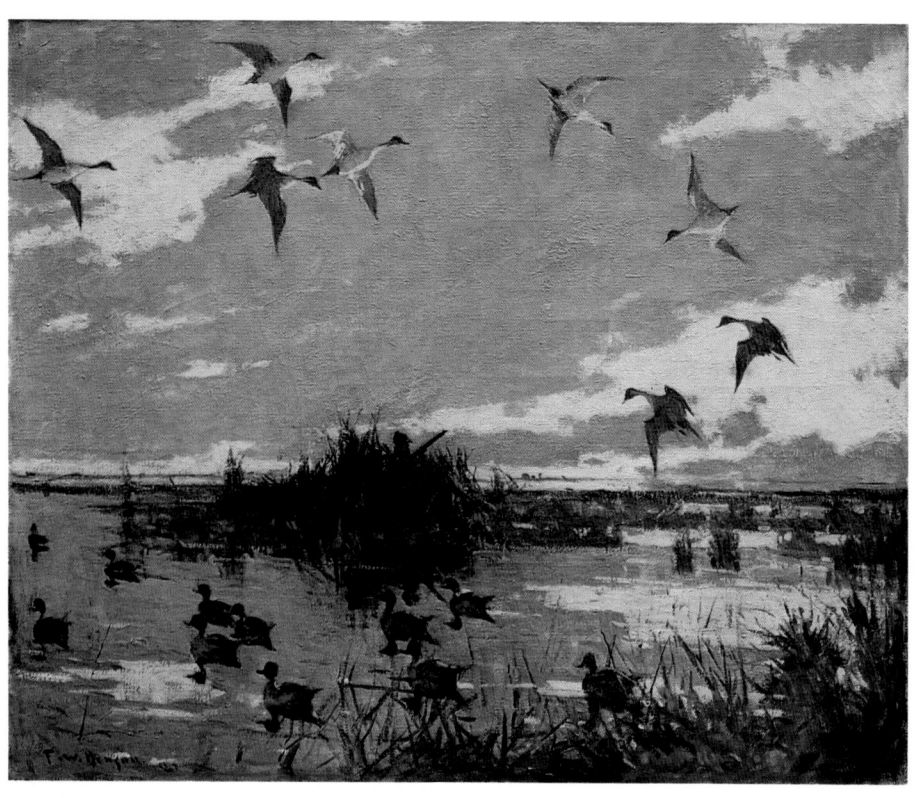

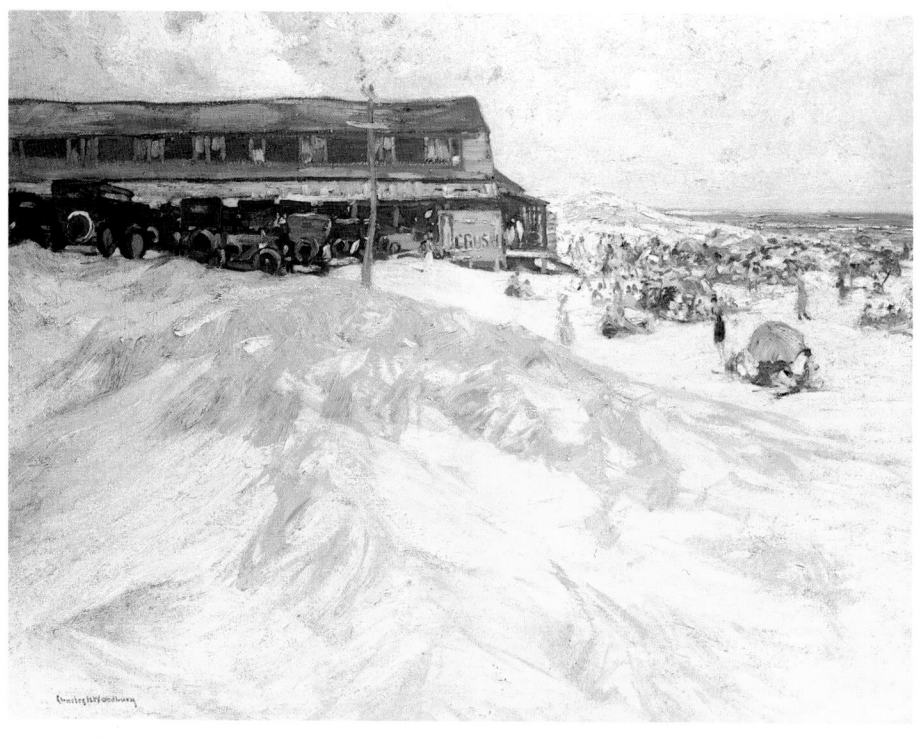

60.
Dennis Miller Bunker, *The Mirror*, 1890
Oil on canvas, 50 x 40 in.
Daniel J. Terra Collection.
Terra Museum of American Art, Chicago.

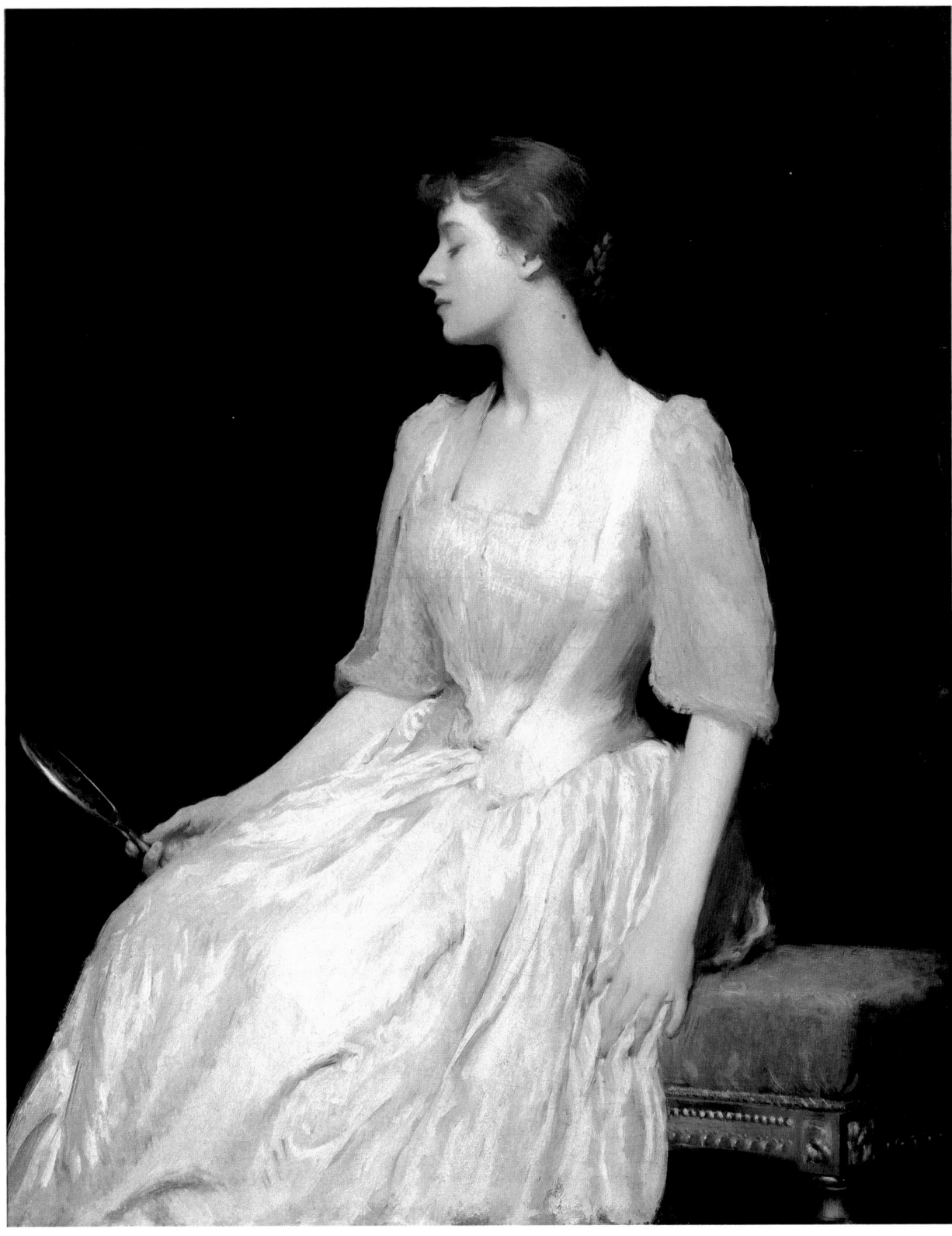

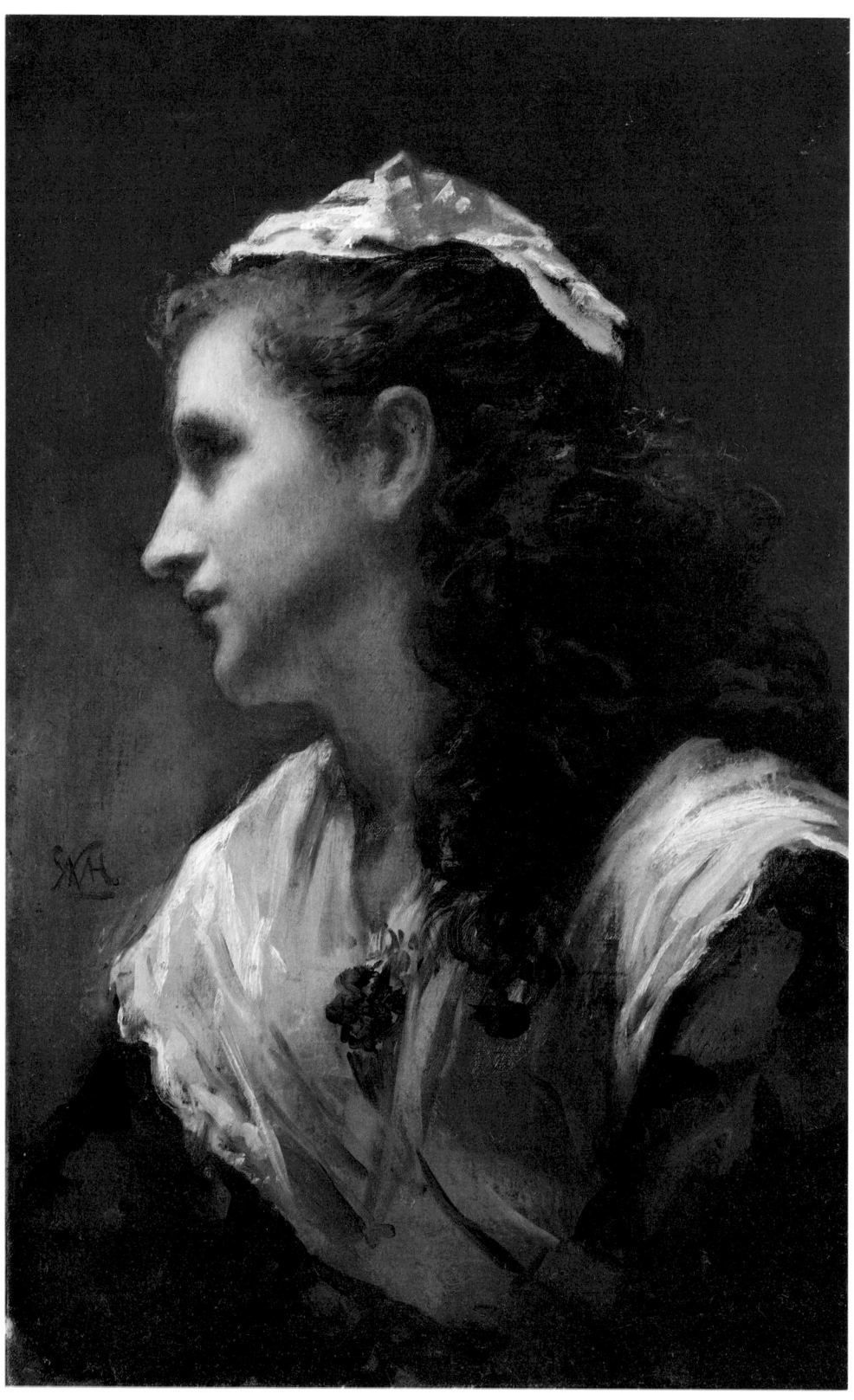

52.
EDMUND C. TARBELL, *The Breakfast Room*
ca. 1903
Oil on canvas, 25 x 30 in.
The Pennsylvania Academy of the Fine Arts,
Philadelphia. Gift of Clement B. Newbold

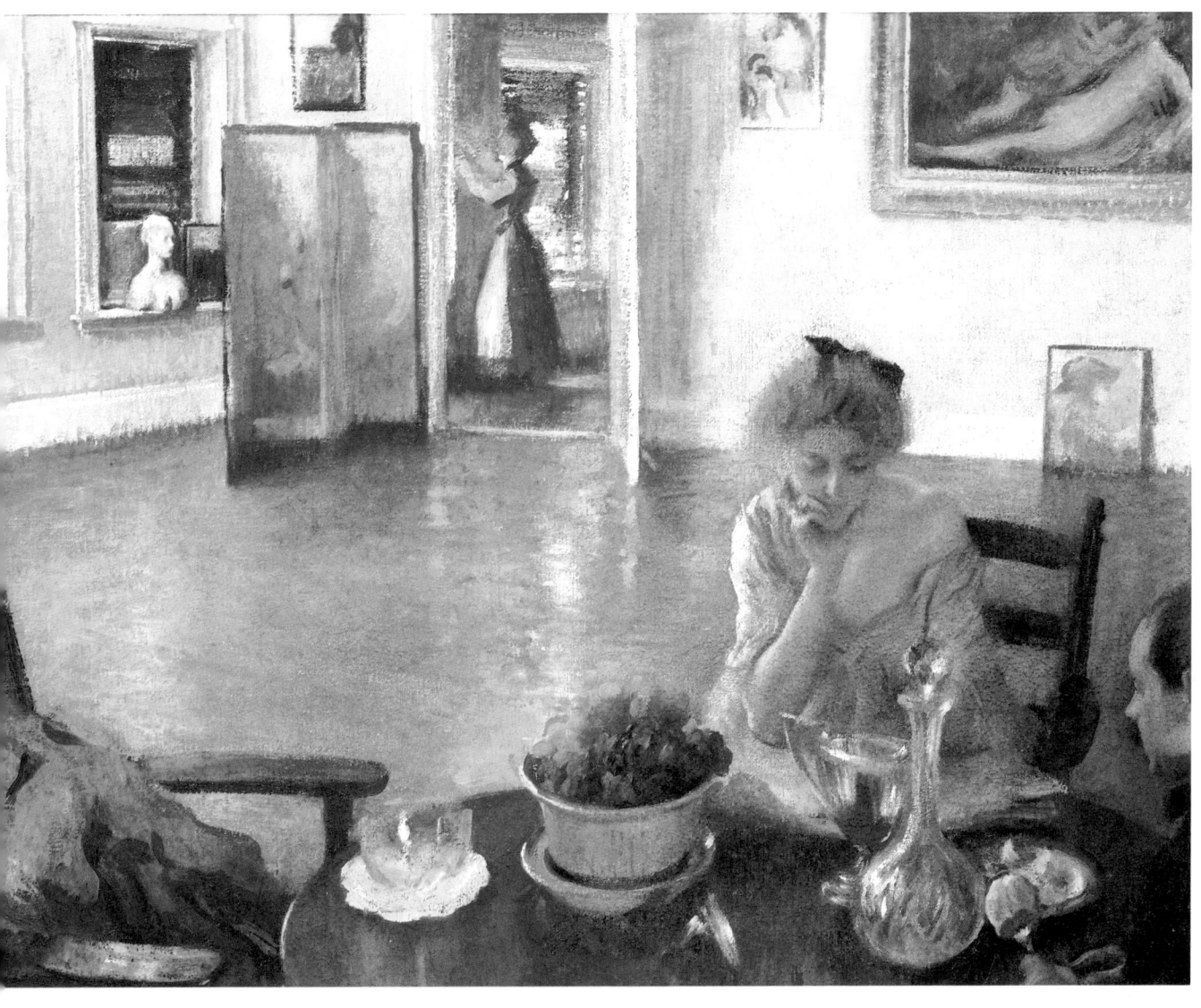

63.
FRANK BENSON, *The Black Hat*, 1904
Oil on canvas, 40 x 32 in.
Museum of Art, Rhode Island School of Design,
Providence. Gift of Walter Callendar, Henry D.
Sharpe, Howard L. Clark, William Gammell, and
Isaac C. Bates. 06.002

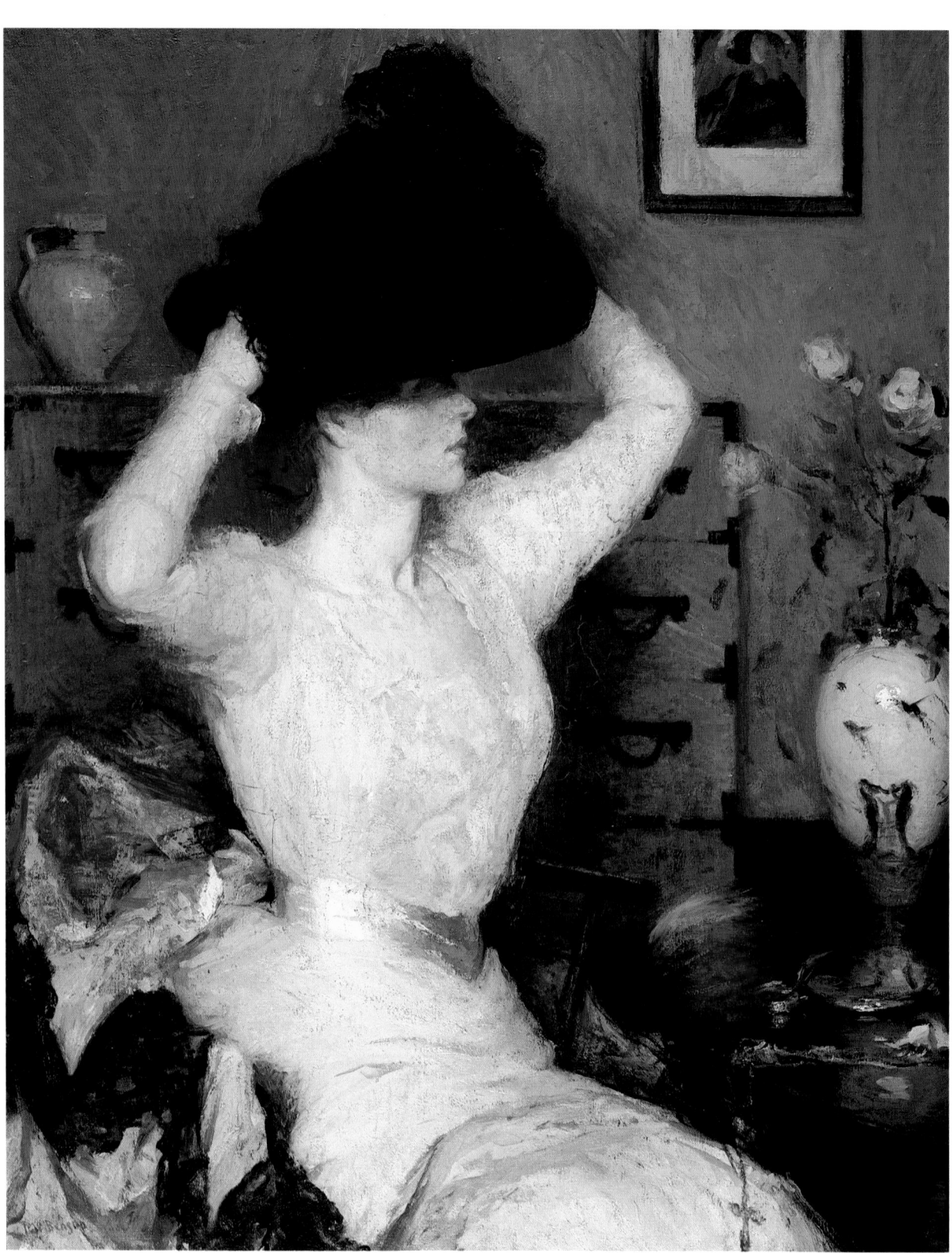

Joseph Rodefer DeCamp, *The Seamstress*, 1916
Oil on canvas, 36¼ x 28 in.
The Corcoran Gallery of Art, Washington, D.C.
Museum Purchase

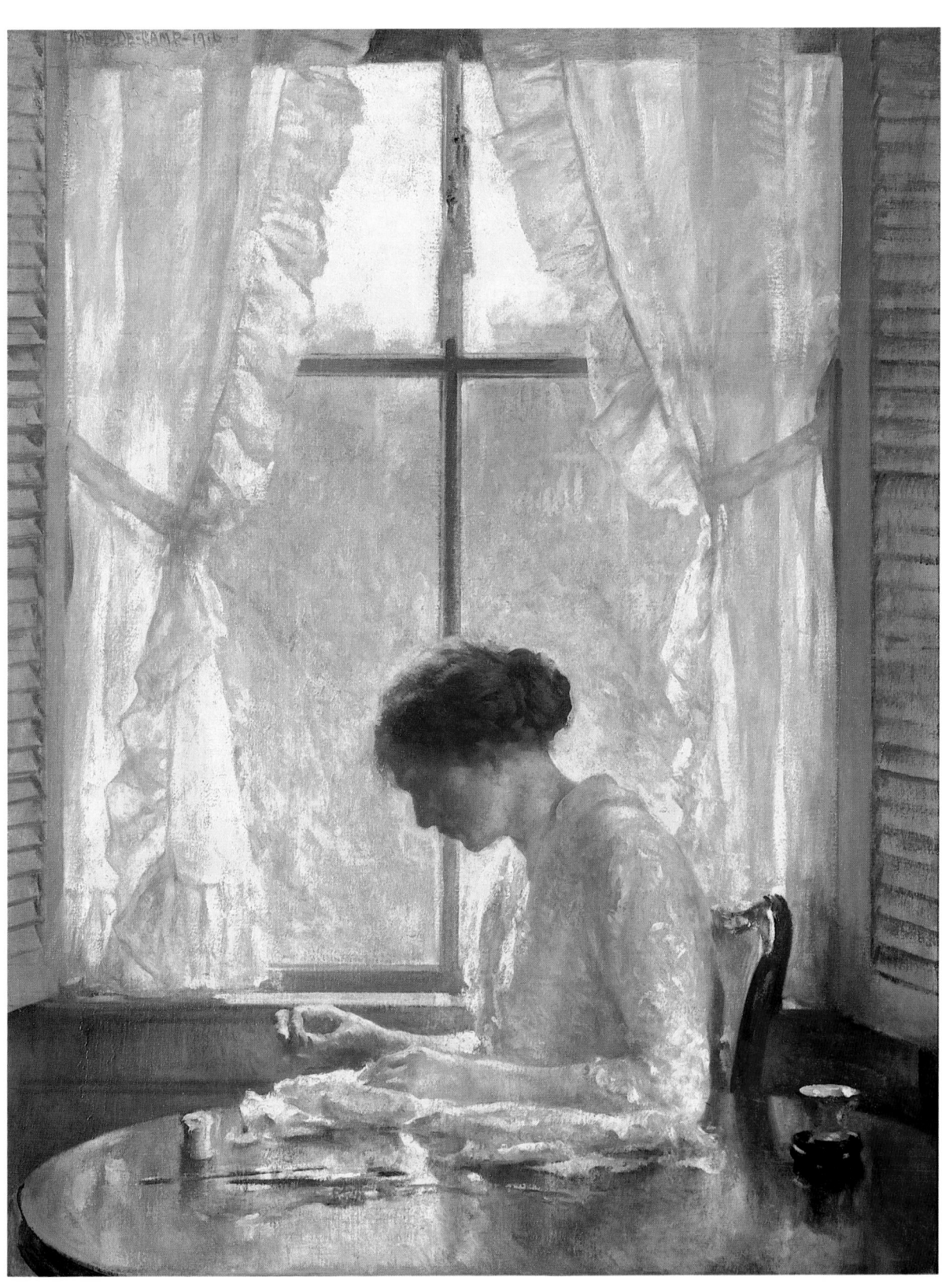

65.
EDMUND C. TARBELL, *New England Interior*
ca. 1906
Oil on canvas, 30⅛ x 25⅛ in.
Museum of Fine Arts, Boston. Gift of Mrs. Eugene
C. Eppinger. 1985.66

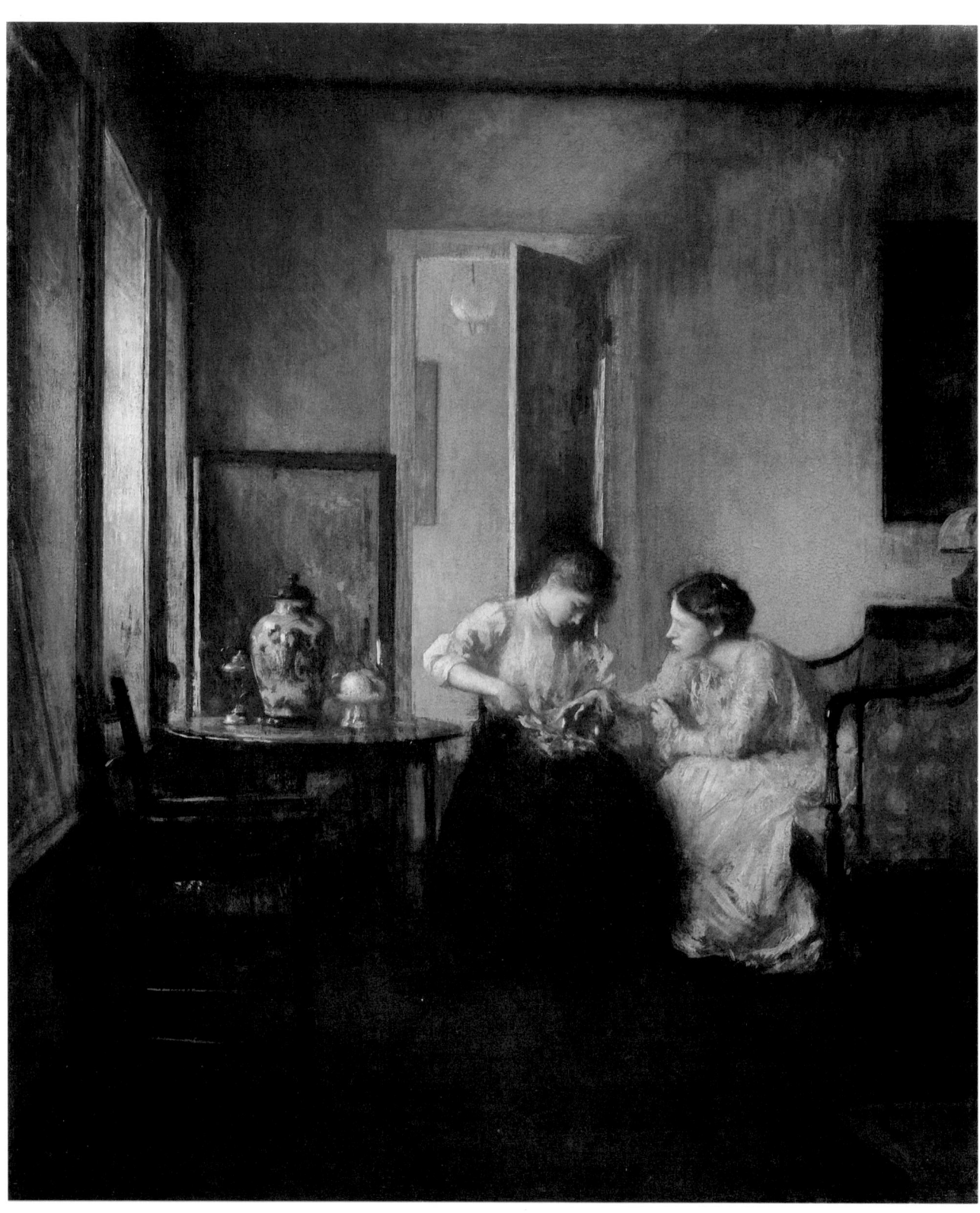

46.
EDMUND C. TARBELL, *Girl Crocheting*, 1904
Oil on canvas, 30 x 25 in.
Canajoharie Library and Art Gallery,
Canajoharie, New York

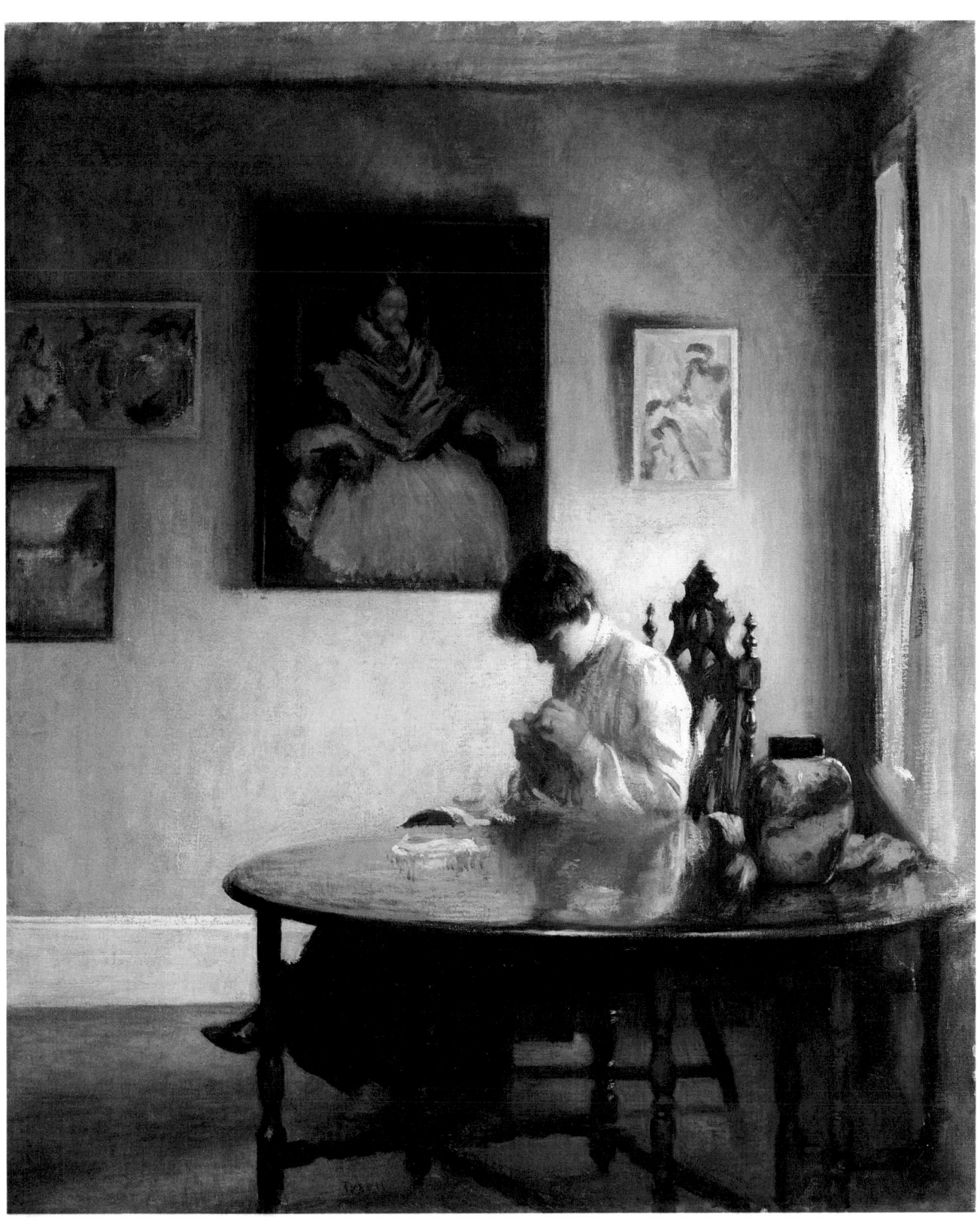

67.
WILLIAM PAXTON, *Tea Leaves*, 1909
Oil on canvas, 36⅛ x 28¾ in.
The Metropolitan Museum of Art, New York.
Gift of George A. Hearn. 10.64.8

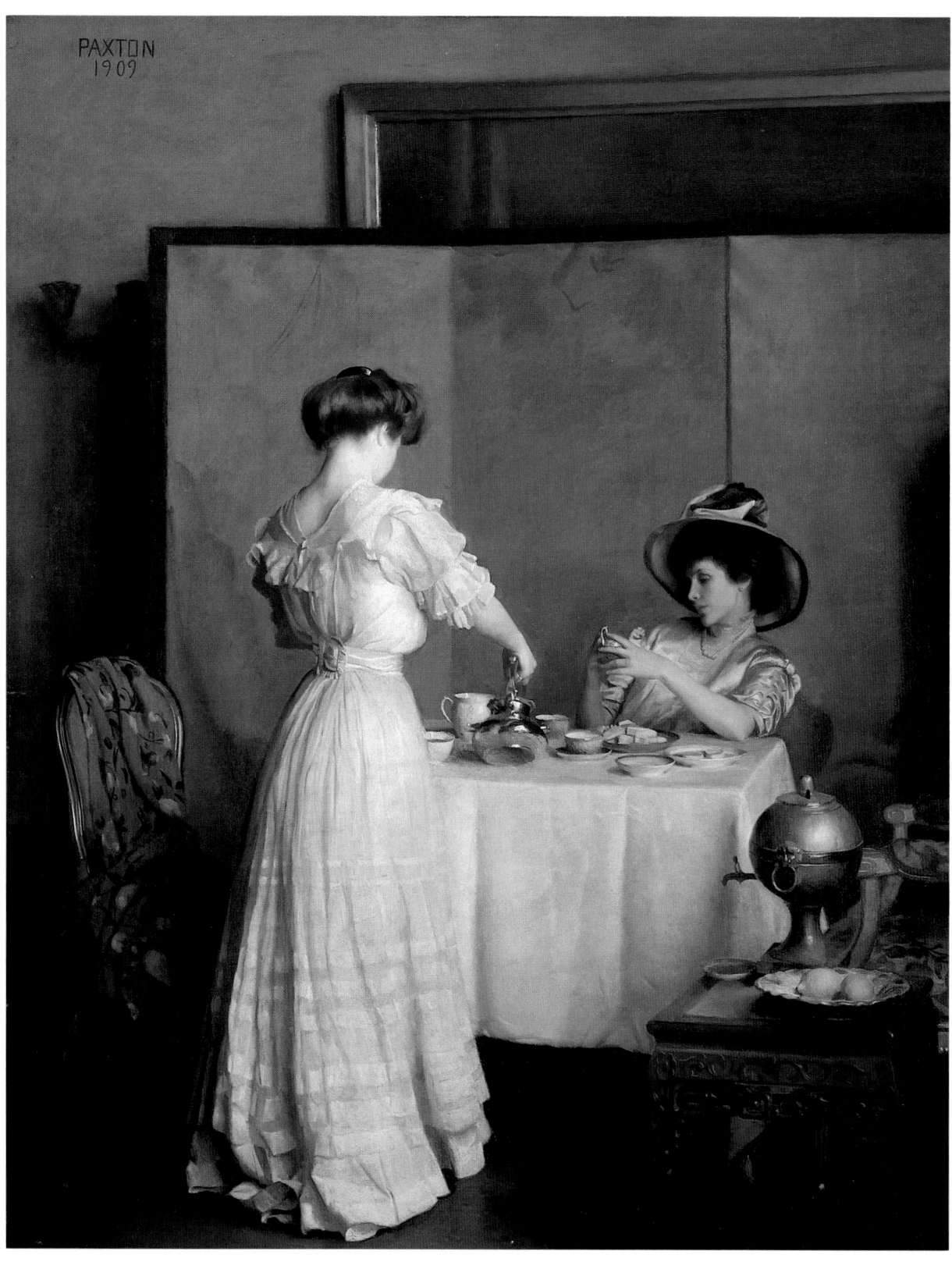

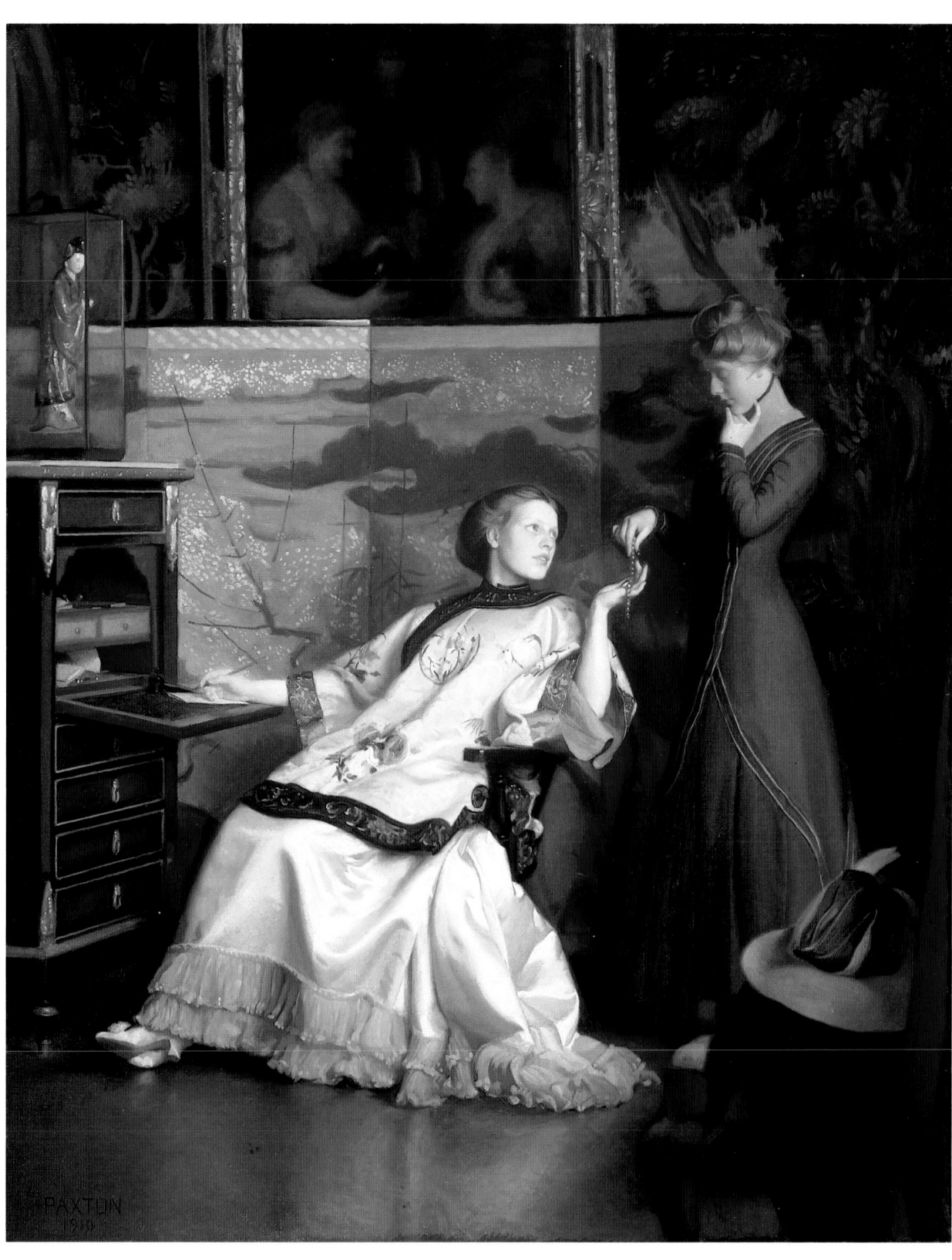

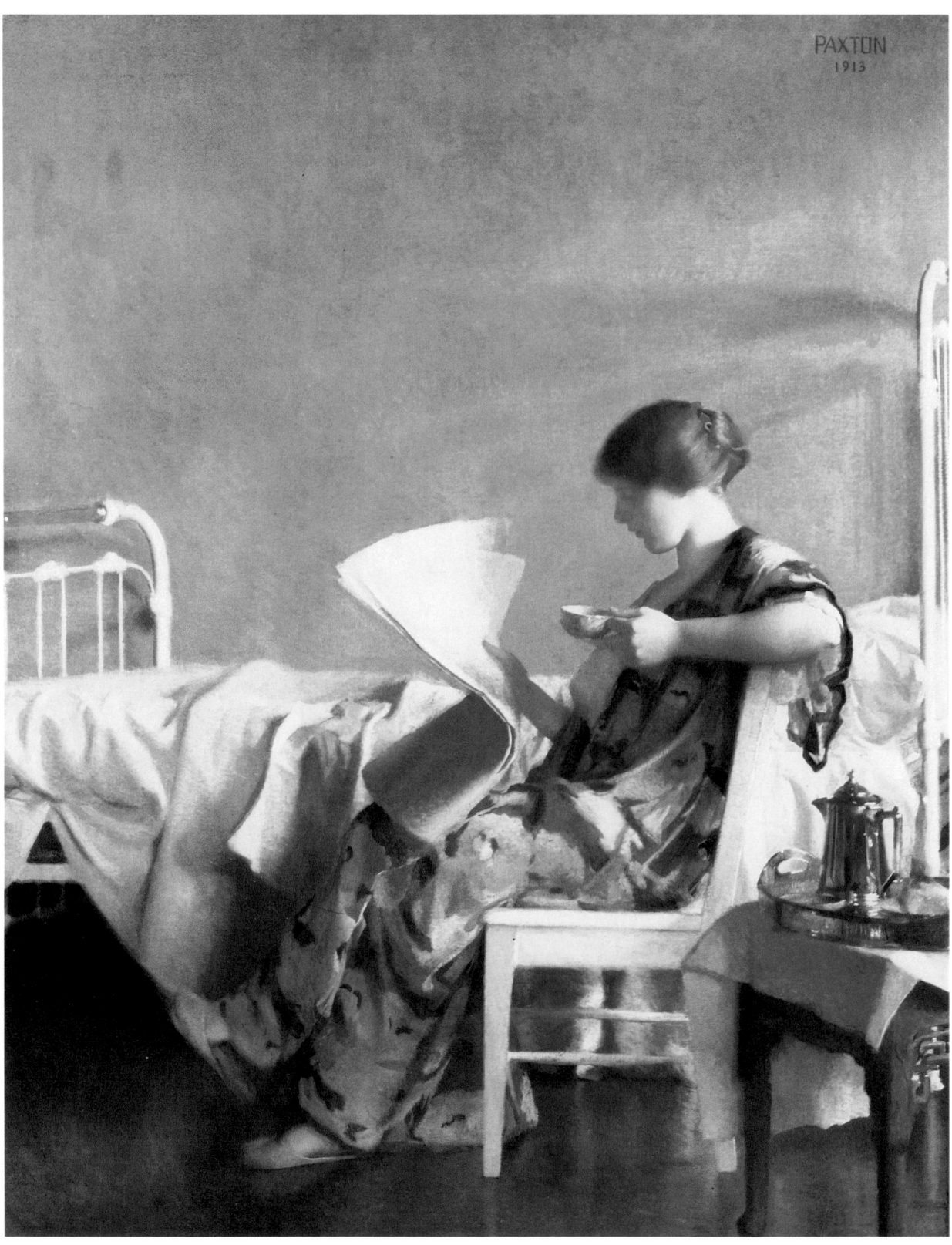

70.
William Paxton, *Nude*, ca. 1916
Oil on canvas, 24 x 33 in.
Museum of Fine Arts, Boston.
The Hayden Collection. 16.98

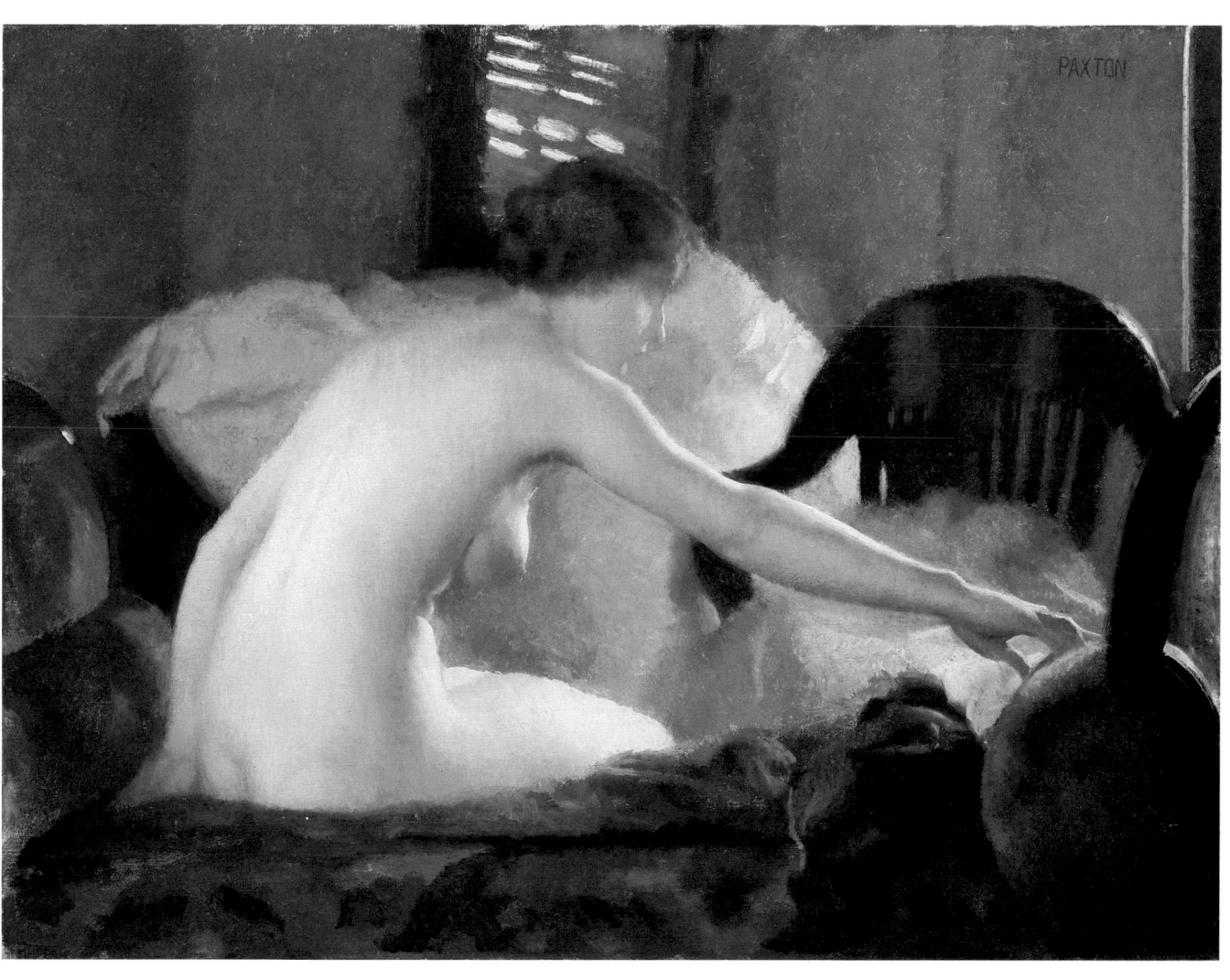

71.
EDMUND C. TARBELL, *Reverie (Katharine Finn)*,
1913
Oil on canvas, 50¼ x 34¼ in.
Museum of Fine Arts, Boston.
Bequest of Georgina S. Cary. 33.400

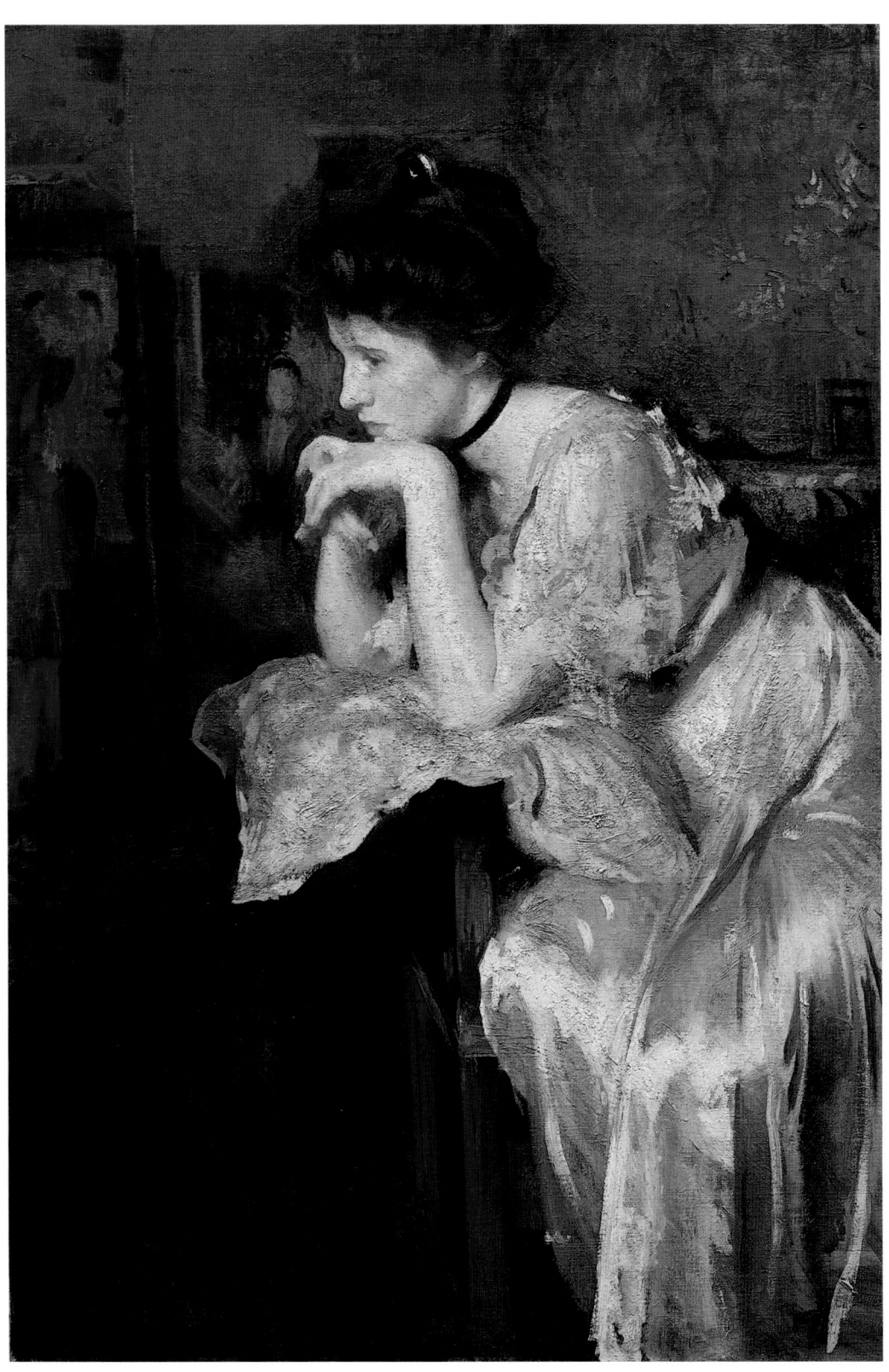

72.
LILIAN WESTCOTT HALE, *Zeffy in Bed*, ca. 1912
Oil on canvas, 30⅛ x 22 in.
Nebraska Art Association, Beatrice D. Rohman
Fund; courtesy of Sheldon Memorial Art Gallery,
University of Nebraska, Lincoln

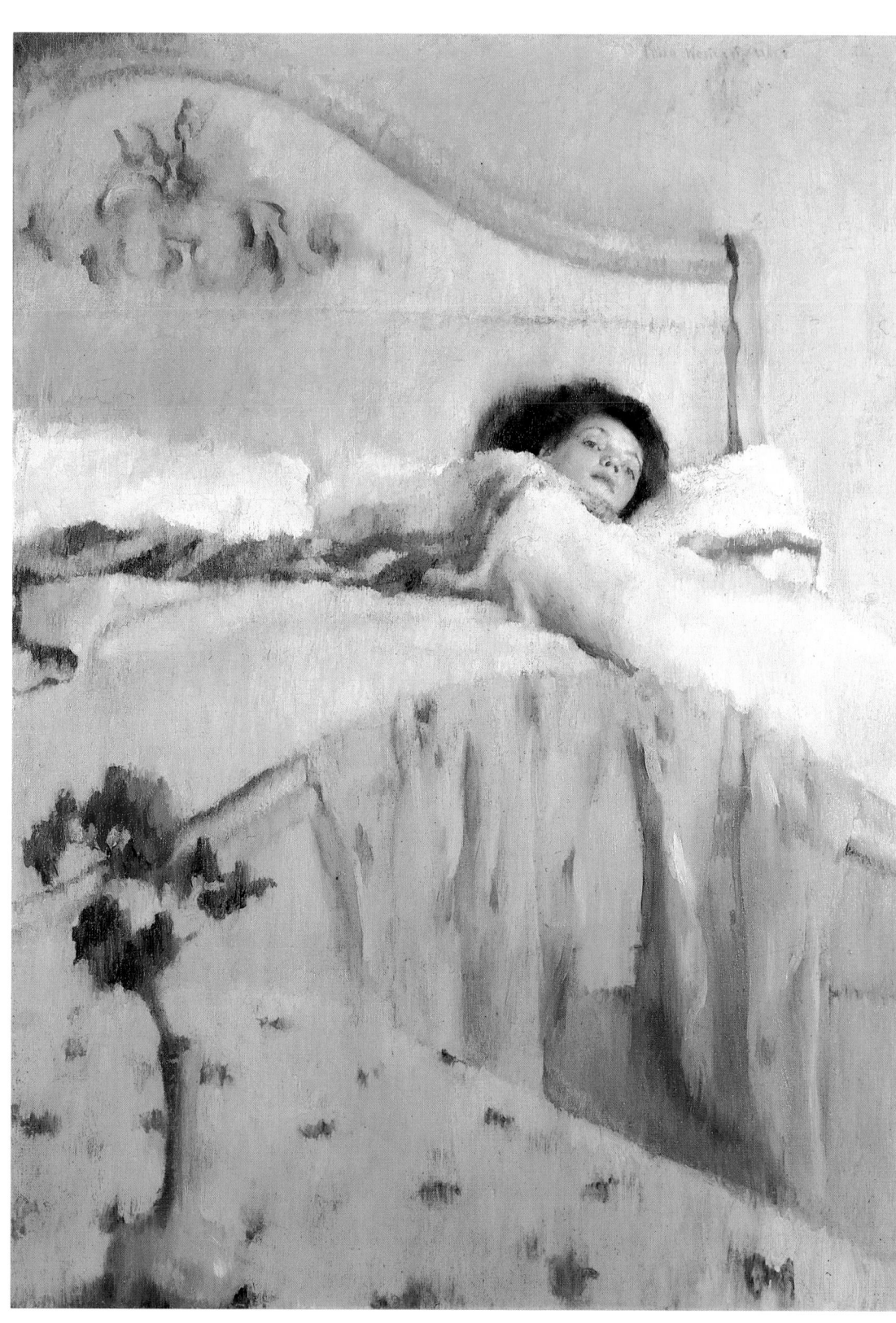

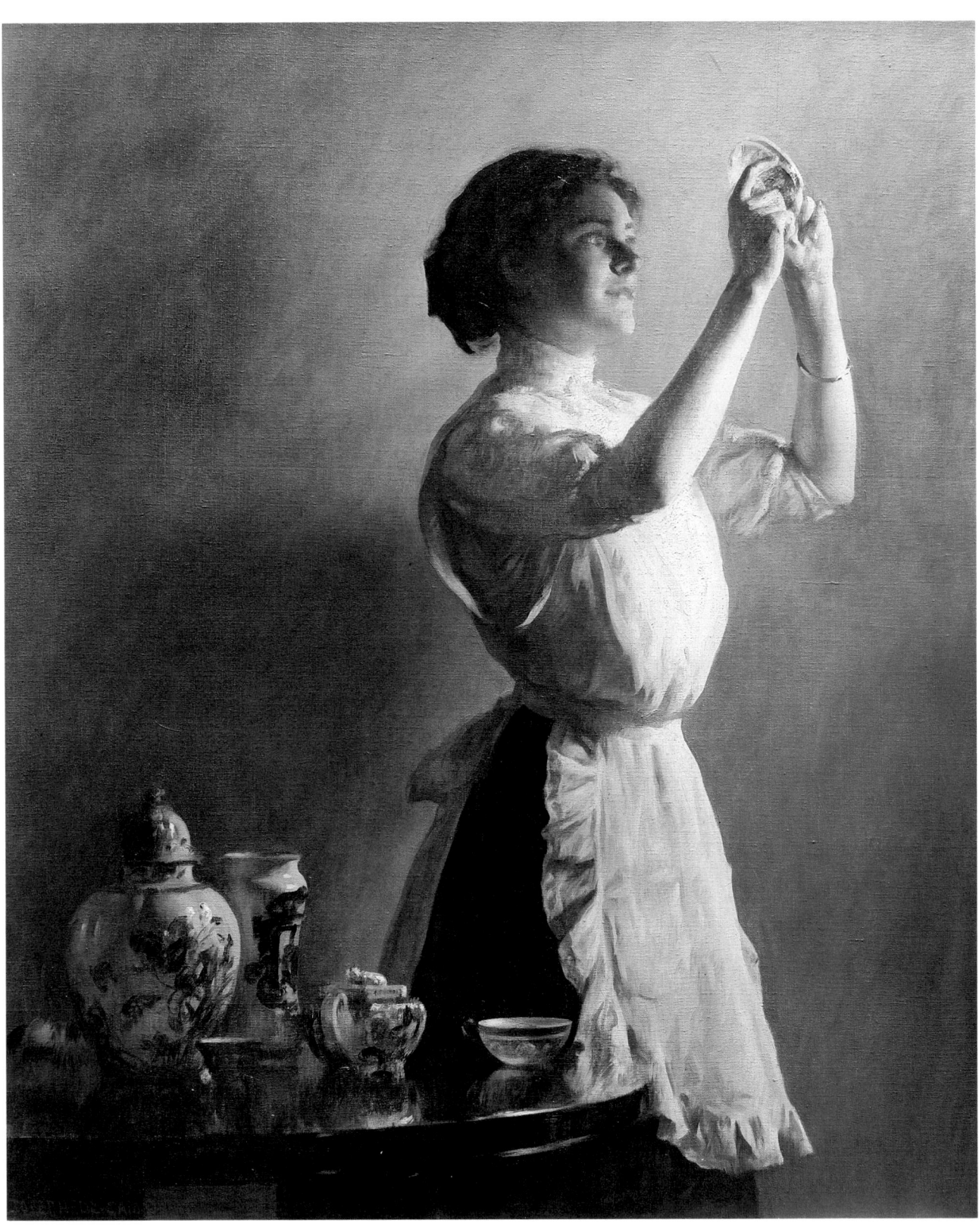

FRANK BENSON, *The Open Window*, 1917
Oil on canvas, 52¼ x 42¼ in.
The Corcoran Gallery of Art, Washington, D.C.

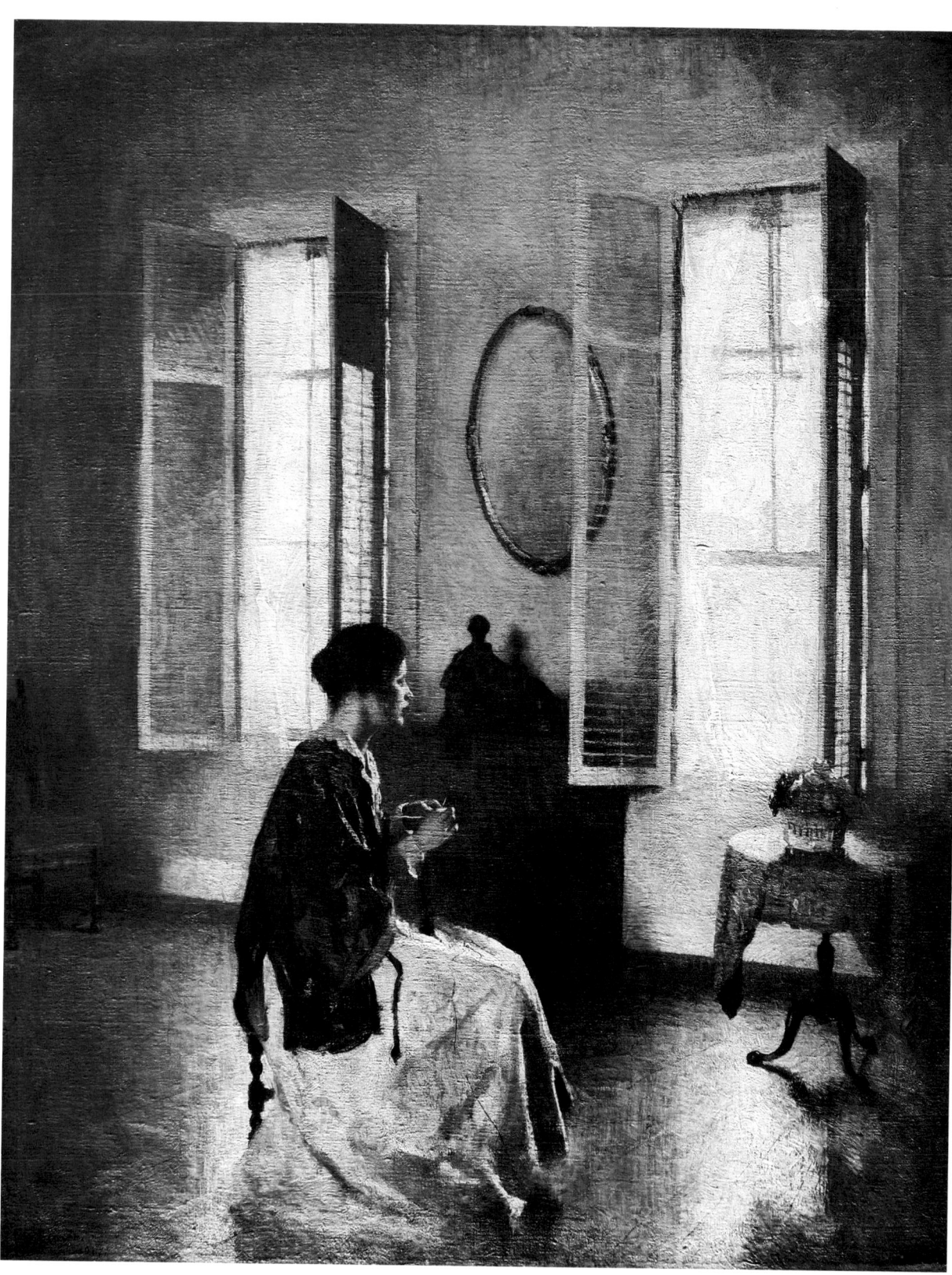

75.
Edmund C. Tarbell, *My Family*, 1914
Oil on canvas, 30 x 38 in.
Private Collection

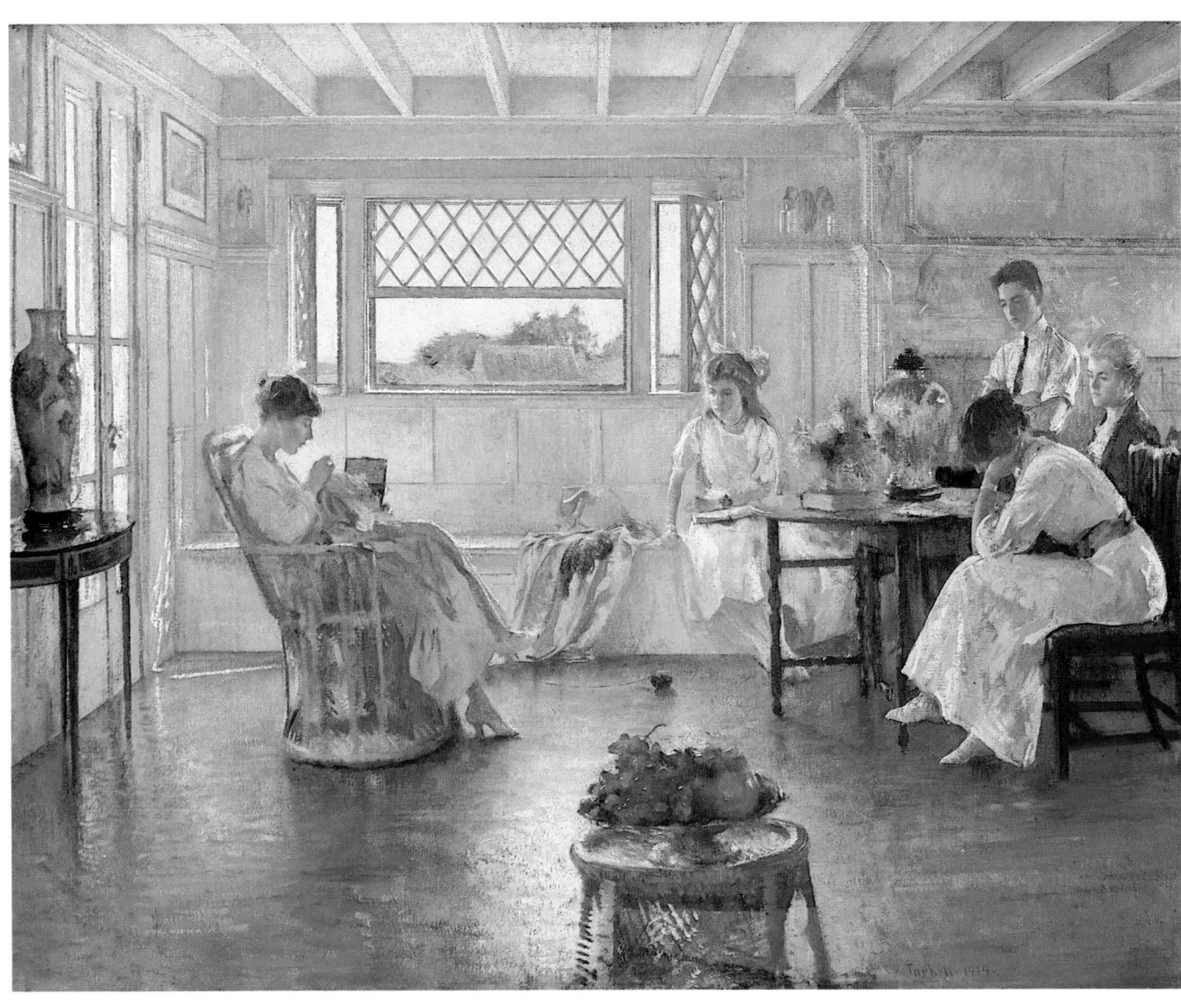

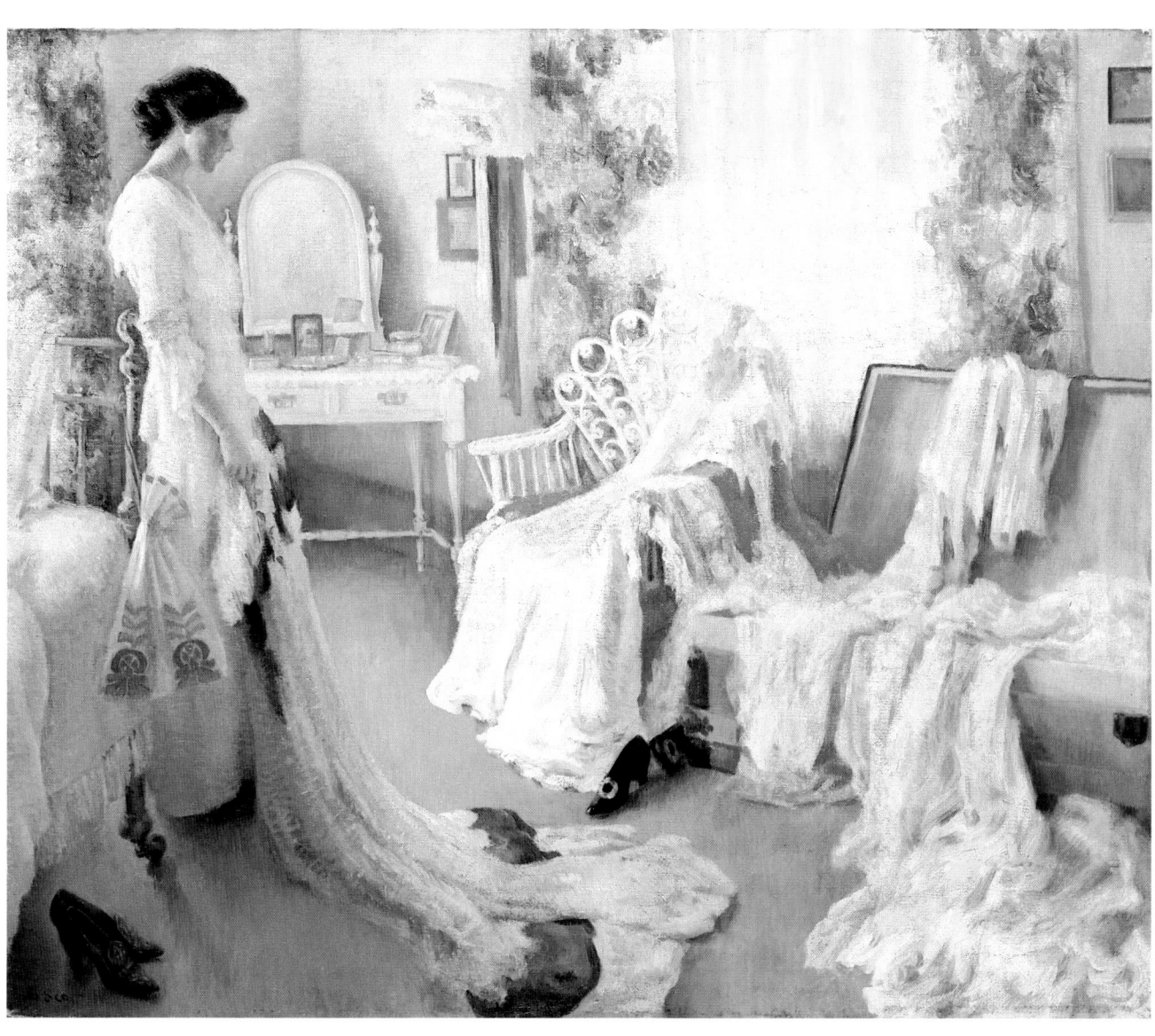

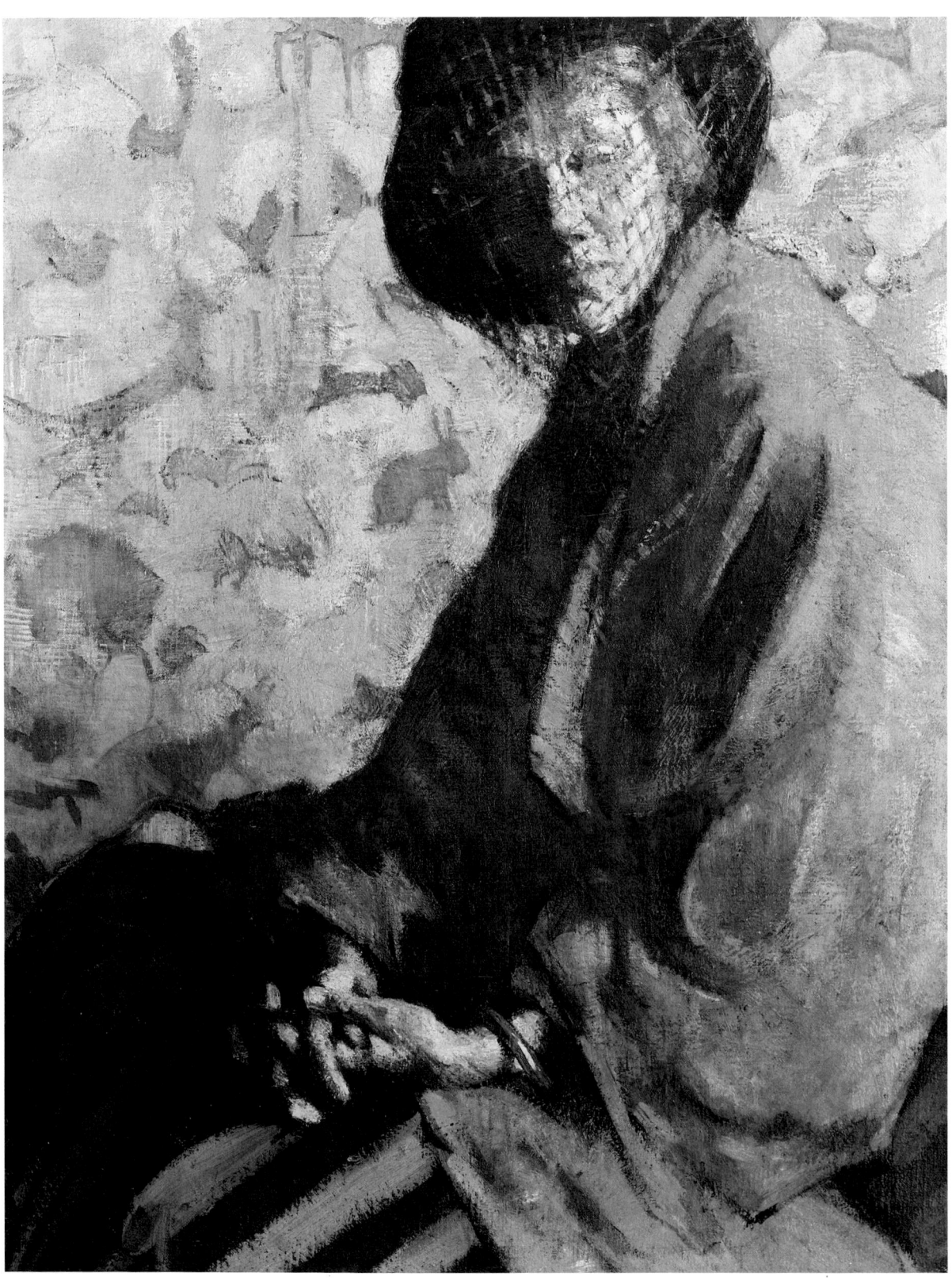

78.
ELIZABETH PAXTON, *Breakfast Still Life*, ca. 1920
Oil on canvas, 12 x 17 in.
Private Collection

82.
GRETCHEN ROGERS, *Still Life*, ca. 1923
Oil on canvas, 19¼ x 21¼ in.
Museum of Fine Arts, Boston.
Gift of the Artist. 1986.59

84.
PHILIP LESLIE HALE, *John M. Whitcomb Sketching*, 1923
Charcoal, white chalk, red and blue colored pencils on light tan wove paper, 22 x 22 in.
Private Collection

JOHN BRIGGS POTTER, *Miss Grace Ellery
Channing*, 1893
Graphite with touches of red and blue wash,
21⅝ x 14⅞ in.
Museum of Fine Arts, Boston. Gift of the Commit-
tee on the Chandler Scholarship. 03.713

86.
Lilian Westcott Hale, *Portrait of Nancy,*
ca. 1914
Charcoal on paper, 28½ x 21½ in.
Private Collection

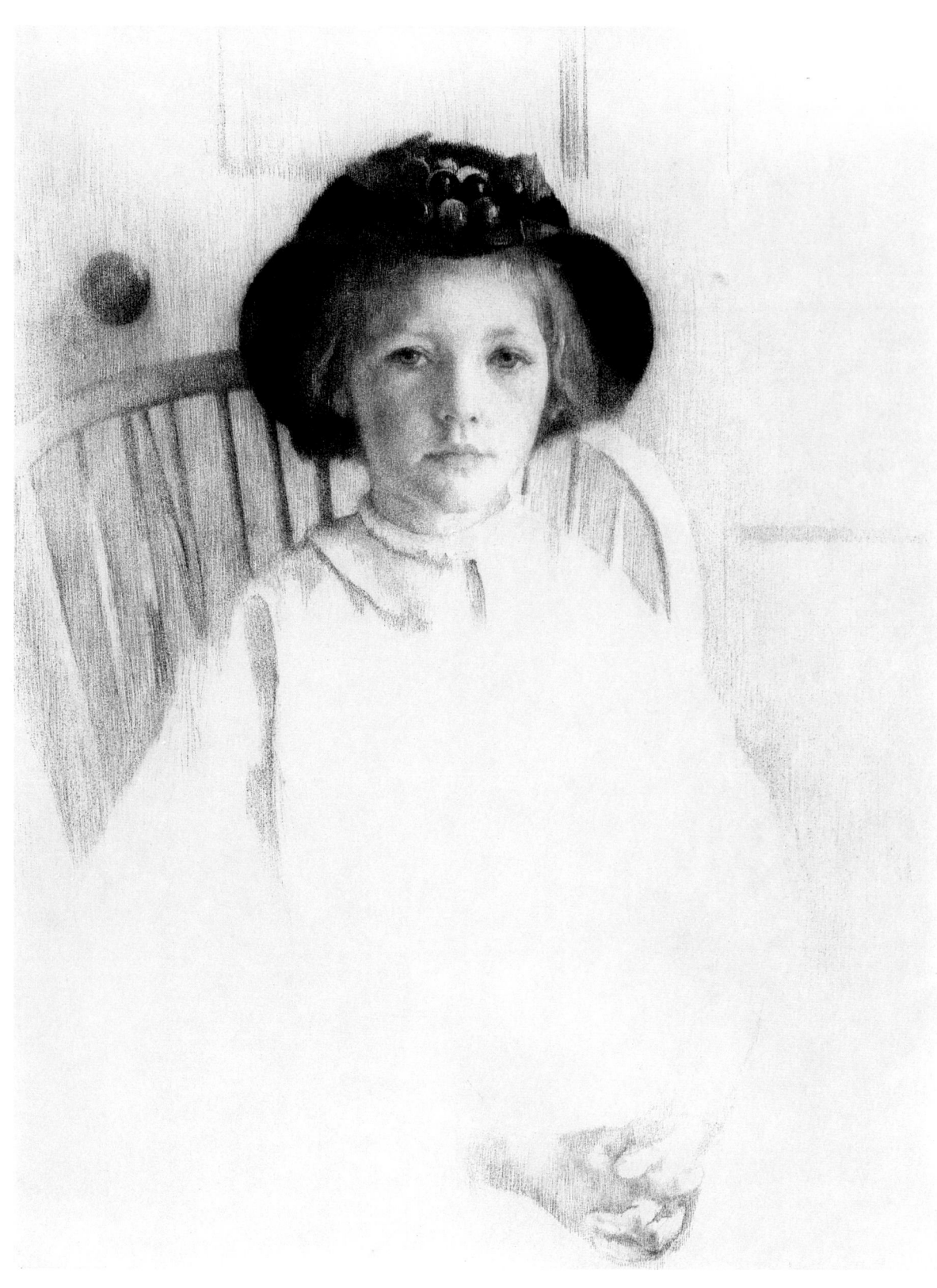

87.
LILIAN WESTCOTT HALE, *Daffydowndilly*, 1907
Charcoal and black chalk on paper, 22½ x 14½ in.
Museum of Fine Arts, Boston. Gift of Miss Mary
C. Wheelwright. 36.83

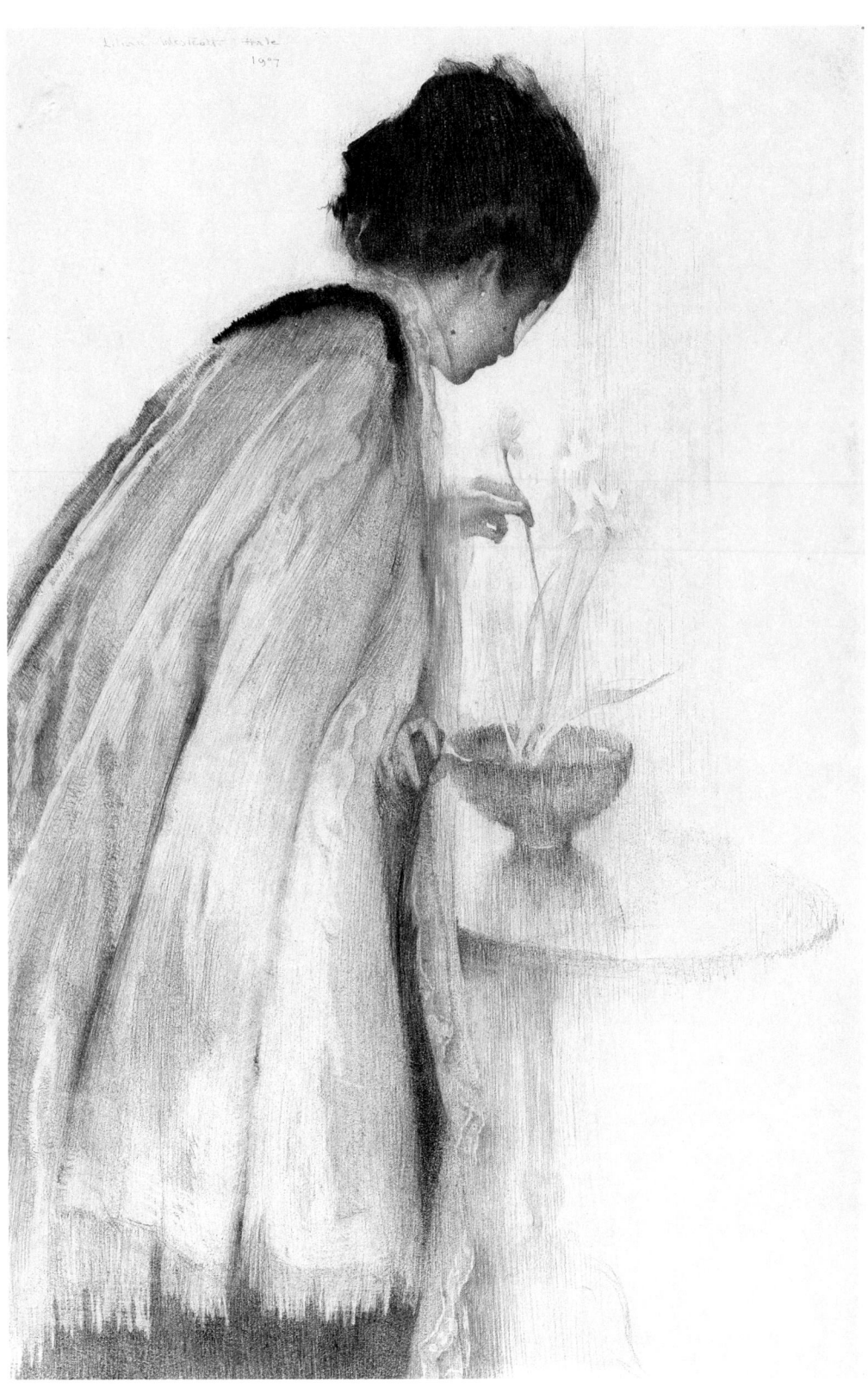

88.
Lilian Westcott Hale, *The Old Ring Box*,
1907
Charcoal and black chalk on paper, 22½ x 14⅛ in.
Museum of Fine Arts, Boston. Gift of Miss Mary
C. Wheelwright. 36.84

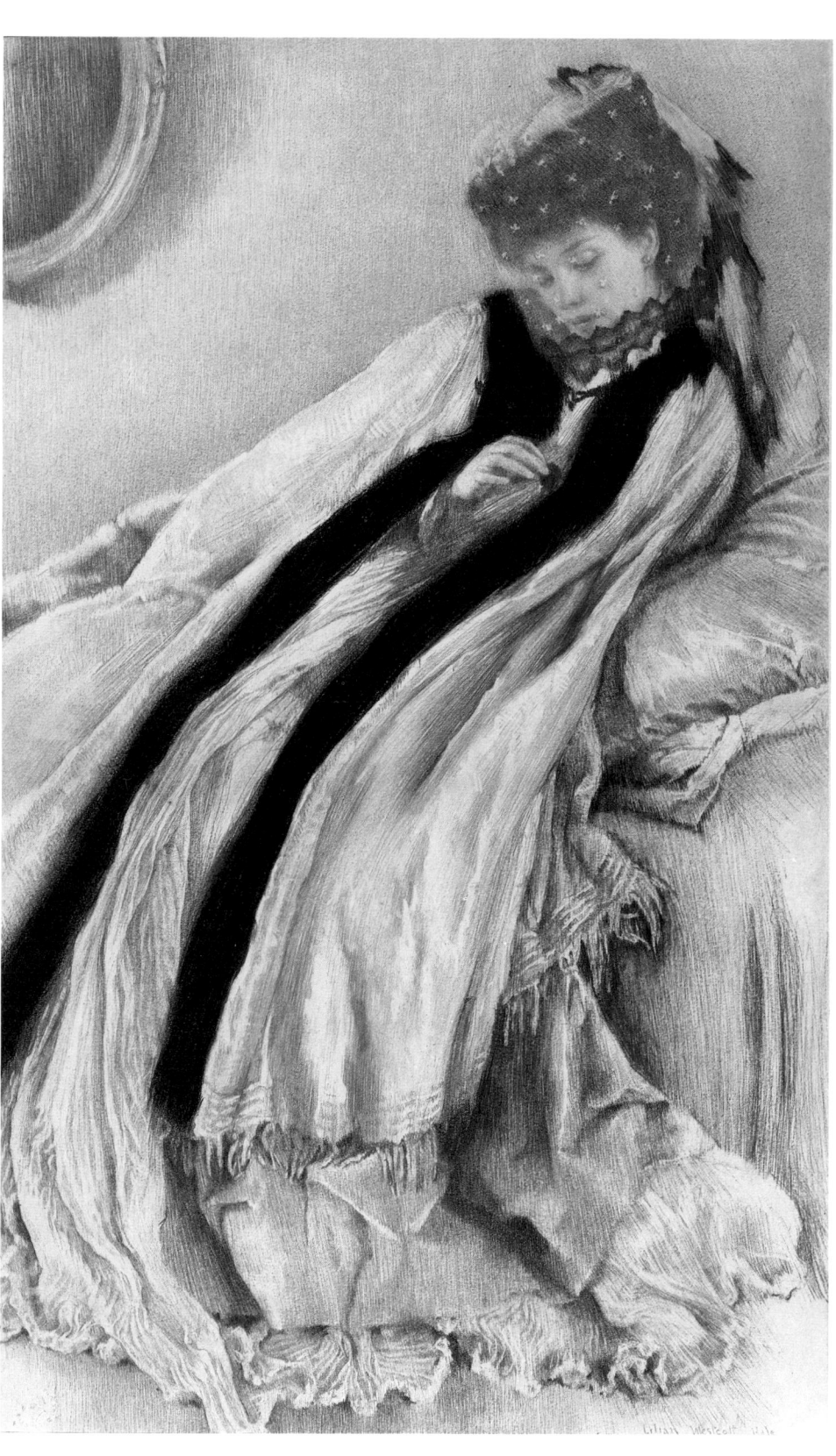

89.
LILIAN WESTCOTT HALE, *On Christmas Day in the Morning (The Wreath)* ca. 1924
Charcoal and red, yellow, and green colored pencils on paper, 29¼ x 20½ in.
Private Collection

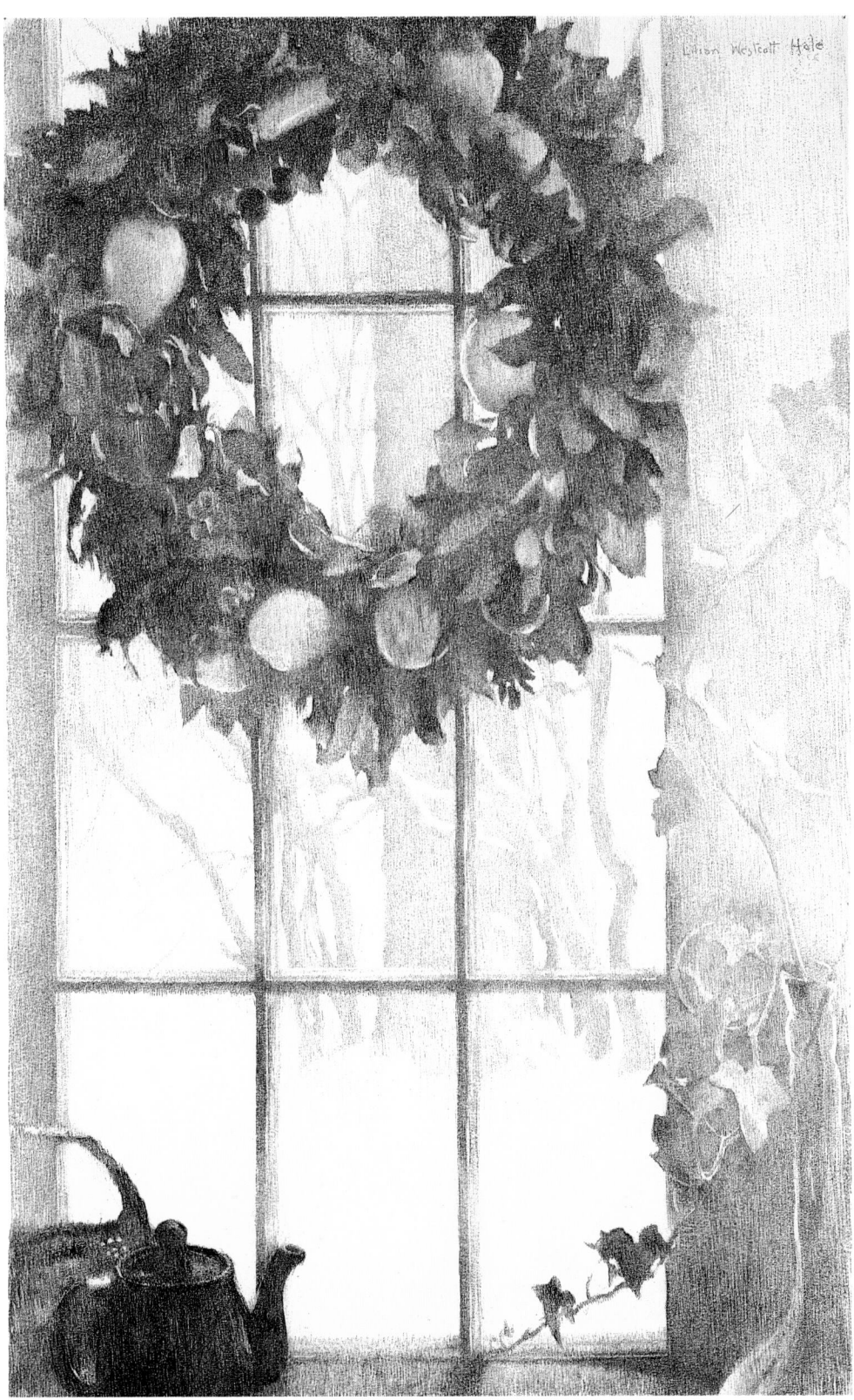

90.
LILIAN WESTCOTT HALE, Untitled *(Interior)*,
ca. 1930
Charcoal on paper, 28 x 21 in.
Private Collection

91.
WINSLOW HOMER, *Trout Breaking*, 1889
Watercolor on paper, 13⁹⁄₁₆ x 19⁹⁄₁₆ in.
Museum of Fine Arts, Boston. Bequest of John T.
Spaulding. 48.729

92.
Winslow Homer, *Ouananiche Fishing, Lake St. John, Québec*, 1897
Watercolor on paper, 14 x 20¾ in.
Museum of Fine Arts, Boston. Warren Collection.
99.30

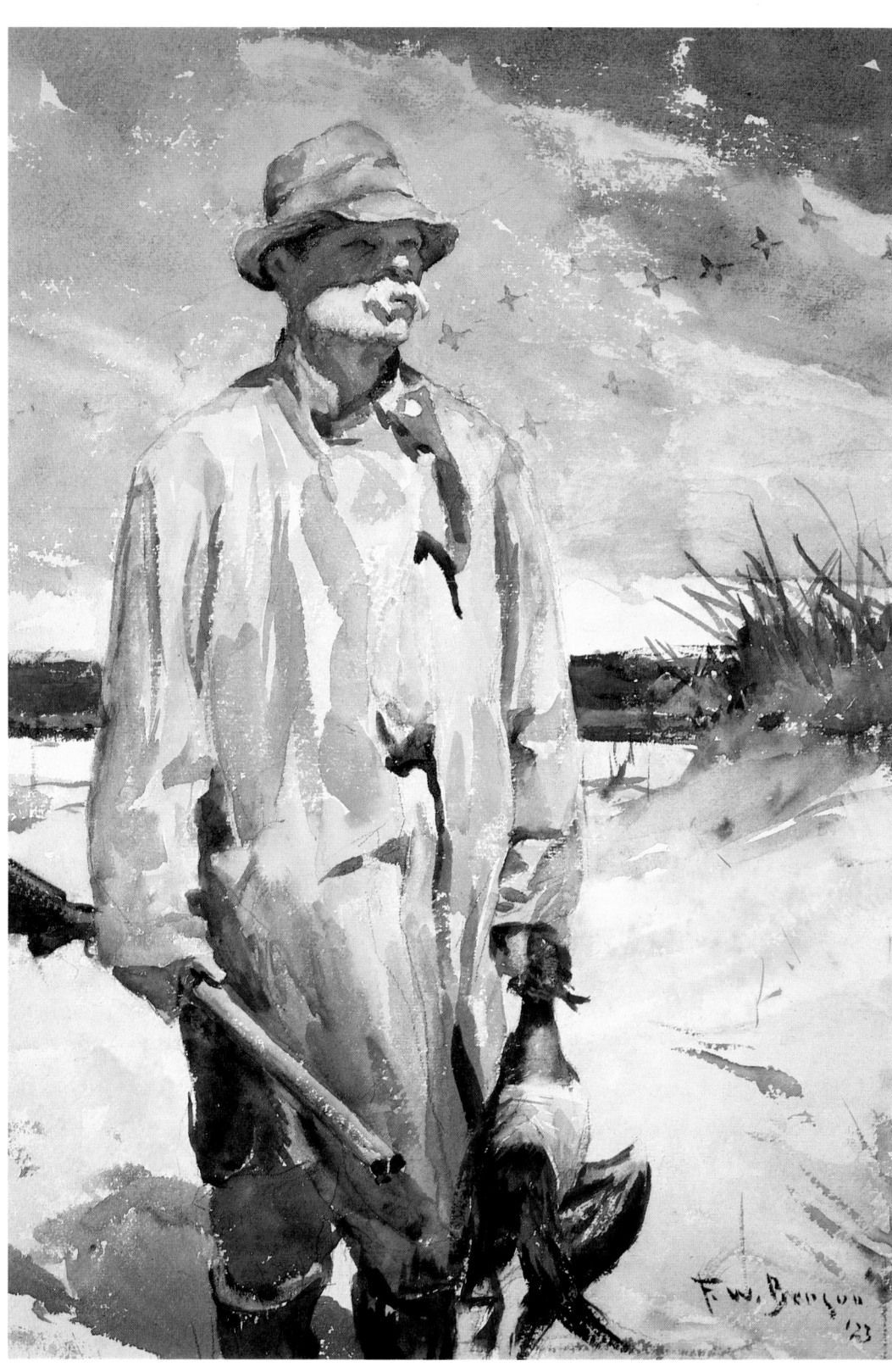

CHARLES HOPKINSON, *The Windmill Pond,*
Manchester, Massachusetts, ca. 1930
Watercolor on paper, 14½ x 21¼ in.
Private Collection

97.
Ross Sterling Turner, *A Garden is a Sea of Flowers*, 1887
Watercolor on paper. 20½ x 30½ in.
Museum of Fine Arts, Boston. Gift of the Estate of Nellie P. Carter. 35.1690

98.
John Singer Sargent, *Magnolias*, ca. 1910
Watercolor on paper, 12 x 18 in.
Private Collection

LAURA COOMBS HILLS, *Larkspur, Peonies, and Canterbury Bells*, ca. 1915
Pastel on paper, 28 x 23¼ in.
Museum of Fine Arts, Boston. Ellen K. Gardner
Fund. 26.240

100.
J. Appleton Brown, *Old Fashioned Garden*,
ca. 1888
Pastel on paper, 21⅞ x 17¹⁵⁄₁₆ in.
Bowdoin College Museum of Art, Brunswick,
Maine. 1904.24

101.
CHILDE HASSAM, *Dexter's Garden*, 1892
Watercolor on paper, 19¹³⁄₁₆ x 14⅛ in.
National Museum of American Art, Smithsonian
Institution, Washington, D.C. Gift of John Gellatly

102.
JOHN SINGER SARGENT, *The Garden Wall*, 1910
Watercolor on paper, 15¾ x 20½ in.
Museum of Fine Arts, Boston. The Hayden Col-
lection. 12.222

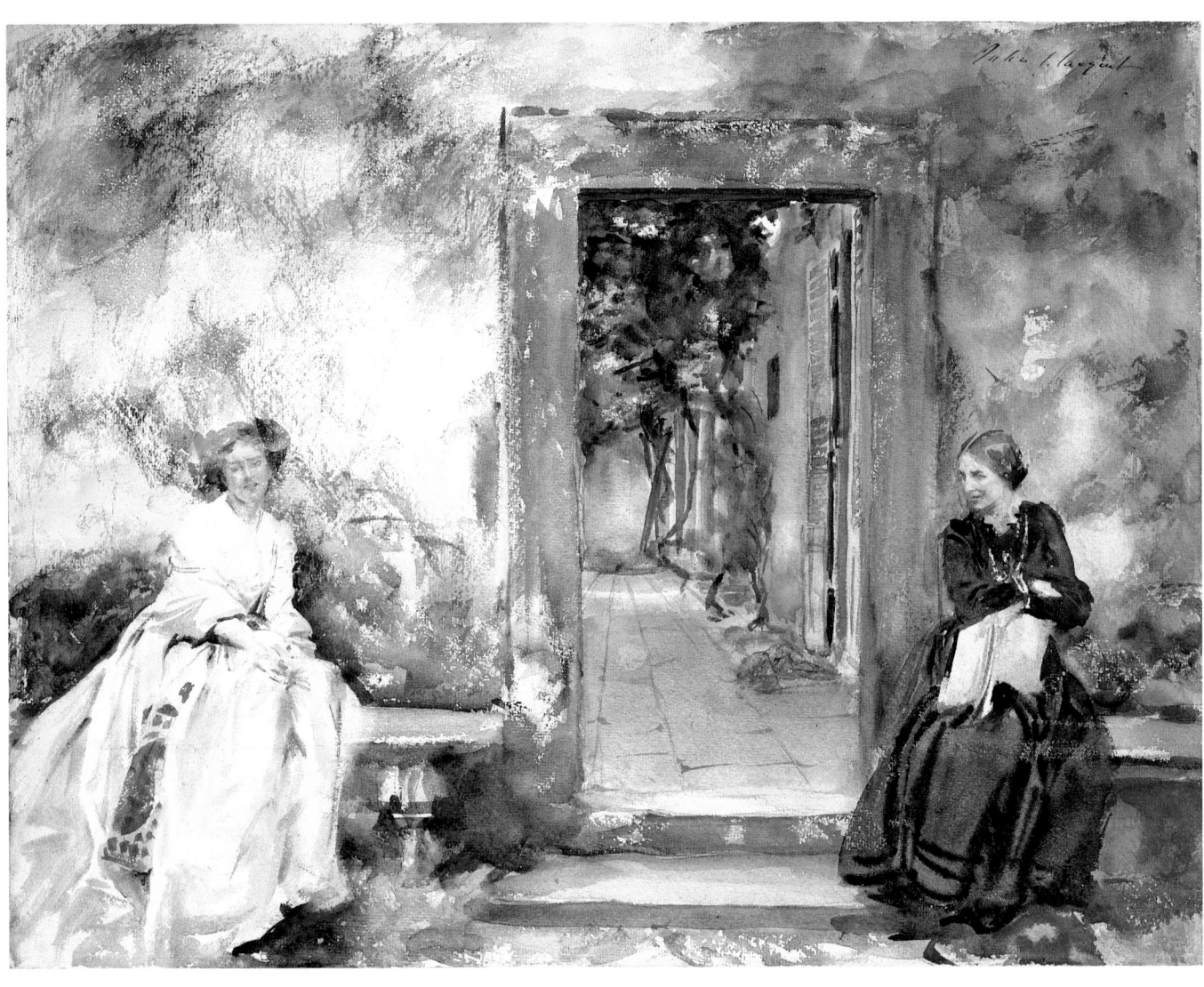

103.
LAURA COOMBS HILLS, *The Nymph*, 1915
Watercolor on ivory, 5¾ x 4½ in.
Museum of Fine Arts, Boston. Abbott Lawrence
Fund. 26.30

104.
LAURA COOMBS HILLS, *The Bride*, 1908
Watercolor on ivory, 5⅛ x 3⅛ in.
Museum of Fine Arts, Boston. Gift of Laura
Coombs Hills. 51.1928

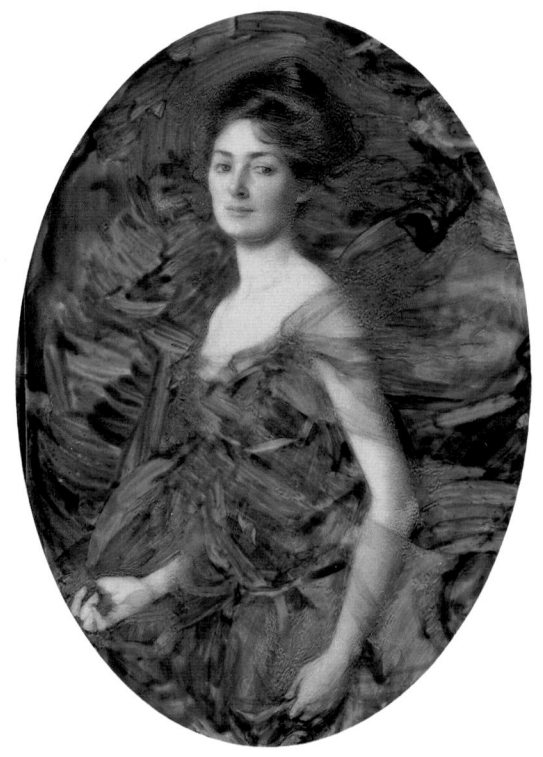

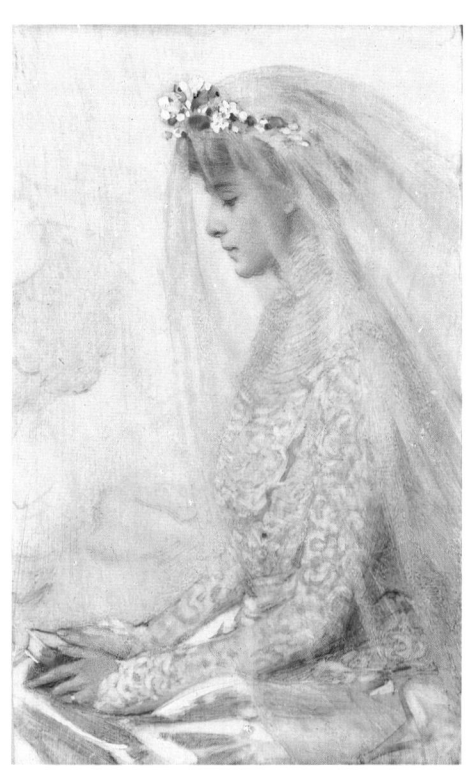

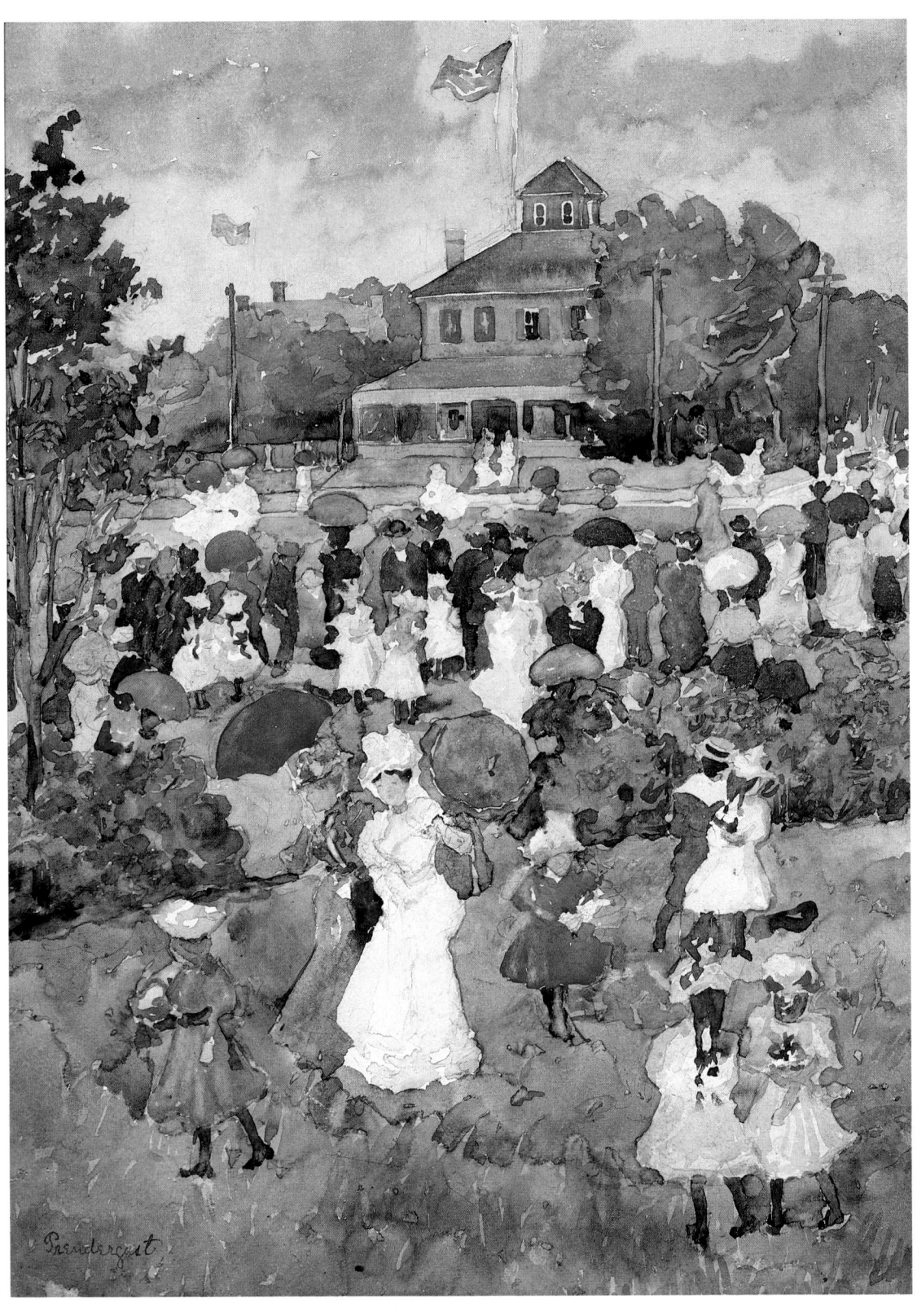

106.
Maurice Prendergast, *West Church, Boston,*
ca. 1900
Pencil, watercolor, and opaque white on paper,
10½ x 15¼ in.
Museum of Fine Arts, Boston.
The Hayden Collection. 58.1199

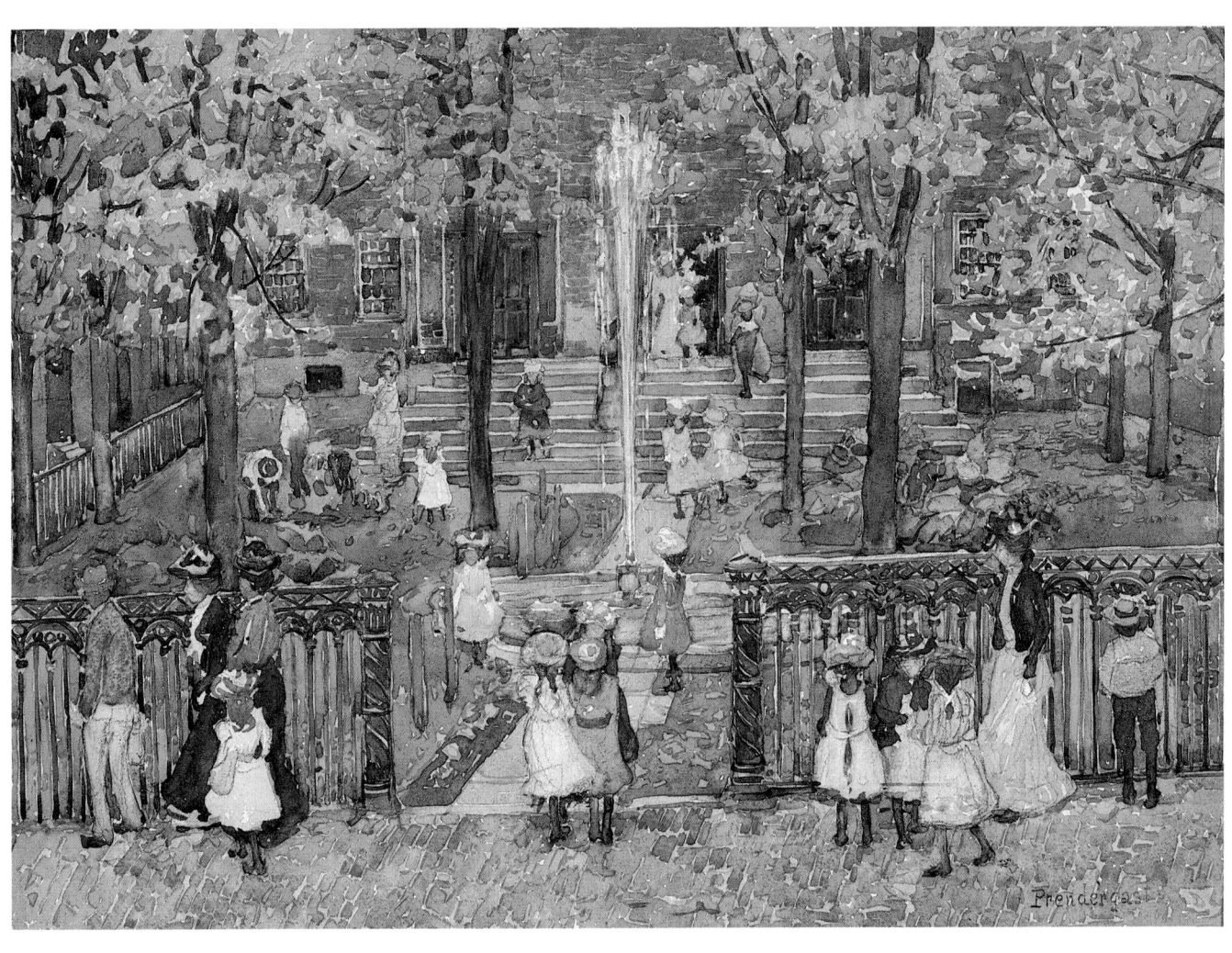

107.
MAURICE PRENDERGAST, *South Boston Pier*, 1896
Watercolor over graphite on paper,
18⅛ x 13¹⁵⁄₁₆ in.
Smith College Museum of Art, Northampton.
Purchased with funds from the Charles B. Hoyt
Fund. 1950:43

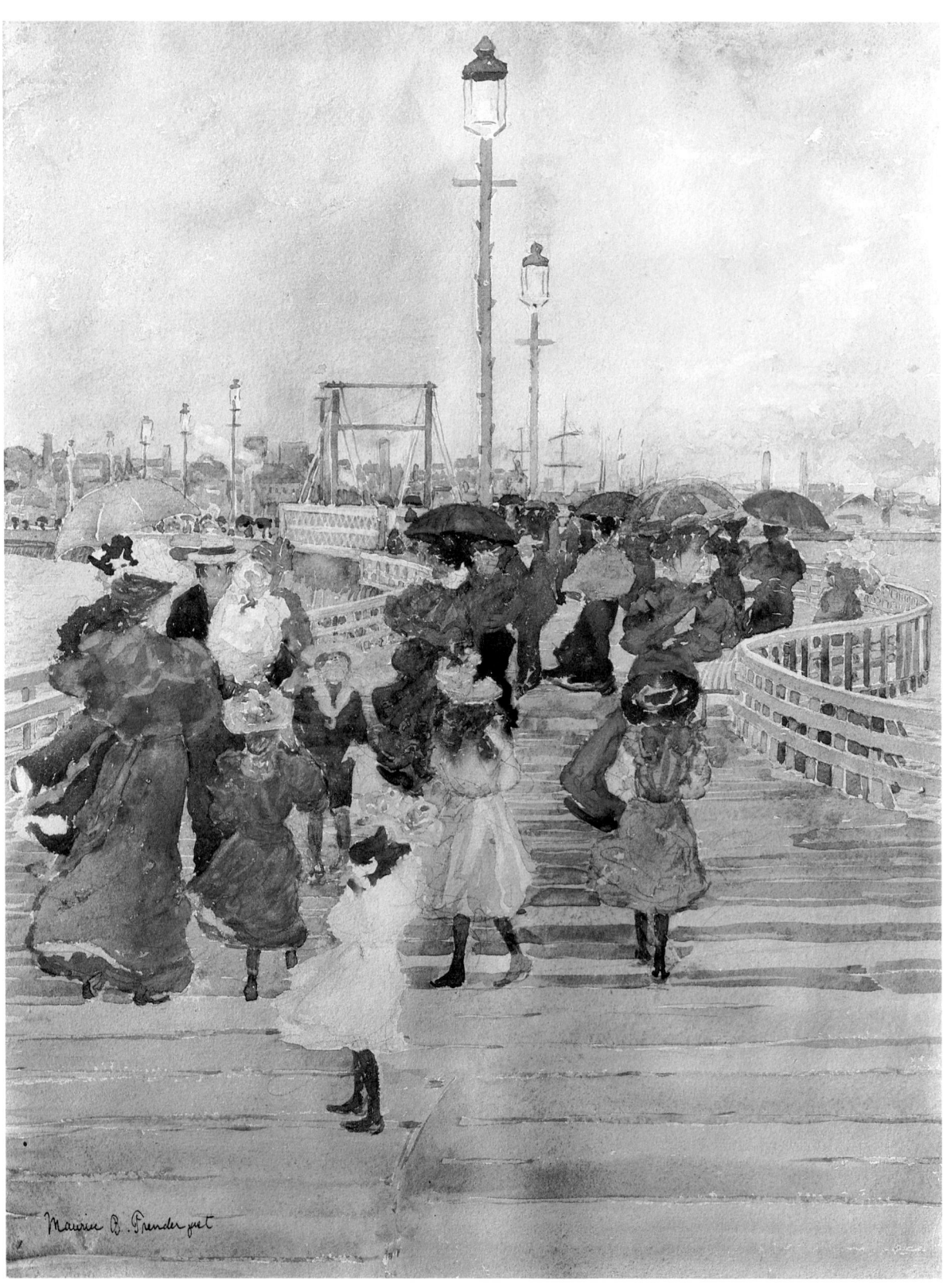

108.
EDWARD D. BOIT, *Winter, Commonwealth Avenue, Boston*, 1909
Watercolor on paper, 16 x 22½ in.
Private Collection

109.
CHILDE HASSAM, *Street in Portsmouth*, ca. 1915
Watercolor on paper, 15⅛ x 22 in.
The Metropolitan Museum of Art, New York.
Rogers Fund. 17.31.2

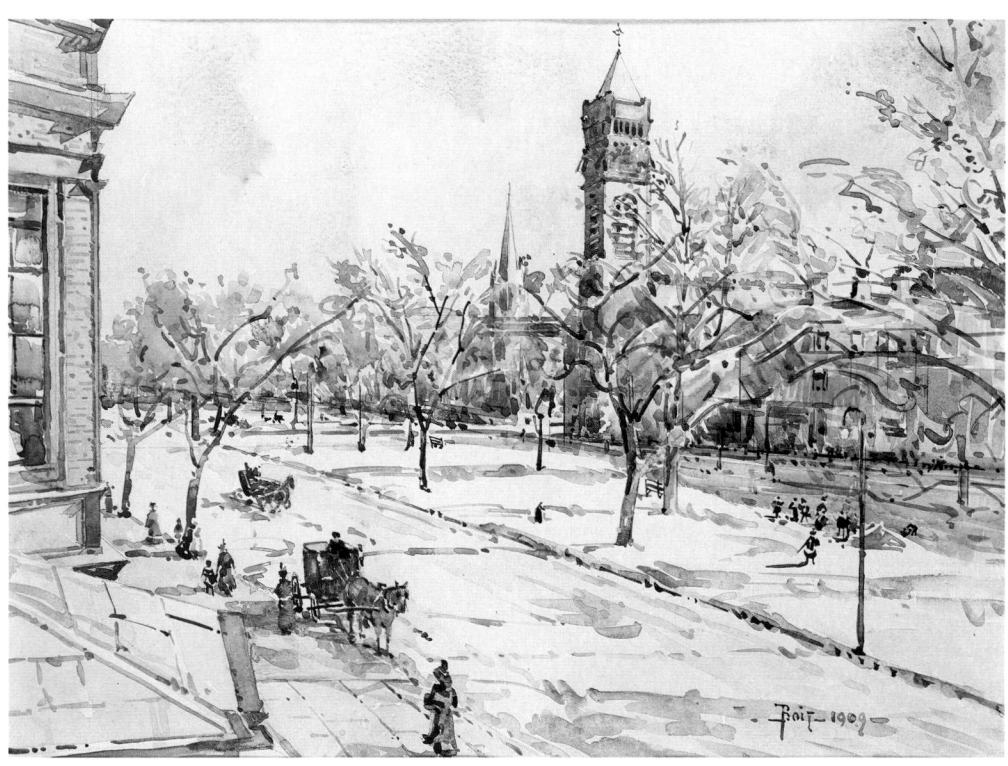

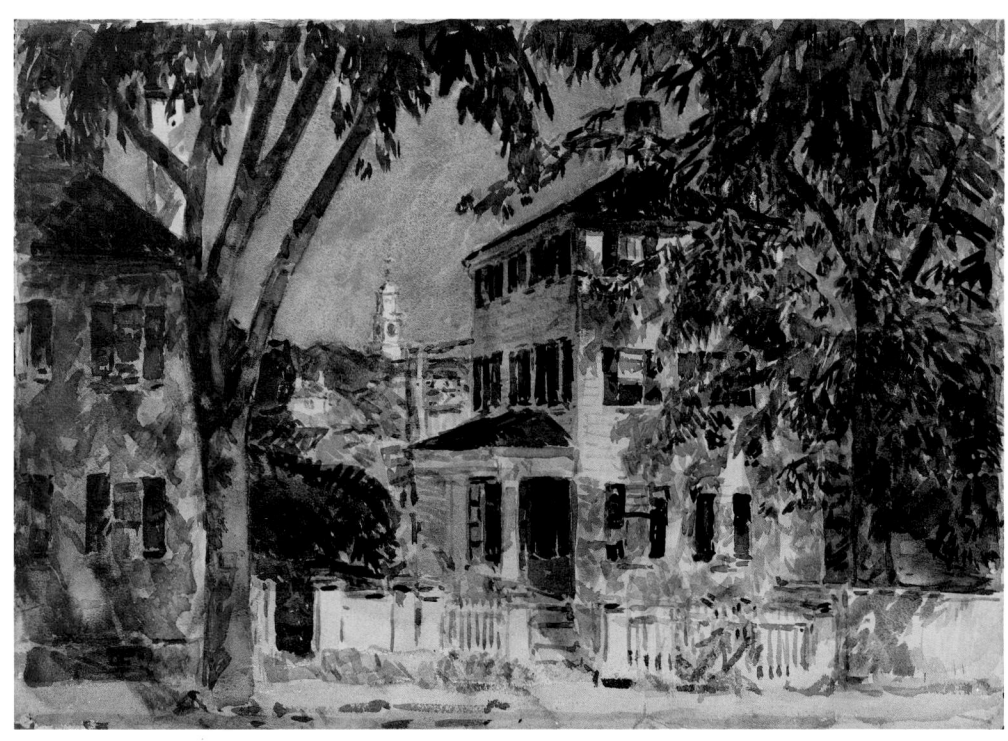

110.
DODGE MACKNIGHT, *Lilacs*, ca. 1915
Watercolor on paper, 17½ x 22 in.
Private Collection

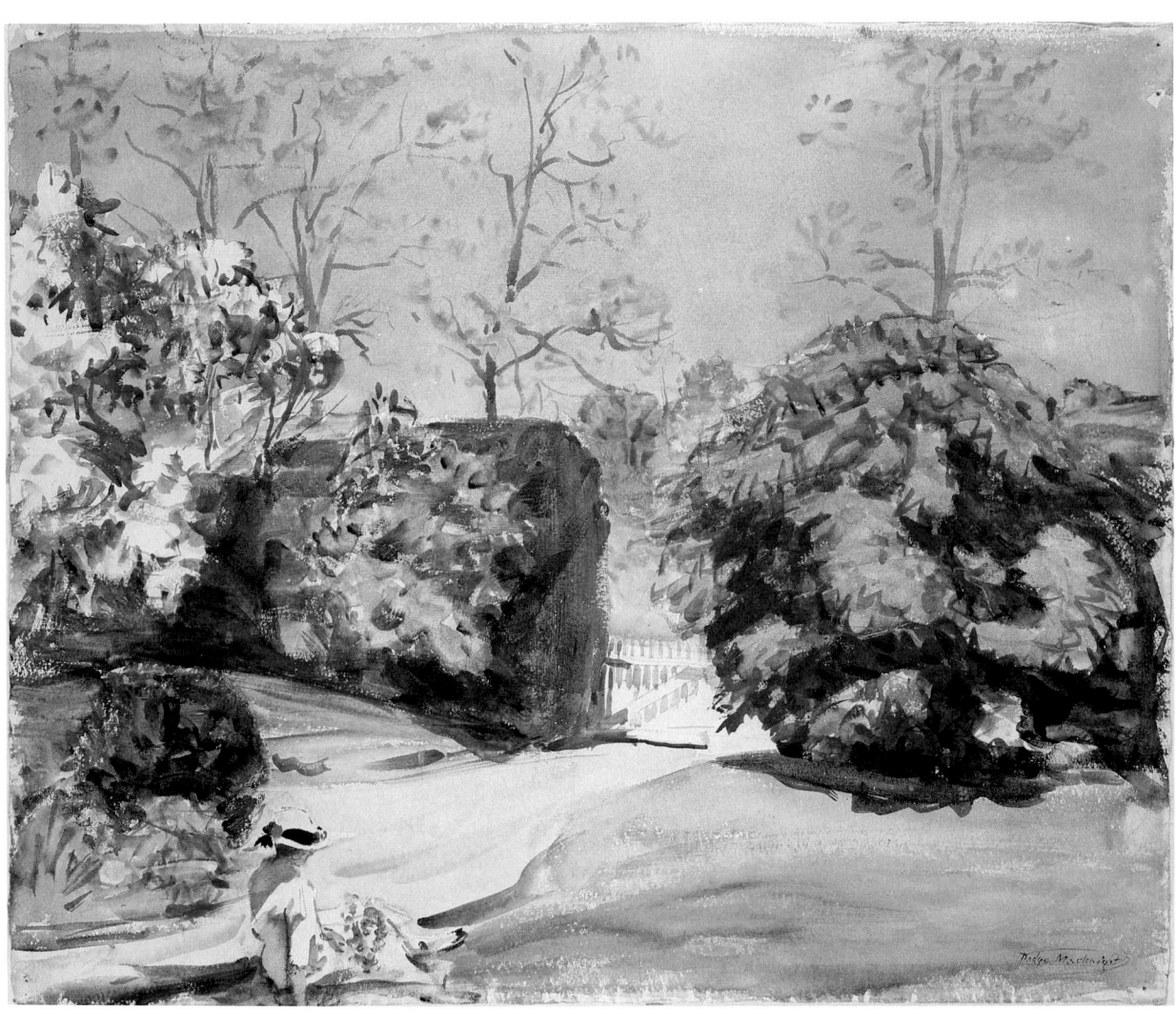

111.
DODGE MACKNIGHT, *Flags, Beacon St., Boston,*
1918
Watercolor on paper, 16½ x 23⅛ in.
Museum of Fine Arts, Boston. Bequest of Mrs.
Edward Jackson Holmes, Edward Jackson Holmes
Collection. 64.2114

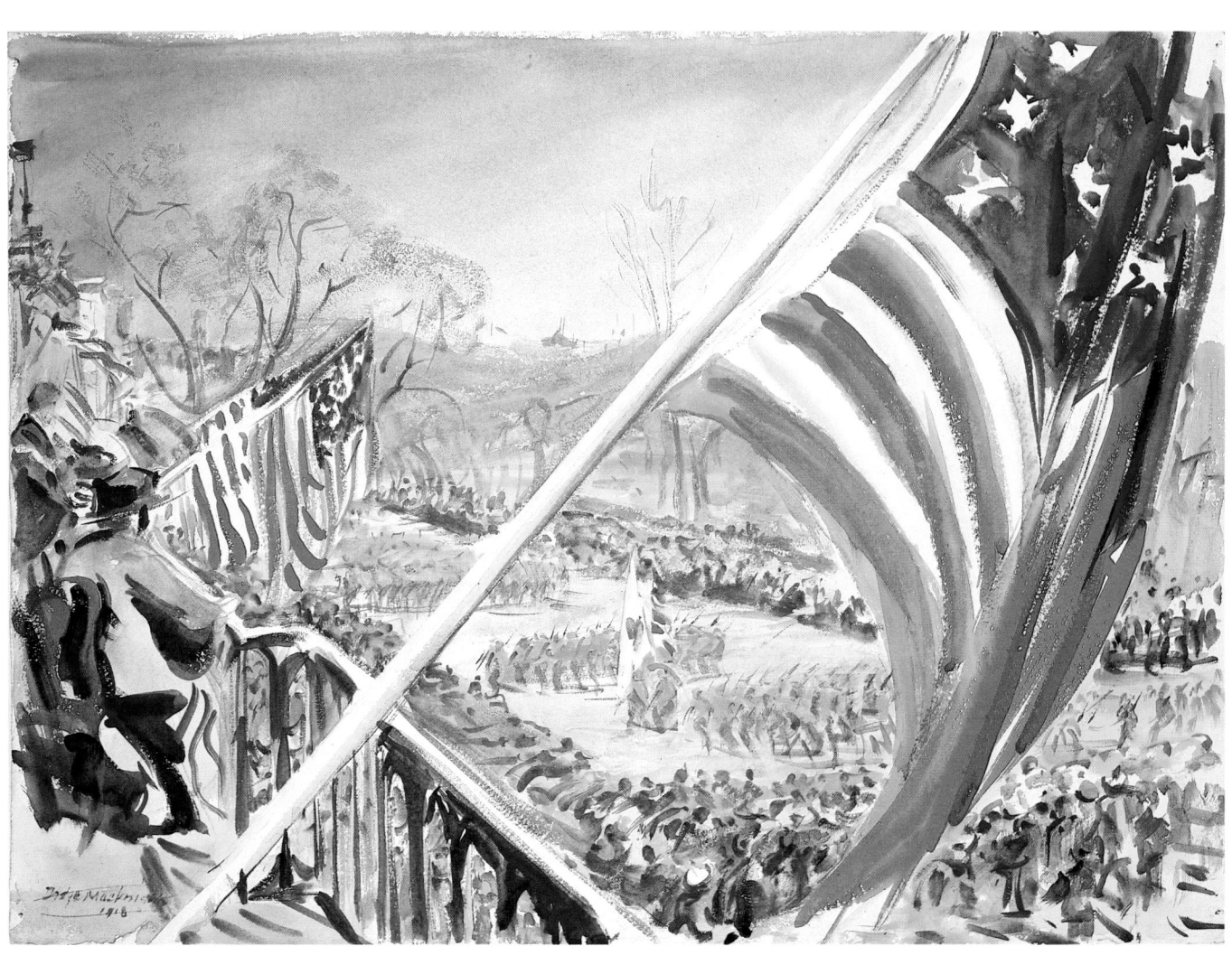

112.
JOHN WHORF, *Winter, North End, Boston*, 1936
Watercolor on paper, 15½ x 22 in.
Museum of Fine Arts, Boston. Gift of Mrs. Charles
Gaston Smith's Group. 37.60

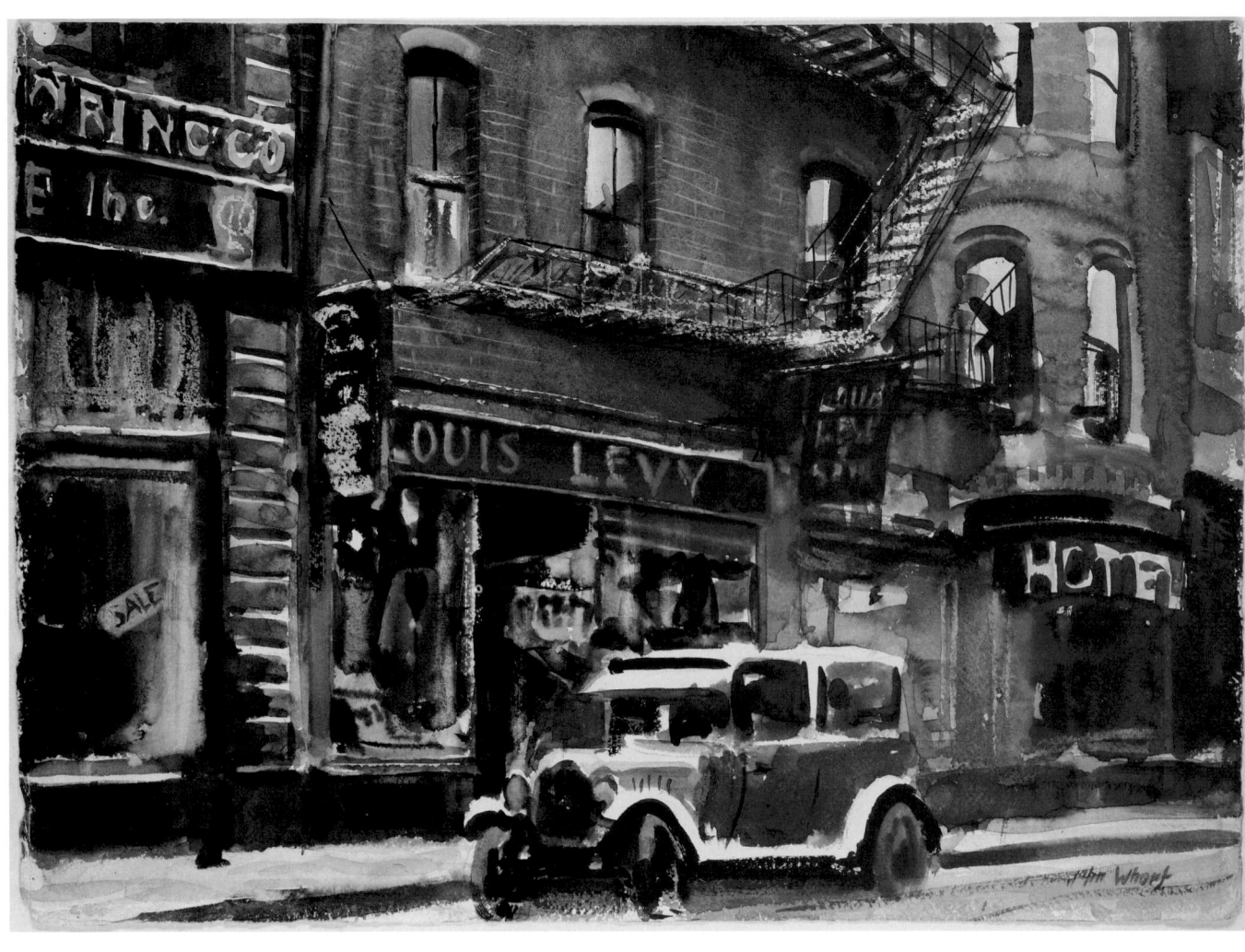

Index of Artists

Artists' Biographies

ERICA E. HIRSHLER

Note: Extensive use has been made of the clippings files of the Boston Public Library (Fine Arts Department), the Vose Archives, Dictionary of American Painters Project, the School of the Museum of Fine Arts, and the Curatorial Files of the Museum of Fine Arts, Boston. The following abbreviations have been used:

NAD – National Academy of Design, New York
Assoc. – Associate of the National Academy of Design
Acad. – Academician of the National Academy of Design
SAA – Society of American Artists, New York
AFA – American Federation of Arts, New York
National Cyclopedia – National Cyclopedia of American Biography (New York, 1931)
DAB – Dictionary of American Biography (New York, 1926-1936)

The term "national annuals" refers to the yearly exhibitions held at institutions such as the Corcoran Gallery of Art, the Pennsylvania Academy of the Fine Arts, the Carnegie Institute, and the Art Institute of Chicago.

A "plus" sign has been used following a date (for example, 1914 +) to indicate that an artist remained in residence for a number of years after the date indicated.

Boldface type is used for the names of artists in the exhibition.

HENRY HAMMOND AHL

Born 1869, East Hartford, Conn.; died 1953, Newbury, Mass.

Painter of portraits, genre scenes, and landscape; muralist. Trained at the Munich Academy and at the Ecole des Beaux Arts in Paris, Ahl first painted commissioned portraits and religious works, often used for church decoration. He moved to Boston in 1912, where he made thickly painted impressionist landscapes reminiscent of Enneking, which he exhibited at Doll and Richards and Vose.

Residences: Washington, D.C., New York, Boston; after 1920- Newbury

Studios: Corcoran Building, Washington, D.C.; by 1912- 12 Harcourt, Boston

Member: Copley Society, Boston Art Club; Salmagundi Club

References: Historical Society of Old Newbury; A. Everette James, *The Ahls* (Marietta, Ga.: Knoke Galleries, 1985)

MARION BOYD ALLEN

Born 1862, Boston; died 1941, Boston

Portrait, figure, and landscape painter. Although she had long shown an aptitude for drawing, marriage to William Augustus Allen and the care of her ailing mother delayed Allen's professional career. She was forty years old when she entered the Museum School in December 1902, encouraged by Connecticut landscapist Charles H. Davis, and she received her diploma in 1910. She won a prize in the Antique Class (1903), a medal in Benson's painting class (1907), then concentrated on portraiture during her studies with Tarbell. In 1910 she had a solo exhibition of portraits and genre scenes at the Copley Gallery, where she continued to exhibit regularly until about 1930.

Allen's portraits were well received and she won the Popular Prize of the Newport Art Association in 1919 with her *Anna Vaughan Hyatt* (cat. no. 18). In the early 1920s, she turned to landscape. She first traveled to the western United States and Canada in 1922 and thereafter made annual excursions to the Rocky Mountains, the Cascades in Washington, and Arizona. Her typically vertical compositions, realistic and richly painted, depicting carefully identified mountains and valleys, were exhibited regularly throughout the 1920s and 1930s at Vose. In the 1930s, Mrs. Allen made a series of portraits of the Arizona Indians, each exhibited with a frame designed and carved by native craftsmen.

Marion Allen also exhibited occasionally at the National Academy of Design, the Pennsylvania Academy of the Fine Arts, and the Art Institute of Chicago, and in Boston at Doll and Richards and the Boston Art Club.

Residence: 60 The Fenway, Boston

Studios: 673 Boylston St., 561 Boylston St., 477 Commonwealth Ave., Fenway Studios, Boston

Member: Copley Society, Boston Art Club, Guild of Boston Artists; Connecticut Academy, French Institute in the United States, National Association of Women Painters and Sculptors, N.Y.

Frank Benson, *Self-Portrait*, ca. 1899
Oil on canvas, 21 x 17 in.
National Academy of Design, New York

References: obituary, *New York Times*, December 29, 1941, p. 15

THOMAS ALLEN, JR.

Born 1849, St. Louis; died 1924, Worcester, Mass.

Painter of pastoral. Barbizon-inspired landscapes, often with cows, in oil and watercolor. After attending Washington University in St. Louis and studying art in Paris in 1871 and at the Düsseldorf Academy (graduating in 1877), Allen first exhibited at the National Academy in 1876; at the Paris Salon in 1882, 1887, and 1889; and in Boston at Vose Galleries and the Water Color Club and Copley Society. He had settled in Boston in 1883 and combined an extremely successful business career (becoming a millionaire) with painting. Allen was a trustee and president of the Museum of Fine Arts and a devoted committeeman for the Museum School.

Residences: 12 Commonwealth Ave., Boston; summers: Princeton, Mass.

Studio: in his home

Member: St. Botolph Club, Copley Society (vice-president), Boston Art Commission, Boston Society of Water Color Painters, Paint and Clay Club, Boston Art Club; Union Club, NAD (Assoc. 1884), SAA, Metropolitan Museum Fellow

References: Dorothy Allen Preston, daughter of the artist (personal communication); *Memorial Exhibition of the Works of Thomas Allen* (Boston: Museum of Fine Arts, 1926); National Cyclopedia

EDWARD HERBERT BARNARD

Born 1855, Belmont, Mass.; died 1909, Belmont

Painter of Barbizon-style landscapes and portraits. A pupil of John B. Johnston, Barnard attended the Museum School from 1877 to 1881 and then worked as a draftsman for stained-glass designs. He studied at the Académie Julian and exhibited portraits in the Salons of 1888 and 1889. With Charles H. Davis and Charles H. Hayden he painted in France; his works were shown at the Jordan Gallery, the South End Free Art Exhibitions, and at the Pennsylvania Academy annuals.

Residence: 603 Belmont St., Belmont

Studio: 23 Irvington St., Boston

Member: St. Botolph Club, Boston Water Color Club

References: MFA School files; David Sellin, *Americans in Brittany and Normandy, 1860-1910* (Phoenix: Phoenix Art Museum, 1982)

REYNOLDS BEAL

Born 1866, New York; died 1951, Rockport, Mass.

Painter of land- and seascapes in oil, watercolor, and crayon. Graduated from Cornell in 1887 with a degree in naval architecture, Beal then studied painting in 1891-1892 with William Merritt Chase at Shinnecock, Long Island. He spent an entire career depicting the harbor towns of the east and west coasts in bright, vivid colors, his quick and lively execution reminiscent of late Hassam and Goodwin. He exhibited locally at Vose (solo exhibition, 1916), the Boston Art Club, and at several New York Galleries.

Residences: 80 Middle St., Gloucester; Rockport, Mass.

Member: Boston Art Club; Salmagundi Club, Century Club, Lotos Club, National Arts Club, NAD (Assoc. 1909), New York Water Color Club, Society of Independent Artists (founder), New Society of American Artists (founder), American Water Color Society

References: *Reynolds Beal: Oils, Watercolors, Drawings, Etchings* (Washington, D.C.: Phillips Collection, 1971); *Reynolds Beal, A.N.A.* (Boston: Vose Galleries, 1983); Robert R. Preato, *Reynolds Beal: Impressions of an American Artist* (New York: Haig Tashjian Collection, 1984)

FRANK WESTON BENSON

Born 1862, Salem, Mass.; died 1951, Salem

Painter of figures in interiors and outdoors, portraits, landscape, still life; muralist; watercolorist, and etcher. In 1880, after his education at Salem High School, Benson entered the School of the Museum of Fine Arts, where he studied for three years under Otto Grundmann and Frederick Crowninshield. In 1883 he traveled to Paris and entered the Académie Julian, along with his classmate Edmund Tarbell. Benson toured extensively in Europe during the next two years. In 1885 he joined the staff of the Portland (Maine) School of Art and began to exhibit his oils (portraits and landscapes) actively in Boston and elsewhere. He married Ellen Perry Peirson, like himself from an old Salem family, in 1888 and was elected to the Society of American Artists the same year. He shared a Boston studio with Tarbell and in 1889 was hired to teach the antique class at the Museum School. From 1893 to 1912, when he resigned to become a visiting instructor, Benson taught painting at the School.

Benson's paintings of the late 1880s and early 1890s were chiefly interior portraits and figure studies that reveal his interest in design, especially evident in a mural cycle for the Library of Congress, completed in 1896. In 1898, when he became a founding member of The Ten American Painters, he had developed a mature impressionist style, creating the sunny, colorful outdoor paintings of children for which he is most admired. Benson regularly exhibited his work at the Boston Art Club, the St. Botolph Club, Chase's Gallery, and the Copley Society as well as the national annuals. By 1909, he could command $2,000 for a portrait; four years later Macbeth Gallery in New York became his agent. In 1914 the *Boston Herald* named Benson the "nation's most medaled painter," testifying to his critical and popular success. His paintings of young women, often dressed in white and silhouetted against a bright summer landscape, were heralded as ideals of American girlhood; his work sold so promptly that his dealers often wrote Benson to ask for pictures.

In the mid-teens, Benson began to develop a long-standing interest in sporting scenes, espe-

cially salmon fishing and duck hunting, painting them in oil and watercolor. He was an avid sportsman and hunter and the critics admired his accuracy in portraying birds in flight while still creating a beautiful composition. Benson became an active printmaker after 1912, participating in the revival of American etching and eventually producing over three hundred plates; he first exhibited them in 1915 at the Guild of Boston Artists. He translated several painted images into prints and he continued to exhibit both paintings and etchings until about 1946, when ill health forced him into inactivity.

Residences: Salem (46 Washington Square, 14 Chestnut St.); summers (1901 +)- North Haven, Maine

Studios: 1886- 2 Chestnut St., then 52 Forrest St., Salem; 1895 + - 20 St. Botolph; 1905 + - Fenway Studios, Boston

Member: Copley Society, Guild of Boston Artists (founding member and president, 1924-1937), Tavern Club; SAA (1888-1898); The Ten, NAD (Assoc. 1897, Acad. 1905), National Institute of Arts and Letters; trustee, Salem Public Library; trustee and honorary curator of ornithology, Peabody Museum, Salem

References: Benson Papers, Essex Institute, Salem, Mass.; William Howe Downes, "Frank W. Benson and his Work," *Brush and Pencil* 6, no. 4 (July 1900), pp. 145-157; Minna Smith, "The Work of Frank W. Benson," *International Studio* 35, no. 140 (October 1908), pp. xcix-xvi; Charles H. Caffin, "The Art of Frank W. Benson," *Harper's Monthly Magazine* (June 1909), pp. 105-114; Anna Seaton-Schmidt, "Frank W. Benson," *American Magazine of Art* 12, no. 11 (November 1921), pp. 365-372; John T. Ordeman, *Frank W. Benson, Master of the Sporting Print* (Brooklandville, Md.: privately printed by the author, 1983)

ALBION HARRIS BICKNELL

Born 1837, Turner, Maine; died 1915, Malden, Mass.

Painter of portraits, genre scenes, historical subjects; etcher and engraver. Following studies with Couture in Paris in the early 1850s and a trip to Venice, Bicknell returned to Boston in 1857 to exhibit his Italian scenes at the Athenaeum and Chase's Gallery (and in New York at the National Academy). His portraits included likenesses of Abraham Lincoln (now Malden Public Library) and Horace Mann (unlocated).

Residence: 4 Parker St., Malden

Studio: in his home

References: Frederic A. Sharf and John H. Wright, *William Morris Hunt and the Summer Art Colony at Magnolia, Massachusetts, 1876-1879* (Salem: Essex Institute, 1981)

JACOB BINDER

Born 1887, Kreslavke, Russia; died 1984, Boston

Painter of portraits, figure studies, and landscape. Binder studied in Vilna and Petrograd before leaving Russia in 1905. He settled in Boston in 1912 and began to teach drawing to the sisters of the Notre Dame Academy. Invited by Joseph DeCamp to share a studio, he was influenced by DeCamp's solid academic portraiture and luminous figure studies; Binder also considered himself a disciple of Sargent. With DeCamp's encouragement, he painted many portraits for academic and religious institutions and exhibited them at the Copley Gallery. He frequently auctioned his landscape paintings for charitable causes.

Residence: 63 Lawrence Ave., Roxbury

Studio: Fenway Studios, Boston

Member: Boston Art Club

References: Peter Barnicle, "Jacob Binder, Master Artist," *Sunday Herald*, May 23, 1965; Gregory J. Sorce, "Jacob Binder-Painter, Renaissance Man," *Boston Ledger*, week of July 6-12, 1979, p. 32; obituary, *Boston Globe*, August 30, 1984

DWIGHT BLANEY

Born 1865, Brookline, Mass.; died 1944, Boston

Gentleman painter of landscapes and seascapes in oil and watercolor. After attending Chauncy Hall School in Boston, Dwight Blaney worked in a tombstone-maker's shop, where his drawing experience gained him a position as a draftsman for Boston architects Peabody and Stearns. In 1892, he traveled to Europe to study and sketch and upon his return he exhibited his work at Walter Kimball and Company, Boston. In Europe he had met Edith Hill of Brookline, whose family owned the Eastern Steamship Company. After their marriage in 1893 Blaney was able to pursue an artistic career comfortably. He bought early American antiques, and in 1910 became a founding member of the Walpole Society, an important collectors' club. In 1895 he purchased Monet's *Haystacks at Giverny* from Durand-Ruel (1893; now in a private collection). The contents of his four houses – two on Mt. Vernon Street in Boston, one in Weston, Mass., and one on Ironbound Island, Maine – were sold at auction in Boston at Blaney's death.

Influenced by Impressionism, Blaney's style changed from tight, thinly drawn renderings in an architectural style to free, broadly painted landscapes with strong local color. His watercolor style was influenced by his friends Ross Turner, Hassam, and Sargent, while his paintings are almost divisionist, their small dabs of color similar to the work of Hassam. A popular man with interests in both arts and sciences, Blaney made his homes social centers for many local painters and naturalists. He exhibited paintings locally at the St. Botolph Club, Doll and Richards Galleries, the Guild of Boston Artists, and the Boston Water Color Club, as well as at the Carnegie Institute, the Corcoran Gallery, the Cincinnati Art Museum, the Pennsylvania Academy of the Fine Arts, the National Academy of Design, and the Society of American Artists. In 1915 he won a bronze medal

at the Panama-Pacific Exposition.

Residence: 82-84 Mt. Vernon St., Boston

Studios: Fenway Studios, Boston; Ironbound Island, Maine

Member: Tavern Club, St. Botolph Club, Guild of Boston Artists, Copley Society, Boston Society of Water Color Painters, Club of Odd Volumes; Walpole Society, Eastern Yacht Club, New York Water Color Club, Baltimore Water Color Club

References: *Important Residuary Sale at Auction: Early American Antiques and Works of Art, Estate of Mr. Dwight Blaney*, June 12, 13, 14, 15, 1945, Walter I. Nichols, Auctioneer, 7 Bosworth St., Boston, Mass.; Laurence C. Wroth, "The Fourth Decade," *The Walpole Society: Five Decades* (Portland, Maine, privately printed for the Walpole Society, 1960); Elizabeth Stillinger, "Dwight Blaney: Portrait of a Collector," *Antiques* 118, no. 4 (October 1980), pp. 748-757.

EDWARD DARLEY BOIT

Born 1840, Boston; died 1915, Rome

Gentleman painter of landscape and city views in oil and watercolor. Edward D. Boit attended Boston Latin School and Harvard College (Class of 1863). He married Mary Louisa Cushing, the wealthy daughter of China trade merchant John Peck Cushing, in 1864 and was admitted to the Massachusetts Bar in 1866. Two years later an exhibition of Corot landscapes at Soule and Ward Gallery in Boston rekindled an early love for art and in 1871 the Boits sold their Newport home and moved to Europe. Boit studied with Frederick Crowninshield in Rome and later with Thomas Couture and François-Louis Français in Paris. His first painting accepted at the Paris Salon of 1876 was a landscape entitled *Rocks, Beach and Ocean*. For the next eighteen years the Boits divided their time between Boston and Paris. In 1882 their four daughters (Florence, born 1868; Jane, 1870; Mary, 1874; and Julia, 1878) were immortalized in Sargent's group portrait (cat. no. 1). Three years after Mary Louisa's death in 1894, Boit moved to Brookline, Mass., and married Florence Little (1876-1902), the daughter of a Newport navy captain. After several winters the family returned to Europe, living in Paris and Rome and spending the summers at Cernitoio, their estate outside of Florence.

Boit's favorite medium was watercolor. He typically painted views of cities (including fine panoramas of Paris and New York), rural and seaside resorts, and countryside on both sides of the Atlantic. Boit wrote that he generally worked on the entire composition at once, first laying in the basic structure and then adding color to achieve the correct atmospheric effect; his use of small patches of bright color, crisply painted and almost abstract in their intensity, is at times reminiscent of Prendergast. He exhibited frequently at Doll and Richards, Williams and Everett's, and the St. Botolph Club in Boston (solo and group shows) and at Knoedler's in New York. After his joint exhibition with his friend Sargent at Knoedler's in 1912, the Museum of Fine Arts, Boston, pur-

chased the entire collection: forty-five watercolors by Sargent and thirty-eight by Boit.

Residences: 1864-1871- "The Rocks," Newport, R.I.; 1871-1897- Paris, Boston, Biarritz, Florence; 1897 + - Brookline, Mass.; 1902-1915- Paris, Rome, Florence

Studios: in his homes

Member: Somerset Club, Boston; Union Club, Paris; St. James Club, London

References: Edward D. Boit, "How I Came to Paint,"unpublished manuscript, Archives of American Art, Edward Darley Boit Papers; Robert Apthorp Boit, *Chronicles of the Boit Family and Their Descendants* (Boston: S.J. Parkhill and Co., 1915)

FREDERICK ANDREW BOSLEY

Born 1881, Lebanon, N.H.; died 1942, Concord, Mass.

Painter of portraits, figures, landscape, and still lifes. Bosley entered the Museum School in 1900 and became a favored pupil of Tarbell and Benson. He won the School's Sears Prize in 1904 and the Paige Traveling Scholarship in 1907, which allowed him two years of European study. Upon his return, he married Emily Sohier and taught at the Abbot Academy in 1909 and at the Groton School until 1912, when he succeeded Tarbell as painting instructor at the Museum School, a position he kept until 1931 (he resigned protesting changes in school policy that allowed for the introduction of modern art). Bosley was a regular exhibitor at the Guild of Boston Artists and the national annuals. His paintings, clearly indebted to Tarbell, Benson, and Abbott Thayer, combine flickering impressionist color with solidly drawn figures. Tarbell took up a subscription among local artists and presented Bosley's *Dreamer* to the Museum of Fine Arts in 1916.

Residences: 1908-1909- 198 Clarendon St., Boston; 1909 + - "Cherrycroft," Lincoln, Mass.; 1922 + - Concord, Mass.; summers after 1926- Piermont, N.H.

Studios: 1908-1909- 198 Clarendon St.; 1909-1918- Fenway Studios; 1918-1924- Guild of Boston Artists building; 1924 + - in his home

Member: Copley Society, St. Botolph Club, Guild of Boston Artists, Concord Art Association; NAD (Assoc. 1931), AFA

References: *National Cyclopedia;* E.S. Bosley, *Frederick A. Bosley, A.N.A.* (Boston: Vose Galleries, 1981 and 1984)

JOHN LESLIE BRECK

Born 1860, at sea near Guam; died 1899, Boston

Painter of landscape, figure studies, and interior scenes. The son of a Boston naval and merchant marine captain, Breck grew up in Newton, Mass. At age eighteen he studied art for three years under Alexander Straehuber at the Munich Academy, then spent the year of 1882 in Antwerp in the studio of history painter Charles Verlat. After three years of painting the Massachusetts landscape (1883-1886), Breck attended the Académie Julian in Paris for two years, spending his sum-

mers painting the French countryside. In 1887 he settled in Giverny, inspired by his friendship with Claude Monet and a romance with one of Monet's step-daughters. Breck first exhibited work at the Salon of 1888 and sent some of his paintings home to Boston, where they were shown in Lilla Cabot Perry's studio. In 1890 he held a solo exhibition of fifty works at the St. Botolph Club, some of these lent by Quincy Adams Shaw, a prominent Bostonian with a superlative collection of works by Jean-François Millet.

Based in Boston, Breck traveled to California in 1890, to Kent, England, in 1892 (exhibiting that year at the New English Art Club in London), and to Venice in 1896. He showed his work at the St. Botolph Club, Chase's Gallery, the Jordan Marsh Art Gallery, and in New York at the Society of American Artists and the National Academy of Design. He died of accidental asphyxiation in the St. Botolph Club.

Residence: 1883-1885- Newton, Mass.

Studio: Auburndale, Mass.

Member: St. Botolph Club

References: *Memorial Exhibition of Paintings by John Leslie Breck*, St. Botolph Club, May 1-18, 1899; Moussa M. Domit, *American Impressionist Paintings* (Washington, D.C.: National Gallery of Art, 1973); David Sellin, *Americans in Brittany and Normandy* (Phoenix: Phoenix Art Museum, 1982)

JOHN APPLETON BROWN
Born 1844, Newburyport, Mass.; died 1902, New York

Painter and pastelist of land- and seascapes. In 1865, at age twenty-one, J. Appleton Brown left his native Newburyport and took a studio in Boston; a year later he traveled to France for artistic training. He copied the old masters in the Louvre and began to study with landscape painter Emile Lambinet, but Brown's admiration for the works of Corot and Daubigny would have a more lasting influence on his style. He returned to Boston in 1868 and married landscapist Agnes Bartlett in 1874. That fall the two painters returned to France, where they worked at Ville d'Avray, Corot's home. Brown exhibited and sold two landscapes at the Salon of 1875. In June 1875 he returned to Boston and became friends with two slightly older Barbizon-inspired artists, J. Foxcroft Cole and William Morris Hunt. For the rest of his career, Brown concentrated on the New England landscape, except for a trip to England in 1886, where he associated with the American painters Frank Millet, John Singer Sargent, Edwin Austin Abbey, and Charles Parsons. He exhibited his work annually from 1879 to 1902 at Doll and Richards and became so consistently identified with soft, pastoral, springtime views that his contemporaries called him "Appleblossom Brown."

While the early work is in oil, Brown had, by the late 1870s, begun to experiment with different media, drawing illustrations for Lucy Larcom's *Landscape in American Poetry* in 1879 and working frequently in pastel in the mid-1880s.

Residences: 1870s- 145 Tremont St.; 1880-1890s- 6 Beacon St., Boston; summers: Newburyport

Studios: 1865-1886- Studio Building; 1868-?, Quincy Mansion, Park St.; 1870s- 145 Tremont St.; 1880-1890s- 6 Beacon St., Boston

Member: NAD (Assoc. 1896)

References: "American Painters: J. Appleton Brown," *Art Journal* 4 (1878), pp. 198-199; G.W. Sheldon, *American Painters* (New York: D. Appleton and Company, 1879); Frank T. Robinson, *Living New England Artists* (Boston: Samuel E. Cassino, 1888); William Howe Downes, "John Appleton Brown," *American Magazine of Art* 14, no. 8 (August 1923), pp. 436-439.

MARGARET FITZHUGH BROWNE
Born 1884, Boston; died 1972, Boston

Painter of portraits, figure studies, and still life. Browne studied at the Massachusetts Normal School with DeCamp and color theorist Albert Munsell in 1908; she took Benson's class in portraiture at the Museum School in 1911. Best known for her portraits for academic institutions, Browne published a book on portrait painting in 1933. A firm traditionalist, she served on the Advisory Board of Josephine Logan's Chicago-based Society for Sanity in Art.

Residence: 259 Beacon St., Boston; summers: "Cove House," Annisquam, Mass.

Studios: 1910+- 384 A Boylston St.; 1916+-194 Clarendon St.; 1930+- Fenway Studios, Boston

Member: Guild of Boston Artists, Copley Society, Boston Art Commission, Rockport Art Association, North Shore Arts Association, Connecticut Academy of Fine Arts, National Association of Women Artists

Reference: Margaret Fitzhugh Browne diaries, Boston Public Library

DENNIS MILLER BUNKER
Born 1861, New York; died 1890, Boston

Painter of landscape, figure studies, portraits, infrequent still lifes, mural studies in oil and occasional pastels. Dennis Bunker began his formal art training in New York in 1878, when he took classes at the National Academy of Design and then at the Art Students League, studying with Charles Melville Dewey and William Merritt Chase. Two years later he exhibited two landscapes at the National Academy, where he showed his work again in 1881, 1882, 1885, and 1890. He exhibited at the Boston Art Club for the first time in 1882. Later that year Bunker traveled to Paris, studying at the Académie Julian and at the Ecole des Beaux Arts under the instruction of Jean-Léon Gérôme. In France he met the American Abbott Thayer, whose *plein-air* landscape painting influenced his work. On his return to New York in 1885 Bunker won the third Hallgarten Prize at the National Academy for *Bohemian* (location unknown), and was elected to the Society of American Artists.

Bunker moved to Boston in the fall of 1885 to teach at the newly formed Cowles Art School. He

led classes in Life and Antique Drawing and Artistic Anatomy, and also offered instruction in Heads, Costume, and Composition. He had a solo exhibition at Noyes and Blakeslee; by 1887 he was busy with lucrative local portrait commissions and had entered the artistic circle of Isabella Stewart Gardner. Late in 1887, when John Singer Sargent was in Boston painting Mrs. Gardner's portrait, Bunker became his friend and admirer; like many of his Boston contemporaries, he followed Sargent's approach in painting portraits and idealized figurative pieces in a dark, academic manner indebted to Velázquez, while at the same time creating *plein-air* landscapes in a quick and high-keyed Impressionist style. Sargent painted a portrait sketch of Bunker in Boston in 1887 (Tavern Club, Boston) and also showed him painting outdoors in an impressionist work made when he and Bunker summered together in 1888 in England (Terra Museum of American Art).

None of Bunker's English work is known to survive, but the following year he created vibrant, brightly colored views of the countryside in Medfield, Mass. He moved to New York City in late 1889, settling in Washington Square near his Paris friend Charles A. Platt. In the summer of 1890 Bunker visited Cornish, New Hampshire, with Platt and returned to Boston to marry Eleanor Hardy, a well-to-do Bostonian. That fall he won a prize at the Chicago Art Institute for *The Mirror* (cat. no. 60) and received a mural commission for Whitelaw Reid's New York home. He died of pneumonia in December. The St. Botolph Club honored Bunker with a memorial exhibition in 1891.

Residences: 1882- 88 Broadway, New York; 1885-1889- 143 Dartmouth St., Boston; 1889-1890- 3 Washington Square, N.Y.

Studios: 1885-1889- 143 Dartmouth St., Boston; 1889-1890- 3 Washington Square, N.Y.

Member: St. Botolph Club, Tavern Club; SAA, NAD

References: Archives of American Art; correspondence with Isabella Stewart Gardner Museum; R.H. Ives Gammell, *Dennis Miller Bunker* (New York: Coward-McCann, 1953); Charles B. Ferguson, *Dennis Miller Bunker Rediscovered* (New Britain, Conn.: New Britain Museum of American Art, 1978)

HORACE ROBBINS BURDICK
Born 1844, East Killingly, Conn.; died 1942, Malden, Mass.

Painter of portraits and still lifes in oil, watercolor, and pastel. After studies at the Lowell Institute with William Rimmer (1864-1876) and at the Museum School with Otto Grundmann (1877), Burdick worked in the 1880s at the Forbes Lithographic Company; he was also a picture restorer, a copyist, and a commercial artist. His own paintings were chiefly still lifes of fruit and flowers and informal crayon portraits.

Residences: 1864 + - Chambers St.; 1871-1878-Clarendon Hill, West Roxbury; 1878- Hyde Park; then Jamaica Plain; 8 Chestnut St., Boston; Moun-

tain Avenue, Malden; Tremont Street, Malden; 16 Park Avenue, Malden

Studio: 1867 + - 12 West Street, Boston

Member: Boston Art Club, Penguin Club

Reference: "Burdick Memorial," *Malden Historical Society Register* 9 (1984)

ISAAC HENRY CALIGA
Born 1857, Auburn, Ind.; died 1944, Provincetown, Mass.

Painter of portraits, figure studies, and landscape in oil. Caliga came to Boston, worked as a store clerk, and painted in his spare time. Encouraged by his friend Marcus Waterman, a local painter, he studied for six years at the Munich Academy with Wilhelm von Lindenschmit in the late 1880s. He exhibited locally at Doll and Richards, Rowlands Galleries, the Society of Independent Artists, and Williams and Everett, as well as at the Chicago, St. Louis, and San Francisco Expositions.

Residences: 1892- 120 Boylston St., Boston; 1898-Danvers; 1901- Chestnut St., Salem; 1902-1921-1422 Federal St., Salem; 1921 + - Provincetown

Studios: 1890- 194 Tremont St.; 1892- 120 Boylston St.; 1898- Trinity Court; 1900 + - St. Botolph Studios, Boston

Member: Copley Society, Society of Independent Artists

Reference:
John Hanley Wright, *A Catalogue of a Loan Exhibition of Paintings by Essex County Artists, 1865-1910* (Salem: Essex Institute, 1971)

SÖREN EMIL CARLSEN
Born 1853, Copenhagen, Denmark; died 1932, New York

Painter of land- and seascapes, still lifes, and figure studies. Carlsen studied architecture at the Danish Royal Academy and came to the United States in 1872; after four years in Chicago and New York, he settled in Boston from 1876 to 1884. He exhibited at the St. Botolph Club and Vose Galleries, and painted Chardin-inspired still lifes on commission for Noyes and Blakeslee while in Paris from 1884-1886; no works from his Boston period are known. He then returned to New York to begin a career teaching at the National Academy of Design. His late seascapes were widely praised and often compared with Woodbury's.

Residences (Boston): 1876-1881- Studio Building; 1881- Somerville

Studios: 1876-1881- Studio Building; 1881- 48 Boylston St., Boston

Member: St. Botolph Club, Paint and Clay Club, Boston; NAD (Acad. 1906), National Institute of Arts and Letters, SAA, Salmagundi Club

References: Duncan Phillips, "Emil Carlsen," *International Studio* 61, no. 244 (June 1917), pp. cv-cx; F. Newlin Price, "Emil Carlsen- Painter, Teacher," *International Studio* 75, no. 302 (July 1922), pp. 300-308; *The Art of Emil Carlsen (1853-1932)* (San Francisco: Wortsman Rowe Galleries, 1975)

ADELAIDE COLE CHASE
Born 1868, Boston; died 1944, Gloucester, Mass.

Painter of portraits, especially of women and children, and decorative still lifes. Adelaide Cole Chase was the daughter of Belgian pianist Irma de Pelgrom and the Boston painter Joseph Foxcroft Cole. When she was about ten she was drawn several times by Winslow Homer, who was a friend of the family. Her first instructors were her father and his friend Frederic Porter Vinton, both of whom encouraged her to pursue a career in art. She married Boston architect William C. Chase in 1892 and entered the Museum School three years later, studying with Benson and Tarbell. In the mid-1890s she traveled to Paris and worked with Jean-Paul Laurens and Carolus-Duran.

Chase was a prolific artist who worked in a fluent style akin to that of Sargent and Cecilia Beaux. She exhibited her work at Doll and Richards, Rowlands Galleries, the Guild of Boston Artists, and the St. Botolph Club in Boston and in New York at the Society of American Artists, Durand-Ruel, and at the National Academy of Design, to which she was elected an associate in 1906. She also showed at the Pennsylvania Academy and in 1904 she won a silver medal for portraiture at the exposition in Saint Louis. Her first solo exhibition of portraits was held at Doll and Richards in 1901. In 1915 she won a silver medal for portraits at the San Francisco exposition.

Residence: 8 Marlborough St., Boston

Studios: 95 Beacon St.; 8 Marlborough St. (in her home), Boston; Annisquam

Member: NAD (Assoc. 1906), Art Students' Association, SAA (1903 +)

Reference: Clara Erskine Clement, *Women in the Fine Arts* (Boston: Houghton, Mifflin and Company, 1904)

WILLIAM WORCESTER CHURCHILL, JR.
Born 1858, Jamaica Plain, Mass.; died 1926, Washington, D.C.

Painter of figure studies, portraits, female nudes, and landscape in oil and pastel. Churchill entered the Museum School in 1877, studied in Paris with Bonnat (1878-1885), and established himself as a Boston portraitist in 1885. His figure studies are similar in style to Paxton's, depicting young women in carefully defined interiors. The Museum of Fine Arts acquired his painting *Leisure* in 1912.

Residence: St. Botolph Club, Boston

Studios: 1890s- Harcourt Studio Building; by 1910- Fenway Studios, Boston

Member: Copley Society, Boston Art Club, St. Botolph Club, Guild of Boston Artists

JOSEPH FOXCROFT COLE
Born 1837, Jay, Maine; died 1892, Winchester, Mass.

Landscape painter who specialized in cows and sheep, and seascapes; printmaker. Cole began his career in the mid-1850s as a draftsman at John Bufford's lithographic company, where he became a lifelong friend of fellow employee Winslow Homer. He also created landscape lithographs for Louis Prang from 1856 to 1860. In the latter year he studied oil painting in the Paris studio of Emile Lambinet, whose Normandy landscapes were admired by American artists and collectors. After a brief trip to Italy, Cole returned to Boston in 1864 and established his studio in the Mercantile Library Building, adjoining the rooms of William Morris Hunt and John LaFarge. His work met with immediate success – his paintings sold well and he achieved national attention when his work was favorably discussed by James Jackson Jarves in *The Art Idea* (1864).

In 1865, encouraged by William Morris Hunt, Cole returned to France to study with Charles Jacque, a Barbizon painter. He married Irma de Pelgrom, a Belgian pianist, in 1865 and for the next twelve years they divided their time between Boston and Paris. Cole exhibited at the Salon in 1866, 1867, 1873, 1874, and 1875, at the international exposition of 1867, and frequently at the Royal Academy in London. In 1877 Cole and his family settled in Winchester, Mass., where the artist created some of his finest Barbizon-inspired landscapes. These were often exhibited locally at the St. Botolph Club and at his dealer's, Doll and Richards. In the next few years Cole returned to the graphic arts, creating both lithographs and etchings of his work for Doll and Richards, Prang, and the *American Art Review*. In 1885, owing to his wife's ill health, he traveled to southern California, where he painted the local landscape; he returned to Boston soon after Irma's death.

Cole, like Hunt, helped bring the Barbizon style and a love of French painting to Boston not only through his own work but also by acting as an agent for local collectors, introducing to them the works of Corot and Daubigny.

Residences: Winchester, Mass.

Studios: 1864-1865- Mercantile Library Building; late 1860s- Studio Building; 1880-1881 + - 433 Washington St.; 1887-1892- Boylston St. Studios, Boston

Member: Paint and Clay Club, St. Botolph Club, Boston; Society of American Artists, N.Y.

References: Frank Robinson, *Living New England Artists* (Boston: Samuel E. Cassino, 1888); Frederic P. Vinton, essay in *Memorial Exhibition of the Works of J. Foxcroft Cole* (Boston: Museum of Fine Arts, 1893); Wayne Craven, "J. Foxcroft Cole (1837-1892): His Art, and the Introduction of French Painting to America," *American Art Journal* 13, no. 2 (Spring 1981), pp. 51-71.

ANSON KENT CROSS
Born 1862, Lawrence, Mass.; died 1944, St. Petersburg, Fla.

Landscape painter and teacher. Following his studies at the Massachusetts Normal School (until 1883) Cross taught drawing there from 1884 to 1927 and at the Museum School from 1890 to 1927. He taught drawing and painting at Columbia University and was the director and founder

(1926) of the Vision Training Art School (the Anson Kent Cross Art School) in Boothbay Harbor, Maine, and St. Petersburg, Florida. Cross published books on drawing in 1892, 1893, 1895, 1896, 1897, 1901, 1904, and 1922; among his twenty-three patents for drawing devices and other inventions was "The Vermeer Finder" (1912), a glass panel somewhat related to the camera lucida. He won a medal at the 1915 San Francisco Exposition for his training method.

Residences: Winthrop, Mass.; summers- Boothbay Harbor, Maine; then St. Petersburg, Florida

Studio: 1890s- 198 Dartmouth St.; by 1910- 6 Beacon St., Boston

Member: Boston Art Club, Copley Society; AFA

Reference: DAB

SALLY M. CROSS
Born 1874, Lawrence, Mass.; died 1950, East Weymouth, Mass.

Painter of portraits in oil, miniatures, and murals for steamships. Cross was a student of Joseph DeCamp (at the Cowles school), Philip Hale, and Ross Turner; she attended the Museum School in 1906-1907. Best known as a miniaturist in the circle of Laura Coombs Hills, she won a silver medal at the San Francisco Exposition (1915) and exhibited at the Guild of Boston Artists and the Society of Independent Artists. She later married artist Carroll Bill, and exhibited as Sally Cross Bill.

Residences: by 1914- Riverway Studios, Boston; 1930s-East Weymouth, Mass.

Studios: by 1900- Harcourt Studios; by 1910- 221 Columbus Ave.; by 1916 to 1930- Riverway Studios, Boston

Member: Guild of Boston Artists, Boston Water Color Club, Boston Art Club, North Shore Art Association, Pennsylvania Society of Miniature Painters, New York Water Color Club, National Association of Women Painters and Sculptors, American Society of Miniature Painters

FREDERICK CROWNINSHIELD
Born 1845, Boston; died 1918, Capri, Italy

Landscape painter, watercolorist, muralist, and maker of stained glass. A wealthy Harvard graduate (1866), Crowninshield studied drawing with Rimmer in 1866 and entered the Ecole des Beaux Arts in Paris in 1867, remaining in Europe until 1878. He taught drawing, painting, and anatomy at the Museum School from 1878 to 1885 and exhibited his watercolors at Doll and Richards. In 1882 he published a pamphlet on mural painting. Crowninshield moved to New York in 1886 and in 1900 became director of the American Academy in Rome.

Residences: 156 Beacon St., Boston; then New York and Europe; summers: Stockbridge, Mass.

Studio: at the Museum of Fine Arts, Boston

Member: National Society of Mural Painters, National Institute of Arts and Letters, NAD (Assoc. 1905)

References: DAB; obituary, *Boston Transcript*, September 14, 1918

HOWARD GARDINER CUSHING
Born 1869, Boston; died 1916, New York

Painter of stylish portraits, figure studies, landscape, and still lifes in oils; muralist. Cushing studied at Harvard (class of 1891) and took classes at the Cowles Art School with Dennis Bunker and in Paris at the Académie Julian (1891-1896). In 1904 he married Ethel Cochrane, the subject of much of his work (her cast-off clothes often outfitted Lilian Hale's models). His brightly colored paintings are often reminiscent of fashionable European artists Edmond Aman-Jean and Antonio de la Gandara. Cushing moved to New York in 1906. He exhibited regularly at the annuals and won a gold medal at the Pennsylvania Academy (1910) and at the Panama-Pacific Exposition (1915).

Residence: 168 Beacon St., Boston

Studio: in 1900- 252 Boylston St., Boston

Member: NAD (Assoc. 1906), SAA, National Society of Portrait Painters

JOSEPH RODEFER DECAMP
Born 1858, Cincinnati, Ohio; died 1923, Boca Grande, Fla.

Portrait and figure painter, landscapist. Joseph DeCamp began his study of art in 1873 at the McMicken School of Design in his native Cincinnati. Two years later he entered the Royal Academy in Munich, soon joining other Americans studying with Frank Duveneck. He followed Duveneck to Florence and Venice (where he met Whistler) and studied old master paintings. DeCamp returned in about 1883 to Cincinnati, where he shared a studio with Munich friend John Twachtman. After an unsuccessful exhibition there he moved to the East, first giving art classes in Philadelphia at the Art Club and then settling in Boston in 1884.

DeCamp felt strongly the importance of solid academic training for young artists and he soon became an influential teacher, first at Wellesley College (1884 to 1886), at the Museum School from 1885 to 1888, and at the Cowles Art School beginning in 1893 (where Paxton was a student). In 1903 he became an instructor in portraiture and painting from life at the Massachusetts Normal Art School, a post he held until his death; he taught occasionally at the New York Art Students' League (1900) and at the Pennsylvania Academy (1906).

DeCamp began exhibiting his work regularly at the Boston Art Club, the St. Botolph Club, and the Guild of Boston Artists; in New York he showed at the Society of American Artists and Macbeth Gallery; and he was a frequent contributor to the annuals in Worcester, Philadelphia, Washington D.C., and Chicago. Like his colleagues Benson and Tarbell, DeCamp became one of the founding members of The Ten American Painters in 1897 and he began to win the first of many medals he would receive. In 1904, DeCamp's studio was destroyed by fire and, in order to support his family, he offered to paint at a reduced rate the likenesses of his fellow St. Botolph Club members, thus beginning a successful career as a portraitist.

In 1909 he painted from life a full-length portrait of Theodore Roosevelt, presented by the president's classmates to the Harvard Union. In 1918 he painted some of the major participants at the negotiation of the Treaty of Versailles.

While DeCamp was famous for his dark, stern portraits of important businessmen and academics, he was equally renowned for figure pieces, scenes of women in interiors painted in a lighter, more freely brushed style. Even more loosely painted and with a brighter palette are DeCamp's landscapes, little-known today, painted during his summers in Maine (cat. no. 32).

Residences: 1888+- 110 Chauncy St.; then Medford, Mass.; summers, Gloucester, Mass., and Camden and North Haven, Maine

Studios: ?-1904- Harcourt Studio; 1905- 336 Boylston St.; 1906-1911- St. Botolph Studios; 1911-1915- Fenway Studios; 1916+- Riverway Studios, Boston; summers: Maine

Member: St. Botolph Club, Society of Arts and Crafts, Boston; The Ten American Painters, National Institute of Arts and Letters, NAD (Assoc. 1902), New York

References: DeCamp Papers, Archives of American Art; Arthur Hoeber, "DeCamp, A Master of Technique," *Arts and Decoration* 1 (April 1911), pp. 248-150; William Howe Downes, "Joseph DeCamp and his Work," *Art and Progress* 4, no. 6 (April 1913), pp. 919-925; Rose V.S. Berry, "Joseph DeCamp: Painter and Man," *American Magazine of Art* 14, no. 4 (April 1923), pp. 192-199; Lee W. Court, ed., *Joseph DeCamp: An Appreciation* (Boston: Massachusetts Normal Art School, 1925)

ARTHUR WESLEY DOW

Born 1857, Ipswich, Mass.; died 1922, New York

Important teacher and author of the influential art manual *Composition* (1899), popularizing Japanese design principles and color theory; painter of landscape and figures in oil, ink, woodcut, watercolor; book designer. Dow studied in Boston in 1881 with James M. Stone and from 1884 to 1886 in Paris at the Académie Julian, where he worked in a Barbizon style. He was introduced to Japanese prints in Boston by Ernest Fenollosa, curator of Japanese art at the Museum (later becoming his assistant). From 1895 to 1904 he taught at the Pratt Institute and from 1904 to 1922 at Columbia University (where Georgia O'Keeffe was his pupil in 1914 and 1916).

Residence: Ipswich

Studio: 1890s- Grundmann Studios, Boston

Member: Society of Independent Artists, AFA

References: Arthur Warren Johnson, "Arthur Wesley Dow: Historian- Artist- Teacher," *Publications of the Ipswich Historical Society* 28 (1934); Frederick C. Moffat, *Arthur Wesley Dow (1857-1922)* (Washington, D.C.: National Collection of Fine Arts, 1977); Nancy Finlay, *Artists of the Book in Boston: 1890-1910* (Cambridge, Mass.: Houghton Library, 1985)

JOHN JOSEPH ENNEKING

Born 1841, Minster, Ohio; died 1916, Hyde Park, Mass.

Prolific painter of landscape as well as occasional figures, interior scenes, and portraits. Enneking grew up in a German community in Ohio, entered St. Mary's College in Cincinnati in 1858, and served in the Union Army. He moved to Boston in 1864 and eventually pursued an art career after failing in business as a tinware tradesman. He studied with Edvard Schleich and Adolphe-Heinrich Lehr in Munich in 1872, then spent three years in Paris working mainly with Léon Bonnat and informally with Daubigny and Boudin. Enneking settled in Boston's suburb of Hyde Park in 1876 and the following year studied at the Museum School with William Rimmer. Williams and Everett mounted his first solo exhibition, mostly landscapes, in 1878, sold every work, and netted the artist $5,000. Secure in his Boston success, Enneking traveled to Paris, Holland, and Venice in the fall.

For the next twenty years Enneking made densely painted landscapes and figurative works in his Boston studio and in his summer house in North Newry, Maine. He painted indoors and often reworked his canvases again and again in a manner reminiscent of the work of George Fuller and Ralph Blakelock. Many of his woodland twilight scenes, in rich reds and browns, recall the Barbizon style, while the bright fresh colors of other landscapes use an impressionist palette. In 1898 the founders of The Ten considered Enneking as a candidate for their group, but membership was eventually restricted to members of the Academy and the Society of American Artists. He made a third trip to Europe in 1903, after auctioning 150 paintings. In 1907, Enneking completed a picture of the Christian Science Church for founder Mary Baker Eddy (now in the collection of the Mary Baker Eddy Museum, Brookline, Mass.), a commission for which he received $10,000. He was also an illustrator for *Brush and Pencil*, *Harper's*, and *Scribner's* magazines. Enneking exhibited regularly in Boston (Boston Art Club, MFA, Copley Gallery, Williams and Everett, Massachusetts Charitable Mechanics' Association), New York (NAD, American Art Galleries), Chicago, Washington D.C., Pittsburgh, and Philadelphia, and at the national expositions in Chicago, Buffalo, and San Francisco. In 1915 he received a gold medal for *December Thaw* at the Panama-Pacific Exposition (one of the only two New England landscapists who won medals) and heard the tribute of one thousand guests at a Boston testimonial dinner.

Residences: 1864-1916- 17 Webster Sq., Boston (Hyde Park)

Studios: 1878-?- Lawrence Building; 1880s- Studio Building (next door to his friend George Fuller), Boston; 1876-1916- in his home; summers: North Newry, Maine

Member: Boston Art Club, Paint and Clay Club, Twentieth Century Club

Gertrude Fiske, *Self-Portrait*, 1922
Oil on canvas, 30¼ x 25½ in.
National Academy of Design, New York

References: Frank T. Robinson, *Living New England Artists* (Boston: Samuel E. Cassino, 1888); *A Conversation with John J. Enneking* (Boston: Coming Age, 1899); Jessie B. Rittenhouse, "The Art of John J. Enneking," *Brush and Pencil* 10, no. 6 (September 1902), pp. 335-345; *Memorial Exhibition of Paintings by John J. Enneking*, Boston Art Club, March 2-17, 1917; William Baxter Closson, "The Art of John J. Enneking," *International Studio* 76, no. 305 (October 1922), pp. 3-6; *John J. Enneking, American Impressionist* (Brockton, Mass.: Brockton Art Center, 1974)

GERTRUDE FISKE

Born 1878, Boston; died 1961, Weston, Mass.

Painter of portraits, figures, landscape, and still lifes. Fiske trained under Benson, Tarbell, and Hale at the Museum School, completing her studies in 1912. She summered in Ogunquit, Maine, where she worked with Charles H. Woodbury, and was one of the founders of the Ogunquit Art Association in 1930. She won a silver medal at the Panama-Pacific Exposition for *The Shadow*, which was purchased by Mrs. E.H. Harriman, wife of the Union Pacific Railroad director. Fiske's first solo exhibition was in 1916 at the Guild of Boston Artists, followed soon afterward by one at the Rhode Island School of Design. She became an associate of the National Academy of Design in 1922 after winning the Shaw Prize in 1922 with *The Nude*; she received the Clark Prize in 1925 (*The Carpenter*) and the Proctor Prize in 1929 and was elected a full member in 1930. The Academy owns her 1916 portrait of Charles Woodbury.

While still within the traditions of Boston's academic style, Fiske's works vibrate with bright colors and active brushwork. Her portraits combine solidly modeled figures with flickering, decorative backgrounds. She used young women in her figure studies, but differed from her Boston colleagues in frequent portrayals of tradesmen and the elderly. Like Woodbury, she confronted the modern world in her landscapes and by 1920 amusement parks and automobiles appear regularly. Although she participated in many national exhibitions, her career was centered in Boston. She was the first woman named to the Massachusetts Art Commission in 1929 and she was one of the founders of the Guild of Boston Artists.

Residence: "Stadhaugh," Weston, Mass.

Studios: 198 Clarendon St. (Copley Hall Studios); 126 Dartmouth St.; Riverway Studios, Boston; summers: Ogunquit, Maine

Member: Guild of Boston Artists (founding member); NAD (Assoc. 1922, Acad. 1930), National Association of Women Painters and Sculptors, AFA, Concord Art Association (founder), Connecticut Academy of the Fine Arts, New Haven Painters and Clay Club and Fine Arts Association, Ogunquit Art Association

Reference: *Gertrude Fiske, Oil Paintings 1910-1928* (Robert Schoelkopf Gallery, New York, 1968)

GEORGE FULLER

Born 1822, Deerfield, Mass.; died 1884, Brookline, Mass.

Portrait and landscape painter. Fuller studied art in the 1840s in Boston, Albany, and New York, then worked as a farmer in Deerfield, painting only intermittently. He returned to an art career in Boston in 1876, after his farm failed. Much influenced by Hunt and the Barbizon school, he was acclaimed as a native genius, a peasant artist in the spirit of Millet and Corot. Fuller exhibited at the Art Club, Doll and Richards, Williams and Everett, and in New York at the National Academy and the Society of American Artists. Enneking especially admired his thick, crusty canvases and wrote about his method of painting in the 1886 memorial volume listed below.

Residences: Deerfield and Brookline, Mass.

Studios: 1876+ - 12 West St.; then 149A Tremont St., Boston; summers- Deerfield

Member: NAD (Assoc. 1857)

References: *George Fuller: His Life and Works*, ed. Josiah B. Millet (Boston: Houghton, Mifflin, and Company, 1886); William Howe Downes, "George Fuller's Pictures," *International Studio* 75, no. 302 (July 1922), pp. 265-273; DAB; Sarah Burns, "A Study of the Life and Poetic Vision of George Fuller," *American Art Journal* 1, no. 4 (Autumn 1981), pp. 11-37

ROBERT HALE IVES GAMMELL

Born 1893, Providence, R.I.; died 1981, Boston

Painter of highly finished portraits, figure studies, religious and literary compositions, landscape, and decorative murals. Scion of a Rhode Island banking family, Gammell graduated from the Groton School in 1911 and, encouraged by Joseph DeCamp, entered the Museum School to study with Hale, Benson, and Paxton. He attended the Académie Julian (1913-1914) and became a private student of Paxton (1915-1941). Gammell had hoped to make a career painting mural decorations; after auspicious beginnings, commissions waned during the Depression and he turned to religious and allegorical figure pictures. Outraged by developments in modern art, he emulated the look of nineteenth-century artists like Bouguereau; the Sargent murals at the Boston Public Library were a constant model for him and he took inspiration from their compositions, poses, and themes on many occasions. He exhibited frequently at the Guild of Boston Artists, Doll and Richards, and the Copley Society. In the 1930s, despite his nomination by Tarbell and Paxton, he was not elected to the National Academy and when membership was offered to him later, he declined.

Residences: 170 Hope Street, Providence; 112 Pinckney St.; 1940-1961- 8 Gloucester St.; 1961+ - 191 Commonwealth Ave., Boston; summers- Provincetown and Williamstown, Mass.

Studios: 162 Newbury St.; by 1922- 22 St. Botolph; in late 1930s- Fenway Studios, Boston

Member: Tavern Club, Guild of Boston Artists, St. Botolph Club, Providence Art Club, AFA

Reference: William A. Coles, *R.H. Ives Gammell* (New York: Hammer Galleries, 1985); Elizabeth Ives Hunter (personal communication)

IGNAZ MARCEL GAUGENGIGL

Born 1855, Passau, Bavaria; died 1932, Boston

Specialist in intimate genre scenes, studio interiors, portraits, and, rarely, landscapes and still lifes. Gaugengigl was Bavarian by birth, the son of a professor of oriental languages. He was trained in Munich at the Royal Academy beginning in 1874, working with Johann Raab and Wilhelm von Diez. Ludwig II, the "Mad King," commissioned him to paint *The Hanging Gardens of Semiramis*. After studies in Italy and Paris, Gaugengigl came to Boston by 1878. His meticulous, small-scale work and ornate historical subject matter soon earned him the nickname "the Meissonier of America." He exhibited work at the Guild of Boston Artists and the St. Botolph Club with great success, and in 1882 he entered into an exclusive agreement with the dealers John A. Lowell and Company.

Gaugengigl's small, highly finished genre scenes of French Revolutionary days were admired for their skill of execution, their decorative qualities, and their spirited humor. Reluctantly, he painted architectural decorations; the best known of these was a "merry cupid" over the stage of the Boston Museum, a local theater and exhibition hall. Gaugengigl was a highly regarded social figure and his connections brought him lucrative portrait commissions. Beginning in the mid-1890s, he depicted many prominent Bostonians in both small panel pictures and – occasionally – larger canvases. He was on the Council of the Museum School for over twenty years as well as one of the directors of the Guild of Boston Artists. He won a gold medal at the New Orleans exposition of 1884-1885 and a bronze medal from the Massachusetts Charitable Mechanics Association.

Residence: 5 Otis Place, Boston

Studio: in his home

Member: Tavern Club, Guild of Boston Artists, Copley Society (honorary), St. Botolph Club; NAD (Assoc. 1906), SAA (1895 +), New York Etching Club (honorary), Paint and Clay Club

References: William Howe Downes, ed., *I.M. Gaugengigl: His Life and Works* (Boston, John A. Lowell and Co., 1883); Frank T. Robinson, *Living New England Artists* (Boston: Samuel E. Cassino, 1888); Kuno Francke, "Ignaz Marcel Gaugengigl: Ein Münchener Maler in Neu-England," *Festschrift zum Sechzigsten Geburtstag von Paul Clemen, 31 Oktober 1926* (Bonn), pp. 503-507

WINCKWORTH ALLAN GAY

Born 1821, West Hingham, Mass; died 1910, West Hingham

Painter of landscapes in a Barbizon style. Gay studied drawing at West Point in 1838 and with Constant Troyon in Paris in 1847. He established himself in Boston in 1850 and was admired for his accurate simplicity in depicting the local landscape. In the late 1870s and 1880s he traveled to Egypt and the Far East, returning in 1884. He was the uncle of the Paris-based painter of interiors Walter Gay.

Residences: 1870-1875- 218 Tremont St., Boston; West Hingham, Mass.

Member: Somerset Club

References: DAB; Henry T. Tuckerman, *Book of the Artists* (New York: G.P. Putnam and Son, 1870)

VESPER LINCOLN GEORGE

Born 1865, Boston; died 1934, Boston

Painter of portraits, landscapes in oil and watercolor, and decorative paintings and murals for public buildings and private homes. George trained at the Art Students' League in New York (1888-1889) and the Académie Julian (1889-1892). He taught design at the Lowell (Mass.) Textile School (1897-1906) and at the Massachusetts Normal School (1901-1927), where he was head of the design department. In 1924, George founded his own school at 131 Columbus Avenue. Extant until 1983, the Vesper George School of Art offered classes in both fine arts and design.

Residences: by 1934- 116 Charles St., Boston; summers- West Gloucester, Mass.

Studios: 12 West St.; by 1910- 144 Boylston St.; by 1916- 248 Boylston; 384 Boylston; by 1922- 221 Columbus Avenue; by 1934- 755 Boylston, Boston

Member: Boston Art Club, North Shore Art Association, New York Architectural League

Reference: obituary, *New York Times*, May 11, 1934

ARTHUR CLIFTON GOODWIN

Born 1864, Portsmouth, N.H.; died 1929, Boston

Painter and pastelist, known for his views of Boston and New York. In about 1900, after trying his luck at various businesses and earning a reputation as a dandy and a dancer in Chelsea, Mass., Arthur Goodwin began his career as a painter. He met artist Louis Kronberg and began to teach himself drawing and painting in Kronberg's studio. Goodwin's work was first exhibited in 1902 at the Copley Gallery, where he showed two pastels. In 1904 he had a solo exhibition of street scenes at Doll and Richards. In the 1910s, he began to paint figure studies in oil and pastel. Goodwin corresponded regularly with New York dealer William Macbeth but apparently did not sell his work there.

In 1921 Goodwin married Jean Allen Safford and took a trip to the Canadian estate of Boston collector John Spaulding, who left eight Goodwins to the Museum of Fine Arts. He spent the next seven years working in New York, both in the city and on a farm in Old Chatham, where Mrs. Goodwin raised dogs. In early 1929, Goodwin returned to Boston, settled at 134 Staniford Street, and began to plan a trip to Paris. On the day of a late spring heat wave Goodwin was found in his home with his steamer ticket nearby, dead from overconsumption of the alcohol he was prone to abuse.

Goodwin exhibited three cityscapes in the 1915 San Francisco exposition; he also showed his work at the Pennsylvania Academy of the Fine Arts, the Brooklyn Museum, Milch Galleries in New York,

the Carnegie Institute, the Art Institute of Chicago, and the National Academy of Design. In Boston he exhibited at the St. Botolph and Union Clubs, Doll and Richards, Vose Galleries, Copley Gallery, and the Guild of Boston Artists.

Residences: ca. 1905-1915- 35 Common St., Boston; 1921-1928- Old Chatham, N.Y.; 1929- 134 Staniford St., Boston

Studios: 35 Common Street; Boylston St.; in care of Louis Kronberg, 3 Winter St., Boston; 41 Washington Square, N.Y.

Member: Guild of Boston Artists (from 1914), Boston Society of Water Color Painters

References: Lionello Venturi, *Arthur Clifton Goodwin* (Andover, Mass.: Addison Gallery of American Art, 1946); Sandra Emerson, Lucretia H. Giese, and Laura C. Luckey, *A.C. Goodwin: 1864-1929* (Boston: Museum of Fine Arts, 1974)

ABBOTT FULLER GRAVES
Born 1859, Weymouth, Mass.; died 1936, Kennebunkport, Maine

Specialist in garden scenes and floral still life in a loose, painterly style analogous to Enneking's approach to landscape. A self-taught painter and a former horticulturalist, Graves was one of America's best-known flower painters; he first exhibited his work in the early 1880s. In 1884 he studied with flower painter Georges Jeannin in Paris, returning to teach at Cowles from 1885 to 1887; he then spent three years at the Académie Julian. He settled in Kennebunkport, Maine, and exhibited his bright, freely brushed views of colonial gardens at the Boston Art Club and Vose and Copley galleries, and in New York at Babcock Galleries.

Residences: 1892- 335 Columbus Ave.; 1898-206 Huntington Ave., Boston; several houses in Kennebunkport; by 1906- "Westlook," Kennebunkport

Studios: 1881- Studio Building; 1892- 335 Columbus Ave.; 1898- 110 Tremont St., Boston

Member: Boston Art Club, Copley Society, Paint and Clay Club, Boston Water Color Society, Boston Art Students' Association; NAD (Assoc. 1926), Salmagundi Club, Allied American Artists, National Arts Club, Artists Fund Society, Paris American Art Association

References: Frank Robinson, *Living New England Artists* (Boston: Samuel E. Cassino, 1888); George Alfred Williams, "A Painter of Colorful Gardens," *International Studio* 76, no. 308 (January 1923), pp. 304-309; Joyce Butler, *Abbott Fuller Graves* (Kennebunk, Maine: Brick Store Museum, 1979)

CHARLES EDWIN LEWIS GREEN
Born 1844, Lynn, Mass.; died 1915, Lynn

Landscape painter and specialist in beach and marine views. Essentially self-taught, Green studied only informally with local Lynn artists in the 1870s and gave up a business career for painting in 1881. His first exhibition in Boston was at the Art Club in 1882 (where he exhibited annually until 1908) and his first solo exhibition was at

Chase's in 1887. He traveled to Europe in 1889-1890, visiting Holland and the Cornish art community of Newlyn. He returned to record the New England coast in luminous colors; the Museum of Fine Arts owns five of his landscapes.

Residences: 1883-1887- 14 Chatham St.; 1888-1890- 22 Chatham St.; 1890-1895- 1 Fayette St.; 1895-1915- 15 Basset St., Lynn

Studios: by 1883- 28 School St., Boston; 1885-1886- 33 School St.; 1887-1889- 22 School St.; 1891-1895- 34 School St.; 1895-1903- 12 West St.; 1903-1907-168 Tremont St., Boston; 1907-1915- in his Lynn home

Member: Boston Art Club, Paint and Clay Club

Reference: Frederic Alan Sharf and John Hardy Wright, *C.E.L. Green* (Salem: Essex Institute, 1980)

EMIL OTTO GRUNDMANN
Born 1844, Dresden (Germany); died 1890, Dresden

Painter of portraits and figure studies; popular and respected teacher. Trained at the Dresden Academy (1861-1864), Grundmann then studied in Antwerp and Düsseldorf (1873), where he painted dark, sober genre scenes of Dutch fishermen and a large mural for the Cloth Hall at Ypres (destroyed in World War I). He came to the United States in 1876 as the first instructor at the Museum School, hired on the recommendation of Frank Millet, whom he had met as a student in Antwerp.

Residence: 9 Harrison Ave., Boston

Studio: in his home

Reference: "The Art Museum School's Great Loss," *Art Amateur* 23, no. 5 (October 1890), p. 83

ELLEN DAY HALE
Born 1855, Worcester, Mass.; died 1940, Brookline, Mass.

Painter of figures, portraits, landscapes, still lifes; muralist; etcher. Ellen Day Hale was one of nine children born to Unitarian clergyman, orator, and novelist Edward Everett Hale and his wife Emily Baldwin Perkins Hale. Like her younger brother Philip, "Nelly" Hale showed an early interest in drawing, perhaps encouraged by her aunt, watercolorist Susan Hale (1838-1910). She attended William Rimmer's artistic anatomy class in 1873 and William Morris Hunt's painting classes the following year (1874-1877). Two years after her brief studies at the Pennsylvania Academy of the Fine Arts, in the spring terms of 1878 and 1879, Hale made a nine-month trip to Europe with Helen Knowlton, Hunt's principal teaching aide, visiting Holland, France, and Italy; she then studied briefly at the Académie Colarossi and in the atelier of Carolus-Duran. Hale returned to Paris to the Académie Julian for six months in 1885; she exhibited at the Salon and sent home articles on the Paris art scene that were published in the *Boston Traveler*. In the late 1880s she taught art classes at the Marlborough Street School (a private school) in Boston and supplemented her income by painting portraits.

In contrast to most women painters, Hale was admired for the power of her execution, for her pictures were broadly painted and strong in color. She exhibited regularly at the Pennsylvania Academy annuals and in Boston at the Charitable Mechanics' Association, Williams and Everett, the Art Club, and the St. Botolph Club, as well as in Washington, D.C., where she made her home after 1904.

Hale was an active etcher, frequently showing her work in this medium. She made her first print in France in 1885 under the direction of Gabrielle Clements, who became her close friend. Sharing the Folly Cove Studio, the two women (and occasionally also Lilian Westcott Hale) experimented with etching techniques and produced small picturesque landscapes and figure studies. Hale traveled widely, visiting California twice in 1891 (returning to Santa Barbara to live in 1892-1893), Washington, D.C. (where she acted as hostess for her father, then chaplain to the U.S. Senate), and Syria and Palestine (1929).

Residences: 1904 + - Washington, D.C.; summers: "The Thickets," Folly Cove, Rockport, Mass.

Studios: 1904 + - Washington, D.C.; in her homes

Member: Boston Art Club, North Shore Art Association; Charleston Etching Club, Society of Washington Artists, Washington Watercolor Club, Washington Art Club, Chicago Society of Etchers

References: Hale Papers, Archives of American Art; Hale Family Papers, The Sophia Smith Collection, Smith College; Martha J. Hoppin, "Women Artists in Boston, 1870-1900: The Pupils of William Morris Hunt," *American Art Journal* 13, no. 1 (Winter 1981), pp. 17-46; Alanna Chesebro, *Ellen Day Hale* (New York: Richard York Gallery, 1981)

LILIAN WESTCOTT HALE

Born 1881, Hartford, Conn.; died 1963, St. Paul, Minn.

Portrait and figure painter, especially admired for her finished charcoal drawings. Lilian Westcott was one of three daughters of Edward Gardiner Westcott, a Hartford gun merchant and inventor of gun sights. About 1897, she attended William Merritt Chase's summer class at Shinnecock, New York. She won a scholarship to study at the Boston Museum School and entered Tarbell's painting class in 1899, skipping the school's preliminary courses. At a Hartford cousin's in 1900 Lilian Westcott met Philip Hale, a drawing instructor at the Museum School; the two were married by Hale's father on June 11, 1901. They spent their honeymoon painting at Niagara Falls and exhibited the results together at the Pennsylvania Academy annual the following January, Lilian's exhibition debut. She graduated from the School in 1904 and held her first solo exhibition of eighteen drawings at Rowlands Galleries in Boston in 1908. After daughter Nancy's birth in 1909, the Hales moved to Dedham, Mass., where Lilian maintained her studio.

Lilian Hale exhibited widely and regularly in national annual exhibitions, in Boston at the Guild of Boston Artists, St. Botolph Club, Copley Society, Rowlands Galleries, and the Boston Art Club; and in New York at Arlington Galleries and Grand Central Galleries. She won critical acclaim for her unique and delicate charcoal style, with its thin, precise, vertical strokes. Hale's paintings show the same tight control and refined technique; in both media her portraits emphasize the faces and hands of her sitters, the landscapes and figure studies as carefully arranged as still life. Her first prize came in 1910, a bronze medal in the Buenos Aires International Exhibition; she won many such awards, including a gold medal for painting and a medal of honor for drawing in the 1915 Panama-Pacific Exposition, the Pennsylvania Academy's Beck Prize in 1923, and the National Academy's Shaw and Altman Prizes (1924 and 1927).

Mrs. Hale continued to exhibit her work after her husband's death in 1931, although with decreasing frequency. In 1955 she moved to Charlottesville, Virginia, to be nearer to her daughter. She traveled to Italy for the first time in 1963 and died soon after her return.

Residences: ?-1909- Fenway Studios, Boston; 1909-1955-Sandy Valley Road, 213 Highland St., Dedham; 1955 + - Charlottesville, Va.

Studios: to 1909- 210-211 Fenway Studios, in her home at Sandy Valley Road, Dedham and 213 Highland Street, Dedham; summers- Folly Cove, Rockport, Mass.

Member: Copley Society, Guild of Boston Artists (founding member), Concord Art Association; National Association of Portrait Painters, AFA, NAD (Assoc. 1927; Acad. 1931), Connecticut Academy of Fine Arts

References: Hale Papers, Archives of American Art; Hale Family Papers, The Sophia Smith Collection, Smith College; Rose V.S. Berry, "Lilian Westcott Hale – Her Art," *American Magazine of Art* 18, no. 2 (February 1927), pp. 59-70; Nancy Hale, *The Life in the Studio* (Boston: Little, Brown, 1969)

PHILIP LESLIE HALE

Born 1865, Boston; died 1931, Boston

Portrait, figure, and landscape specialist. Hale was the fifth of nine children born to Edward Everett Hale and his wife Emily. His siblings included painter Ellen Day Hale and architect Herbert Dudley Hale. After Roxbury Latin School, Hale's father insisted that he pass the Harvard entrance examinations before he could begin art training. He studied at the Museum School in 1883, then at the New York Art Students' League with J. Alden Weir, and finally in Paris at the Académie Julian and the Ecole des Beaux Arts; he then visited Spain to see the works of Velázquez before returning to New York. After exhibiting his work in Boston (at the Art Club), Philadelphia (Pennsylvania Academy), New York (Society of American Artists, National Academy of Design), and Chicago (Art Institute), Hale went again to France in the fall of 1890. In 1891 he traveled to England and the following year settled in Boston, becoming an instructor of antique drawing at the Museum

Lilian W. Hale, *Self-Portrait*, ca. 1927
Oil on canvas, 30¼ x 25¼ in.
National Academy of Design, New York

Philip L. Hale, *Self-Portrait*, ca. 1917
Oil on canvas, 20 x 16 in.
National Academy of Design, New York

School in 1893. About the same time, he began to spend his summers in Giverny (France) with his friend Theodore Butler, Monet's son-in-law, and began a demanding exhibition schedule that he would maintain throughout his career. In 1898 Hale taught summer classes in Matunuck, Rhode Island, offering instruction at six dollars a week in his own high-keyed style: "Students are advised to bring... plenty of chrome yellow no. 1. It is well to anticipate the yellow fever." The following year he exhibited twenty-eight paintings and seven pastels at Durand-Ruel Galleries in New York, the major dealers of Impressionist painting in both France and America. The pictures were mainly the results of his Rhode Island summers' work – critics gave mixed reviews, finding the post-impressionist color and dissolution of form bold and rather extreme.

Philip Hale's reputation would come to rest more upon his merits as a teacher than upon his own painting. Aside from instruction in antique and life drawing and artistic anatomy at the Museum School (1893-1931), he taught art history classes at Boston University, lectured at the Boston and the Metropolitan museums, gave studio classes at the Pennsylvania Academy (1913-1928), and wrote critical reviews for local papers. In 1913 he published the first American text on Vermeer, a lengthy study on the life and work of an artist much admired by Boston painters. That same year Hale exhibited two pictures in the Armory show. He won many prizes and awards, continuing to show his works nationwide, and served on the jury of the Panama-Pacific Exposition in 1915. He remained an active figure on the Boston art scene throughout the 1920s.

Residences: Fenway Studios, Boston; 1909 + - Sandy Valley Road, 213 Highland St., Dedham

Studios: 1894- St. Botolph St.; 1895- Grundmann Studio Building, Clarendon St.; 1896-1931- 210-211 Fenway Studios, Boston

Member: St. Botolph Club, Copley Society, Guild of Boston Artists, Boston Art Club (1894 on), Philadelphia Art Club (1915 on), San Francisco Society of Artists (1915 on), NAD (Assoc. 1907), National Art Club, National Association of Portrait Painters

References: Hale Papers, Archives of American Art; Hale Family Papers, The Sophia Smith Collection, Smith College; Frederick W. Coburn, "Philip L. Hale: Artist and Critic," *World To-Day* 14 (October 1907), pp. 59-67; Nancy Hale, *The Life in the Studio* (Boston: Little, Brown, 1969)

GEORGE HAWLEY HALLOWELL
Born 1871, Boston; died 1926, Boston

Designer; painter of landscapes and genre scenes in oil and watercolor; muralist; book and poster designer; stained glass artist. Trained to draw by Harvard faculty members Charles E. Norton and Charles H. Moore in the late 1880s, then by Boston architect Arthur Rotch, Hallowell entered the Museum School in 1890, working with Tarbell and Benson for three years. Until about 1900 he contributed drawings to the *Boston Herald* and

designed book covers and posters. After a trip to Europe in 1903 he exhibited paintings for the first time at the St. Botolph Club. He occupied himself with decorative work until about 1906, creating altarpieces and glass for local churches, and then turned to landscape. *Foxes*, purchased by the Museum of Fine Arts in 1935, is characteristic of Hallowell's carefully drawn depictions of forests; his brilliant, jewel-like colors are reminiscent of Maxfield Parrish, a cousin.

Residences: 6 Beacon St., Boston; 229 Park Ave., Arlington Heights

Studio: 10 Marlborough St., Boston

Member: Copley Society, Boston Water Color Club, St. Botolph Club, Boston Society of Arts and Crafts; New York Water Color Club

References: "Hallowell and His Work," *Boston Herald*, February 1, 1903; William H. Downes, "George H. Hallowell's Pictures," *American Magazine of Art* 15, no. 9 (September 1924), pp. 451-457; Nancy Finlay, *Artists of the Book in Boston: 1890-1910* (Cambridge, Mass.: Houghton Library, 1985)

EDWARD WILBUR DEAN HAMILTON
Born 1864, Somerfield, Penna.; died 1943, Kingston, Mass.

Painter of portraits, figure studies, and genre scenes. Hamilton was the fifth son of the Reverend William Hamilton and his wife Henrietta. He studied painting in Boston and graduated from the Massachusetts Normal School of Art in 1883. Upon moving to Providence, he became a student of Tomasso Juglaris (also a teacher at the Cowles Art School) at the Rhode Island School of Design, exhibiting his work there in 1885. In 1889, Hamilton traveled to Paris and won entry to the Ecole des Beaux-Arts, where he worked with Jules Eli Delaunay. He began to exhibit his landscapes and portraits in Paris at the Salon (1889,1890), the International Exposition (1890), and the American Art Club. Returning to Boston in 1892, he showed widely in Boston, New York, Atlanta, and at the annuals; his work was admired for its refinement and attention to detail.

Hamilton and his wife spent eleven summers at Campobello, New Brunswick, an island resort, and he was an active member of the Campobello Club, of which Franklin D. Roosevelt was later president. He painted landscapes there and in Europe, mostly in Brittany and Venice. In 1915 he won a gold medal at the Panama-Pacific Exposition with a tonalist landscape. While he painted many portraits for institutions such as McLean Hospital, Boston University, Lincoln College (Oxford), and the Corcoran Gallery, Hamilton also accepted decorative commissions, including paintings for the altar of Boston's Church of All Nations (Morgan Memorial). He taught at the Massachusetts (Normal) School of Art for over forty years (1891-1942) and became head of its Fine Arts Department. In the mid-1920s, he purchased an eighteenth-century house in Kingston, which he filled with antiques and decorated with a gazebo, gardens, and a sunken swimming pool, described in

the local paper. The house was the site of his own summer art school, formed in 1936, with lessons in portraiture and *plein-air* landscape painting.

Residence: "Studio Landing," Kingston, Mass.

Studio: in his home

Member: Boston Art Club, Guild of Boston Artists, St. Botolph Club, Copley Society; New York Architectural League, Campobello Club

Reference: Edward Wilbur Dean Hamilton Papers, Archives of American Art

FREDERICK CHILDE HASSAM

Born 1859, Dorchester, Mass.; died 1935, East Hampton, N.Y.

Prolific painter of impressionist landscape and city views, figures, and still life in oil; active also in watercolor, pastel, etching, and lithography. Childe Hassam was raised in Dorchester, then a prosperous middle-class suburb of Boston. As a boy he took drawing lessons from Walter Smith (1836-1886), the principal of the Massachusetts Normal School, and during high school he worked in the publishing offices of Little, Brown, and Company. In 1876 he became an apprentice in George E. Johnston's wood-engraver's shop. He made illustrations freelance for local books and magazines and from 1877 to 1879 he studied painting and drawing with Ignaz Gaugengigl privately and at the Boston Art Club, and at the Lowell Institute with William Rimmer. After a trip to Europe in 1883, Hassam held his second solo exhibition of watercolors at Williams and Everett's (the first in 1882) and began to paint Boston street scenes using a blond palette and dramatic perspective. In 1884 he married Kathleen Maude Doane; two years later they moved to Paris, where he studied at the Académie Julian with Boulanger and Lefebvre. He sent work home to be shown at Noyes, Cobb and Company and Doll and Richards in Boston, and also exhibited in Munich and Paris, winning a bronze medal at the 1889 Exposition, the first of almost forty awards he would receive.

When Hassam came back to the United States in 1889 he settled in New York, summering in New England until about 1920, first in Gloucester and on Appledore Island, later at Provincetown and Old Lyme. Among his finest works are the brilliantly colored impressionist pictures of the 1890s: views of the new Beaux-Arts landmarks of New York enlivened by cosmopolitan passers-by and the shimmering ocean at Appledore. Hassam never lost contact with Boston – he exhibited his work regularly at Doll and Richards, Rowlands, the St. Botolph Club, and the Copley Society. His New York shows were frequently reviewed in the Boston newspapers.

In 1897 Hassam became one of the founding members of The Ten. His first solo exhibition in New York was held at Montross Gallery in 1905. Twelve of his works (six oils, five pastels, and one drawing) were included in the Armory Show, though the artist found himself opposed to the most radical modernist painting displayed there.

Hassam maintained an active interest in the graphic arts, producing illustrations for *Harper's*

and *Scribner's* and the children's journal *Saint Nicholas*. His watercolors were reproduced in William Dean Howells's *Venetian Life* (1892) and Celia Thaxter's *An Island Garden* (1894). Between 1915 and 1933 he produced 376 etchings and drypoints.

Residences: 1884-1886- 282 Columbus Ave., Boston; 1889-?- 95 Fifth Avenue; ca. 1902-1920- 27 W. 67th St.; 1920+- 130 W. 57th St., New York

Studios: 1883-1886- 149 Tremont St., Boston; 1889-1892- 95 Fifth Ave.; 1892-1893- Chelsea Hotel, 23rd St.; 1893-ca. 1902- 152 W. 57th St., ca. 1902-1920- 27 W. 67th St.; 1920+- 130 W. 57th St., New York

Member: Boston Art Club (ca. 1878+), Paint and Clay Club, Boston; The Ten (1897-1918), SAA (to 1897), NAD (Assoc. 1902, Acad. 1906), American Academy of Arts and Letters (1920+), American Painters, Sculptors, and Gravers, New York Water Color Club (founding member 1889), Society of American Painters in Pastel, N.Y. (1890+), American Water Color Society, Players Club, Lotos Club (1897+), New York; Munich Secession (corresponding member); Société Nationale des Beaux-Arts (Assoc.)

References: Hassam Papers, American Academy of Arts and Letters, New York (and Archives of American Art); Frank Robinson, *Living New England Artists* (Boston: Samuel E. Cassino, 1888); Frederick W. Morton, "Childe Hassam: Impressionist," *Brush and Pencil* 8, no. 3 (June 1901), pp. 141-150; Israel L. White, "Childe Hassam – A Puritan," *International Studio* 45 (December 1911), pp. 29-36 (suppl.); Adeline Adams, *Childe Hassam* (New York: American Academy of Arts and Letters, 1938); Charles E. Buckley, *Childe Hassam: A Retrospective Exhibition* (Washington, D.C.: Corcoran Gallery of Art, 1965); William E. Steadman, *Childe Hassam: 1859-1935* (Tucson: University of Arizona Museum of Art, 1972)

CHARLES WEBSTER HAWTHORNE

Born 1872, Lodi, Ill.; died 1930, Baltimore

Painter of portraits and figures, genre, and religious scenes in oil and watercolor. Raised in Richmond, Maine, Hawthorne settled in New York in 1890, worked in a stained glass factory, and attended classes at the Art Students' League. After studies with Chase at Shinnecock in 1896 and working as his teaching assistant, he went to Europe in 1898 and the following year established the Cape Cod School of Art in Provincetown, where he taught until his death. Hawthorne traveled and exhibited widely. His portraits were dark and vital in the manner of Luks and Henri; his watercolors, mostly landscapes, are freely brushed in bright colors onto wet paper. Hawthorne was not a member of the Boston School, but several Bostonians studied with him in Provincetown.

Residences: 1900- 146 W. 55th St, New York; 1 Miller Hill Road, Provincetown

Studios: 7 MacDougall Alley and 280 W. 4th St., New York; Provincetown

Member: NAD (Assoc. 1908, Acad. 1911), Salma-

Studios: 1867-1872- Studio Building; 1872+- Harcourt Building; 1902- 2 Winter St., Boston

Member: Copley Society

References: Frederic A. Sharf, "Helen Mary Knowlton," *Notable American Women, 1607-1956* (Cambridge: Harvard University Press, 1971); Martha J. Hoppin, "Women Artists in Boston, 1870-1900: The Pupils of William Morris Hunt," *American Art Journal* 13, no. 1 (Winter 1981), pp. 17-46

LOUIS KRONBERG

Born 1872, Boston; died 1965, Palm Beach, Fla.

Specialist in scenes of ballet dancers in oil and pastel. Kronberg studied at the Museum School (1886-1894) and the New York Art Students' League and won a scholarship to spend three years at the Académie Julian (1894-1897). He exhibited widely in Boston and in the national annuals; he was a good friend of Isabella Stewart Gardner and late in her life acted as her art adviser in Paris. His work is reminiscent of that of Degas.

Residence: in 1902- 2 Winter St., Boston

Studios: by 1900- 12 West St.; by 1916- 198 Clarendon St., Boston

Member: Boston Art Club, Guild of Boston Artists, Copley Society, Salmagundi Club, NAD, Society of Odd Brushes, London Pastel Society, New York Water Color Club, Lotos Club, Chevalier of the Legion of Honor

References: Teresa Cerutti-Simmons, "Behind the Scenes with Louis Kronberg," *American Magazine of Art* 19, no. 3 (March 1928), pp. 194-200

JOHN LAVALLE

Born 1896, Nahant, Mass.; died 1971, New York (?)

Painter of portraits and tropical landscape watercolors. A member of Harvard's class of 1918 and an air force veteran, Lavalle exhibited watercolor "aviation studies" in 1919 at Doll and Richards. He studied with Leslie Thompson and Philip Hale at the Museum School from 1919 to 1922, taking classes in painting and etching, then at the Académie Julian in Paris. Returning to Boston in the late 1920s, he showed his work at the Art Club, Vose, and at several New York galleries. Lavalle rejoined the air force as a camouflager during World War II, serving in Italy and Africa, where he painted oils of plane maneuvers and detailed watercolor studies of African tribesmen.

Residences: 1919- 186 Commonwealth Ave., Boston; 32 Bates St., Cambridge; after 1945- 5th Ave., New York, and Southhampton, Long Island

Studios: Fenway Studios, Boston; after 1945- 1 W. 67th St., New York

Member: Guild of Boston Artists, Boston Society of Water Color Painters, Copley Society, St. Botolph Club, Brush and Chisel Club, Gloucester Art Association

References: Harvard University Alumni Records

PHILIP LITTLE

Born 1857, Swampscott, Mass.; died 1942, Salem, Mass.

Landscape and marine painter, watercolorist, and etcher. Philip Little had the independence of means to support his career as a landscapist, and never had to resort to portraiture for an income: his father was an owner of Pacific Mills, a cotton and wool manufacturing company. After two years at the Massachusetts Institute of Technology (1875-1877) and a trip to the West Indies, Little entered his father's firm. Mostly interested in the design process, he left to study at the Lowell Institute. After a year's work at the Forbes Lithographic Company in Boston (1880) he entered the Museum School, completing his studies in 1882. Little married Lucretia Jackson in 1883 and first exhibited his work at the Boston Art Club, where he continued to show regularly. In 1886, he moved to Salem and shared a studio with Frank Benson. He became associated with Salem both artistically and politically; his work depicted local landmarks, and he served in various political posts in city government.

Little's first solo exhibition was held at Rowlands Galleries in Boston in late 1907 and national success came quickly. The Rhode Island School of Design, the Utica (New York) Library and Art Museum, and the Worcester Art Museum gave him shows in 1909 and the following year forty-five paintings were shown at the St. Louis City Art Museum (and again in 1913). He exhibited in the annuals, at Boston galleries, and in several international exhibitions (Rome, Buenos Aires, San Francisco); his work was critically acclaimed for its freedom from European influence, its "Americanism." (Little had traveled to England once, but not to the continent.) By the early teens he summered in Maine and painted enthusiastic, rough landscapes and sporting scenes.

Little worked actively throughout the twenties and thirties, exhibiting widely and winning several awards for both paintings and etchings. His wife died in 1938 and the following year, on his eighty-second birthday, Little married Caroline King. A memorial exhibition of etchings was held at the Minneapolis Institute of Arts.

Residences: 1886-1888- 35 Warren St.; 1888-1942- 10 Chestnut St., Salem; summers- MacMahan Island, Maine

Studios: 1884- 44 Boylston St., Boston; ca. 1886(?)-1914- 2 Chestnut St.; 1914-1942- 2 Daniel St., Salem

Member: Guild of Boston Artists (founder), Boston Society of Etchers, Boston Water Color Club, American Society of Etchers, Essex Institute (curator of fine arts and council member), Chicago Society of Etchers, National Art Club, Union Club, Portland Society of Arts (Maine)

References: E. Oscar Thalinger, "Paintings by Philip Little," *Art and Progress* (November 1913), pp. 19-21; Caron LeBrun Danikian, *Philip Little* (Boston: Arvest Galleries, 1976)

ROBERT WILTON LOCKWOOD

Born 1861, Wilton, Conn.; died 1914, Brookline, Mass.

Painter of portraits and flowers (peonies a specialty). Lockwood began his art training in 1880 as an assistant in John LaFarge's New York glass studio, where he spent four years (his portrait of LaFarge is in the Museum of Fine Arts, Boston). He studied at the Art Students' League and in 1886 traveled to Paris, spending ten years studying abroad. Lockwood exhibited in the 1894 and 1895 Salons and at the Munich Exposition. In 1895 he settled in Boston, had his first solo exhibition at the St. Botolph Club, and exhibited his portraits widely.

Residence: summers and later year-round- South Orleans, Mass.

Studios: 1896- 280 Boylston St.; by 1910- 282 Boylston St., Boston; 1912 + - New York City

Member: NAD (Assoc. 1906, Acad. 1912), SAA

References: T.R. Sullivan, "Wilton Lockwood," *Scribner's* 23 (February 1898), pp. 178-183; M.I.G. Oliver, "An American Portrait-Painter, Wilton Lockwood," *International Studio* 32 (October 1907), pp. 262-268

ERNEST WADSWORTH LONGFELLOW

Born 1845, Cambridge, Mass.; died 1921, Boston

Painter of portraits and firmly drawn, colorful landscapes. Son of poet Henry Wadsworth Longfellow, Ernest was a Harvard graduate (1865) who studied with Bonnat in Paris (1869) and Couture at Villiers-le-Bel (1876, 1877). He spent his professional life in Boston, exhibiting at the St. Botolph Club (his first show there in 1880, was panned in the *Art Amateur*). Longfellow made frequent trips to New York and Europe and was a trustee of the Boston Museum and the donor of the Longfellow scholarship for Boston art students. He taught a class in life drawing at the School in 1877-1878. An important collector, he left many pictures to the Museum, including John W. Alexander's *Isabella and the Pot of Basil*.

Residence: 108 Brattle St., Cambridge; summers: Coolidge Point, Manchester

Studio: in his home

Member: St. Botolph Club

References: Greta, "Boston Art Notes," *Art Amateur* (February 1880), p. 49; Marchal E. Landgren, *American Pupils of Thomas Couture* (College Park: University of Maryland Art Gallery, 1970); John Hanley Wright, *A Catalogue of a Loan Exhibition of Paintings by Essex County Artists, 1865-1910* (Salem: Essex Institute, 1971)

DODGE MACKNIGHT

Born 1860, Providence, R.I.; died 1950, East Sandwich, Mass.

Prolific, popular landscape watercolorist. After an apprenticeship to a theatrical scene designer, Macknight began in 1878 to work at the Taber Art Company of New Bedford, Mass., a firm that made reproductions of paintings and photographs. In 1883 he entered the Paris studio of Fernand Cormon, Léon Bonnat's successor, and spent three years studying drawing and painting, and exhibiting at the Salons of 1885, 1886, and 1887. From 1886 to 1897 he traveled throughout Europe, spending much of his time in southern France, Spain, and Algeria. Macknight befriended Vincent van Gogh in Paris in 1886 and two years later van Gogh wrote to his brother Theo that he hoped the American painter and Gauguin would join him in an artists' colony in Arles. Macknight visited van Gogh several times, but he did not stay. According to Desmond Fitzgerald, Macknight's biographer and most important local patron from 1889 to 1926, he exhibited his work in John Singer Sargent's London studio in 1890.

Macknight had begun to show his watercolors in Boston in 1888, when he sent thirty-five works to Doll and Richards. He would exhibit there annually (except for 1893-1896) for the rest of his career. After returning to the United States in 1897, with his French-born wife and their son, the artist settled in East Sandwich on Cape Cod. He painted winter landscapes there and in New Hampshire. Each summer he traveled to paint exotic locations, usually ones where he could find picturesque scenery combined with spectacular color effects such as the Grand Canyon, Jamaica, Morocco, and Mexico. At first the critics found his paintings shocking and distasteful; the pure, intense colors Macknight used were dismissed as savage, though he was admired by local artists such as Philip Hale and Denman Ross.

In 1901, his new friend Isabella Stewart Gardner bought ten watercolors and hung them in a "Macknight Room" at Fenway Court. The Museum of Fine Arts purchased one, a winter scene, in 1907, five years before the first Sargent watercolor entered the collection. In 1921 his work was shown with that of Sargent and Homer at the Boston Art Club (in an exhibition that then traveled to Paris). Macknight, active until about 1930, had become so popular that annual shows sold out within an hour, netting him a minimum of $10,000. Albert Gallatin, the great collector of modern art, ranked him along with Whistler, Homer, Sargent, Marin, and Demuth as one of the American masters of the medium.

Residence: 1900-1950- "The Hedges," East Sandwich, Mass.

Studios: East Sandwich, Mass. (in his home)

Member: Boston Water Color Club; New Society of Artists, New York Water Color Club

References: Gardner Museum archives; Desmond Fitzgerald, *Dodge Macknight: Water Color Painter* (Brookline, Mass.: privately printed by Riverdale Press, 1916); Albert Eugene Gallatin, *American Water-Colourists* (New York: E.P. Dutton and Company, 1922); Dorothy Adlow, *Dodge Macknight: 1860-1950* (Boston, Museum of Fine Arts, 1950); Karen E. Haas, "Dodge Macknight – *painting the town red and violet*," *Fenway Court* (Boston: Isabella Stewart Gardner Museum, 1982), pp. 36-47

Hermann Dudley Murphy, *Self-Portrait*, 1930
Oil on canvas, 30 x 25 in.
National Academy of Design, New York

MARY LIZZIE MACOMBER
Born 1861, Fall River, Mass.; died 1916, Boston

Figure painter; specialist in religious and literary themes. Macomber first studied with still-life painter Robert Dunning in Fall River and attended the Museum School from 1884 to 1886. Because of her frail health she never traveled to Europe, but her religious paintings (often part of a large decorative scheme) show the influence of Italian masters and also of the Pre-Raphaelites, both of whom were well represented in Boston. After 1898, with the encouragement of Frank Benson, Macomber began to paint more freely brushed figure studies. She exhibited at the Art Club, Vose, the National Academy, and frequently at the national annuals.

Residences: Waverly, Mass.; by 1910- in her studio

Studio: by 1910- St. Botolph Studios, Boston

Member: Copley Society, Guild of Boston Artists

Reference: William Howe Downes, "Miss Macomber's Paintings," *New England Magazine* 29 (November 1903), pp. 276-288

ERNEST LEE MAJOR
Born 1864, Washington, D.C.; died 1950, Boston

Portrait, figure, and still-life painter and pastelist; teacher. Major first studied art with E.C. Messer at the Corcoran Gallery of Art and in 1882 entered the New York Art Students' League, studying with William Merritt Chase. Two years later he won the Hallgarten Prize and an opportunity to study in Europe for three years. He entered the Académie Julian and in 1885 first exhibited his work at the Salon.

Major came to Boston in late 1888 and began to teach at the Cowles Art School, replacing Dennis Bunker. He was soon exhibiting locally at the Jordan Marsh Art Gallery and the Boston Art Club. In 1896 he began to teach drawing and painting at the Massachusetts Normal Art School. He married Estelle Leighton, who had modeled for him in his most successful paintings, but after a few years she left him to become an opera singer. Major devoted himself to teaching and remained at the Normal School for forty-six years; he exhibited regularly at the national annuals and locally at the Guild of Boston Artists. He won a silver medal at the Panama-Pacific Exposition in 1915 and the Pennsylvania Academy's Bok Prize in 1917. His execution was always fluid, whether applied to pale landscapes, rich still lifes, or stridently colored figure works (cat. no. 14). A memorial exhibition was held at Vose Galleries in 1951.

Residence: by 1914- in the Fenway Studios, Boston; summers- Tamworth, N.H.

Studios: 1907+ - 20 St. Botolph St., by 1914- Fenway Studios

Member: Boston Art Club, Guild of Boston Artists

Reference: Corcoran Gallery of Art Archives

MARTIN MOWER
Born 1870, Lynn; died 1960, Vancouver, B.C.

Landscape and portrait painter. Mower studied at Harvard in the 1890s and became an instructor in its Fine Arts Department in 1900. For thirty-one years he taught freehand drawing and landscape painting. He was a friend and art adviser to Isabella Stewart Gardner, whose portrait he painted in 1917 (Gardner Museum).

Residence: 18 Ash St., Cambridge

Studio: at Harvard University

References: Fogg Museum Archives; Philip Hendy, *European and American Paintings in the Isabella Stewart Gardner Museum* (Boston: Isabella Stewart Gardner Museum, 1974)

HERMANN DUDLEY MURPHY
Born 1867, Marlboro, Mass.; died 1945, Lexington, Mass.

Specialist in seascapes and floral still lifes; portrait painter and frame-maker. The son of a shoe manufacturer in Stoneham, Mass., Murphy decided to become an artist soon after his education at Boston's Chauncy Hall School. He studied at the Museum School with Otto Grundmann and Joseph DeCamp in 1886. The following year he worked as a map maker for the Nicaragua Canal Survey and then spent two years as an illustrator for newspapers and popular magazines; his earliest known works are 1886 sketches after Whistler for *American Art Illustrated*. Late in 1891 he went to France for five years: he studied at the Académie Julian and first exhibited his work at the Salon of 1895, having become fully acquainted with the works of Whistler and the Aesthetic Movement. After his marriage to artist Caroline Bowles in 1895, the couple returned to America in 1897, settled in Winchester, Mass., and by the end of that year Murphy exhibited two tonalist landscapes and three portraits at the Pennsylvania Academy annual. In 1898 he held a one-man exhibition in his Boston studio and the following year showed his hand-carved frames at the Boston Arts and Crafts Society. Like Whistler, Murphy made the frame an integral part of his artistic statement. A close friend of the Prendergast brothers, Murphy had a joint exhibition of paintings with Maurice at the Art Institute of Chicago in 1900. He then joined Charles and W. Alfred Thulin in a frame-making venture that they named "Carrig-Rohane," after Murphy's home. First located in Winchester in 1903, the shop moved to Boston two years later, and after tremendous success was incorporated into Vose Galleries.

Teaching was an important part of Murphy's career. He held summer painting classes on Cape Cod as early as 1899; by 1901 he had joined the faculty of Harvard's School of Architecture, teaching drawing there for thirty-six years, a colleague of fellow colorist Denman Ross. From 1903 to 1907 he was a painting instructor at the Worcester Art Museum.

In 1915 the Murphys were divorced and the following year he married Nellie Littlehale Umbstaetter, a flower painter and a girlfriend of Murphy's youth. The two traveled and exhibited frequently together; by the late 1920s Murphy had also devoted himself to floral still life, which he painted in a tight, academic style.

Murphy's work was critically acclaimed for its spirituality and its poetry. He exhibited widely, and held many solo shows outside of Boston (Chicago, Utica, Buffalo, Detroit, St. Louis, Rochester, and New York City) as well as at the Twentieth Century Club, the Guild of Boston Artists, the St. Botolph Club, and Vose Galleries. In addition to his artistic prowess, Murphy was a champion sailing canoeist and an avid outdoorsman.

Residences: 1903-1916- "Carrig-Rohane," Winchester, Mass.; 1916-1945- Lexington, Mass.

Studios: 1905- Grundmann Studios, Boston; 1903-1916- "Carrig-Rohane," Winchester, Mass.; 1916-1945-Lexington, Mass.

Member: St. Botolph Club, Copley Society (1886 +), Guild of Boston Artists, Boston Art Club, Boston Water Color Society, Boston Society of Arts and Crafts, Boston Society of Water Color Painters, Mass. State Art Commission (1916-1943); American Canoe Association, New York Water Color Club, Salmagundi Club, NAD, National Arts Club, Connecticut Academy of Fine Arts, North Shore Art Association, Ogunquit Art Association

References: Dora M. Morrell, "Hermann Dudley Murphy," *Brush and Pencil* 5, no. 2 (November 1899), pp. 49-57; William A. Coles, *Hermann Dudley Murphy (1867-1945)* (New York, Graham Gallery, 1982); *Hermann Dudley Murphy: Boston Painter at Home and Abroad* (New York: Graham Gallery, 1985)

GEORGE LOFTUS NOYES
Born 1864, Bothwell, Ontario; died 1959, Peterborough, N.H.

Painter of impressionist landscapes, harbor views, and still lifes. Noyes began his training at the Massachusetts Normal School with George Bartlett in the early 1880s and studied at the Académie Colarossi in Paris (1890-1893). He centered his career in Boston and traveled frequently to Algeria, Mexico, and Europe. His first solo exhibition was at the St. Botolph Club in 1915. In 1931 he moved to Florida and in 1935 to Vermont.

Residences: in 1929- 81 Chestnut St., Boston; summers- Annisquam

Studios: 1896- 27 School St.; 1900- Studio Building; 1910- Fenway Studios; 1915- 384 A Boylston St.; 1916- 82 Chestnut St.; 1922- 100 Revere St.; 1930- 81 Chestnut St., Boston

Member: Boston Art Club, Guild of Boston Artists, Boston Society of Water Color Painters, Copley Society

Reference: Randolph Richter, "Rediscovering George Loftus Noyes" (master's paper, Boston University, 1986)

MARIE DANFORTH PAGE
Born 1869, Boston; died 1940, Boston

Painter of portraits and figures (especially of children) and occasional landscapes; graphic artist of posters and book illustrations (Alice Aspinwall's *Short Stories for Young People*, 1895). Page began taking drawing classes when she was seventeen,

studying with Hunt's collaborator Helen Knowlton. In Knowlton's studio in 1889 she met Frank Duveneck, whose informal instruction influenced her lifelong interest in portraiture. Duveneck painted two portraits of her at this time (private collection and Cincinnati Museum of Art). From 1890 to 1895, under the sponsorship of Edward Everett Hale, she studied with Benson and Tarbell at the Museum School. She exhibited her work for the first time at the Boston Art Club in 1894. Although she won the Museum School's traveling fellowship in 1894, care for her ailing mother prevented her going abroad. She married Calvin Gates Page, a Boston doctor and research bacteriologist, in 1896 and toured Europe in 1903, copying the work of Velázquez in Spain. In 1904 she studied color theory and tonal relationships with Denman Ross. Page's first solo exhibition (fifteen portraits) was held at Walter Kimball and Company in 1902. She was admired for her ability to capture the sprightly personalities of young sitters.

In the mid-teens, the motif of mothers and children together began to appear frequently in Page's work. For these paintings she preferred to select subjects from Boston charity homes to avoid the fashionable "look" of professional models (fig. 45). These pictures were well received, and she repeated the theme in her posterwork for the Liberty Loans in 1918 and the YWCA International Conference of Women Physicians in 1919. Page won a bronze medal at the 1915 Panama-Pacific Exposition and the Shaw Prize at the National Academy of Design the following year, as well as many later awards. By the mid-1920s her prices ranged from $500 to $1,000; ten years later they had almost doubled. In Boston she exhibited at the Guild, Vose, and Walter Kimball galleries, in New York at the Academy and Grand Central Art galleries, and nationally at the annual exhibitions. Her popular work was often reproduced in women's magazines.

Residence: 128 Marlborough St., Boston

Studio: in her home

Member: MFA School Board of Visitors, Copley Society, Guild of Boston Artists; Connecticut Academy of Fine Arts, National Society of Portrait Painters, NAD (Assoc. 1927), League of American Artists, American Artists Professional League, N.Y., Union Internationale des Beaux-Arts et des Lettres, Paris

References: Marie Danforth Page Papers, Archives of American Art; Martha J. Hoppin, *Marie Danforth Page: Back Bay Portraitist* (Springfield, Mass.: George Walter Vincent Smith Art Museum, 1979)

ELIZABETH VAUGHAN OKIE PAXTON
Born 1877, Providence, R.I.; died 1971, Newton, Mass.

Painter of still lifes and figure studies in oil. Specific details of Elizabeth Paxton's life are not well known. She studied at the Cowles Art School with Ernest Major and Joseph DeCamp in the early 1890s and there met William Paxton in 1893. They became engaged in 1896 and married in

Marie Danforth Page, *Self-Portrait*, 1928
Oil on canvas, 30 x 25 in.
National Academy of Design, New York

William Paxton, *Self-Portrait*, ca. 1919
Oil on canvas, 30 x 25¼ in.
National Academy of Design, New York

1899, traveling to Europe first in 1901 and several times thereafter. Elizabeth does not seem to have enrolled in art classes or studied with anyone aside from her husband. She maintained a studio in their Newton home and they spent the summers on Cape Ann and Cape Cod.

Known primarily from a few surviving tabletop still lifes, Paxton often painted simple household items such as breakfast trays, but there are also more cluttered works devoted to bric-a-brac and stylish window displays. Like those of her husband, Paxton's objects are invested with a pearly glow and are carefully drawn in a restricted palette of creams and grays. She exhibited her work at the Guild of Boston Artists, the Pennsylvania Academy, Concord Art Association, and the North Shore Art Association. In 1910 she won a medal at the international exhibition in Buenos Aires and, at the Panama-Pacific Exposition of 1915, a silver medal for *In the Morning* (unlocated).

Residences: 43 Elmwood Street and 19 Montvale Road, Newton, Mass.; summers- East Gloucester, Cape Cod

Studios: in her homes; summers- East Gloucester, Cape Cod

Member: Guild of Boston Artists, North Shore Art Association

References: Paxton Papers, Archives of American Art; *Artist-Members*, Boston: Guild of Boston Artists, 1970; Ellen Wardwell Lee et al., *William McGregor Paxton: 1869-1941* (Indianapolis: Indianapolis Museum of Art, 1979)

WILLIAM MCGREGOR PAXTON

Born 1869, Baltimore, Md.; died 1941, Newton, Mass.

Popular figure and portrait painter. The son of a Newton caterer, Paxton began to study art in 1887, when he won a scholarship to attend the Cowles Art School. He worked with Dennis Bunker for two years and then went to Paris to study with Jean-Léon Gérôme, Bunker's teacher, at the Ecole des Beaux-Arts and the Académie Julian. Paxton returned to Boston in 1893, took a studio on Clarendon Street, and began to study with Joseph DeCamp at Cowles. Here he met Elizabeth Okie, also an art student, whom he married in 1899. Paxton made his living drawing posters for the *Boston Herald* (fig. 21) and painting portraits; he began to exhibit his work locally at the Worcester Art Students' Club, the St. Botolph Club, and in Philadelphia at the Art Club. He returned to Europe in 1897 and studied the works of Velázquez in Madrid.

In 1900, Paxton had the first of many solo exhibitions at the St. Botolph Club. He went on to establish himself as a major painter, winning awards at the Buffalo and St. Louis expositions and showing his paintings at the annual exhibitions. One hundred canvases, mostly early works, were lost in the Harcourt Studio fire in 1904 but since his most recent work was being shown at the St. Botolph Club at the time, the losses were minimized. He began a career as a teacher in 1906, when he was appointed instructor of antique

drawing at the Museum School, a position he kept for seven years.

Paxton's paintings were carefully arranged studio pieces created in a more tightly painted, highly finished style than those of his colleagues Benson and Tarbell. His detailed, luminescent pictures of elegant young women and housemaids in interiors were often compared to the work of the little Dutch masters: indeed, he had studied that school and helped Philip Hale to edit his book on Vermeer. Paxton used a method of selective focus (which he called "binocular vision") whereby one central area within the painting was sharply depicted and the more peripheral objects were slightly blurred; again, Vermeer was his inspiration.

In 1912 Paxton was selected to paint two murals for the Washington, D.C., Army and Navy Club, the only decorative works of his career. He had one-man shows in 1918 in Philadelphia (at Rosenbach Co.) and the following year in New York (Folsom Gallery), with reviews that were not enthusiastic; the critics, while appreciative of Paxton's craftsmanship, called him "shallow" and "tawdry" (*New York Evening Post*, quoted in unidentified clipping). By now Paxton was outspoken in his opposition to modernist painting, declaiming its lack of harmony and beauty, which he felt were intrinsic to good art. Yet by 1935 he had won more popular prizes than any other American painter. He suffered a stroke in 1939 and died in his home two years later.

Residences: 43 Elmwood Street (his parents' home); 1917-1941- 19 Montvale Road, Newton, Mass.

Studios: 1893-1896- Grundmann Studios; 1896-1904- Harcourt Studios; 1905-1915-Fenway Studios; 1915-1941- Riverway Studios, Boston; summers- East Gloucester, Cape Cod

Member: Copley Society (1894 +), Boston Art Club (1898 +), Guild of Boston Artists (1914 +), St. Botolph Club, North Shore Arts Association, NAD (Assoc. 1917, Acad. 1928), National Arts Club, Allied Artists of America, N.Y., Union Internationale des Beaux-Arts et des Lettres (Paris), Philadelphia Art Club

References: Paxton Papers, Archives of American Art; Philip Hale, "William MacGregor Paxton," *International Studio* 39, no. 154 (December 1909), pp. xlvi-xlviii; Ellen Wardwell Lee et al., *William McGregor Paxton: 1869-1941* (Indianapolis: Indianapolis Museum of Art, 1979) with extensive bibliography

CHARLES HOVEY PEPPER

Born 1864, Waterville, Maine; died 1950, Brookline, Mass.

Painter of portraits, figure studies, and landscape in gouache, watercolor, and (infrequently) oil. An 1889 graduate of Colby College (son of its president), Pepper studied at the New York Art Students' League in 1890. He worked at the Académie Julian (1893-1897) and with Edmond Aman-Jean; his first solo exhibition was held in 1897 at L'Art Nouveau, a Paris gallery. Pepper

settled in the Boston area in 1897 and in 1903-1904 traveled around the world, living for several months in Japan. A friend of most of the progressive artists who visited Boston – such as Sloan, Hartley, Bakst, Prendergast, and Hopkinson – Pepper collected their work. His own watercolors consisted of strongly colored rugged landscapes and portraits reminiscent of Hartley's work of the 1930s. He exhibited with the "Boston Five" (Marion Monks Chase, Carl Gordon Cutler, Charles Hopkinson, Harley Perkins, and himself), a group dedicated to bringing modernism to Boston.

Residence: 1897-1933- Concord, Mass.; 1933-1950- 33 Griggs Road, Brookline; summers-Attean Lake, Maine

Studio: 1905-1930- Fenway Studios, Boston

Member: Copley Society, Boston Art Club, Boston Water Color Club, St. Botolph Club, Concord Art Association, New York Water Color Society, New Haven Paint and Clay Club

Reference: Joseph Coburn Smith, *Charles Hovey Pepper* (Portland, Maine: Southworth-Anthoensen Press, 1945)

LILLA CABOT PERRY
Born 1848, Boston; died 1933, Hancock, N.H.

Painter of portraits, figure studies, and landscape in oil; important proselytizer on behalf of Monet. Daughter of Samuel and Hannah Lowell Cabot, Lilla married Thomas Sargent Perry (a writer and scholar) in 1874 and attended the Cowles School with Dennis Bunker and Robert Vonnoh (mid-1880s), as well as the Académies Julian and Colarossi in Paris (1887-1889). In 1889 she met Monet at Giverny, where she summered for several years; her work was influenced by the French master. Perry exhibited at the Salon for the first time in 1889; she also showed her work at the international expositions. From 1898 to 1901 she and her husband lived in Japan. Perry was also a writer, publishing articles on Monet and several volumes of poetry.

Residences: 312 Marlborough St., Boston; summers- 1889-1909- Giverny; 1903-1933- Hancock, N.H.

Studio: 1910-1922- Fenway Studios, Boston

Member: Guild of Boston Artists (founder and secretary), Concord Art Association, AFA, International Society of Arts and Letters, Women's International Art Club

References: Stuart P. Feld, *Lilla Cabot Perry: A Retrospective Exhibition* (New York: Hirschl and Adler Galleries, 1969); Carolyn Hilman and Jean Nutting Oliver, "Lilla Cabot Perry – Painter and Poet," *American Magazine of Art* 14, no. 11 (November 1923), pp. 601-604

JOHN BRIGGS POTTER
Born 1864, Lansing, Mich.; died 1949, Boston

Curator and draftsman. Potter entered the Museum School in December 1886 and the following year he won the Longfellow Scholarship to travel to Europe. He received the Chandler Scholarship in 1888 and remained abroad throughout the early 1890s. Entering the Ecole des Beaux-Arts in March 1892, Potter studied with Gérôme and made several exquisite pencil portraits that were signed by his teachers and exhibited at the Museum of Fine Arts under the conditions of his scholarship. He went to Italy and returned to Boston by 1902, when he was appointed Keeper of Paintings at the Museum, the first such professional position at the institution.

In 1908, Potter married Ellen Sturgis Hooper, daughter of the late Edward Hooper (treasurer of Harvard and a serious art collector) and sister-in-law of Bancel LaFarge. Potter's pencil drawings were exhibited at the MFA that year and in 1914 at the Copley Society. He also worked as a restorer of paintings for Isabella Stewart Gardner. In 1928 Potter's title was changed to Advisor to the Department of Paintings (and in 1931 to Fellow) with the arrival of Philip Hendy, the first permanent curator of the department. Potter retired in 1935, and became an Honorary Fellow until his death in 1949.

Residence: 94 Pinckney St., Boston

Reference: Walter Muir Whitehill, *Museum of Fine Arts, Boston: A Centennial History*, 2 vols. (Cambridge: Belknap Press, 1970)

CHARLES PRENDERGAST
Born ca. 1863, Boston; died 1948, Westport, Conn.

Painter of figure studies, landscape, genre scenes in tempera on panel (often with incised gesso and gold leaf) and watercolor; frame and furniture maker. Charles Prendergast lived and worked with his older brother Maurice and was a staunch supporter of his career. He attended Rice Grammar School and became an errand boy for Boston's Doll and Richards Gallery. He traveled to Europe several times with his brother and in 1903 joined Hermann Dudley Murphy in a shop specializing in hand-carved frames. By 1912, Charles had started his career as a panel painter and in 1915, soon after moving to New York with Maurice, he exhibited his work for the first time at Montross Gallery. After Maurice's death, Charles married and soon settled in Connecticut. His modernist works were purchased by two great collectors, Duncan Phillips of Washington, D.C., and Albert Barnes of Philadelphia.

Residence: 1895 + - 83 Hillside St., Roxbury; 1898 + - 27 Winthrop St., Winchester; 1900 + -81 Walnut St., Winchester; 1903 + - 56 Mt. Vernon St., Boston; 1914-1924- 50 Washington Square South, New York; 1929 + - Westport, Conn.

Studios: ca. 1897-1898- 641 Huntington Ave.; in his home; 1903 + - 56 Mt. Vernon St., Boston; 1914-1924- 50 Washington Square South, New York; 1929 + - Westport, Conn.

Member: Boston Society of Arts and Crafts, Society of Independent Artists (1917- vice-president); NAD (Assoc. 1943)

References: Prendergast Papers, Williams College; Carol Clark, *Charles Prendergast: Figures and Carved Panels* (Williamstown, Mass.: Williams College

Museum of Art, 1984); Richard J. Wattenmaker, *The Art of Charles Prendergast* (Boston: Museum of Fine Arts, 1968)

MAURICE BRAZIL PRENDERGAST

Born ca. 1859, St. John's, Newfoundland; died 1924, New York

Innovative painter and watercolorist of landscape, city views, figures, and still lifes; printmaker and illustrator. In 1861 the Newfoundland trading post of Prendergast's father failed and the family moved to Boston. After his education at Rice Grammar School, he worked in a drygoods store, but by 1883 was earning his living as a commercial artist lettering show cards. In 1886 he and his younger brother Charles visited Europe for a few months. Maurice went to Paris in 1891 for his first professional studies: he spent three years, working first at the Académie Colarossi and later at the Académie Julian. His friend James Morrice, a Canadian painter, introduced him to members of the English avant-garde such as Walter Sickert and Aubrey Beardsley. Prendergast's watercolors, small oil sketches, and monotypes of Paris and the seaside resorts of Dieppe and St. Malo reflect his admiration for the Post-Impressionist painters Pierre Bonnard and Edward Vuillard.

Prendergast began to show his watercolors at the Boston Art Club in 1895 (where he continued to exhibit throughout his career). Using the flat decorative compositions complementary to his interests as a painter, he illustrated books for publisher Joseph Knight and Company: Hall Caine's *Shadow of a Crime* (1895), J.M. Barrie's *My Lady Nicotine* (1896), and Ouida's *Muriella* (1897). When he had exhibited more widely – at the Water Color Club and the Society of American Artists in New York, the Chicago Art Institute, and the Pennsylvania Academy – he attracted the attention of Boston collectors and artists Sarah Bradley, Sarah Choate Sears, Charles Woodbury, and Hermann Dudley Murphy (with whom he had a joint exhibition in Chicago in 1899). In June 1898, Prendergast went to Europe for eighteen months, spending most of his time in Venice, captivated by the works of Renaissance painter Vittore Carpaccio. He would return to Europe in 1907, 1909, 1911, and 1914.

William Macbeth became Prendergast's New York dealer in 1900, giving him his first solo exhibition in March of that year. When Macbeth hosted the first exhibition of "The Eight" in 1908, sixteen paintings by Prendergast were included. He had just begun to favor oils as much as watercolor. By the early teens, Prendergast's modernist style had drawn him closer to the New York art world despite his continued involvement in exhibitions at Boston's Art Club, Chase's Gallery, Copley Society, Water Color Club, and the St. Botolph Club. After serving on the selection committee for the 1913 Armory Show, he moved to New York with his brother the following year. He continued to summer along the Massachusetts coast and to draw subject matter from it throughout the rest of his career.

Residences: 1895 + - 83 Hillside St., Roxbury; 1898 + - 27 Winthrop St., Winchester; 1900 + -81 Walnut St., Winchester; 1903 + - 56 Mt. Vernon St., Boston; 1914-1924- 50 Washington Square South, New York

Studios: ca. 1897-1898- 641 Huntington Ave.; in his home; 1903 + - 56 Mt. Vernon St., Boston; 1914-1924- 50 Washington Square South, New York

Member: Guild of Boston Artists, New York Water Color Club, Society of Independent Artists, New York

References: Archives of American Art; Prendergast Papers, Williams College; William M. Milliken, "Maurice Prendergast, American Artist," *Arts* 9 (1924), pp. 181-192; Duncan Phillips, "Maurice Prendergast," *Arts* 5 (1924), pp. 125-131; Hedley Howell Rhys, *Maurice Prendergast, 1859-1924* (Boston: Museum of Fine Arts, 1900); Elizabeth Green et al., *Maurice Prendergast* (College Park: University of Maryland Art Gallery, 1976); George Szabo, *Prendergast, The Large Boston Public Garden Sketchbook* (Oklahoma City: Oklahoma Museum of Art, 1981)

MARGARET F. RICHARDSON

Born 1881, Winnetka, Ill.; died ca. 1945

Portrait painter. Richardson entered Tarbell's portrait class at the Museum School in 1905 and was a special student from 1906 to 1908, acting as Anson Cross's assistant. She exhibited her portraits at the Copley Gallery and won the Harris Bronze Medal (Chicago) in 1911 and the National Academy's portrait prize in 1913.

Residence: by 1929- 274 Commonwealth Ave., Boston

Studios: 1905 + - St. Botolph Studios; 1916 + - Fenway Studios, Boston

Member: Union Internationale des Beaux-Arts et des Lettres

WILLIAM RIMMER

Born 1816, Liverpool, England; died 1879, South Milford, Mass.

Sculptor, painter, and teacher. Rimmer grew up in Boston and became a self-trained businessman, itinerant portraitist, and doctor. His reputation as a teacher and an artist began to be formed in the 1860s with his dynamic sculpture *Falling Gladiator* (1861, Museum of Fine Arts, Boston) and his classes in drawing and anatomy, first offered in the Studio Building, then at the Lowell Institute (1863-1864), Rimmer's own school (1864-1866, 1870-1876), and the Museum School (1877-1879). Books on design (1864) and artistic anatomy (1877) allowed his methods and classical vision to travel beyond the classroom. His best-known works – including the painting *Flight and Pursuit* (1872), several sculptures, and many drawings – are in the Museum of Fine Arts's collection.

Residences: 1840-1855- Randolph; 1855-1863- East Milton; 1863-1879- Chelsea, Mass.

References: Truman H. Bartlett, *The Art Life of William Rimmer: Sculptor, Painter, and Physician* (Boston: James R. Osgood and Company, 1882);

Lincoln Kirstein, *William Rimmer, 1816-1879* (New York: Whitney Museum of American Art, 1946); Jeffrey Weidman, "William Rimmer: Critical Catalogue Raisonné" (Ph.D. dissertation, Indiana University, 1982); Jeffrey Weidman et al., *William Rimmer: A Yankee Michelangelo* (Brockton: Brockton Art Museum, 1985)

AIDEN LASSELL RIPLEY

Born 1896, Wakefield, Mass.; died 1969, Lexington, Mass.

Painter and watercolorist of sporting scenes, Boston views, portraits; muralist, and etcher. Ripley studied briefly at the Fenway School of Illustration and attended the Museum School (1919-1923), winning the Paige Traveling Fellowship to spend two years in Europe. Best known for his duck and grouse hunting scenes, created under the influence of Benson, he taught drawing and painting at the School from 1926 to 1931. His first solo exhibition was at the Guild of Boston Artists in 1926.

Residences: 1929- 28 Chestnut St., Boston; Lexington, Mass.

Studio: in his Lexington home

Member: Guild of Boston Artists, Boston Water Color Society, Copley Society, NAD, American Water Color Society, Allied Artists of America, National Society of Mural Painters

References: Edward Weeks, *A. Lassell Ripley: Paintings* (Boston: Guild of Boston Artists, 1972)

GRETCHEN W. ROGERS

Born 1881, Boston; died 1967, New Haven

Painter of figure studies, portraits, still lifes, landscapes, and interiors in oil. Gretchen Rogers was the daughter of Harry Ashton Rogers, a Boston banker, and his wife Mary. She was educated in private schools and her art training was accomplished in seven years at the Museum School (1900-1907), where she was a pupil of Tarbell and won several school prizes in portraiture and advanced painting.

Rogers was a close friend of Philip and Lilian Hale. In 1915 her work won a silver medal at the San Francisco exposition. She had a solo exhibition at the Guild of Boston Artists in 1917 and showed her work there regularly. She also exhibited in the annuals and at the MacDowell Club Gallery in New York.

Residences: 126 Newbury St.; 250 Beacon St. (with her mother); The Lenox, Boylston St., Boston

Studio: Fenway Studios, Boston

Member: Guild of Boston Artists, AFA

DENMAN WALDO ROSS

Born 1853, Cincinnati, Ohio; died 1935, London, England

Important collector, color theorist, and occasional painter of portraits, figures, and infrequent landscapes and still lifes. Ross graduated from Harvard in 1875, studied at the Académie Julian in 1876, and received his doctorate in history from Harvard in 1890. He did not become active in the

arts until 1893, when he began to lecture on design at the Museum School; in 1899 he joined the faculty of Harvard. Ross was the author of *A Theory of Pure Design* (1907), *On Drawing and Painting* (1912), and *The Painter's Palette, A Theory of Tone Relations* (1919). He traveled widely and was an astute collector, eventually donating over 11,000 objects to the Museum of Fine Arts, including a Tiepolo oil sketch, three Monets, Middle Eastern textiles, and many Chinese porcelains.

Residence: 1871-1935- 24 Craigie St., Cambridge

Studio: in his home

Member: Copley Society, Boston Society of Arts and Crafts (founder), Boston Society of Architects, AFA

References: DAB; Harvard University Alumni Records; Walter Muir Whitehill, *Museum of Fine Arts, Boston: A Centennial History* (Cambridge, Mass.: Belknap Press, 1970)

JOHN SINGER SARGENT

Born 1856, Florence (Italy); died 1925, London

Internationally known for stylish portraits, innovative impressionist figure pieces and landscapes, and later for watercolors, portrait drawings, and Boston murals. Sargent was born in Italy to American parents: a Philadelphia surgeon and his wife, an amateur watercolorist, who had settled in Europe in 1854. At age fourteen he began to attend classes at the Academy in Florence and four years later entered the Paris atelier of Carolus-Duran. Sargent traveled to Spain in 1879 and Holland in 1880, where he admired and copied the bravura painting of Velázquez and Hals. He showed his grand-manner portraits and figure studies regularly at the Paris Salon from 1877; in 1884, his portrait of Mme. Pierre Gautreau (*Madame X*, Metropolitan Museum) caused a scandal at the Salon, forcing the artist to seek commissions in London, his permanent home from 1886. Exhibiting frequently at the Royal Academy, he quickly became the leading portraitist in England and the United States.

On his first working visit to Boston in 1887 Sargent painted the portraits of several European acquaintances, including Isabella Stewart Gardner and members of the Boit and Fairchild families. His first solo exhibition was at the St. Botolph Club in January 1888. He returned in 1890, and was commissioned to paint murals for the Boston Public Library, an expanding project that kept him occupied until 1919, though most of the work was done in England. The first major retrospective of his paintings and drawings was held in 1899 at Copley Hall, Boston. In 1903 he made portraits in the Gothic Room of Mrs. Gardner's recently completed Fenway Court and his work was shown at the Museum of Fine Arts later that year.

By the time Sargent returned to Boston in 1916 to install his latest library murals, he had virtually abandoned portrait painting in favor of watercolor, creating technically brilliant outdoor studies suffused with light and color. The watercolors he made on holidays in Venice, the Alps, the Canadian Rockies, and Florida were eagerly collected

John Singer Sargent, *Self-Portrait*, 1892
Oil on canvas, 21 x 17 in.
National Academy of Design, New York

by Bostonians after the Museum of Fine Arts purchased forty-five in 1912. He accepted a second mural project for the Museum of Fine Arts and a third in 1922 for Widener Library at Harvard. Sargent made frequent trips to Boston after 1918, exhibiting locally at Doll and Richards. He made charcoal portrait sketches of prominent Bostonians, worked on the murals, and became an integral part of the social and artistic circles of the city. He died in London on the eve of his departure for America with the completed museum decorations.

Residences: 1887-1888- St. Botolph Club, Boston; 1890- travels continuously; 1903 + - Hotel Vendôme; 1919 + - Copley Plaza, Boston

Studios: 1887-1888, 1890, 1895, 1903-improvised studios in the homes of his patrons and occasionally borrowed Frederic Vinton's studios at 17 Exeter St. and 247 Newbury St.; 1916-1925- Pope Building, 221 Columbus Avenue (for his mural work); Copley Plaza Hotel, Boston (for charcoal portraits)

Member: Tavern Club, St. Botolph Club; NAD (Assoc. 1894, Acad. 1897), SAA (1880 +), Chevalier, French Legion of Honor, 1889 (Officer, 1895), Société des Beaux-Arts, Paris, Royal Academy, London (Assoc. 1893, Acad. 1897)

References: William Howe Downes, *John S. Sargent: His Life and Work* (Boston: Little, Brown, and Company, 1925); Evan Charteris, *John Sargent* (New York: Charles Scribner's Sons, 1927); David McKibbin, *Sargent's Boston* (Boston: Museum of Fine Arts, 1956); Richard Ormond, *John Singer Sargent: Paintings, Drawings, Watercolors* (New York: Harper and Row, 1970); Carter Ratcliff, *John Singer Sargent* (New York: Abbeville Press, 1982), with extensive bibliography; Trevor J. Fairbrother, *John Singer Sargent and America* (Ph.D. dissertation, Boston University, 1981; New York: Garland Publishing, 1986)

EDITH A. SCOTT
Born 1877, Malden, Mass.; died 1978, Norwood, Mass.

Portrait and miniature painter. Scott entered the Museum School in the fall of 1897 and was awarded her diploma in 1901. She returned to the School to study advanced painting in 1902-1903 and 1904-1905, winning an honorable mention in the Sears Prize Competition and a prize for portraiture (1903). In 1906 she was included in a group exhibition of miniature painters at the Twentieth Century Club. She had studied in Europe by 1913, but details of her travels are unknown. Scott was a close friend of Elizabeth Paxton, and her brother married Adele Okie, Mrs. Paxton's sister. She taught painting for many years at Miss Porter's School for Girls in Farmington, Conn., which now owns some of her portraits; she was the only artist to portray Amelia Earhart from live sittings (now Schlesinger Library, Radcliffe College). Her work was shown at Vose Galleries and the Pennsylvania Academy.

Residences: 220 Forest St., Medford, Mass.; later in the Fenway Studios, Boston; summers: Annisquam, Mass.

Studio: Fenway Studios, Boston

Member: Copley Society

References: MFA School Scrapbooks; Elizabeth Ives Hunter (personal communication)

SARAH CHOATE SEARS
Born 1858, Cambridge, Mass.; died 1935, West Gouldsboro, Maine

Painter of portraits and floral still lifes. Wife of Joshua Montgomery Sears, the richest man in Boston, Sarah studied painting with Dennis Bunker at the Cowles School (about 1885), worked informally with Abbott Thayer and George deForest Brush and attended the Museum School (1889-1891). She exhibited widely and won several medals for her paintings; she was also a photographer and a supporter of F. Holland Day, exhibiting her work in Paris in 1901 at the Photo-Club along with Clarence White and Edward Steichen. A friend of Sargent and Prendergast's patron, Sears owned works by these artists and by Cézanne, Degas, and Cassatt. She donated Manet's *Street Singer* and Abbott Thayer's *Virgin Enthroned* to the Museum of Fine Arts. In 1891 she began annual donations of the Sears Prize to the Museum School.

Residences: 12 Arlington St., Boston; Westborough, Mass.

Studio: in her home

Member: Copley Society, Boston Water Color Club, Boston Society of Arts and Crafts (founder), New York Water Color Club, National Art Club, Philadelphia Water Color Club

References: Estelle Jussim, *Slave to Beauty* (Boston: David R. Godine, 1981); Stephanie Mary Buck, "Sarah Choate Sears: Artist, Photographer, and Art Patron" (master's thesis, Syracuse University, 1985)

EDWARD EMERSON SIMMONS
Born 1852, Concord, Mass.; died 1931, Baltimore

Landscape and portrait painter; specialist in mural decorations after 1893. Simmons grew up in the Old Manse in Concord, surrounded by relatives and family friends who included Ralph Waldo Emerson, Henry David Thoreau, and Louisa May Alcott. He was graduated from Harvard in 1874 and traveled west, first to Cincinnati, Ohio, where he became an oil company agent and a tutor, and later to California. He worked in a San Francisco department store and then left to experience the frontier in the northern counties near Mt. Shasta. Determined to become an artist, he returned to Boston in 1878 and studied at the Museum School with Frederick Crowninshield and at the Lowell Institute with William Rimmer. In 1879 he continued his training at the Académie Julian in Paris. He first exhibited his work at the 1881 Salon, and from 1881 to 1886 maintained a studio at Concarneau, Brittany. After his marriage in 1886, he made an extended trip to Spain, and moved to St. Ives, Cornwall, where a sizable artists' community, including Laurence Alma-Tadema and Anders Zorn, was forming. Simmons stayed in England for five years, exhibiting his romanticized genre

scenes and more freely painted landscapes at the Royal Academy, and spent his summers in France visiting Barbizon, Montreuil, and Grèz.

After thirteen years abroad, Simmons returned to the United States in 1891 and settled in New York. He designed a memorial window for his Harvard class, and the following year traveled to Chicago, where he completed his first mural commission for the Liberal Arts Building of the Columbian Exposition. Simmons became known primarily as a decorative painter, producing compositions for the New York Criminal Courts Building (1895), the Library of Congress (1896), the Panama Pacific Exposition (1913), countless state capitol buildings, and private homes. In 1902, he was commissioned to paint two murals for the Boston State House, one depicting the Battle of Concord and the other the Return of the Flags to the State after the Civil War. Simmons also continued to create easel paintings, though these are less known, in a colorful, linear style. He was a founding member of The Ten, with whom he occasionally exhibited portraits and studies for his mural commissions.

Residences: 1890-1893- St. Ives, Cornwall; early 1900s- 43 E. 27th St.; 1920s- 130 W. 44th St., New York

Studios: 1890-1893- St. Ives, Cornwall; by 1899+- Carnegie Hall, New York

Member: SAA, The Ten, Player's Club, Lambs Club, New York

References: William Henry Howe and George Torrey, "Edward Simmons," *Art Interchange* 33, no. 5 (November 1894), p. 121; Arthur Hoeber, "Edward Simmons," *Brush and Pencil* 5, no. 6 (March 1900), pp. 241-248; Edward Simmons, *From Seven to Seventy: Memories of a Painter and a Yankee* (New York: Harper and Brothers, 1922)

JOSEPH LINDON SMITH

Born 1863, Pawtucket, R.I.; died 1950, Dublin, N.H.

Specialist in depictions of antique reliefs; painter of landscape; muralist. Smith studied at the Museum School (1877) and Académie Julian and became a protegé of Denman Ross. He was extremely interested in Egyptian antiquities; in 1898 he went to the Nile Valley and painted the relief carvings. From 1904 he accompanied archaeologist George A. Reisner (who valued Smith's paintings as records) as part of the joint team from Harvard and the Museum of Fine Arts excavating in Egypt. He taught decorative drawing and design at the Museum School from 1887 to 1891 and at Harvard from 1903 to 1906. He was Honorary Curator of Egyptian Art from 1927 to 1950.

Residences: 1910+- 31 Massachusetts Ave.; 1916+- 93 Mt. Vernon St., Boston; New York City; 1890-1950, summers- Dublin, N.H.

Studios: 1896+- 24 Pinckney St.; 1900- Hotel Ludlow; 1910+- 31 Massachusetts Ave.; 1916+- 93 Mt. Vernon St., Boston

Member: Boston Society of Arts and Crafts, Copley Society, Tavern Club, Society of Mural Painters, Century Association, AFA

Reference: Susan Faxon Olney et al., *A Circle of Friends: Art Colonies of Cornish and Dublin* (Durham: University of New Hampshire, 1985)

ARTHUR PRINCE SPEAR

Born 1879, Washington, D.C.; died 1959, Waban, Mass.

Painter and illustrator; specialist in genre and fantasy scenes. Spear studied at the New York Art Students' League (1899-1902) and the Académie Julian (1902-1907). He settled in Boston in 1907 and taught life drawing at the Fenway School of Illustration. Sometime after 1944 he stopped painting and destroyed much of his work.

Residences: 35 Winchester St.; 156 Winchester St., Brookline; after W.W. II- Waban, Mass.; summers- Friendship and Warren, Maine

Studios: 1910- 11 Hamilton Place; by 1916- Fenway Studios, Boston; in the 1930s- his home

Member: St. Botolph Club, Guild of Boston Artists, Copley Society, Allied American Artists, NAD (Assoc. 1920)

Reference: Arthur P. Spear, Jr., *Arthur Spear: 1879-1959* (Warren, Maine: Warren Historical Society, 1981)

HARRY SUTTON, JR.

Born 1897, Salem, Mass.; died 1984, North Andover, Mass.

Painter of portraits and brightly colored, broadly painted landscapes and still lifes; watercolorist. Sutton studied at the Museum School from 1915 to 1921, won the Paige Traveling Fellowship (1917), and worked at the Académie Julian. He exhibited at the Guild, Vose, Doll and Richards, and Copley galleries.

Residence: North Andover, Mass.

Studio: 85 Newbury St., Boston

Member: Guild of Boston Artists, Boston Water Color Club, Copley Society, St. Botolph Club, Brush and Chisel Club, Tavern Club, AFA

EDMUND CHARLES TARBELL

Born 1862, West Groton, Mass.; died 1938, New Castle, N.H.

Teacher and leader of the "Boston School"; painter of figures in interiors, *plein-air* figure pieces and landscapes, portraits, and still lifes. Tarbell aspired to be an artist at a young age and during his grammar school education in South Boston, he took an evening course in drawing with George H. Bartlett at the Massachusetts Normal Art School. After three years with the Forbes Lithographic Company he entered the Museum School in 1879, studying with Otto Grundmann and Frederick Crowninshield. He went to Paris in 1883 with his classmate Frank Benson, entering the Académie Julian under Boulanger and Lefebvre. They traveled together to England, France, and Germany. Tarbell returned to Boston in 1886, settling in Dorchester and making his living painting portraits. He began to exhibit

Edmund C. Tarbell, *Self-Portrait*, 1889
Oil on canvas, 21 x 17 in.
National Academy of Design, New York

locally in 1887 at the Boston Art Club and the following year in New York at the National Academy of Design and the Society of American Artists. He married Emeline Arnold Souther in 1888; their four children would become frequent subjects of Tarbell's painting. In 1889, following Grundmann's death, Tarbell began to teach painting at the Museum School (continuing until his resignation in late 1912). By 1891 he had assimilated impressionist color and subject matter, painting brilliant canvases of figures outdoors. Tarbell's first solo exhibition, at Chase's Gallery in 1894, included sixteen paintings, primarily the outdoor figurative works for which he was best known. In 1898 he became one of the founding members and most admired painters of The Ten. The mood of Tarbell's work changed by 1905 to a quieter, smoother style, the interiors suffused with light, which critics compared with the works of the little Dutch masters of the seventeenth century. In 1907 he had his first solo exhibition in New York at Montross Gallery; he continued to show his work there and at Knoedler's, although by 1918 the New York critics began to find his work old-fashioned and dispassionate.

In 1918 Tarbell left Boston to direct the Corcoran School of Art, and thenceforth divided his time between Washington, D.C., and New Castle, N.H., where he had made his summer home since the late 1880s. Retiring to New Castle in 1926, he continued to paint and exhibit his work in Boston and in the important annuals. He was also able to devote more time to his favorite hobbies: golf, horses, and baseball. He died in August 1938, a few months before the opening of a joint exhibition with Frank Benson at the Museum of Fine Arts.

Residences: 1895- ca. 1907- 24 Alban St., Dorchester; 1908-1913- Readville; 1914- Dedham; 1915+- Hotel Somerset, Boston

Studios: 1895- ca. 1900- St. Botolph Studios; 1900-1901- Harcourt Studios; 1908-1910- 126 Dartmouth St.; 1911-1938- Fenway Studios, Boston; Washington, D.C.; summers- New Castle, N.H.

Member: Guild of Boston Artists (1914+; served as its first president, 1914-1924), Copley Society, Tavern Club, Myopia Hunt Club, Portsmouth Country Club, NAD (Assoc. 1902, Acad. 1906), SAA (1886-1898), The Ten American Painters, New Society of Artists, American Academy of Arts and Letters

References: Homer Saint-Gaudens, "Edmund C. Tarbell," *Critic* 48 (February 1906), pp. 136-137; Frederick W. Coburn, "Edmund C. Tarbell," *International Studio* 32, no. 127 (September 1907), pp. lxxv-lxxxvii; Charles H. Caffin, "The Art of Edmund Tarbell," *Harper's Monthly* 117, no. 697 (June 1908), pp. 65-74; Kenyon Cox, "The Recent Work of Edmund C. Tarbell," *Burlington Magazine* 14, no. 70 (January 1909), pp. 254-260; Philip L. Hale, "Edmund C. Tarbell – Painter of Pictures," *Arts and Decoration* 2, no. 4 (February 1912), pp. 129-133ff.; John E.D. Trask, "About Tarbell," *American Magazine of Art* 9, no. 6 (April 1918), pp.

216-228; Patricia Pierce, *Edmund C. Tarbell and the Boston School of Painting* (Hingham, Mass.: Pierce Galleries, 1980), with many errors

POLLY THAYER (ETHEL THAYER STARR)
Born 1904, Boston

Painter of portraits, figure studies, landscape, and Boston views. Thayer studied at the Museum School for eighteen months (1923-1925) and took private lessons from Philip Hale. She worked briefly at the New York Art Students' League and in 1929 won the Hallgarten Prize at the National Academy. Her Boston views were exhibited at Childs Gallery.

Residences: 77 Bay State Rd.; 198 Beacon St., Boston; summers- Hingham, Mass.

Studio: in her home

Member: Guild of Boston Artists

References: "The Boston Scene, An Artist's View," *BPL News* 20, no. 5 (May 1969), pp. 1-2; the artist (personal communication)

LESLIE PRINCE THOMPSON
Born 1880, Medford, Mass.; died 1963, Boston

Painter of landscape, still life, portraits in oil, and watercolor. Thompson began his art training at the Massachusetts Normal School in 1900 and the following year entered the Museum School, where he studied with Tarbell until 1904. He won the Paige Traveling Fellowship and worked in Europe until 1906. Thompson taught drawing and painting at the School from 1913 to 1930. He won many awards and taught summer classes in outdoor painting at Ogunquit, Maine.

Residence: Medford; 1940s- Newton, Mass.

Studio: Fenway Studios, Boston

Member: Copley Society, Guild of Boston Artists, St. Botolph Club, Tavern Club, Newport Art Association, NAD (Assoc.)

GIOVANNI BATTISTA TROCCOLI
Born 1882, Lauropoli, Italy; died 1940, Santa Barbara, Calif.

Painter of portraits and (occasionally) landscape and still life in oil. Troccoli came to the United States at age eleven. He became an artist's model for sculptor Hugh Cairns and studied painting in Cambridge with Hermann Dudley Murphy and Denman Ross. Upon completion of his studies at the Académie Julian (from 1900 to 1903), he returned to Boston and had a solo exhibition of portraits at Charles Cobb's gallery in 1910. The following year he won an honorable mention at the Carnegie Institute, in 1913 the Harris Silver Medal at the Chicago Art Institute, and in 1915 a gold medal at the San Francisco Exposition. Troccoli's Italianate studio (described in the December 1917 issue of *House Beautiful* as monkish and cloister-like) was built around 1916; the artist even had a gilding room in which he made frames. A craftsman member of the Boston Society of Arts and Crafts, Troccoli gave classes in woodcarving and made frames for some of his fellow artists. His

large panel portrait of Denman Ross (1934, Museum of Fine Arts, Boston) exemplifies his exacting detail and superb finish, which he mastered in emulation of Italian masters such as Bronzino.

Troccoli began to exhibit regularly at the Guild of Boston Artists and the Boston Art Club in the early 1920s. He married Margaret Champney, the daughter of Edwin and Anna Champney, both Boston painters, and painted his mother-in-law's portrait in 1922 (cat. no. 19). The couple traveled often to California and Troccoli exhibited at the Santa Barbara Art League and in San Francisco. In about 1938, they moved to Santa Barbara.

Residences: Cambridge; 1906- 46 Hudson St., Boston; 1907-1909- 19 Morseland Ave., Newton; 1910-1911- 10 Morseland Ave.; 1912-1915- 19 Morseland Ave.; 1916-1925- 108 Ward St., Chestnut Hill; 1926- 94 Somerset St., Belmont; 1927-1938- 21 Morseland Ave., Newton; 1938+- 526 E. Valerio St., Santa Barbara

Studio: by 1916- 108 Ward St., Chestnut Hill

Member: Guild of Boston Artists, Boston Society of Arts and Crafts (1906-1927); Copley Society; AFA

Reference: "The Studio of Giovanni Battista Troccoli at Chestnut Hill, Massachusetts: Derby and Robinson, Architects," *House Beautiful* 43, no. 1 (December 1917), pp. 13-15

ROSS STERLING TURNER

Born 1847, Westport, N.Y.; died 1915, Nassau, Bahamas

Painter of landscapes and floral still lifes, ship portraits in oil, watercolor, and pastel; illustrator; muralist. Turner was born in upstate New York; in 1862 his family moved to Alexandria, Virginia, and his first job was as a mechanical draftsman, working for a time for the U.S. Patent Office in Washington. In 1876 he went to Europe, first to Paris and then to study at the Munich Academy, where he met fellow Americans Chase and Duveneck. Like them, Turner developed a thick, painterly style. He became close friends with Constantin Bolonachi (1837-?), a Greek painter whose marine subject matter influenced his work. About 1879 Turner traveled to Florence, Rome, and Venice to study the old masters, and in Italy his work became increasingly concerned with the effects of color and light.

In 1883 Turner returned to America and settled in Boston, exhibiting his watercolors and oils at the Boston Art Club and annually at Doll and Richards. He entered the intimate circle of Childe Hassam and the artistic community surrounding Celia Thaxter at Appledore, where he painted gardens in short, quick, colorful strokes that are similar to Hassam's style (cat. no. 97). Upon his marriage to Louise Blaney (artist Dwight Blaney's oldest sister) in 1885, he moved to Salem, but maintained a Boston studio for private lessons. Teaching formed a large part of Turner's career, both in person and through books such as his *Use of Water Color for Beginners*, published by Louis Prang and Company in 1886. He was an instructor

in the architecture department at the Massachusetts Institute of Technology (1884-1885, 1886-1914) and in 1909 he began to teach at the Massachusetts Normal Art School.

Turner traveled frequently in search of new subject matter; his talents as a colorist and his love of the sea took him to Mexico, the Caribbean, and Venice. He died in Nassau, the Bahamas, where he had gone for reasons of health. A memorial exhibition was held at the Guild of Boston Artists in 1915.

Residences: 1885+- 135 Bridge St., Salem; summers- "Rossmore," Wilton, N.H.

Studios: 1883-?- 12 West St., then Boylston St., Boston; in his Salem and Wilton homes

Member: Boston Water Color Club, Boston Society of Arts and Crafts, Boston Art Club (vice president); New York Water Color Club, American Water Color Society

Reference: Archives of American Art; Frank Robinson, *Living New England Artists* (Boston: Samuel E. Cassino, 1888)

FREDERIC PORTER VINTON

Born 1846, Bangor, Maine; died 1911, Boston

Portrait and landscape painter. Vinton spent his childhood in Maine and at age ten moved with his parents to Chicago, returning east to Boston in 1861. About 1864 he met William Morris Hunt, who encouraged his ambition to become a painter. Vinton took classes in drawing at the Lowell Institute with William Rimmer and studied from casts at the Athenaeum while working at a bank, saving money for a European study tour. He began to write art criticism and was a regular contributor to the *Boston Advertiser*. By 1875, Vinton was able to travel to France. He entered Léon Bonnat's studio, but the following year went to Germany, convinced by Frank Duveneck to study at the Munich Academy, where he stayed for one year. Vinton preferred the French approach and returned to Paris to become one of the first American students of Jean-Paul Laurens. He went to Europe for the second time in 1882, accompanied by William Merritt Chase and Robert Blum, traveling to Spain to study and copy the works of Velázquez. Soon after his marriage to Annie Pierce of Newport in 1888 he made a third trip abroad – to Holland to explore the work of Franz Hals.

Vinton's first important Boston commission was his 1878 portrait of Thomas Gold Appleton, the local collector and philanthropist (Harvard University). Other orders followed and Vinton was on his way toward winning a reputation as one of the foremost American portraitists; he specialized in men (unlike most of his Boston contemporaries), and over 300 portraits are known. In style they are dark and elegant, featuring stern expressions and great dignity, and they were often seen as male counterparts to Sargent's brilliant representations of women. In fact, Vinton was occasionally host to his friend Sargent during his Boston trips. For several years in the mid-1880s Vinton occupied the studio of the late William Morris Hunt, and he perpetuated that artist's enthusiasm for painters

of the Barbizon School and, later, for the Impressionists, encouraging his patrons to purchase their work. His own fresh, colorful, and broadly brushed landscapes, little known until the 1911 memorial exhibition, reveal his admiration for these French masters. Vinton's work received great critical acclaim, winning gold medals in Chicago (1893), Buffalo (1901), and St. Louis (1904) among many other awards.

Residences: 17 Exeter St.; 1892-1911- 247 Newbury St., Boston

Studios: 1878- Winter St.; West St.; 1881- Park Square (Hunt's old studio); by 1887- 17 Exeter St. (in his home); 1892-1911- in his home, Boston

Member: St. Botolph Club (founder, 1880), Lowell Institute, Tavern Club; NAD (Assoc. 1882, Acad. 1891), SAA (1880+), Royal Academy

References: DAB; Frank T. Robinson, *Living New England Artists* (Boston: Samuel E. Cassino, 1888); Arlo Bates, *Memorial Exhibition of the Works of Frederic Porter Vinton* (Boston: Museum of Fine Arts, 1911); William H. Downes, "The Vinton Memorial Exhibition," *Art and Progress* 3, no. 4 (February 1912), pp. 474-477

THEODORE WENDEL

Born 1859, Midway, Ohio; died 1932, Ipswich, Mass.

Landscape painter and pastelist. Wendel's parents were German and he, like Enneking, grew up in a small Ohio community. Enrolled in 1876 at the University of Cincinnati's School of Design, he met fellow student Joseph DeCamp and the two young artists traveled to Germany in 1878 to study at the Munich Academy. His academic, solidly drawn work won him a medal there the following year and he joined Frank Duveneck's colony of Americans in Pölling, Bavaria. Following the group to Italy, he spent the next two years (1879-1881) in Florence and Venice; in 1880 he met James MacNeill Whistler and was inspired to take up etching. By 1881 Wendel returned to the United States and exhibited his work for the first time at the Pennsylvania Academy. There is little documentation of his career in the 1880s – only that he showed his work at the Society of American Artists in 1881 and shared a Rhode Island studio with Kenyon Cox in 1883. He returned to Europe and studied at the Académie Julian for a short time; by 1887 he had traveled to Giverny, the home of Monet. Wendel adopted the bright color and sketchy technique of the French master, applying it to his native landscape upon his return to America in 1888.

By 1892 Wendel had settled in Boston, where he had a joint exhibition with Theodore Robinson at Williams and Everett Gallery. He exhibited at the St. Botolph Club and taught at Wellesley College and at the Cowles Art School, where he met student Philena Stone, whom he married in 1897. The two traveled in Europe for a year and then took over the Stone family farm in Ipswich. Maintaining a Boston studio until about 1904, Wendel's paintings and pastels were devoted to the landscape of Ipswich and Gloucester. He had frequent solo exhibitions at the Copley Gallery starting in 1907; his work also appeared at the St. Botolph Club and the Guild of Boston Artists. Artists such as Hale, Benson, and Tarbell expressed their enthusiasm for Wendel's work and its fidelity to nature, but in the 1890s local critics disliked his casual, "modern" compositions. His emphatically brushed landscapes won him the Sesnan Medal at the Pennsylvania Academy in 1909, a bronze medal in Buenos Aires in 1910, and a silver medal at the 1915 Panama-Pacific Exposition. After an illness in 1917 Wendel painted infrequently.

Residences: 1892-1897- 239 Pleasant Square, Boston; 1898-1932- Ipswich, Mass.

Studios: 1892-1894- 135 Huntington Ave.; 1894-1897- 239 Pleasant Square; 1899+ - 12 St. Botolph Street, Boston, and in his Ipswich home

Member: Tavern Club (1893+), Guild of Boston Artists

References: John I.H. Baur, "Introducing Theodore Wendel," *Art in America* 64, no. 6 (November-December 1976), pp. 102-105; John I.H. Baur, *Theodore Wendel: An American Impressionist, 1859-1932* (New York: Whitney Museum of American Art, 1976)

SARAH WYMAN WHITMAN

Born 1842, Lowell, Mass.; died 1904, Boston

Painter of landscape, still lifes, portraits, murals; artist in stained glass and book cover design. A student of William Morris Hunt (1868-1871) and of Thomas Couture in France (1877 and early 1979), Whitman exhibited her work in Boston at Doll and Richards and the St. Botolph Club and in New York at the Academy and the Society of American Artists. After 1880 she devoted herself primarily to innovative Art Nouveau book cover designs (mostly for Houghton Mifflin) and to stained glass, working in both a pictorial format learned from her friend John LaFarge and a clear, decorative, architectural style.

Residence: 1867-1879- 7 Chestnut St.; 1877-1904- 77 Mt. Vernon St., Boston

Studio: in her home and 184 Boylston St., Boston (Lily Glass Works)

Member: Boston Society of Arts and Crafts (founder), Boston Water Color Club, SAA

References: *Letters of Sarah Wyman Whitman*, ed. Bruce Rogers (Cambridge: Riverside Press, 1907); Martha J. Hoppin, "Women Artists in Boston, 1870-1900: The Pupils of William Morris Hunt," *American Art Journal* 13, no. 1 (Winter 1981), pp. 17-46; Nancy Finlay, *Artists of the Book in Boston: 1890-1910* (Cambridge, Mass.: Houghton Library, 1985)

JOHN WHORF

Born 1903, Winthrop, Mass.; died 1959, Provincetown, Mass.

Watercolorist and oil painter, best known for his sporting scenes, city views, and landscapes. Whorf was the son of Harry C. Whorf, a commercial artist and graphic designer, and his wife Sarah. At age fourteen he began to study art with Sherman

Kidd at the St. Botolph Studio. That same year (1917) he began two years of study at the Museum School, under Philip Hale and William James, and also took a class with Charles W. Hawthorne in Provincetown. About 1919 Whorf traveled to France, Spain, Portugal, and Morocco. He studied briefly at the Ecole Colarossi and the Académie des Beaux-Arts, and began to favor watercolor for his brightly colored sketches. By 1924 he had returned to Boston and his first solo exhibition was held at the Grace Horne Gallery, attracting the attention of accomplished watercolorists Sargent and Macknight, each of whom purchased a painting. Whorf credited Sargent with giving him informal instruction that year.

A popular and a prolific painter, Whorf exhibited his work annually at Grace Horne in Boston and at Milch Galleries in New York for over thirty years. His most individual works are probably city views (cat. no. 112), which parallel the contemporary watercolors of Edward Hopper and Reginald Marsh, but a facility with the medium allowed him to make pastiches of the styles of several leading American exponents, including Sargent, Homer, Macknight, and Benson. He was a firm traditionalist and during the 1930s showed his work in Chicago at the "Sanity in Art" exhibitions organized by Mrs. Frank G. Logan. Whorf also exhibited regularly at the Shore Galleries in Provincetown and taught at the Massachusetts Institute of Technology. In 1937 he and his wife Vivienne moved to Provincetown, where he had spent most of his summers since boyhood. Critically well received in both New York and Boston, Whorf was one of two contemporary Massachusetts painters represented in the Museum of Modern Art's 1938 exhibition of American art in Paris.

Residences: 1920s- Brookline; 1937-1945- Nickerson St.; 1945-1950- 17 Commercial St.; 1950-1959- 52 Commercial St., Provincetown, Mass.

Studio: West Vine St., Provincetown

Member: Provincetown Art Association; NAD (Acad. 1947), American Water Color Society

References: "A Colorist in Water Color," *Art in America* 14 (1926), pp. 195-196; *John Whorf, N.A. (1903-1959)* (Boston: Arvest Galleries, 1984)

CHARLES HERBERT WOODBURY
Born 1864, Lynn, Mass.; died 1940, Boston

Painter of land- and seascapes, genre scenes in oil and watercolor; etcher; illustrator. Woodbury graduated from the public schools of Lynn and entered the Massachusetts Institute of Technology in 1882, the same year he exhibited his first landscape at the Boston Art Club. For the next four years, while in school, Woodbury taught sketching along the North Shore and took night classes in life drawing at the Boston Art Club. He received a degree with honors in mechanical engineering from MIT in 1886, and maintained an active interest in science. In 1887 he had his first exhibition at Chase's Gallery, Boston, where he showed his work until about 1900. In addition to oil painting, Woodbury began to etch in 1882 and in 1887 to paint in watercolor. In 1890 he married Marcia

Oakes, also a painter, and the two traveled to Europe. Woodbury studied at the Académie Julian with Boulanger and Lefebvre during the winter of 1890-1891. For the next four years the Woodburys spent their summers in Holland and winters in Boston. In 1896, he built a studio in Ogunquit, Maine, the picturesque summer resort he had first visited in 1888. He began giving summer art classes there in 1898 and added a house to the studio. The classes were held annually until 1915 and again from 1923 to 1939. From 1899 to 1906 and from 1913 to 1914 Woodbury also taught at Wellesley College.

Woodbury had both a scientific and an artistic fascination with the shifting surfaces of the sea, which he explored in thickly painted, richly colored views of the shore and of monumental waves. After his wife's death in 1914 he traveled frequently to Europe and the Caribbean, but he returned annually to Maine. He exhibited in Boston at Chase's Gallery, Doll and Richards, the St. Botolph Club, Guild of Boston Artists, Vose, and the national annual shows. Woodbury was honored with one-man exhibitions at the Art Institute of Chicago (1902), Durand-Ruel in New York (1904), the City Art Museum of Saint Louis (1910 and 1915), the Cincinnati Art Museum (1910 and 1913), the Albright Art Gallery in Buffalo (1912), the Detroit Institute (1913), the Pratt Institute (1914), and with a retrospective at the Addison Gallery of American Art in 1935.

Residences: 1893- 175 Tremont St., Boston; summers- 1898-1940- Ogunquit, Maine; 1916, 1919, 1920-Gerrish Island, Maine

Studios: 1886-1889- 22 School St.; 1889-1890- 3 Winter St.; 1891-1892- Evans House (Tremont and School Streets); 1894 + - 192 Boylston St.; 1901- Harcourt Studios; 1902-1903, 1906, 1914- Grundmann Studios; 1913- Hampton Court; 1917- 16 Arlington St.; 1919- Park Square; 1923- 132 Riverway, Boston; summers- 1896-1940- Ogunquit, Maine

Member: Boston Water Color Club (1900- president), Technology Club, Copley Society, Boston Art Club (1883 +), Guild of Boston Artists (1915 + - founder, board of managers), St. Botolph Club, Ogunquit Art Association (founder); SAA (1889 +), NAD (Assoc. 1906, Acad. 1907), American Water Color Society, New York Water Color Club

References: William Howe Downes, "Charles Herbert Woodbury and his Work," *Brush and Pencil* 6, no. 1 (April 1900), pp. 224-228; William Howe Downes, "The Ideas of a Marine Painter," *Art and Progress* 4, no. 1 (November 1912), pp. 761-766; L.M. [Leila Mechlin], "Charles H. Woodbury's Etchings," *American Magazine of Art* 7, no. 6 (April 1916), pp. 224-228; David C. Woodbury, *Charles H. Woodbury, N.A., 1864-1940* (Boston: Vose Galleries, 1978); *Charles H. Woodbury, N.A. (1864-1940); Marcia Oakes Woodbury (1865-1914)* (Boston: Vose Galleries, 1980)

Bibliography

Amory, Cleveland. *The Proper Bostonians*. New York: E.P. Dutton, 1947.

Baltzell, E. Digby. *Puritan Boston and Quaker Philadelphia*. New York: Free Press, 1979.

Bartolo, Christine. *The Ten: Works on Paper*. Williamstown, Mass.: Sterling and Francine Clark Art Institute, 1980.

Bermingham, Peter. *American Art in the Barbizon Mood*. Washington, D.C.: National Collection of Fine Arts, 1975.

Betsky, Celia. "Inside the Past: The Interior and the Colonial Revival in American Art and Literature, 1860-1914." In *The Colonial Revival in America*. Ed. Alan Axelrod. New York: W.W. Norton and Company for the Henry Francis Dupont Winterthur Museum, 1985, pp. 241-277.

Boyle, Richard J. *American Impressionism*. Boston: New York Graphic Society, 1974.

Brooks, Van Wyck. *New England: Indian Summer, 1865-1915*. New York: E.P. Dutton, 1940.

Burke, Doreen Bolger. *American Paintings in the Metropolitan Museum of Art*. Vol. 3. New York: Metropolitan Museum of Art, 1980.

Caffin, Charles H. *The Story of American Painting*. New York: Frederick A. Stokes Company, 1907.

Corn, Wanda M. *The Color of Mood, American Tonalism, 1880-1910*. San Francisco: M.H. de Young Memorial Museum, 1972.

Davidson, Carla. "Boston Painters, Boston Ladies." *American Heritage* 23, no. 3 (April 1972), pp. 4-7.

Domit, Moussa M. *American Impressionist Painting*. Washington, D.C.: National Gallery of Art, 1973.

Downes, William Howe. "American Paintings in the Boston Art Museum." *Brush and Pencil* 6, no. 5 (August 1900), pp. 201-210.

– . "Boston as an Art Centre." *New England Magazine* 30 (April 1904), pp.155-166.

– . "Boston Art and Artists." In *Essays on Art and Artists* by F. Hopkinson Smith, et al. Boston: American Art League, 1896, pp. 265-280.

– . "Boston Painters and Paintings." *Atlantic Monthly* 62, nos. 3, 4, 5, 6 (July-December 1888).

– . "Impressionism in Painting." *New England Magazine* n.s. 6, no. 5 (July 1892), pp. 600-603.

– . "The New Museum in Boston." *Art and Progress* 1, no. 2 (December 1909), pp. 29-33.

DuBois, Guy Pène. "The Boston Group of Painters: An Essay on Nationalism in Art." *Arts and Decoration* 5 (October 1915), pp. 457-460.

Eldridge, Charles C. *American Imagination and Symbolist Painting*. New York: Grey Art Gallery, New York University, 1979.

Fifty Years of Boston: A Memorial Volume Issued in Commemoration of the Tercentenary of 1930. Ed. Elisabeth M. Herlihy. Boston: Subcommittee on Memorial History of the Boston Tercentenary Commission, 1932.

Fink, Lois Marie. *Academy: The Academic Tradition in American Art*. Washington, D.C.: National Collection of Fine Arts, 1975.

Finlay, Nancy. *Artists of the Book in Boston 1890-1910*. Cambridge, Mass.: Houghton Library, Harvard University, 1985.

Gammell, R.H. Ives. *Boston Painters, 1900-1930*. Ed. Elizabeth Ives Hunter. Orleans, Mass.: Parnassus Imprints, 1986.

– . "A Reintroduction to the Boston Painters." *Classical America* 3 (1973), pp. 94-104.

– . *Twilight of Painting: An Analysis of Recent Trends to Serve in a Period of Reconstruction*. New York: G.P. Putnam's Sons, 1946.

Gerdts, William H. *American Impressionism*. Seattle: Henry Art Gallery, 1980.

– . *American Impressionism*. New York: Abbeville Press, 1984.

– . *Down Garden Paths*. Montclair, N.J.: Montclair Art Museum, 1983.

Green, Martin. *The Problem of Boston*. New York: W.W. Norton, 1966.

Hale, Philip L. *Jan Vermeer of Delft*. Boston: Small, Maynard and Company, 1913.

Haley, Kenneth Coy. *The Ten American Painters: Definition and Reassessment*. Ph.D. diss., State University of New York at Binghamton, 1975.

Harris, Neil. "The Gilded Age Revisited: Boston and the Museum Movement." *American Quarterly* 14, no. 4 (Winter 1962), pp. 545-566.

Hartmann, Sadakichi. *The History of American Art*. 2 vols. Boston: L.C. Page, 1902.

Hayes, Bartlett. *Art in Transition: A Century of the Museum School*. Boston: Museum of Fine Arts, 1977.

Hendy, Philip J. *European and American Paintings in the Isabella Stewart Gardner Museum*. Boston: Isabella Stewart Gardner Museum, 1974.

Hills, Patricia. *Turn of the Century America*. New York: Whitney Museum of American Art, 1977.

Hoopes, Donelson F. *The American Impressionists*. New York: Watson-Guptill Publications, 1972.

Hoppin, Martha J. "Women Artists in Boston, 1870-1900: The Pupils of William Morris Hunt." *American Art Journal* 13, no. 1 (Winter 1981), pp. 17-46.

Item, Samuel. *The History of American Painting*. New York: Macmillan Company, 1905.

Jussim, Estelle. *A Slave to Beauty* [on Boston photographer F. Holland Day]. Boston: David R. Godine, 1981.

Keyes, Donald D. *The Genteel Tradition*. Winter Park, Fla.: George D. and Harriet W. Cornell Fine Arts Center, Rollins College, 1985.

King, Pauline. *American Mural Painting*. Boston: Noyes, Platt and Company, 1901.

Korzenik, Diana. *Drawn to Art: A Nineteenth-Century American Dream*. Hanover, N.H.: University Press of New England, 1985.

Lack, Richard, ed. *Realism and Revolution: The Art of the Boston School*. Dallas: Taylor Publishing Company, 1985.

Lane, Jerrold. "Boston Painting 1880-1930." *Artforum* 10 (January 1972), pp. 49-50.

Leader, Bernice Kramer. "The Boston School and Vermeer." *Arts Magazine* 55 (November 1980), pp. 172-176.

– . "Antifeminism in the Paintings of the Boston School." *Arts Magazine* 56 (January 1982), pp. 112-119.

– . *The Boston Lady as a Work of Art: Paintings by the Boston School at the Turn of the Century*. Ph.D. diss., Columbia University, 1980.

Lears, T.J. Jackson. *No Place of Grace: Antimodernism and the Transformation of American Culture, 1880-1920*. New York: Pantheon, 1981.

Lyczko, J.E. "Dewing's Sources: Women in Interiors." *Arts Magazine* 54 (November 1979), pp. 152-157.

McCoy, Garnett. "The Post-Impressionist Bomb." *Archives of American Art Journal* 20, no. 1 (1980), pp. 13-17.

Mumford, Lewis, and Whitehill, Walter Muir. *Back Bay Boston: The City as a Work of Art*. Boston: Museum of Fine Arts, 1969.

Olney, Susan Faxon. *Two American Impressionists: Frank W. Benson and Edmund C. Tarbell*. Durham, N.H.: University Art Galleries, 1979.

– et al. *A Circle of Friends: Art Colonies of Cornish and Dublin*. Durham, N.H.: University Art Galleries, 1985.

Perry, Lilla Cabot. "Reminiscences of Claude Monet from 1889 to 1909." *American Magazine of Art* 18, no. 3 (March 1927), pp. 119-126.

Pierce, H. Winthrop. *The History of the School of the Museum of Fine Arts, Boston, 1877-1927*. Boston: Museum of Fine Arts, 1930.

Pierce, Patricia Jobe. *Edmund C. Tarbell and the Boston School of Painting: 1889-1980*. Hingham, Mass.: Pierce Galleries, Inc., 1980 (with many errors).

Rathbone, Perry T. *Boston Painters* [pamphlet for an exhibition]. Boston: Museum of Fine Arts, 1971.

Reichlin, Ellie, et al. *A Photographic Intimacy, The Portraiture of Rooms, 1865-1900*. Boston: Society for the Preservation of New England Antiquities, 1984.

Robinson, Frank T. *Living New England Artists*. Boston: Samuel E. Cassino, 1888.

Saisselin, Rémy G. *The Bourgeois and the Bibelot*. New Brunswick, N.J.: Rutgers University Press, 1984.

Schweizer, Paul D. "Genteel Taste at the National Academy of Design's Annual Exhibitions, 1891-1900." *American Art Review* 2, no. 4 (July - August 1975), pp. 77-89.

Sellin, David. *Americans in Brittany and Normandy 1860-1910*. Phoenix: Phoenix Art Museum, 1982.

Soissons, S.C. de. *Boston Artists: A Parisian Critic's Notes*. Boston: Carl Schoenhof, 1894.

Spassky, Natalie, et al. *American Paintings in the Metropolitan Museum of Art*. Vol. 2. New York: Metropolitan Museum of Art, 1985.

Spencer, Harold; Larkin, Susan G.; and Anderson, Jeffrey W. *Connecticut and American Impressionism*. Storrs: University of Connecticut, 1980.

Stebbins, Theodore E., Jr. *American Master Drawings and Watercolors*. New York: Harper and Row, 1976.

Stevens, William B., Jr. *Boston Painters, 1720-1940*. Boston: Boston University School of Fine and Applied Arts, 1968.

Troyen, Carol. *The Boston Tradition*. New York: American Federation of Arts, 1980.

– and Tabbaa, Pamela S. *The Great Boston Collectors*. Boston: Museum of Fine Arts, 1984.

Tucci, Douglas Shand. *Built in Boston: City and Suburb, 1800-1950*. Boston: New York Graphic Society, 1978.

Vose, Robert C., Jr. "Boston's Vose Galleries: A Family Affair." *Archives of American Art Journal* 21, no. 1 (1981), pp. 8-20.

Watson, Forbes. "Sargent – Boston – and Art." *Arts and Decoration* 7 (February 1917), pp. 194-197.

Weber, Nicholas Fox, et al. *American Painters of the Impressionist Period Rediscovered*. Waterville, Maine: Colby College, 1975.

Weinberg, H. Barbara. *The American Pupils of Jean-Léon Gérôme*. Fort Worth: Amon Carter Museum, 1984.

– . "The Lure of Paris: Late Nineteenth-Century American Painters and Their French Training." In *A New World: Masterpieces of American Painting, 1760-1910*. Boston: Museum of Fine Arts, 1983.

Whitehill, Walter Muir. *Museum of Fine Arts, Boston: A Centennial History*. Cambridge, Mass.: Belknap Press, 1970.

Wilson, Richard Guy, et al. *The American Renaissance, 1876-1917*. Brooklyn: Brooklyn Museum, 1979.

Winsor, Justin, ed. *The Memorial History of Boston*. 4 vols. Boston: James R. Osgood, 1880-1881.

Instructors and Courses in the Museum School, 1876-1935

CYNTHIA D. FLEMING

The School of the Museum of Fine Arts, Boston, opened January 2, 1877

1876-1877
Otto Grundmann, 1844-1890, Director *(antique and life drawing, exercises in sketching, and drawing from memory);* **Dr. William Rimmer,** 1816-1879 *(anatomy);* **Francis D. Millet,** 1846-1912 *(drawing [for three weeks; then left for Europe]);* **Edwin Graves Champney,** 1842-1899 *(drawing)*

1877-1878
Grundmann *(drawing and painting);* **Champney** *(drawing);* **Rimmer** *(anatomy, modeling [sculpture]);* **Thomas Dewing,** 1851-1938, Assistant; **James M. Stone,** 1841-1880, Assistant; **William Robert Ware,** 1832-1915 *(perspective);* **Ernest Wadsworth Longfellow,** 1845-1921 *(life drawing [male students only])*

1878-1879
Grundmann *(drawing, painting, life drawing);* **Rimmer** *(anatomy, modeling);* **Frederick Crowninshield,** 1845-1918 *(sketching);* **Champney** *(still life);* **Ware** *(perspective);* **Stone,** Assistant; **Charles Eliot Norton,** 1827-1908 *(history of the arts);* **Charles C. Perkins,** 1823-1886, Lecturer

1879-1880
Grundmann *(drawing and painting);* **Crowninshield** *(drawing and painting; introductory anatomy);* **Edward A. Smith,** active 1880s *(anatomy);* **Anson Cross,** 1862-1944 *(theory of color [assistant: Mr. Woodbridge]);* **Edward H. Greenleaf,** active 1870s-1890s *(ancient mythology);* **Millet** *(ancient costume [Greek and Roman]);* **John LaFarge,** 1835-1910, Lecturer; **Norton,** Lecturer; **Perkins,** Lecturer; **Truman H. Bartlett,** 1835-1923 *(sculpture)*

1880-1881
Grundmann *(drawing and painting [assistants: Miss Purdie and Mr. Claus]);* **Crowninshield** *(drawing and painting [assistants: Miss A.C. Walker, Lilian Greene, E.C. Potter, Robert Reid]);* **Ware** *(perspective);* **Smith** *(anatomy);* **Millet** *(ancient costume [Greek and Roman]);* **Cross** *(theory of color [taught at MIT])*

1881-1882
Grundmann *(drawing and painting [assistants: Mr. Tolman and Miss Purdie]);* **Crowninshield** *(drawing and painting [Grundmann and Crowninshield alternated weekly life drawing and portrait classes]);* **Ware** *(perspective);* **Smith** *(anatomy);* **Greenleaf** *(mythology [classical mythology and its representation in art]);* **Millet** *(ancient costume)*

1882-1883
Grundmann *(drawing and painting [assistants: Miss Hallowell and W.H.W. Bicknell]);* **Crowninshield** *(drawing and painting [assistants: Lilian Greene, Edward C. Potter, Robert Reid, William Stone]);* **Crowninshield** *(anatomy);* **Ware** *(perspective);* **Cross** *(theory of color);* **Sir Seymour Hayden,** 1818-1910 *(etching);* **Perkins** *(history of art)*

1883-1884
Grundmann *(painting [assistants: Miss Hallowell and Edmund C. Tarbell]);* **Crowninshield** *(draw-ing and painting, anatomy [assistants: Greene, Reid, Stone]);* **Ware** *(perspective);* **Greenleaf** *(mythology in art [given every other year])*

1884-1885
Grundmann *(painting [assistants: Miss White, Mr. Bicknell]);* **Crowninshield** *(anatomy, antique drawing, painting [assistants: Lilian Greene, John Redmond, William Stone]);* **William P.P. Longfellow,** 1836-1913 *(perspective)*

1885-1886
Grundmann *(life and portrait painting);* **Robert W. Vonnoh,** 1858-1933 *(painting);* **Joseph DeCamp,** 1858-1923 *(antique drawing);* **Lilian Greene,** active 1880s *(preliminary instruction);* **Dr. Edward Waldo Emerson,** 1844-1930 *(anatomy);* **Longfellow** *(perspective)*

1886-1887
Grundmann *(life drawing);* **Vonnoh** *(painting);* **DeCamp** *(antique drawing);* **Greene** *(preliminary instruction);* **Emerson** *(anatomy);* **Longfellow** *(perspective)*

1887-1888
Grundmann *(life drawing);* **Frank H. Tompkins,** 1847-1922 *(painting);* **DeCamp** *(antique drawing);* **Emerson** *(anatomy);* **Greene** *(preliminary instruction);* **Joseph Lindon Smith,** 1863-1950 *(design [decorative drawing class])*

1888-1889
Grundmann *(life drawing);* **Tompkins** *(painting);* **DeCamp** *(antique drawing);* **Emerson** *(anatomy);* **Greene** *(preliminary instruction)*

1889-1890
Grundmann *(life drawing);* **Frank Weston Benson,** 1862-1951 *(antique drawing and preliminary instruction [assistant: Lucy Fitch]);* **Edmund C. Tarbell,** 1862-1938 *(life painting, still life);* **Emerson** *(artistic anatomy, perspective);* **C. Howard Walker,** 1857-1936 *(decorative design [assistants: J.L. Smith, Helen Coit])*

1890-1891
Benson *(antique drawing [assistant: Lucy Fitch]);* **Tarbell** *(life painting, still life, portraiture);* **Benson and Tarbell** *(life drawing);* **Emerson** *(artistic anatomy);* **Cross** *(practical perspective);* **Walker** *(decorative design [assistants: J.L. Smith, Helen Coit])*

1891-1892
Benson *(antique drawing);* **Tarbell** *(life painting, still life [assistant: Lucy Fitch]);* **Benson and Tarbell** *(life drawing);* **Emerson** *(artistic anatomy);* **Cross** *(practical perspective);* **Ernest Fenollosa,** 1853-1908 *(history of Japanese art);* **Norton** *(theory of art)*

1892-1893
Benson *(antique, life drawing [assistant: Mary Hazelton]);* **Tarbell** *(life painting, still life [assistant: Lucy Fitch]);* **Emerson** *(artistic anatomy, life drawing);* **Cross** *(perspective);* **Edward Robinson,** 1858-1931 *(history of Greek art);* **William R. Emerson,** 1873-1957 *(architecture of the Renaissance);* **Herbert Langford Warren,** 1857-1917 *(art of the Renaissance);* **Charles H. Moore,** 1840-1930 *(Gothic architecture [with Boston Art Students' Association])*

1893-1894
Tarbell *(painting);* **Benson** *(life drawing and painting);* **Philip Leslie Hale,** 1865-1931 *(antique drawing);* **Dr. George Monks,** 1853-1933 *(artistic anatomy);* **Cross** *(perspective);* **Mary B. Hazelton,** 1882-1953 *(drawing);* **Walker** *(decorative design);* **Mrs. William Stone (Alice Hinds),** active 1890s *(decorative design);* **Bela Pratt,** 1867-1917 *(modeling);* **Denman Waldo Ross,** 1853-1935 *(decorative design [household art])*

1894-1895
Tarbell *(painting);* **Benson** *(life drawing and painting);* **Hale** *(antique drawing);* **Monks** *(anatomy);* **Hazelton** *(drawing);* **Cross** *(perspective);* **Pratt** *(modeling);* **Stone** *(decorative design);* **Walker** *(history, theory, and practice of decorative design);* **John Ferguson Weir,** 1841-1926 *(relation of the student to his art);* **Warren** *(Renaissance architecture)*

1895-1896
Tarbell *(painting);* **Benson** *(life drawing and painting);* **Hale** *(antique drawing);* **Emerson** *(anatomy);* **Cross** *(perspective);* **Hazelton** *(drawing);* **Robinson** *(principles of Greek art);* **Pratt** *(modeling)*

1896-1897
Tarbell *(painting);* **Benson** *(life drawing and painting);* **Hale** *(antique drawing);* **Emerson** *(anatomy);* **Cross** *(perspective);* **Hazelton** *(drawing);* **Pratt** *(modeling)*

1897-1898
Tarbell *(painting);* **Benson** *(drawing and painting);* **Hale** *(antique drawing);* **Hazelton** *(drawing);* **Emerson** *(anatomy);* **Cross** *(perspective);* **Pratt** *(modeling);* **Crowninshield** *(mural decoration)*

1898-1899
Tarbell *(painting);* **Benson** *(drawing and painting);* **Hale** *(antique drawing);* **Rosamund L. Smith (Mrs. Bouvé),** ?- ca. 1945 *(drawing);* **Emerson** *(anatomy);* **Cross** *(perspective);* **Pratt** *(modeling)*

1899-1900
Tarbell *(painting);* **Benson** *(drawing and painting);* **Hale** *(antique drawing);* **R. Smith** *(drawing);* **Emerson** *(anatomy);* **Cross** *(perspective);* **Norton** *(imagination in art);* **Pratt** *(modeling)*

1900-1901
Tarbell *(painting);* **Benson** *(drawing and painting);* **Hale** *(antique drawing);* **R. Smith** *(drawing);* **Emerson** *(anatomy);* **Cross** *(perspective);* **Pratt** *(modeling)*

1901-1902
Tarbell *(painting);* **Benson** *(drawing and painting, still-life painting);* **Hazelton** *(painting and drawing, preliminary instruction);* **Emerson** *(anatomy);* **Cross** *(perspective)*

1902-1903
Tarbell *(painting);* **Benson** *(life drawing and painting);* **Hale** *(antique drawing);* **Hazelton** *(still-life painting);* **Emerson** *(artistic anatomy);* **Cross** *(perspective);* **Pratt** *(modeling)*

1903-1904
Tarbell *(painting);* **Benson** *(drawing and painting);* **Hale** *(antique drawing);* **Hazelton** *(still-life painting);* **Emerson** *(artistic anatomy);* **Cross** *(perspective);* **Pratt** *(modeling)*

1904-1905
Tarbell *(painting);* **Benson** *(life drawing and painting);* **Hale** *(antique drawing, artistic anatomy);* **Hazelton** *(still-life painting);* **Cross** *(perspective);* **Walker** *(design [assistant: K. Child]);* **Pratt** *(modeling)*

1905-1906
Tarbell *(painting);* **Benson** *(life drawing);* **Hale** *(antique drawing, artistic anatomy);* **Hazelton** *(still-life painting);* **Cross** *(perspective);* **Pratt** *(modeling)*

1906-1907
Tarbell *(advanced painting, portraiture);* **Benson** *(painting);* **Hale** *(life drawing, artistic anatomy);* **William M. Paxton,** 1869-1941 *(antique drawing);* **Cross** *(perspective);* **Pratt** *(modeling)*

1907-1908
Tarbell *(advanced painting, portraiture);* **Benson** *(painting);* **Hale** *(life drawing, artistic anatomy);* **Paxton** *(antique drawing);* **Cross** *(perspective);* **Pratt** *(modeling)*

1908-1909
Tarbell *(advanced painting, portraiture);* **Benson** *(painting);* **Hale** *(life drawing [classes for men and women separate], artistic anatomy);* **Paxton** *(antique drawing);* **Cross** *(perspective);* **Pratt** *(modeling)*

1909-1910
Tarbell *(advanced painting, portraiture);* **Benson** *(painting);* **Hale** *(life drawing, artistic anatomy);* **Paxton** *(antique drawing [assistant: Arthur Hutchins]);* **Cross** *(perspective [assistant: Margaret Fuller]);* **Pratt** *(modeling)*

1910-1911
Tarbell *(advanced painting, portraiture);* **Benson** *(painting);* **Hale** *(life drawing, artistic anatomy);* **Paxton** *(antique drawing [assistant: Ralph McLellan]);* **Cross** *(perspective);* **Pratt** *(modeling [assistant: Anna Pell Woollet])*

1911-1912
Tarbell *(advanced painting, portraiture);* **Benson** *(painting);* **Hale** *(life drawing, artistic anatomy);* **Paxton** *(antique drawing [assistant: McLellan]);* **Cross** *(perspective);* **Pratt** *(modeling [assistant: Woollett])*

1912-1913
Tarbell *(painting);* **Benson** *(painting);* **Frederick A. Bosley,** 1882-1942 *(painting);* **Hale** *(life drawing, artistic anatomy);* **Paxton** *(antique drawing [assistant: McLellan]);* **Cross** *(perspective [assistant: Adeline Wolever]);* **Pratt** *(modeling [assistant: Frederick W. Allen]);* **Huger Elliott,** 1877-1948, Director of Dept. of Design *(evolution of painting)*

1913-1914
Benson, Visiting Instructor *(painting);* **Hale** *(life drawing, anatomy);* **Bosley** *(painting);* **William James,** 1882-1962 *(painting);* **Leslie Thompson,** 1880-1963 *(drawing);* **Ralph McLellan,** 1884- ? *(drawing);* **Pratt** *(modeling [assistant: Allen]);* **Cross** *(perspective [assistant: Wolever])*

1914-1915
Benson, Visiting Instructor *(painting);* **Hale** *(life drawing; anatomy);* **Bosley** *(painting);* **James** *(painting);* **Thompson** *(drawing);* **McLellan** *(drawing);* **Cross** *(perspective [assistant: Wolever]);* **Pratt** *(modeling [assistant: Allen])*

1915-1916
Benson, Visiting Instructor *(painting);* **Hale** *(life drawing, artistic anatomy);* **Bosley** *(painting);* **James** *(painting);* **Thompson** *(drawing);* **McLellan** *(drawing);* **Cross** *(perspective* [assistant: Wolever]); **Pratt** *(modeling* [assistant: Allen])

1916-1917
Benson, Visiting Instructor *(painting);* **Hale** *(life drawing, anatomy);* **Bosley** *(life painting);* **James** *(life painting);* **Thompson** *(antique drawing);* **McLellan** *(antique drawing);* **Cross** *(perspective* [assistant: Wolever]); **Pratt** *(modeling* [assistant: Allen])

1917-1918
Hale *(life drawing, anatomy);* **Bosley** *(life painting);* **James,** on leave of absence, serving in France; **Thompson** *(antique drawing);* **McLellan** *(antique drawing);* **Cross** *(perspective);* **Frederick W. Allen,** 1888-1962 *(modeling)*

1918-1919
Hale *(life drawing, anatomy);* **Bosley** *(painting);* **James** *(painting);* **Thompson** *(drawing);* **McLellan** *(drawing);* **Cross** *(perspective);* **Allen** *(modeling)*

1919-1920
Hale *(life drawing, anatomy);* **Bosley** *(painting);* **James** *(painting);* **Thompson** *(drawing);* **Cross** *(perspective)*

1920-1921
Hale *(life drawing; anatomy);* **Bosley** *(painting);* **James** *(painting);* **Thompson** *(antique drawing* [assistant: MacIvor Reddie]); **Cross** *(perspective)*

1921-1922
Hale *(life drawing, anatomy);* **Bosley** *(painting);* **James** *(painting);* **Thompson** *(drawing);* **Cross** *(perspective)*

1922-1923
Hale *(life drawing, anatomy);* **Bosley** *(painting);* **James,** on leave; **Thompson** *(drawing);* **Cross** *(perspective)*

1923-1924
Hale *(life drawing, anatomy);* **Bosley** *(painting);* **James** *(painting);* **Thompson** *(drawing);* **Cross** *(still life, perspective)*

1924-1925
Hale *(life drawing, anatomy);* **Bosley** *(painting);* **James** *(painting);* **Thompson** *(drawing);* **Cross** *(still life, artistic perspective);* **Florence L. Sullivan,** active 1920s *(drawing)*

1925-1926
Hale *(life drawing, anatomy);* **Bosley** *(painting);* **James** *(painting);* **Thompson** *(drawing);* **Cross** *(still life, artistic perspective);* **Sullivan** *(drawing)*

1926-1927
Hale *(life drawing, anatomy);* **Bosley** *(painting);* **Thompson** *(painting);* **Aiden L. Ripley,** 1896-1969 *(drawing);* **Cross** *(still life, perspective);* **Bernard M. Keyes,** 1898-1973 *(drawing)*

1927-1928
Hale *(life drawing, artistic anatomy);* **Bosley** *(painting [advanced]);* **Thompson** *(portrait painting);* **Ripley** *(antique drawing);* **Keyes** *(antique drawing, perspective)*

1928-1929
Tarbell, Director *(drawing and painting);* **Benson,** Director *(drawing and painting);* **Hale** *(life drawing, artistic anatomy);* **Bosley** *(painting [advanced], history of technique of painting and sculpture);* **Thompson** *(portrait painting);* **Ripley** *(antique drawing);* **Keyes** *(antique drawing, perspective)*

1929-1930
Tarbell, Director *(drawing and painting);* **Benson,** Director *(drawing and painting);* **Hale** *(life drawing, artistic anatomy);* **Bosley** *(painting [advanced]);* **Thompson** *(portrait painting);* **Ripley** *(antique drawing);* **Keyes** *(antique drawing, perspective)*

1930-1931
Tarbell, Director; **Benson,** Director; **Hale** *(life drawing, artistic anatomy);* **Bosley** *(painting [advanced]);* **Thompson** *(portrait painting);* **Ripley** *(antique drawing);* **Keyes** *(antique drawing, perspective)*

1931-1932
Rodney J. Burn, 1899-? *(drawing and painting);* **Robin Guthrie,** 1902-? *(drawing and painting);* **James,** Chairman of Administrative Council

1932-1933
Burn, Director *(drawing, painting, and composition);* **Guthrie,** Director *(drawing, painting, and composition);* **John Sharman,** 1879-1971 *(drawing, painting, and composition);* **Dr. Torr Wagner Harmer,** 1881-1940 *(anatomy)*

1933-1934
Burn *(drawing, painting, and composition);* **Sharman** *(drawing, painting, and composition);* **Ture Bengtz,** 1907-1973, Assistant; **James,** Visiting Instructor *(painting)*

1934-1935
Alexandre Iacovleff, 1887-1938 *(drawing, painting, and composition);* **Sharman** *(drawing, painting, and composition);* **Bengtz** *(drawing, painting, and composition)*